Métiers et techniques du cinéma et de l'audiovisuel : sources, terrains, méthodes

PETER LANG

Bruxelles · Bern · Berlin · New York · Oxford · Wien

ICCA

Industries culturelles, création, numérique

sous la direction de Bertrand Legendre et François Moreau

Sous l'égide du LABoratoire d'EXcellence ICCA (Industries Culturelles et Création Artistique), cette collection réunit les résultats de recherches consacrées aux différentes industries culturelles, traditionnelles comme le cinéma, la télévision, la musique ou l'édition, ou plus récentes comme la vidéo ou le jeu vidéo. Elle privilégie une perspective interdisciplinaire pour étudier les dispositifs de médiation et de promotion, les pratiques de consommation et les mutations induites par des mouvements de fond comme la mondialisation ou la numérisation, qui bouleversent aussi bien les processus de création des contenus que les modes de financement et de distribution de la production.

Conseil scientifique de la collection :
Bertrand LEGENDRE – LabSIC (Université Paris 13)
Fabrice ROCHELANDET – IRCAV (Université Paris 3)
François MOREAU – CEPN (Université Paris 13)
Pascale GARNIER – EXPERICE (Université Paris 13)
François MAIRESSE – CERLIS (Université Paris 3)
Emmanuel MAHÉ – ENSADLab (ENSAD)
Bruno HENOCQUE – CEISME (Université Paris 3)
Philippe BOUQUILLION – LabSIC (Université Paris 13)
Pierre MOEGLIN – LabSIC (Université Paris 13)
Céline BLOUD-REY – IRDA (Université Paris 13)

Métiers et techniques du cinéma et de l'audiovisuel : sources, terrains, méthodes

Sous la direction de
Hélène Fleckinger, Kira Kitsopanidou et
Sébastien Layerle

ICCA – Industries culturelles, création, numérique
Vol. 10

Publié avec le soutien du LabEx Industries culturelles et Création artistique (ICCA), du laboratoire IRCAV de l'Université Paris 3, de la Direction des services de la Recherche et du laboratoire ESTCA de l'Université Paris 8.

Cette publication a fait l'objet d'une évaluation par les pairs.

© P.I.E. PETER LANG S.A.
Éditions scientifiques internationales
Brussels, 2020
1 avenue Maurice, B-1050 Bruxelles, Belgium
brussels@peterlang.com ; www.peterlang.com

ISSN 2506-8741
ISBN 978-2-8076-0770-5
ePDF 978-2-8076-1276-1
ePub 978-2-8076-1277-8
Mobi 978-2-8076-1278-5
DOI 10.3726/b16260
D/2019/5678/52

Information bibliographique publiée par « Die Deutsche Bibliothek »

« Die Deutsche Bibliothek » répertorie cette publication dans la « Deutsche Nationalbibliografie » ; les données bibliographiques détaillées sont disponibles sur le site <http://dnb.ddb.de>.

À la mémoire de Chantal Duchet

Remerciements

Cet ouvrage réunit les contributions remaniées et enrichies du colloque « Métiers et techniques du cinéma et de l'audiovisuel : approches plurielles (objets, méthodes, limites) » qui s'est tenu à l'Institut national d'histoire de l'art (INHA) à Paris les 12 et 13 février 2016, sous la direction d'Hélène Fleckinger, Kira Kitsopanidou et Sébastien Layerle.

Ce travail de recherche n'aurait pas pu être mené à bien sans le concours ni le soutien de personnes et d'institutions que nous remercions ici :

Le LabEx Industries culturelles et Création artistique (ICCA), en particulier Vanessa Berthomé ;

L'Institut de Recherche sur le Cinéma et l'Audiovisuel (IRCAV) de l'Université Sorbonne Nouvelle - Paris 3 (Jean-Pierre Bertin-Maghit et Guillaume Soulez) et le laboratoire Esthétique, Sciences et Technologies du Cinéma et de l'Audiovisuel (ESTCA) de l'Université Paris 8 Vincennes Saint-Denis (Cécile Sorin, Dork Zabunyan et Emmanuel Dreux) ;

Le Conseil scientifique et le Service des Relations internationales de l'Université Paris 3 ;

La Direction des services de la Recherche de l'Université Paris 8 ;

Le département Cinéma et Audiovisuel de l'UFR Arts & Médias de l'Université Paris 3 et le département Cinéma de l'UFR Arts, Philosophie, Esthétique de l'Université Paris 8 ;

La Bibliothèque nationale de France (Alain Carou), la Cinémathèque française (Joël Daire), la Direction du patrimoine cinématographique du Centre national du cinéma et de l'image animée (Éric Le Roy), l'École nationale supérieure Louis-Lumière (Giusy Pisano et Pascal Martin), la Fondation Jérôme Seydoux-Pathé (Stéphanie Salmon et Anne Gourdet-Marès) et l'Institut national de l'audiovisuel (Géraldine Poels et Catherine Gonnard) ;

La Chapman University pour la mise à disposition de photographies issues de leurs fonds et reproduites dans cet ouvrage ;

L'INHA et ses techniciens.

Nous adressons également nos remerciements aux partenaires, enseignants-chercheurs, professionnels, étudiants et ayant-droits qui ont permis la réussite du colloque à l'origine de cet ouvrage et assuré l'expertise des textes avant publication : Clémence Allamand, Jacques Ayroles, Claude Bailblé, Martin Barnier, Jean-Pierre Beauviala, Lauren Benoit, Jean-Pierre Bertin-Maghit, Christa Blümlinger, Bérénice Bonhomme, Dominique Bougerol, Teresa Castro, Jamil Dakhlia, Bénédicte Delesalle, Chantal Duchet, Marthe Fieschi, Simon Fieschi, Marie Frappat, Anaïs Gagliardi, Mary Georgakopoulou, Evgenia Giannouri, Arnaud Gosset, Antoine Guichard, Caroline Guigay, Julie Guillaumot, Réjane Hamus-Vallée, Barbara Laborde, Morgan Lefeuvre, Emmanuel Loiseau, Raphaëlle Moine, Damien Mottier, Roger Odin, Alexandre Odzioba, Aurélie Pinto, Marie Pruvost-Delaspre, Nils Ramme, Gilles Remillet, Caroline Renouard, Françoise Risterucci, Mélanie Roero, Sébastien Roffat, Frédéric Sabouraud, Renée Saulnier, Frédéric Tabet, Marie-Charlotte Téchené, Olivier Thévenin, François Thomas, Stéphane Tralongo, Alexandre Tsekenis, Benoît Turquety, Rachel Van De Merrsche, Cécile Welker et Dominique Willoughby.

Un grand merci enfin à Thomas Pillard pour ses retranscriptions et ses relectures attentives.

Table des matières

Deuxième partie
Les métiers du cinéma et leurs évolutions

Troisième partie
Faire l'histoire des techniques et des métiers

Introduction

Kira KITSOPANIDOU ET Sébastien LAYERLE

La réflexion méthodologique est au cœur de cet ouvrage qui rassemble les contributions de jeunes chercheurs dont les travaux, parmi les plus innovants, témoignent d'une dynamique significative au sein des études cinématographiques et audiovisuelles en France. La principale ambition de ce livre est de conjuguer, à partir de terrains d'exploration divers, les apports des approches anthropologiques, historiques, sociologiques, économiques et esthétiques pour penser la recherche sur les métiers et les techniques du cinéma et de l'audiovisuel. Une série de programmes scientifiques à dimension collective et pluridisciplinaire a vu le jour ces dernières années, qui situent explicitement la question des métiers et des techniques au centre de leur démarche[1]. Ces initiatives, auxquelles s'ajoutent des séminaires d'enseignement et de recherche, constituent autant de chantiers qui concourent à la structuration, à l'organisation et à la visibilité des travaux sur les métiers et les techniques, rompant ainsi avec un relatif désintérêt pour ce champ d'étude.

[1] Au niveau national, citons le programme *La création collective au cinéma*, sur l'évolution des pratiques de coopération au sein de l'équipe du film (<https://creationcollectiveaucinema.com/le-projet/>) et le projet ANR Beauviatech (<https://beauviatech.hypotheses.org>), consacré à l'étude historique et esthétique des techniques audiovisuelles ; à un niveau international, le programme *Technès*, sur les techniques audiovisuelles et leurs usages (<http://technes.org/fr/Projet>) et *Les Arts trompeurs : machines, magie, médias*, sur l'archéologie des techniques du cinéma et de l'audiovisuel (<http://www.lesartstrompeurs.labex-arts-h2h.fr/fr>). Un premier colloque a eu lieu à Cerisy en août 2016 sur les rapports entre la magie et les médias, et un second spécifiquement sur la stéréoscopie en septembre 2016.

Une lente intégration des métiers et des techniques dans l'historiographie du cinéma

Dans l'avant-propos du numéro de la revue *1895* consacré à l'histoire des métiers du cinéma en France avant 1945[2], Priska Morrissey et Laurent Le Forestier mettent en évidence le long processus d'intégration des métiers et des techniques dans l'historiographie française du cinéma. L'histoire technologique a d'abord intéressé des praticiens, à l'image de Jean Vivié[3] et de Michel Wyn[4], mais aussi des pédagogues et des vulgarisateurs tels que Guillaume-Michel Coissac[5] ou Maurice Noverre[6], dont les travaux, pour les plus anciens, ont longtemps constitué en France les seules bases d'une histoire du cinéma encore à écrire. L'« auteurisme » cinéphile et son influence sur les études cinématographiques et les programmes d'enseignement à compter de la fin des années 1960 sont des facteurs souvent évoqués pour expliquer le retard avec lequel l'historiographie a pris en compte la dimension collective de la création cinématographique (l'équipe du film) et la matérialité du cinéma (au-delà des effets de la technique sur la seule dimension esthétique). Priska Morrissey et Laurent Le Forestier précisent toutefois que la « politique des auteurs » a aussi « permis la ré-émergence de "grands" collaborateurs de création avec ce cercle élargi d'auteurs »[7], non sans échapper à une certaine tentation de les « panthéoniser » à leur tour. En témoigne le nombre croissant

[2] Priska Morrissey et Laurent Le Forestier, « Pour une histoire des métiers du cinéma, des origines à 1945 », *1895, revue d'histoire du cinéma*, n° 65, AFRHC, 2011, p. 8–27.

[3] Jean Vivié, *Traité général de la technique du cinéma : 1. Historique et développement de la technique cinématographique*, Paris, Bureau de presses et d'informations, 1946.

[4] Voir notamment *Le cinéma et ses techniques*, Paris, Éditions techniques européennes, 1982, 345 p. [1965] et *L'assistant réalisateur de télévision* (avec Alain Blancel), IDHEC, 1958.

[5] Militant catholique et fervent défenseur de l'éducation par le cinéma, Coissac a notamment écrit « Le cinéma, son passé, son présent, son avenir », dans *Annuaire de la cinématographie*. Paris, publications *Ciné-journal*, 1917–1918, p. 457–507 et *Histoire du cinématographe des origines à nos jours*, Paris, Cinéopse-Gauthier Villars, 1925.

[6] Ancien avocat, collaborateur de la revue *Cinéopse*, Noverre est considéré par Jacques Deslandes comme le premier historien du cinéma. Voir *Émile Reynaud, sa vie, ses travaux*, Brest, Imprimé pour l'auteur, 1926 et « L'œuvre de Georges Méliès : étude rétrospective sur le premier "studio cinématographique" machiné pour la prise de vues théâtrales », *Le nouvel art cinématographique*, 2ᵉ série, n° 3, Brest, juillet 1929, p. 64–83.

[7] *Pour une histoire des métiers du cinéma, des origines à 1945*, *op. cit.*, p. 21.

de monographies, de biographies et d'entretiens exposant, à partir des années 1970 et 1980, la méthode personnelle et la conception du métier de quelques grandes figures de collaborateurs – ces derniers jouant, par ailleurs, un rôle actif dans l'historicisation et la théorisation d'un art du métier qu'ils ont souvent enseigné. Une conséquence majeure de cette survalorisation du geste de l'auteur, individu par excellence, et de quelques personnalités exceptionnelles parmi les collaborateurs de création, est la quasi-invisibilisation de nombreux métiers techniques, à commencer par les « petites mains » des plateaux et des laboratoires, pourtant essentiels à la fabrique et à la diffusion des films. Comme le note Yann Darré, « la division du travail dans le cinéma d'auteur reproduit la division sociale : on a remis poliment la technique à sa place, et les "travailleurs" hors champ. »[8]

L'indifférence manifeste à l'égard des métiers techniques transparaît de manière tout aussi flagrante dans les études consacrées à la télévision, en particulier dans les approches historiques. Lorsque la sociologie du travail a commencé à s'intéresser aux professions de la télévision dans les années 1990, l'attention des chercheurs s'est portée prioritairement vers les métiers plus artistiques ou se situant au sommet de la « fabrique télévisuelle » (scénaristes, producteurs, présentateurs, animateurs, entre autres[9]). Les métiers plus techniques, importés d'autres secteurs d'activité et représentant la grande masse des effectifs, n'ont guère suscité l'intérêt des chercheurs. Ces derniers ont généralement reconduit des hiérarchies établies dès les débuts de la télévision entre des métiers technico-artistiques et de production, souvent issus du cinéma (opérateurs, scriptes, monteurs), et des métiers proprement techniques (ingénieurs, techniciens d'exploitation). Plus récemment, la recherche s'est surtout concentrée sur l'histoire politique de la télévision, les programmes et leur production. L'importance accordée à ces deux derniers aspects témoigne là encore d'une démarche héritée de la tradition auteuriste, soucieuse de mettre en avant les créateurs et les contenus. Comme pour le cinéma, l'étude de l'histoire des métiers de la télévision passe encore essentiellement par celle

[8] Yann Darré, « Le cinéma, l'art contre le travail », *Mouvements*, n° 27–28, 2003, p. 125.

[9] Sabine Chalvon-Demersay et Dominique Pasquier, *Drôles de Stars : sociologie de la télévision des animateurs*, Paris, Aubier, « Res Babel », 1990 ; Dominique Pasquier *Les scénaristes et la télévision : une approche sociologique*, Paris, Nathan/Ina, 1995 ; Monique Dagnaud, *Les artisans de l'imaginaire : comment la télévision fabrique la culture de masse*, Paris, Armand Colin, 2006.

de quelques grandes figures, pères fondateurs (voir le travail de Sylvie Pierre sur Jean d'Arcy[10]) et réalisateurs de premier plan (voir la recherche d'Isabelle Danel consacrée à Marcel Bluwal[11]). Signalons toutefois, à l'instar du regain d'intérêt pour l'histoire orale du cinéma, la création à la fin des années 2000 de l'Atelier d'histoire orale par le Comité d'histoire de la télévision (aujourd'hui Observatoire de l'audiovisuel et du numérique) dont l'objectif est de collecter la mémoire de professionnels. En 2013, la revue *VIEW* (*The Journal of European Television History and Culture*) a, à son tour, consacré l'un de ses numéros aux « métiers de l'ombre de la télévision »[12] (costumière, assistant réalisateur, doubleur, etc.).

Pour autant, la tradition auteuriste ne constitue pas l'unique raison de l'inertie, voire du retard français en la matière[13]. Le constat dressé en 1969 par Maurice Daumas, co-fondateur du Centre d'histoire des techniques du Conservatoire national des arts et métiers (CNAM), dans un article intitulé « L'histoire des techniques : son objet, ses limites, ses méthodes », trouve encore un écho de nos jours auprès des chercheurs spécialisés :

> C'est un lieu commun de dire que l'histoire des techniques en est à ses débuts et procède encore sans méthode à l'exploration d'un domaine mal défini. Dans sa présente diversité, elle va de la biographie anecdotique à l'histoire économique pure, en passant par l'histoire évènementielle des inventions et de leur destin et la description technique des procédés et des machines. Cela ne forme pas une discipline très cohérente et toujours égale à elle-même.[14]

Dans ce même article, Maurice Daumas insiste, comme Lucien Febvre avant lui[15], sur le caractère éminemment interdisciplinaire d'une

[10] Sylvie Pierre, *La télévision, le temps des constructeurs : Jean d'Arcy, pensée et stratégie d'un père fondateur*, Paris, L'Harmattan/Ina, 2012.

[11] Isabelle Danel, *Marcel Bluwal, pionnier de la télévision*, Paris, Scrineo, 2014.

[12] Andy O'Dywer et Tim O'Sullivan, *The Hidden Professions of Television*, VIEW (*The Journal of European Television History and Culture*), vol. 2/3, 2013 (en ligne).

[13] Sur ce mépris pour la technique, comme pour l'enseignement technique et professionnel, lire Jacques Perriault « "Culture technique". Éléments pour l'histoire d'une décennie singulière (1975–1985) », *Les cahiers de médiologie*, vol. 6, n° 2, 1998, p. 197–214.

[14] « L'histoire des techniques : son objet, ses limites, ses méthodes », *Documents pour l'histoire des techniques*, n° 7, 1969, p. 5.

[15] « Qu'est-ce que faire l'histoire des techniques ? », *Annales d'histoire économique et sociale*, n° 36, 30 novembre 1935.

telle histoire, la collaboration entre divers spécialistes (techniciens, historiens, documentalistes, archivistes) étant la mieux à même à en saisir la complexité et les spécificités. Il note toutefois que si les monographies, les biographies et les recherches spécialisées se sont multipliées, « il ne semble pas que chaque catégorie de spécialistes ait fait un effort pour sortir de son domaine propre, de son époque et parfois de son pays »[16].

L'impact de la « révolution numérique » sur la recherche

La « révolution numérique »[17] survenue à la fin des années 1990 a connu une accélération au tournant des années 2010 dans l'ensemble de la filière cinématographique. La disparition de l'argentique sur les tournages et dans le secteur de l'exploitation, l'ampleur des transformations auxquelles ont été confrontées les industries techniques en termes de modèle économique, d'activité professionnelle et d'écosystème des métiers, ont sensibilisé une partie de la communauté scientifique : des connaissances, des gestes techniques et des pratiques professionnelles étaient menacés de disparition ; des métiers se trouvaient redéfinis tandis que d'autres commençaient à émerger[18]. En 2008, la Cinémathèque française a donné un signal fort en créant un espace chargé de la collecte d'archives et de témoignages auprès de collaborateurs de création, de travailleurs du film et de sociétés techniques. Depuis lors, le Conservatoire des techniques cinématographiques joue un rôle essentiel dans la promotion et la diffusion de la recherche : cycles de conférences, colloques et journées d'études, accompagnement de chercheurs, numérisation et mise en ligne de catalogue d'appareils et de notices d'utilisation[19]. Dans ce contexte de transition, il est apparu nécessaire non seulement d'historiciser l'étude

[16] « L'histoire des techniques : son objet, ses limites, ses méthodes », *op. cit.*, p. 6.

[17] Pour Stéphane Vial, la « révolution numérique » est aussi un événement philosophique qui affecte l'expérience phénoménologique du monde (*L'être et l'écran : comment le numérique change la perception*, Paris, PUF, 2013).

[18] Ces dernières années, les historiens de l'art ont également investi le champ de la recherche sur le geste technique : voir Martine Millé et Joëlle Petit, « L'art et la manière : bilans et perspectives sur le geste technique », dans *Gestes techniques, techniques du geste*, Villeneuve d'Ascq, Presses universitaires du Septentrion, « Histoire et civilisations », 2017, p. 349–441.

[19] En 2011, le Conservatoire des techniques a organisé, avec le Centre national du cinéma et de l'image animée (CNC), le colloque « Révolution numérique : et si le cinéma perdait la mémoire », tandis que se tenait à Montréal le colloque « L'impact des innovations technologiques sur la théorie et l'historiographie du cinéma ».

des techniques mais aussi de repenser l'écriture d'une telle histoire afin de s'inscrire en rupture avec les approches internalistes (l'histoire technique des techniques) longtemps critiquées. Dans un texte de 2015 sur l'histoire du cinéma à l'ère du numérique, la revue *1895* a souligné les problèmes « tout à la fois méthodologiques, matériels, mais aussi, pour une bonne partie, épistémologiques » auxquels se trouve confrontée l'histoire technique du cinéma[20]. Ses auteurs insistent sur le fait que son renouvellement passe par une approche systémique, articulant l'histoire sociale des métiers et l'histoire des innovations avec l'épistémologie des dispositifs de vision et d'audition qui permet, pour sa part, l'étude des discours et des cadres conceptuels rendant possibles ou orientant les usages des techniques à un moment donné. Les auteurs invitent aussi à « envisager les possibles circulations d'un pays à l'autre, les modes de réception et d'adaptation, les pratiques de bricolage induites par des situations d'inégalité de développement »[21].

L'histoire culturelle et socio-économique comme la sociologie du travail créateur et des professions[22] ont également nourri l'étude historique des métiers du cinéma et de l'audiovisuel. La parution de l'ouvrage de Kristian Feigelson, *La fabrique filmique : métiers et professions*[23] et celle du numéro de *1895* sur l'histoire des métiers en France est significative de l'émergence, dans le domaine des études cinématographiques et audiovisuelles, d'une sociologie attentive aux dynamiques historiques et d'une historiographie s'enrichissant des apports de la sociologie des professions[24]. Les sociologues du travail manifestent un intérêt grandissant pour le milieu professionnel du cinéma (Gwénaëlle Rot sur les scriptes et les décorateurs, Laure de Verdalle sur les producteurs), ou pour celui de la télévision (Dominique Pasquier, Monique Dagnaud, Nicolas Brigaud-Robert). Dans l'introduction de son ouvrage *The System*

[20] Voir « L'histoire du cinéma à l'ère du numérique », *1895, revue d'histoire du cinéma*, n° 75, AFRHC, 2015/1, p. 15.

[21] « L'histoire du cinéma à l'heure du numérique », *op. cit.*, p. 16.

[22] Soulignons l'influence des travaux de Pierre-Michel Menger (sur les comédiens), Florent Champy (sur les architectes), ainsi que ceux des sociologues américains, en particulier de la deuxième école de Chicago (Eliot Freidson, Howard Becker).

[23] Kristian Feigelson, *La fabrique filmique : métiers et professions,* Paris, Armand Colin, 2011.

[24] Voir la thèse « Qu'appelle-t-on "qualifier" ? Le cas des ouvriers et des techniciens du cinéma », commencée par Samuel Zarka en 2015 au CNAM sous la direction de Fabienne Berton et Marie-Christine Bureau (CNRS).

of Professions, Andrew Abbott soutient quant à lui qu'il est impossible de faire l'histoire d'une profession indépendamment des professions qui l'entourent. Son approche, formulée à travers le concept d'« écologie professionnelle », permet de saisir l'unité, la substance et la cohérence d'une profession, les relations de concurrence avec d'autres professions qui structurent l'environnement professionnel et les interactions avec les arènes publiques et politico-juridiques[25]. Dans le champ qui nous concerne ici, historiciser les métiers du cinéma suppose nécessairement un décentrement disciplinaire (« une capacité, ou du moins la volonté, d'excéder la discipline "cinéma" ») ou méthodologique (« la façon d'interroger les objets »[26]), comme le notent Priska Morrissey et Laurent Le Forestier, pour saisir la dynamique des circulations et des héritages, la construction des savoirs et des réseaux professionnels à l'intersection de plusieurs arts ou médias[27].

Dès lors, c'est un champ de recherche particulièrement fructueux qui semble se construire, parallèlement aux évolutions récentes de l'historiographie du cinéma et de celle de l'historiographie des techniques. Comme le constate Édouard Arnoldy, l'histoire des techniques cinématographiques et audiovisuelles « est maintenant sur des rails qui la conduisent à s'interroger sur elle-même, à s'inquiéter de ses objets et de ses méthodes »[28] et à « excéder le cadre épistémologique de la discipline »[29]. Un courant particulièrement fécond de la recherche universitaire s'inscrit dans cette dernière tendance. Il s'intéresse à la question du genre sur le plan des représentations[30] mais aussi, et de manière croissante, à la

[25] Andrew Abbott, *The System of Professions. An Essay on the Division of Expert Labor*, The University of Chicago Press, Chicago, 1988 et « Écologies liées : à propos du système des professions », dans Pierre-Michel Menger (dir.), *Les professions et leurs sociologies : modèles théoriques, catégorisations, évolutions*, Paris, MSH, 2003, p. 29–50.

[26] *Pour une histoire des métiers du cinéma, des origines à 1945, op. cit.*, p. 9.

[27] Pour appréhender, par exemple, l'émergence du décorateur du cinéma ou bien, de manière plus contemporaine, la construction de la figure du *showrunner* à la télévision

[28] Édouard Arnoldy, « Histoires croisées des images : objets et méthodes », *Cinémas*, vol. 14, n° 2–3, 2004, p. 8.

[29] Formule empruntée par Édouard Arnoldy à Georges Didi-Huberman (Didi-Huberman, « Savoir-Mouvement (L'Homme qui parlait aux papillons) », *Aby Warburg et l'image en mouvement*, Paris, Macula, 1998, p. 12).

[30] Voir la thèse de Taline Karamanoukian, *Les figures de femme moderne dans les feuilletons de la télévision française (1963–1973)*, sous la direction de Geneviève Sellier, Université Bordeaux Montaigne, 2011, et celle de Mélanie Lallet, *Le féminin*

dimension professionnelle[31], en particulier dans le domaine des études sur la télévision, comme le montrent le séminaire « Les professionnelles de la télévision : approches historiques et socio-culturelles », créé par Kira Kitsopanidou, Géraldine Poels et Catherine Gonnard (Université Paris 3, IRCAV/Ina) et le projet de recherche « Les scénaristes en collectifs : genre et reconnaissance professionnelle dans l'écriture des séries télévisées », conduit par Sarah Lecossais et Anne-Sophie Béliard (Université Paris 13, LABSIC/Université de Grenoble-Alpes, PACTE).

Des interfaces entre enseignement, recherche et monde professionnel

Ces dernières années ont vu se développer, dans plusieurs universités françaises dispensant des formations en études cinématographiques et audiovisuelles, des modules d'enseignement consacrés à l'histoire des métiers et des techniques du cinéma et de l'audiovisuel[32]. Ces démarches pédagogiques présentent une certaine nouveauté en ce qu'elles permettent non seulement de développer avec les étudiants des projets de recherche en archives au côté d'institutions patrimoniales en charge de leur collecte et de leur conservation (la Bibliothèque nationale de France, la Cinémathèque française, la Fondation Jérôme Seydoux-Pathé, l'Inathèque), mais aussi d'inventer des points de contact et d'échange entre l'enseignement, la recherche académique et les actrices et acteurs du monde professionnel. Cette évolution est d'autant plus remarquable que la place accordée aux collaborateurs de création et aux métiers dits

dans les séries animées françaises pour enfants : le genre joué et déjoué par les personnages d'animation, sous la direction d'Éric Maigret, Université Paris 3, 2017.

[31] Voir notamment Sophie Hofsteter, Techniciennes et professionnelles du cinéma pendant la Nouvelle Vague : quels statuts et quelles fonctions pour ces femmes de l'ombre ?, mémoire de Master 2 sous la direction de Frédéric Gimello-Mesplomb, Université Paul Verlaine Metz, 2009 et Lucia Pagliardini, Le rôle de la femme dans la production cinématographique française depuis la Nouvelle Vague jusqu'à nos jours, thèse sous la direction de Laurent Creton, Université Paris 3, en cours.

[32] Parmi les enseignements de niveau master, évoquons l'exemple du séminaire « Cinéma et vidéo à l'Université Paris 8 : collecte, sauvegarde et valorisation des archives » à l'Université Paris 8 Vincennes Saint-Denis, en collaboration avec la BnF, de l'atelier « Archives et ateliers des images » à l'Université Paris Diderot, en partenariat avec la Cinémathèque française, et les cours « Écrire une histoire des techniques cinématographiques » ou « Histoire des métiers » à l'Université Rennes 2.

techniques est longtemps demeurée marginale, réservée principalement aux filières professionnalisantes, elles aussi en nombre croissant[33]. Ainsi, dès 2008, l'Université Paris 1 Panthéon-Sorbonne a-t-elle organisé, en lien avec ses enseignements de master, de nombreuses rencontres avec des professionnels dans le cadre de « Ciné-débats » au Forum des Images à Paris (les cycles « Cinéaste et producteur : un duo infernal » en 2008– 2009 et « Les techniciens du cinéma, simples collaborateurs ou créateurs méconnus ? » en 2011–2012), puis de « Ciné-rencontres » à la Bibliothèque nationale de France (le cycle « Écrire pour le cinéma » en 2017). Depuis 2015, le séminaire « Outils, équipe et création cinématographique » accueille lui aussi, à l'École supérieure d'audiovisuel (ESAV) de l'Université de Toulouse, des artistes, des techniciens, des inventeurs et des chercheurs sur des sujets traitant, par exemple, des collaborateurs de création face à l'innovation technique, des modèles de production de l'animation traditionnelle ou des techniques d'enregistrement et de diffusion du son dans le cinéma des premiers temps[34].

L'idée du présent ouvrage trouve précisément son origine dans les activités d'enseignement du master recherche en études cinématographiques et audiovisuelles de l'Université Sorbonne Nouvelle - Paris 3. Le séminaire « Questions d'histoire des métiers et des techniques du cinéma et de l'audiovisuel » a été pensé, dès sa création en 2011, comme un espace de réflexion méthodologique et de diffusion de la recherche auprès des étudiants[35]. Son objectif n'est pas de faire l'éloge de la technique mais de mettre en lumière la place qu'elle occupe dans la création d'un film et dans l'évolution des formes cinématographiques et audiovisuelles. Qu'est-ce que faire l'histoire des métiers et des techniques?

[33] Citons, sans être exhaustif, les masters « Écritures et réalisation documentaire » de l'Université de Poitiers à Angoulême, « Documentaires et archives » à l'Université Bordeaux Montaigne, « Cinéma, documentaire, médias » à l'Université Paris Diderot, « Documentaire de création » à Lussas avec l'Université Grenoble Alpes.

[34] <https://creationcollectiveaucinema.com/seminaire-outils-equipe-et-creation-cinematographique/>

[35] Cette réflexion d'ordre méthodologique a fait l'objet de deux rencontres à Paris : l'une dans le cadre de la Journée d'études « Histoire des techniques cinématographiques : où en sommes-nous ? » organisé par le Conservatoire des techniques cinématographiques le 17 octobre 2014 (intervenant·e·s : Jean-Baptiste Hennion, Kira Kitsopanidou, Sébastien Layerle, Priska Morrissey et Benoît Turquety), l'autre dans le cadre du séminaire GRÉCA de l'Université Sorbonne Nouvelle - Paris 3 (IRCAV), le 15 décembre 2014 (intervenant·e·s : Hélène Fleckinger, Réjane Hamus-Vallée, Kira Kitsopanidou, Sébastien Layerle et Caroline Renouard).

à travers quelles approches ? sur la base de quelles sources ? Au tournant des années 2010, ces questionnements de principe se sont vu reconfigurés au regard des effets immédiats et pour le moins tangibles de la « révolution numérique ». Les partenariats avec des institutions telles que l'Inathèque ou la Cinémathèque française ont ainsi joué un rôle décisif. En ouvrant ses fonds d'archives de techniciens et de « collaborateurs de création », la Bibliothèque de la Cinémathèque française a offert l'opportunité aux étudiants de contribuer concrètement à la recherche en développant, documents à l'appui ou à partir d'entretiens directs, des travaux sur les métiers de scripte, de chef opérateur, d'assistant réalisateur, de chef décorateur, d'attaché de presse ou de photographe de plateau. De même, des répertoires de sources et des banques de données ont été constituées à partir de la presse technique et professionnelle (*Micro et caméra* à l'Inathèque ; *Le film français*, *La technique cinématographique*, *L'exploitation cinématographique* à la Cinémathèque française), interrogeant, par exemple, des moments d'innovations techniques ou des discours portés sur telle activité professionnelle : comment les métiers évoquent-ils leur propre histoire ? à travers quels types de récits identitaires ? Un des prolongements immédiats du séminaire fut l'organisation en février 2014, avec l'association professionnelle Les Scriptes Associés, d'une journée d'études « Être scripte aujourd'hui : échanges sur un métier méconnu » à l'Université Paris 3.

S'il y a urgence à étudier un monde qui semble disparaître et se transformer sous nos yeux, il est tout aussi urgent de s'attarder sur les modalités de la recherche, sur les outils méthodologiques et les sources à disposition. C'est dans cette optique que cet ouvrage collectif, tiré d'un colloque organisé en 2016 à Paris[36], a été pensé et conçu. Trois ensembles de textes, sur des sujets d'étude concrets, structurent son propos. Ils sont précédés d'un prologue qui s'attache à souligner le rôle moteur des institutions patrimoniales qui collectent, numérisent et donnent accès aux chercheurs une grande variété d'archives (Martin Barnier).

La première partie, intitulée « Machines et gestes techniques », livre une série de réflexions à partir de travaux de recherche consacrés successivement à l'histoire de la marque d'appareils cinématographiques

[36] « Métiers et techniques du cinéma et de l'audiovisuel : approches plurielles (objets, méthodes, limites) », colloque organisé par Hélène Fleckinger, Kira Kitsopanidou et Sébastien Layerle les 12 et 13 février 2016 à l'INHA avec le soutien du Labex ICCA et des Universités Paris 3 et Paris 8.

Bolex et de ses liens avec les pratiques des cinéastes amateurs (Benoît Turquety), à l'intégration d'un « cinéma utilitaire » dans le secteur de l'aviation et des voyages aériens (Stéphane Tralongo), au devenir des « travailleurs de l'intervalle » des studios d'animation dans une industrie mondialisée et fortement concurrentielle (Dominique Willoughby) et au savoir-faire technique de l'un des pionniers des effets spéciaux aux États-Unis, Norman O. Dawn (Réjane Hamus-Vallée).

Les contributions de la deuxième partie s'intéressent à des métiers spécifiques du cinéma, aux mutations qu'ils ont eu à subir, depuis la « révolution numérique » notamment, ainsi qu'aux documents auxquels ils donnent accès : chefs décorateurs (Alexandre Tsekenis et Jacques Ayroles), spécialistes des effets visuels (Caroline Renouard), opérateurs de prises de vue, au temps du muet (Priska Morrissey) et dans le cinéma contemporain (Bérénice Bonhomme), *sound designers* (Violette Libault).

Dans la troisième et dernière partie du livre, les textes interrogent les modalités d'écriture d'une histoire des techniques et des métiers, envisagées du point de vue de l'histoire de l'art magique, des techniques et techniciens de spectacles illusionnistes (Frédéric Tabet), de catégories longtemps négligées comme celle des travailleurs de la production cinématographique (Morgan Lefeuvre), des pratiques du métier de scripte (Lauren Benoit), des processus d'innovation technique dans le cinéma d'animation (Marie Pruvost-Delaspre) ou la fabrication d'images de synthèse (Cécile Welker), de l'identité pédagogique d'une école d'enseignement professionnel telle que l'Institut des hautes études cinématographiques (Marie-Charlotte Téchené).

En guise d'épilogue, Hélène Fleckinger propose enfin une série de réflexions autour de l'opération théorique et pratique de « rematérialisation » du cinéma par ses techniques, en lien avec la pensée de l'historien et philosophe des sciences François Dagognet.

Toutes ces contributions sont portées par une même problématique : quels questionnements et quels problèmes méthodologiques la recherche sur les métiers et les techniques du cinéma et de l'audiovisuel soulève-t-elle, notamment au regard des mutations présentes ou déjà intervenues au sein de la filière cinématographique ? Souhaitons que, par leur exemple et les réflexions qu'ils proposent, les différents articles de ce livre offrent une visibilité à des travaux en cours et aide les étudiants à développer et à nourrir leurs propres recherches.

Prologue

Pour une histoire des appareils et des métiers du cinéma et de l'audiovisuel

Martin BARNIER

L'accès aux archives sur les techniques et les métiers du cinéma et de l'audiovisuel est relativement récent. Depuis une dizaine d'années, les fonds des institutions patrimoniales se sont constamment enrichis. La numérisation, la mise en ligne de photographies d'appareils, de plaques de lanternes magiques, ont permis à chacun de découvrir, souvent de chez soi, des fonds patrimoniaux conservés dans plusieurs collections. Des conférences ont fait connaître et contribué à accroître les richesses de certaines collections. De cette vitalité nouvelle insufflée par les institutions patrimoniales témoigne également l'organisation de grandes expositions à la Cinémathèque française, mais aussi à la Fondation Jérôme Seydoux-Pathé, qui a constitué une collection d'appareils et d'accessoires grâce à des acquisitions et à des dons. Les sources se font ainsi plus nombreuses et la possibilité d'observer les appareils existe désormais, même s'il faut reconnaître que cette ouverture vers les chercheurs a mis du temps à se faire. Il y a vingt-cinq ans, remarque Éric Le Roy, la plupart des documents des Archives françaises du film n'étaient ni consultables ni divulgables[1].

[1] Ce texte est tiré d'une table ronde « Problématique des sources » organisée le 12 février 2016 et animée par Martin Barnier. Elle réunissait Alain Carou (conservateur au département de l'Audiovisuel de la Bibliothèque nationale de France, responsable du Service Images animées), Joël Daire (directeur délégué du patrimoine de la Cinémathèque française), Anne Gourdet-Marès (responsable des appareils et des ateliers de la Fondation Jérôme Seydoux-Pathé), Éric Le Roy (chef du Service Accès Valorisation et Enrichissement des Collections aux Archives françaises du film du CNC et président de la FIAF, la Fédération internationale des archives du film entre 2011 et 2017), Géraldine Poels (responsable de la valorisation scientifique à l'Ina) et Stéphanie Salmon (directrice des collections historiques et des expositions de la Fondation Jérôme Seydoux-Pathé).

« Vider les caves »

Les occasions pour les chercheurs d'accéder à des fonds souvent très riches sont de plus en plus nombreuses. Selon Joël Daire, il y a aujourd'hui plus de 6 000 appareils dans les collections de la Cinémathèque française, c'est-à-dire 3 000 de plus qu'il y a dix ans. Le passage assez brutal au numérique, qui a rendu obsolète un certain nombre de machines dans les années 2010, y est pour beaucoup : mis au rebut, des appareils ont pu être récupérés dans des collections. Les archives « non-film », qui incluent, entre autres, les catalogues, les brevets, des notices, des rapports d'ingénieurs, mais aussi le matériel publicitaire comme les affiches ou les photos, tous les documents de production, les revues et les journaux spécialisés en cinéma ou télévision, sont de plus en plus valorisées. Les programmes de numérisation dont elles font l'objet alimentent des inventaires accessibles en ligne. Hors des institutions traditionnelles, telles que la Cinémathèque française ou les Archives françaises du film du Centre national du cinéma et de l'image animée (CNC), il faut citer le travail exemplaire mené depuis 2000 par Stéphane Lerouge au sein d'un label discographique qui réédite, et parfois édite pour la première fois, en disque ou en CD, des musiques de film[2]. Au cours de ses interventions dans le cadre de *master class* sur la musique de film, au Festival Lumière de Lyon, ce dernier a expliqué comment Agnès Varda lui a confié des mini-cassettes datant des années 1960, sans trop savoir ce qu'elles contenaient. Il y a découvert, après restauration, plus de trente versions de la Chanson des jumelles des *Demoiselles de Rochefort* (1967). Jacques Demy chante avec Michel Legrand au piano, ce dernier proposant des versions chaque fois différentes. Cette archive sonore montre le travail de création en train de se faire. Le métier de compositeur peut ainsi être analysé en détail grâce à ce document unique.

Tous les types de films sont dignes de figurer dans les archives et tous contribuent à écrire l'histoire du cinéma et de ses métiers. Entre autres stocks de films récupérés, Éric Le Roy raconte comment les Archives françaises du film ont eu l'occasion de « vider la cave » du cinéaste José Bénazéraf, réalisateur et producteur de cinéma indépendant connu pour ses films politiques, érotiques et pornographiques. Dans les bobines retrouvées figuraient quatre montages complets et différents d'un même

[2] CD édités par le label Emarcy de Universal Music Jazz France.

film. Ce type de source offre la possibilité de comprendre les hésitations du réalisateur et de l'équipe de montage. Le travail du monteur ou de la monteuse s'étudie alors en observant les modifications et les repentirs. Le CNC conserve également un grand nombre de chutes. Ces bouts de film non retenus ne sont pas uniquement à penser comme des bonus potentiels de DVD : ils constituent des documents exceptionnels pour appréhender les métiers du montage et du son, les approches d'une mise en scène ou le jeu des acteurs en montrant, par exemple, différentes manières de jouer des dialogues identiques. Les bouts d'essai, les tests de lumière ou de couleur témoignent aussi de l'évolution technique et du maniement subtil des appareils par les chefs opérateurs, les pointeurs, les cadreurs ou les machinistes. Parmi les essais techniques, citons l'exemple des tests provenant de la société Rouxcolor que le fils d'un des inventeurs du procédé a donnés aux Archives françaises du film. Dès 1930, les frères Roux avaient mis au point un système par procédé additif qui permettait de filmer en couleur à partir d'une pellicule noir et blanc[3]. Le Rouxcolor a été utilisé pour le tournage de quelques-uns des premiers films français en couleur, notamment pour *La Belle Meunière* de Marcel Pagnol (1948)[4]. Les Archives françaises du film possèdent également ce qui reste des tests menés, dans les années 1920, par le professeur Henri Chrétien pour le procédé d'anamorphose Hypergonar sur lequel reposera le développement du format Cinémascope. Une partie de ce matériel avait été malheureusement détruit avant que le CNC ne s'y intéresse.

Des recherches sur les métiers et sur les appareils

Dans les universités françaises, il existe encore peu de thèses de doctorat consacrées à l'histoire des techniques et des métiers. Les responsables des institutions patrimoniales regrettent que peu de chercheurs ou d'étudiants en Master ne s'intéressent à ce domaine malgré son incroyable richesse.

[3] Pascal Martin, « Le Rouxcolor : un procédé additif de reproduction des couleurs », *1895. Mille huit cent quatre-vingt-quinze* [En ligne], 71 | 2013, mis en ligne le 1er décembre 2016, consulté le 16 janvier 2017. URL : <http://1895.revues.org/4791> ; DOI : 10.4000/1895.4791.

[4] Alain J. Roux et Pascal Martin, « Le Rouxcolor : descriptif technique et histoire de son inventeur », *1895. Mille huit cent quatre-vingt-quinze* [En ligne], 71 | 2013, mis en ligne le 01 décembre 2016, consulté le 15 janvier 2017. URL : <http://1895. revues.org/4788> ; DOI : 10.4000/1895.4788.

Alain Carou évoque l'exemple du séminaire « Vidéo des premiers temps », qu'il a organisé à la Bibliothèque nationale de France (BnF) avec Hélène Fleckinger, Sébastien Layerle et Catherine Roudé[5], soulignant la grande complémentarité entre conservateurs et chercheurs. Si l'analyse s'appuie sur des bandes vidéo anciennes, numérisées et parfois restaurées, des archives et des témoignages, elle favorise également la collecte de sources complémentaires. Ce type de séminaire est ainsi l'occasion d'étudier l'évolution des supports techniques et des pratiques sociales et culturelles. Dans ce cas précis, le travail scientifique et la collecte patrimoniale sont menés simultanément.

De nombreuses opérations d'enregistrements audio et vidéo en cours se donnent pour objectif de conserver la mémoire des métiers du cinéma et de la télévision. Ainsi, des étudiants de La Fémis réalisent des entretiens avec des techniciens à la retraite ou encore en activité sur les pratiques anciennes ou récentes. À la demande de la Commission paritaire nationale emploi et formation de l'audiovisuel (CPNEF-AV) qui a commandité ces films pour l'Observatoire des métiers de l'audiovisuel, Réjane Hamus-Vallée et Caroline Renouard ont mené un travail similaire avec des représentants de différents métiers du cinéma. Depuis 2012, six ou sept entretiens ont été mis en ligne chaque année. Certains d'entre eux ont aidé à l'écriture à quatre mains d'un ouvrage sur un nouveau métier, celui de superviseur d'effets visuels[6]. L'histoire des effets spéciaux s'enrichit avec les transformations apportées par les pratiques numériques. Si dès 1908 des plaques de verre peintes ont été placées pour transformer les paysages devant la caméra (le *matte painting*), le numérique a considérablement modifié cette façon de faire puisque tout paysage peut désormais être transformé sans limite sur ordinateur[7]. Bérénice Bonhomme a procédé à de nombreux entretiens qui ont permis d'écrire un livre synthétisant l'évolution des métiers face aux transformations techniques des années 2000[8]. Dans les dix dernières années, ces entretiens se sont multipliés à l'initiative de chercheurs qui ont incité leurs étudiants à interroger

[5] On pourra se reporter au carnet de recherche en ligne : <earlyvideo.hypotheses.org>

[6] Réjane Hamus-Vallée et Caroline Renouard, *Superviseur des effets visuels*, Paris, Eyrolles, 2016.

[7] Réjane Hamus-Vallée, *Peindre pour le cinéma. Une histoire du* matte painting, Villeneuve d'Ascq, Presses universitaires du Septentrion, 2016.

[8] Bérénice Bonhomme, *Techniques du cinéma : image, son, post-production*, Paris, Dixit, 2011.

les divers opérateurs de la création audiovisuelle. C'est le cas du séminaire « Question d'histoire des métiers des techniques du cinéma et de l'audiovisuel », animé par Kira Kitsopanidou et Sébastien Layerle à l'Université Sorbonne Nouvelle - Paris 3.

Une archéologie des métiers ?

La mise en perspective comparative des différentes technologies s'inscrit dans le vaste projet d'archéologie des médias, en développement au sein de la recherche universitaire. Au Québec, l'analyse de l'intermédialité (André Gaudreault, Viva Paci) a poussé très tôt vers l'étude comparative des techniques audiovisuelles[9]. En France, un numéro des *Cahiers Louis Lumière* fait le point sur ce sujet en abordant autant les questions du son que de l'image[10]. Ce type de recherche joue un rôle majeur dans la mise en valeur des ressources de l'Institut national de l'audiovisuel. Géraldine Poels note que l'Ina dispose de 12 millions d'heures d'émissions à voir et à écouter, dont certaines nous permettent de plonger dans le passé des techniciens de plateau. Dans ce choix gigantesque se trouve un grand nombre d'« émissions réflexives » qui étudient le fonctionnement des médias télévisuel et radiophonique. Ainsi, l'émission télévisée *Micros et caméras*, diffusée dans les années 1960 et 1970, témoigne de façon précise des problèmes qui se posaient pour la réalisation des programmes. On peut aussi citer les travaux récents de doctorants qui étudient des supports oubliés tels que le scopitone. Comme le montre la thèse d'Audrey Orillard[11], ce procédé permettant de « projeter des chansons » dans les bars a lancé la production d'appareils ressemblant à des *juke-boxes* (appelés comme les courts films en 16 mm illustrant les chansons à la mode, des scopitones) qui se sont vendus, en grand nombre, en Europe dans les années 1960. Une autre thèse, actuellement en cours d'écriture, élargit le propos, toujours dans le cadre d'une histoire culturelle d'un média

[9] André Gaudreault et Philippe Marion, *La fin du cinéma ? Un média en crise à l'ère du numérique*, Paris, Armand Colin, 2013 ; Viva Paci, *La machine à voir. À propos de cinéma, attraction, exhibition*, Villeneuve d'Ascq, Presses universitaires du Septentrion, 2012.

[10] Gérard Pelé et Giusy Pisano (dir.), *Archéologie des médias*, dossier de la revue numérique de l'ENS Louis-Lumière, *Cahiers Louis Lumière*, n° 10, décembre 2016.

[11] Audrey Orillard, *Scopitone. Histoire culturelle du télé-box et de la chanson filmée yéyé (1959–2010)*, thèse sous la direction de Myriam Tsikounas, Université Paris 1 Panthéon-Sorbonne, 2014.

populaire. Robin Cauche y développe des recherches sur la chanson écrite et projetée, depuis les plaques de lanternes magiques au XVIII^e siècle jusqu'aux *lyric videos* produites en masse par des amateurs sur Internet, en passant par les scopitones[12]. Ces travaux de recherche peuvent aider à comprendre la longue lignée des médias d'une même série, croisant ici chansons et images depuis le XIX^e siècle jusqu'à la transmission sur Internet. Elles soulignent la continuité de phénomènes médiatiques au-delà du changement de support technique. La Cinémathèque française et l'Ina accueillent très favorablement les recherches de ce type et mettent à leur disposition les ressources dont ils disposent.

Les archives écrites et audiovisuelles de l'Ina ont aussi permis d'étudier la transformation des stratégies des chaînes et montré que le contrôle de la direction de l'ORTF sur les programmes s'est intensifié lors du passage de la dramatique diffusée en direct à des émissions enregistrées ou à des téléfilms[13]. Le matériel technique a changé et considérer l'évolution des pratiques de la vidéo, qu'il s'agisse de vidéo légère pour les appropriations militantes et plasticiennes ou de vidéo « lourde » pour la télévision, peut permettre d'aborder l'histoire du matériel sous l'angle de la prise de vue, du montage et de la diffusion. Les métiers de l'animation et les appareils inventés pour faire du dessin animé restent aussi à explorer. Par exemple, peu de textes ont été écrits sur l'Animographe, une machine utilisée à l'ORTF qui a servi notamment à créer la série des *Shadoks*[14]. De même, l'identité professionnelle, le statut des travailleurs de la télévision et leur rapport au monde du cinéma se sont transformés selon les passerelles établies, les pratiques de tournage ou les attitudes de la hiérarchie télévisuelle[15].

Les fonds de l'Ina sont aujourd'hui consultables dans les médiathèques et dans six délégations régionales. Les émissions sur les inventions, les discussions entre techniciens enregistrées à la télévision française, sont

[12] Robin Cauche, *Des lanternes magiques aux* lyric videos *: la chanson écrite projetée (XIX^e-XXI^e siècles)*, thèse en cours sous la direction de Martin Barnier, Université Lumière Lyon 2 et Université de Montréal, bénéficiant d'une aide de la Cinémathèque française.

[13] Jérôme Bourdon, *Histoire de la télévision sous De Gaulle*, Paris, Anthropos/Ina, 1990, réédition augmentée, Paris, Presses des Mines, 2014.

[14] Sébastien Denis, *Les Shadoks : histoire, esthétique et pataphysique*, Paris, Ina, 2016.

[15] Jérôme Bourdon, « Les réalisateurs de télévision. Le déclin d'un groupe professionnel », *Sociologie du travail*, vol. 35, n° 4, octobre 1993, p. 431–445.

une mine pour les historiens. L'ingénieur François Savoye a ainsi été interviewé à propos de son cyclo-stéréoscope qui permettait de voir des films en relief stéréoscopique sans lunettes. Son entretien vient compléter nos connaissances sur la diversité des procédés 3-D lors de la vague stéréoscopique des années 1950[16]. Les archives écrites représentent, par ailleurs, une masse considérable et souvent peu valorisée car les chercheurs pensent encore que seuls les supports audiovisuels sont conservés à l'Ina. Or des structures comme TDF (Télé Diffusion de France), les studios de la SFP (la Société Française de Production, privatisée en 1987) et d'anciens techniciens de télévision ont déposé leurs archives. Des fonds syndicaux sont aussi consultables, ainsi que des collections de périodiques comme *Le haut-parleur* ou *Le technicien du film*[17]. Toutes ces sources écrites permettent de comprendre les problèmes d'utilisation du matériel, les choix effectués par les réalisateurs et les techniciens ou l'évolution technique globale.

La Fondation Jérôme Seydoux-Pathé, pour sa part, dispose de 550 appareils commercialisés par la firme Pathé (caméras, projecteurs, phonographes), ainsi qu'un ensemble constitué de caméras et d'accessoires de prise de son et de montage des opérateurs du Pathé-Journal, entre 1950 et 1970. Si l'on excepte la thèse de Priska Morrissey, peu de travaux ont porté sur les métiers dans les premières années de l'industrie cinématographique[18]. En 2014, la mise à disposition des rapports des ingénieurs Pathé (1926–1929) a ouvert néanmoins de nouveaux chantiers de recherche et a récemment donné lieu à publication[19]. Étudier les machines, c'est aussi interroger la conception technique et l'évolution des métiers. En s'intéressant aux appareils et à leurs notices, on comprend

[16] Martin Barnier et Kira Kitsopanidou, *Le cinéma 3-D : histoire, économie, technique, esthétique*, Paris, Armand Colin, 2015.

[17] *Le haut-parleur* est la première revue française de vulgarisation de la technique électronique. Créée en 1925, elle a existé jusqu'en 1999. *Le technicien du film* est une revue mensuelle corporative donnant des informations techniques et sur la vie de la profession. Elle a été publiée de 1954 à 2008.

[18] Signalons toutefois la thèse de Priska Morrissey, *Naissance d'une profession invention d'un art : l'opérateur de prise de vues cinématographiques de fiction en France (1895–1926)*, thèse sous la direction de Jean A. Gili, Université Paris 1 Panthéon-Sorbonne, 2008.

[19] Jacques Malthête et Stéphanie Salmon, *Recherches et innovations dans l'industrie du cinéma : les cahiers d'ingénieurs Pathé (1906–1929)*, Paris, Fondation Jérôme Seydoux-Pathé, 2017.

mieux les gestes de certains métiers, celui de projectionniste par exemple. Le fait de ne pas pouvoir tourner la manivelle et alimenter en même temps le projecteur en charbon pour conserver sa luminosité maximale explique ainsi la présence de deux personnes assurant chacune ces opérations. On mesure comment se déroulait une projection et ce qui se faisait alors dans la cabine. De la même manière, Stéphanie Salmon rappelle que le Pathé-Baby a encouragé, dès les années 1920, la mise au point d'un matériel parfaitement sécurisé pour éviter tout accident domestique et permis des tournages amateurs grâce à de « petites cassettes de film ».

La Fondation Jérôme Seydoux-Pathé a mis en ligne sur son site des photographies d'appareils et des fiches descriptives précises[20]. Récemment, elle a bénéficié de la donation de Ralph Laclötre, qui a été un représentant du Pathé-Baby. Ce fonds d'appareils et de documents est particulièrement intéressant parce qu'il comporte les schémas techniques détaillés de divers appareils. Ces fiches techniques permettent de comprendre aujourd'hui comment fonctionnaient les amplificateurs qui servaient à diffuser le son des films. Ces éléments sont fondamentaux pour aider à une restauration. Le Pathé-Baby était conçu pour être bon marché et fonctionner de façon très simple, loin de la sophistication du matériel professionnel. Il est nécessaire d'étudier les différents types d'appareils et les usages qui en sont faits. Tous les conservateurs de matériels soulignent qu'il faut pouvoir faire fonctionner les machines pour bien savoir les utiliser. Cela rejoint le travail de l'ingénieur et du restaurateur de film belge Jean-Pierre Verscheure qui, dans son centre d'étude sur les techniques cinématographiques, Cinévolution, recherche et restaure les anciens appareils, permettant de la sorte une projection la plus proche possible de celle qui existait à l'époque de la sortie des films. Il a, par exemple, reconstitué le son réel (autant que faire se peut) des films Vitaphone, avec leurs amplificateurs particuliers, leurs haut-parleurs étonnants et leurs tourne-disques d'époque[21]. Ce son n'a que peu à voir avec celui des films d'aujourd'hui dans les salles actuelles. Les recherches en histoire du cinéma demandent un minimum d'observation des techniques. Les changements de formats de pellicule ont des incidences sur la réception des films. Une projection désanamorphosée en Cinémascope-Hypergonar sur un écran gigantesque donne des sensations bien différentes de celle

[20] Voir le site <www.fondation-jeromeseydoux-pathe.com>

[21] Voir la page <www.canal- u.tv/video/cinematheque_francaise/les_premiers_systemes_ sonores_une_conference_jean_pierre_verscheure.6674>

en 1,33 sur un écran presque carré. L'histoire des techniques rejoint aussi celle des spectateurs, en passant par l'histoire économique[22].

Les inventaires de sociétés telles que Pathé permettent enfin de dater l'apparition d'un appareil ou la mise en construction en usine. L'analyse des ventes de l'entreprise est essentielle pour apprendre quand un projecteur a été mis en service dans les salles de cinéma. Certains prototypes sont développés mais n'arrivent pas jusqu'à la production en série. À ce titre, les archives Pathé constituent des sources fondamentales pour étudier l'industrie cinématographique. Le fonds du laboratoire GTC fournit ainsi des informations précises sur l'organisation d'un laboratoire[23]. On peut également envisager, à travers divers documents, l'intégralité de la chaîne des métiers du cinéma, depuis la fabrication de la pellicule jusqu'à la projection dans les salles de cinéma, en passant par toutes les techniques de prise de vue, de son, ainsi que le tirage de copies en laboratoire. Les documents des laboratoires révèlent à quel point il était délicat de réussir l'étalonnage d'un film. Des teintes d'un précédent tirage pouvaient rester dans le fond d'une cuve mal lavée et une copie pouvait sortir dans des couleurs bien éloignées de ce qui était prévu. Sur le dosage chimique des couleurs et les métiers liés à la production de film en couleur, la thèse de Céline Ruivo a ainsi permis de faire le tri entre légende et réalité à propos de la firme Technicolor[24].

De nouveaux sujets de recherche ?

Une histoire des techniques et des métiers passe par l'analyse des traces de tournage : photos, comptes rendus, mémos, rapports, demandes de matériel, échanges divers entre la production et l'équipe… Stéphanie Salmon incite les chercheurs à étudier les photos de plateau en observant les clichés pris sur le vif pendant les tournages et surtout

[22] Kira Kitsopanidou, *L'innovation technologique dans l'industrie cinématographique hollywoodienne : le cinéma-spectacle des années 1950, une mise en perspective des stratégies liées à l'Eidophor et au Cinémascope*, thèse sous la direction de Laurent Creton, Université Sorbonne Nouvelle - Paris 3, 2002.

[23] François Ede, *GTC, histoire d'un laboratoire cinématographique*, Paris, Fondation Jérôme Seydoux-Pathé, 2016.

[24] Céline Ruivo, *Le Technicolor trichrome : histoire d'un procédé et enjeux de sa restauration*, thèse sous la direction de François Thomas, Université Sorbonne Nouvelle - Paris 3, 2016.

pendant les pauses. Le matériel qui apparaît sur les photos contredit parfois les souvenirs des techniciens, des réalisateurs ou des acteurs. Quelles étaient les caméras utilisées pour tourner ? Étaient-elles toujours *blimpées* (insonorisées) au cours des années 1930 ? Comment le plateau s'organisait-il ? Où l'ingénieur du son se trouvait-il ? À quels types de micros avait-il recours ? Une observation globale des métiers du cinéma sur une période donnée est possible, comme l'a montré la thèse de Morgan Lefeuvre. Son étude socio-historique des professions du cinéma décrit aussi bien les conditions de travail, les déplacements quotidiens que les statuts sociaux ou les rapports hiérarchiques au sein des studios[25].

Pour développer de nouvelles recherches il faut également s'appuyer sur des connaissances anciennes. Géraldine Poels souligne la nécessité de comprendre le fonctionnement des appareils devenus obsolètes avec le numérique. L'Ina conserve des machines anciennes en état de marche pour effectuer des transferts et permettre la restauration de supports révolus, mais ces appareils permettent aussi de faire redécouvrir le « matériel d'antan ». Peu de recherches ont été menées sur les magnétophones et leur utilisation dans l'audiovisuel, par exemple[26]. Quand des travaux évoquent des bandes magnétiques, il s'agit le plus souvent d'analyser les choix effectués au montage et au mixage[27]. Tous les appareils ayant servi au son des films restent à étudier. Si un numéro de la revue *1895* est consacré aux métiers du cinéma, les différents articles ne font qu'effleurer des sujets qui demanderaient chacun des années de recherche[28]. On note toutefois le développement international des *sound studies*. Des colloques

[25] Morgan Lefeuvre, *De l'avènement du parlant à la Seconde Guerre mondiale : histoire générale des studios en France 1929–1939*, thèse sous la direction de Michel Marie, Université Sorbonne Nouvelle - Paris 3, 2016. Voir la contribution de Morgan Lefeuvre dans cet ouvrage.

[26] Les thèses sur le sujet de la bande magnétique sont plutôt en physique ou en mécanique comme pour Frédéric Souchon, *Tribologie d'un enregistreur magnétique hélicoïdal : contact tête silicium/bande magnétique*, thèse sous la direction d'Yves Berthier, INSA Lyon, 1997.

[27] Citons l'exemple d'Orson Welles étudié par François Thomas (*La composition sonore dans le cinéma d'Orson Welles et ses rapports avec son œuvre radiophonique et théâtrale*, thèse sous la direction de Jacques Aumont, Université Sorbonne Nouvelle - Paris 3, 1997).

[28] Dans ce numéro, l'article sur les ingénieurs du son reste très succinct et demanderait des développements ultérieurs. Martin Barnier, « Les premiers ingénieurs du son français », *1895, revue d'histoire du cinéma*, n° 65, AFRHC, hiver 2011, p. 200–217.

et des publications permettent de comprendre l'archéologie sonore du cinéma, du théâtre et de la télévision[29].

Un métier mérite enfin d'être reconnu et étudié, celui de documentaliste. Géraldine Poels explique que l'ORTF employait des documentalistes professionnels qui, à l'aide de fiches, pouvaient retrouver des émissions anciennes. Des extraits de ces reportages pouvaient être réemployés dans de nouvelles émissions. Ce réemploi d'anciens extraits de la télévision, fondamental pour le montage de nouveaux sujets, est comparable à celle des *stock-shots* au cinéma. Comment retrouver des images précises dans des millions d'heures d'enregistrement de la télévision ou de la radio ? Les documentalistes actuels et leur base de données poursuivent le travail commencé, il y a très longtemps, avec des fiches cartonnées. L'archivistique et la bibliothéconomie ne datent pas de l'âge du film puisque les systèmes d'indexation pour les livres ont été mis au point au XIXe siècle. Contemporain des premiers enregistrements sonores sur des rouleaux de cire, le système Dewey, toujours utilisé dans les bibliothèques du monde entier, date de 1876, vingt ans avant les premiers tournages réguliers de films. Il reste aussi à faire l'histoire des notices des documentalistes de l'audiovisuel et l'évolution d'un métier qui est passé lui aussi par la numérisation et l'informatisation[30]. La BnF, précise Alain Carou, a gardé elle aussi une collection d'appareils de façon à montrer à tous les chercheurs, les jeunes documentalistes, conservateurs et bibliothécaires l'évolution des procédés d'enregistrement des sons et des images ainsi que les systèmes de restitution. De la lecture sur cylindres de cire aux cassettes vidéo numériques, l'évolution des appareils s'est faite de manière relativement lente. Aujourd'hui pourtant, la transformation du matériel n'est plus visible à l'œil nu. Pour comprendre les modifications d'un logiciel, il faut être informaticien alors que le passage d'un pavillon de phonographe à un haut-parleur en carton – inventé par Louis

[29] Les travaux de Rick Altman, de Jonathan Sterne ou les colloques dirigés par Giusy Pisano et Jean-Marc Larrue ont fait avancer la recherche dans ce domaine, mais il reste beaucoup à faire. Jonathan Sterne (dir.), *The Sound Studies Reader*, New York, Routledge, 2012 ; Jean-Marc Larrue et Giusy Pisano, *Les archives de la mise en scène : hypermédialité du théâtre*, Villeneuve d'Ascq, Presses universitaires du Septentrion, 2014.

[30] Voir la thèse d'Anna Tible en préparation à l'Université Sorbonne Paris Cité sous la direction de Claire Blandin, *Documentaliste audiovisuel.le : histoire d'un métier à connotation féminine, des années 1950 à nos jours*.

Lumière[31] – est compréhensible par un néophyte. Alain Carou évoque la
« fin de la transparence technique » : avec la fin des techniques analogiques
disparaissent également les gestes qui accompagnaient chaque appareil.

L'histoire des métiers de l'audiovisuel et des machines de captation et
de restitution des images et des sons donne lieu à de nombreux chantiers
de recherche. Des expositions[32], des colloques universitaires se penchent
sur l'histoire du matériel et de ses utilisations. En raison du passage de
l'analogique au numérique, les centres d'archives jouent un rôle plus
important dans l'observation des métiers et des techniques. Il y a vingt-
cinq ans, constate Éric Le Roy, les collections n'étaient ni consultables ni
divulgables. Si aujourd'hui la situation s'est nettement améliorée, Joël Daire
souligne qu'il y a encore beaucoup de travail à faire *entre* institutions, par
exemple, pour la mise au point d'une plateforme nationale du patrimoine
cinématographique. Les chercheurs demandent à avoir accès au matériel lui-
même pour savoir comment se manipulait une caméra ou se tournait une
manivelle. Or la conservation des fonds reste encore aujourd'hui la priorité,
une priorité qui gêne ce type de manipulation des objets. Le numérique
aide par ailleurs grandement les recherches. La possibilité de consulter en
ligne les revues anciennes numérisées est un confort qui n'avait jamais été
proposé aux historiens par le passé. Toutefois, il n'est pas sans importance
que quelques périodiques soient encore consultables sur papier à la fondation
Jérôme Seydoux-Pathé : cela favorise un autre type de lecture par rapport à
celle qui se fait sur ordinateur. Des formats rares ou des films réalisés de façon
totalement marginale, par des amateurs, des artistes ou des filmeurs solitaires,
sont maintenant accessibles dans les archives cinématographiques, et
particulièrement dans les cinémathèques régionales comme la Cinémathèque
de Bretagne, la Cinémathèque des Pays de Savoie et de l'Ain, la Cinémathèque
de Toulouse, Ciclic ou les Archives audiovisuelles de Monaco. On le voit, de
nouvelles perspectives s'ouvrent. Aux chercheurs de s'en emparer.

[31] Louis Lumière a imaginé le système d'une membrane cartonnée qui vibre pour
 transmettre les sons en 1908. Il a déposé immédiatement un brevet pour ce
 diaphragme en papier. Le procédé a été commercialisé par Gaumont dans les années
 1920 et par d'autres compagnies. On trouve un bel exemplaire de 1928 dans les
 collections de la Cinémathèque française (<www.cinematheque.fr/fr/catalogues/
 appareils/collection/haut-parleurcnc-ap-97-867.html>).

[32] « De Méliès à la 3-D : la machine cinéma », exposition programmée à la Cinémathèque
 française du 5 octobre 2016 au 29 janvier 2017, accompagnée d'un colloque sous
 la direction d'André Gaudreault (Université de Montréal), Laurent Mannoni
 (Cinémathèque française), Gilles Mouëllic (Université Rennes 2) et Benoît Turquety
 (Université de Lausanne).

Première partie

Machines et gestes techniques

Histoire des machines / histoire des techniques : à partir de Bolex

Benoît Turquety

Nous avons entrepris, à l'Université de Lausanne, un projet de recherche sur l'histoire de la marque d'appareils cinématographiques Bolex[1], développée à Sainte-Croix (Canton de Vaud) par l'entreprise Paillard. Les appareils Bolex les plus célèbres furent certainement les caméras de la série H16, mais sous le sigle Bolex apparurent également des projecteurs, des colleuses et de nombreux autres objets liés à un cinéma d'amateur exigeant. Le projet s'intitule « Histoire des machines et archéologie des pratiques : Bolex et le cinéma amateur en Suisse ». À y revenir aujourd'hui, il m'apparaît que ce titre repose sur deux postulats qui devraient sans doute être considérés comme discutables :

1. On peut faire une histoire des machines.
2. Il y a un lien entre machines et pratiques.

La seconde de ces propositions est bien sûr cruciale pour notre recherche. Elle n'est pas le seul fondement nous permettant de faire le lien entre « Bolex et le cinéma amateur en Suisse », car l'entreprise Paillard est aussi intervenue directement de plusieurs manières dans le milieu du cinéma amateur. Néanmoins, elle constitue un enjeu important du projet.

[1] Ce projet est financé par le Fonds national suisse de la recherche scientifique. Il prend place au sein de la Collaboration UNIL+Cinémathèque suisse, et du Partenariat international de recherche sur les techniques et technologies du cinéma *Technès*, financé par le Conseil de recherches en sciences humaines du Canada. Je remercie Nicolas Dulac, Vincent Sorrel et Stéphane Tralongo, chercheurs engagés dans le projet. Pour plus d'information : <http://wp.unil.ch/cinematheque-unil/projets/bolex-et-le-cinema-amateur/>.

Archéologie, Technologie, Histoire

Après l'usage qui en a été fait par C.W. Ceram ou Laurent Mannoni[2], le terme d'«archéologie» s'est chargé ces dernières années, dans les études cinématographiques et médiatiques, d'une assez grande polysémie, suite notamment à la diffusion d'une *Media Archaeology*[3] se réclamant plus ou moins de l'*Archéologie du savoir* de Michel Foucault. Or si nos problématiques peuvent croiser certaines des leurs, c'est à une tradition différente que le terme entend d'abord renvoyer. André Leroi-Gourhan en aura posé les fondements dès son projet de « technologie comparée », avancé en 1936 dans l'*Encyclopédie française* de Lucien Febvre, et jusque notamment dans *Milieu et techniques* en 1945. Selon lui, « l'ethnologie peut, jusqu'à un certain point, tirer de la forme d'une lame d'outil des prévisions sur celle du manche et sur l'emploi de l'outil complet »[4]. C'est ainsi que, pour Madeleine Akrich, « la forme [de certains outils] décrit (comme dans un "Sherlock Holmes") précisément l'utilisateur »[5]. Elle reprend notamment l'exemple présenté avant elle par François Sigaut de « l'extraordinaire houe à deux manches de l'Angola », qui est « employée par les femmes » et dont la « morphologie très particulière s'expliqu[e] par le fait que celles-ci travaillent avec leur enfant sur le dos »[6].

[2] C.W. Ceram [Kurt Wilhelm Marek], *Eine Archäologie des Kinos*, Reinbek bei Hamburg, Rowohlt, 1965 (trad. fr. : *Archéologie du cinéma*, Paris, Plon, 1966) ; Laurent Mannoni, *Le grand art de la lumière et de l'ombre : archéologie du cinéma*, Paris, Nathan Université, 1999.

[3] Voir notamment Siegfried Zielinski, *Archäologie der Medien : Zur Tiefenzeit des technischen Hörens und Sehens*, Reinbek bei Hamburg, Rowohlt, 2002 (trad. *Deep Time of the Media: Toward an Archaeology of Hearing and Seeing by Technical Means*, Cambridge [MA], MIT Press, 2006) ; Siegfried Zielinski, « Trouvailles fortuites au lieu de vaines recherches : emprunts et affinités méthodologiques pour une anarchéologie de la vision et de l'audition technicisées », *1895, revue d'histoire du cinéma*, n° 81, AFRHC, printemps 2017, p. 8–35 ; Erkki Huhtamo, Jussi Parikka (dir.), *Media Archaeology: Approaches, Applications, and Implications*, Berkeley & Los Angeles, University of California Press, 2011 ; Thomas Elsaesser, *Film History as Media Archaeology: Tracking Digital Cinema*, Amsterdam, Amsterdam University Press, 2016.

[4] André Leroi-Gourhan, *Évolution et techniques : I. L'homme et la matière*, Paris, Albin Michel, 1971 [1943], p. 15.

[5] Madeleine Akrich, « Comment décrire les objets techniques ? », *Techniques et culture*, n° 9, 1987, repris dans *Techniques et culture*, n° 54–55, 2010, p. 209.

[6] François Sigaut, « Essai d'identification des instruments à bras de travail du sol », dans Christian Seignobos, Jacqueline Peltre-Wurtz (dir.), *Les instruments aratoires en*

D'une part, la machine détermine certains aspects de son usage et d'autre part, sa conception même se fait en fonction d'un usage imaginé correspondant aux pratiques contemporaines. C'est pourquoi, comme l'explique Akrich, la compréhension des objets techniques impose mais aussi permet de « sans arrêt effectuer l'aller-retour entre le concepteur et l'utilisateur, entre l'utilisateur-projet du concepteur et l'utilisateur réel, entre le monde inscrit dans l'objet et le monde décrit par son déplacement »[7]. Les objets techniques sont donc un lieu d'inscription – d'un ensemble social complexe pour Akrich, et déjà d'une gestuelle pour Gilbert Simondon : « Ce qui réside dans les machines, c'est de la réalité humaine, du geste humain fixé et cristallisé en structures qui fonctionnent. »[8]

Après *Du mode d'existence des objets techniques* en 1958, Simondon reviendra sur cette matérialisation à plusieurs reprises, notamment dans son cours « Psychosociologie de la technicité » de 1960–1961 : « Or, s'ils [les objets techniques] ne sont pas vivants, ils contiennent pourtant la cristallisation de quelque chose de vivant : les heures de travail humain consommées à les produire, et l'effort d'invention qui a permis de les concevoir. »[9] Cet aspect est très important pour le philosophe, en ce qu'il fonde la nécessité éthique d'un respect de l'objet technique dans sa technicité même, car c'est elle qui en constitue la valeur réelle, au-delà de l'usage. Dans cette perspective, l'obsolescence ou même ce qu'il nomme la « condition de vénalité » des objets techniques, laissés à la merci d'un acheteur doté du pouvoir extraordinaire de les délaisser, sont, pour Simondon, proprement scandaleux. La machine comme cristal est une archive de la gestuelle et de la pensée opératoire humaines ; comme telle, elle réclame une archéologie qui permettra de déceler en elle sa technicité, et toute la vie humaine qui s'y trouve fixée.

Le projet technologique initié par André Leroi-Gourhan, s'est trouvé assez tardivement prolongé au sein de l'approche qui s'est nommée « technologie culturelle », dont le programme fut énoncé par Robert

Afrique tropicale : la fonction et le signe, Paris, Cahiers de l'ORSTOM, série Sciences humaines, vol. XX, n° 3–4, 1984, p. 368.

[7] Madeleine Akrich, *op. cit.*, p. 208–209.

[8] Gilbert Simondon, *Du mode d'existence des objets techniques*, Paris, Aubier, 1989 [1958], p. 12.

[9] Gilbert Simondon, *Sur la technique*, Paris, Presses universitaires de France, 2014, p. 56.

Cresswell au moment de la création du laboratoire « Techniques et culture » par le CNRS en 1976 : « Le postulat de base est qu'il existe des rapports entre phénomènes techno-économiques et manifestations socio-culturelles. »[10] Quelques années plus tard, Pierre Lemonnier en précisait les attendus, en rappelant que, pour la technologie culturelle, « les phénomènes techniques sont des phénomènes sociaux à part entière et sont affaire d'ethnologue ; celui-ci n'étudiera les techniques que pour en faire apparaître les relations avec les autres phénomènes sociaux »[11]. Il ajoutait en note : « Libre à d'autres disciplines de considérer (provisoirement ?) les techniques comme un champ d'études en soi. Ce ne peut être le cas en technologie culturelle. »[12] Pour moi, c'est sur ce point qu'une divergence apparaît. Je dois pouvoir m'intéresser aux techniques en elles-mêmes, sans me poser d'emblée le problème de la pertinence du trait considéré pour le social dans son ensemble. L'historienne des techniques Anne-Françoise Garçon rappelait que les fondateurs de sa discipline se rejoignaient notamment sur un point essentiel :

> il y a bel et bien une autonomie de la technique, autonomie relative certes, mais réelle [...] Je l'exprimerai ainsi : prétendre faire une histoire des techniques impose de considérer que le fait technique, conception, évolution, impact, est individualisable et discernable à l'échelle historique, comme sont individualisables et discernables le fait religieux, le fait économique, le fait politique, le fait social, le fait linguistique, le fait culturel [...][13]

Il n'y a bien sûr pas de cloison étanche entre ces niveaux, plutôt un entremêlement de plans différents. Analyser les machines en historien des techniques implique donc un double mouvement : d'une part, prendre les appareils du point de vue du social, de l'usage, de la culture ; d'autre part, isoler les machines pour saisir leur évolution proprement technique, au niveau de leur conception interne, de leur structure, autant que de la gestuelle qu'elles matérialisent ou qu'elles conditionnent.

[10] Robert Cresswell, « Techniques et culture : les bases d'un programme de travail », *Techniques et culture*, Bulletin de l'Équipe de recherche 191, n° 1, 1976, p. 7.

[11] Pierre Lemonnier, « L'étude des systèmes techniques, une urgence en technologie culturelle », *Techniques et culture*, n° 1, 1983, repris dans *Techniques et culture*, n° 54–55, 2010, p. 49–50.

[12] *Ibid.*, p. 64.

[13] Anne-Françoise Garçon, *L'imaginaire et la pensée technique : une approche historique (XVI^e-XX^e siècles)*, Paris, Classiques Garnier, 2012, p. 15–16.

La Bolex H16

Une Bolex H16 est une caméra de cinéma amateur, c'est-à-dire adoptant un format dit *substandard*, 16 mm ou (double) 8 mm en l'occurrence[14]. Relativement légère (2.85 kg sans film), son ergonomie en fait une caméra de poing plutôt que d'épaule. Elle accepte des bobines de 15 ou 30 mètres, soit une autonomie de 4'05" de tournage sans changement de cartouche. Son moteur étant entraîné par un ressort, les plans ne peuvent dépasser 28 secondes, temps de détente du ressort, suivis d'un nécessaire intervalle avant la reprise du tournage, dévolu au remontage du moteur grâce à la manivelle. Ces contraintes sont le revers d'un avantage qui peut être important : la totale indépendance de sources électriques.

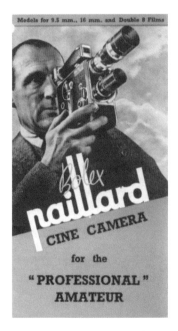

Figure 1. Publicité Bolex (années 1950). Viseur clair en position haute.

[14] Il y a eu un modèle 9,5 mm au milieu des années 1930, mais Bolex semble ne pas avoir développé ce format. Le double 8 mm consiste au tournage en du film 16 mm à double perforations : une fois la bobine exposée, on la retourne pour impressionner l'autre moitié du film (la cassette audio reprendra plus tard ce principe). Celui-ci est ensuite coupé en deux dans le sens de la longueur au laboratoire, pour donner en projection du 8 mm standard.

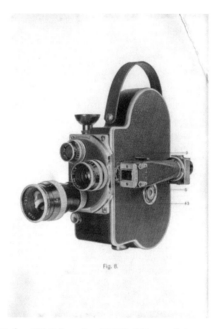

Figure 2. Notice Bolex H16 (années 1950). Viseur clair en position latérale, œilleton supérieur pour la mise au point.

La H16 Reflex, qui date de 1956, est sans doute le modèle le plus célèbre de la série. Sa nouveauté consiste en une visée reflex utilisant un système de renvoi de l'image même qui s'inscrira sur la pellicule par un système de prismes, dont un prisme semi-réflecteur situé entre l'objectif et la fenêtre d'impression. Cela implique que la visée détourne une partie de la lumière normalement destinée à l'image. C'est *a priori* dommageable, d'autant qu'il faut, par conséquent, tenir compte de cette absorption dans la graduation des objectifs, ainsi que des posemètres… Il y aura donc des objectifs et des cellules spéciaux pour Bolex H16 Reflex, sauf à corriger soi-même l'exposition selon les tables présentées dans la notice de la machine.

La compréhension des raisons du choix d'un système à prisme par les ingénieurs Bolex est importante car elle met en jeu la conception que ces ingénieurs pouvaient avoir de la machine qu'ils étaient en train de réaliser et de son utilisatrice ou utilisateur – le cinéaste amateur. Ils doivent imaginer ce qu'elle ou il désirerait pouvoir faire et ce qu'elle ou il serait capable d'accepter pour l'avoir, en termes de prix ou de complexité

d'utilisation. Cette conception implique une certaine cohérence de la machine dans son ensemble mais ne porte *a priori* que sur ce que François Albera et Maria Tortajada nomment les « dispositifs internes »[15], les éléments structurels auxquels les utilisateurs n'ont pas forcément accès, dont ils n'ont peut-être pas même connaissance, et qui peuvent ne pas avoir d'impact direct sur leur rapport à l'objet caméra. Tout cela ne concerne donc pas directement l'appareil *en tant qu'il entre en relation avec d'autres phénomènes sociaux* ; cela touche plutôt à la machine *en tant que matérialisation d'une technicité*, de manière partiellement autonome. Nous sommes alors renvoyés au premier des postulats induits par le titre de notre projet, postulat selon lequel on peut faire l'histoire des machines. Comment penser une telle histoire ?

Machines et Histoire

La marque Bolex suscite l'intérêt de collectionneurs assidus et passionnés, dont certains ont établi des relevés chronologiques assez remarquables de l'ensemble des modèles proposés à la vente par la société vaudoise, précisant les principales variantes et innovations. Comment envisager une histoire des machines qui problématise cette chronologie et permette d'en tirer des conclusions technologiques et historiques ?

Bertrand Gille, à la fin des années 1970, avait établi son projet d'histoire des techniques sur deux concepts fondamentaux : celui de *lignée technique* et celui de *système technique*. Le premier désigne « cette longue descendance, avec des formes diverses, avec des objectifs différents d'une même construction »[16]. Il donnait l'exemple du couple cylindre-piston, utilisé dans des dispositifs nombreux et variés à travers les âges. Le système technique, quant à lui, est le vaste réseau d'interrelations et de cohérences nécessaires entre machines, procédures, sources d'énergie, formes sociales du travail, connaissances, représentations, etc. qui caractérise une époque. Un objet technique n'est effectivement technique qu'à l'intérieur de son système ; un décalage entre système et objet est ce qui constitue l'obsolescence. Il rend l'objet insignifiant et lui fait perdre

[15] François Albera et Maria Tortajada, « Le dispositif n'existe pas ! », dans François Albera et Maria Tortajada (dir.), *Ciné-dispositifs : spectacles, cinéma, télévision, littérature*, Lausanne, L'Âge d'homme, 2011, p. 14.

[16] Bertrand Gille, « La notion de "système technique" (essai d'épistémologie technique) », *Technique et culture [Culture technique]*, n° 1, 1979, p. 16.

toute technicité. Dans un monde entièrement numérique, une Bolex H16 n'est plus qu'un objet d'exposition, sa technicité a été intégralement perdue, « aliénée » dit Gilbert Simondon. On ne sait plus à quoi elle sert. On ne comprend plus ses spécificités. On ne saisit plus pourquoi telle manivelle est située là, ce qu'elle produit et pourquoi une Bolex peut être techniquement « supérieure » à une Beaulieu ou une Bell & Howell (ou l'inverse bien sûr).

Simondon est certainement celui qui a développé de la manière la plus singulière et complexe la réflexion sur l'évolution des machines. Dès *Du mode d'existence des objets techniques*, il montre que « l'évolution de l'objet technique obéit à la fois à un processus de différenciation [...] et à un processus de concrétisation »[17] – deux processus qui sont liés l'un à l'autre dialectiquement. La concrétisation résulte de la compréhension progressive de la logique interne réelle de fonctionnement de l'objet, de ses synergies, de ses incompatibilités. L'objet technique concret « a réalisé au niveau industriel sa cohérence interne », écrivait Guy Fihman[18] ; en lui, « aucun effet secondaire ne nuit au fonctionnement de l'ensemble ou n'est laissé en dehors de ce fonctionnement »[19], chaque élément structural venant à « remplir plusieurs fonctions au lieu d'une seule »[20]. Parallèlement à cette évolution de réel progrès technique se joue la tendance à la différenciation qui va, elle, vers une spécialisation de sous-ensembles de l'objet.

On peut toutefois se demander – comme cela a été fait par quelques commentateurs de Simondon – si ces modes d'évolution sont réellement d'ordre historique, s'ils correspondent à des événements datables ou s'ils représentent plutôt un modèle théorique qui ne serait pas véritablement concerné par une inscription concrète dans l'histoire. Or Simondon se pose aussi des problèmes d'historien. Il le fait d'abord en interrogeant la forme de la temporalité de cette évolution technique. Il revient en effet sur l'ancienne distinction entre *innovation* et *invention*. Pour lui, ces deux concepts correspondent aux deux formes concurrentes et

[17] Gilbert Simondon, *Du mode d'existence des objets techniques*, *op. cit.*, p. 31.

[18] Guy Fihman, « La stratégie Lumière : l'invention du cinéma comme marché », dans Pierre-Jean Benghozi, Christian Delage (dir.), *Une histoire économique du cinéma français (1895–1995) : regards croisés franco-américains*, Paris, L'Harmattan, 1997, p. 36.

[19] Gilbert Simondon, *Du mode d'existence des objets techniques*, *op. cit.*, p. 34.

[20] *Ibid.*, p. 31.

nécessaires d'évolution de l'objet technique. Celui-ci ne cesse d'abord d'intégrer de petites modifications, par adaptation à l'usage ou au milieu, par augmentation de l'intégration dans le système technique, etc. Ces innovations de surface, par nature mineures, produisent une « saturation progressive du système »[21] qui finit par créer des incompatibilités dans l'objet. Alors advient un palier dans l'évolution de l'objet technique, qui impose une refonte radicale de sa structure même : c'est l'invention, qui se définit pour Simondon comme « résolution de problème ».

L'évolution technique se joue donc à la fois selon la temporalité continue des innovations mineures et selon la temporalité discontinue de ces ruptures majeures que sont les inventions. Or la distinction entre ces deux niveaux constitue bien une préoccupation historiographique, en ce qu'elle recouvre la séparation entre « faits » et « événements » historiques qui pour Michel de Certeau garantissait pour l'historien, par le jeu de la périodisation, la possibilité même de la construction de son objet[22]. L'invention est littéralement ce qui fait événement dans une évolution technique. Il s'agit alors de pouvoir déterminer les critères de cette discrimination entre faits et événements techniques. Où se situent, dans l'histoire de la Bolex H16, les innovations mineures et les inventions majeures ? L'arrivée de la H16 Reflex par exemple est-elle une invention dans cette histoire-là ? Induit-elle une refonte structurelle de l'objet, un agencement interne entièrement nouveau ?

Pour comprendre le statut de cette innovation du reflex, il faut d'abord complexifier l'idée qu'elle consisterait en un moyen de supprimer la parallaxe lors du cadrage. Les H16 précédant le modèle reflex sont en fait munies de deux viseurs. Le viseur dit « clair » peut occuper deux positions sur la caméra. La première est située en haut de l'appareil, emplacement conseillé pour le transport mais qui peut être utilisé aussi pour le tournage : « elle suffit tout à fait pour les prises de vues courantes, à plus de deux mètres de distance », dit la notice. L'autre position consiste à fixer le viseur contre la porte de la machine, à hauteur de fenêtre d'impression, juste à côté donc de l'objectif médian de la tourelle. Assez tôt, ces viseurs d'abord trifocaux avant d'être multifocaux et parfois nommés « octamètres » sont munis de deux manettes ou

[21] *Ibid.*, p. 28.
[22] Michel de Certeau, *L'écriture de l'histoire*, Paris, Gallimard, 1975, notamment p. 133–134.

molettes (selon les modèles) de réglage, l'une pour l'adaptation à la focale de l'objectif, l'autre pour le report de la distance de mise au point. Ces deux molettes permettent une correction de la parallaxe, pour présenter à l'œil un cadre « rigoureusement exact » selon la notice et très lumineux – beaucoup plus que ne le sera plus tard la visée reflex. À ce viseur clair multifocal est ajouté un second œilleton placé sur le haut de la caméra. Il permet, grâce à un prisme à réflexion totale placé dans l'axe de l'objectif supérieur de la tourelle, d'effectuer une mise au point sur dépoli. C'est un élément de concrétisation du principe de la tourelle à trois objectifs car on réutilise ainsi la multiplicité des axes optiques. L'introduction de la visée reflex permettra donc non pas tant de corriger les problèmes de parallaxe que de réorganiser ces deux opérations que sont *cadrer* et *mettre au point*, en les homogénéisant partiellement sur la base d'une priorité donnée à l'unicité, dans la machine, de la place de l'œil de l'opérateur. Ceci permettra une simplification opératoire, mais se fera au prix de l'absorption d'une partie de la lumière de la scène par le prisme semi-réflecteur du système reflex. Les modèles reflex seront d'ailleurs toujours munis de ce viseur clair qui permet notamment de préparer avec confort et précision la focale et le cadrage avant la prise. La transition des modèles H vers le système reflex – contemporaine d'une autre transformation majeure, le remplacement progressif de la tourelle d'objectifs par un unique zoom – est donc inscrite dans une évolution technique finalement complexe. S'agit-il alors d'une suite continue d'innovations mineures, d'adaptations, ou peut-on tout de même repérer, à un certain moment, une discontinuité faisant événement et donc invention ? La visée reflex doit-elle être dotée de ce statut ?

Concrétisation et différenciation constituent pour Simondon les deux aspects de l'évolution proprement technique des machines, mais dans « Psychosociologie de la technicité », il développe un autre niveau du lien des objets techniques à l'histoire, celui qu'il nomme « surhistoricité ». Celle-ci consiste en une surdétermination de l'évolution des machines à partir de la culture dans son ensemble. Par ses « normes et exigences extra-techniques », elle « enveloppe l'objet technique et surcharge sa production, au point de compromettre des progrès essentiels »[23]. Si, par exemple, « le matériel ferroviaire est historique, mais très peu surhistorique », les automobiles au contraire sont marquées par une grande surhistoricité, qui se manifeste par

[23] Gilbert Simondon, *Sur la technique, op. cit.*, p. 58.

« le choix de couleurs, de peintures, d'émaillages fragiles, tôt dégradés », mais aussi par la nécessité de « cré[er] assez fréquemment des modèles nouveaux, ce qui revient à fractionner volontairement les réformes de structure correspondant à un progrès réel de technicité, parfois même à les différer »[24]. Se joue ici l'intrusion, dans le niveau technique, de la culture dans son ensemble, contre-force pesant sur l'historicité proprement technique à partir de problématiques externes. Il y a donc bien une histoire des machines, qui interagit avec l'histoire générale. Lignées et systèmes en conditionnent la description ; concrétisation, différenciation et surhistoricité en constituent les forces agissantes.

Histoire des machines, archéologie des pratiques

Comment peut-on articuler concrètement l'histoire des machines avec leur archéologie vers les pratiques, tout en conservant la tension dialectique entre le niveau proprement technique et les niveaux culturel, social, économique, etc. ? Tout d'abord, l'analyse technologique des machines dans leur cohérence doit, il me semble, s'agencer avec une appréhension par les opérations. D'après Sigaut, les classifications technologiques doivent être réalisées sur deux plans :

> Le premier plan est celui de l'*opération*. […] il faut commencer par identifier la ou les opérations dont il s'agit. C'est seulement ensuite qu'on peut s'interroger sur les différentes façons dont cette opération peut être exécutée […]. Façons différentes qui constituent les *techniques* proprement dites.[25]

À l'histoire des modèles de H16 doit être superposée l'histoire de ces opérations que sont par exemple *cadrer* et *mettre au point*. La classification des opérations est parfois bien sûr passablement complexe. En l'occurrence, celles-ci sont institutionnalisées comme opérations individualisables dans le système de production professionnel du cinéma, puisque *cadreur* et *assistant-opérateur* sont deux professions distinctes (même si liées par une hiérarchie d'apprentissage), chargées chacune de l'une de ces opérations. Ensuite, si selon Simondon l'invention se définit

[24] *Ibid.*
[25] François Sigaut, « Essai d'identification des instruments à bras de travail du sol », *op. cit.*, p. 362.

comme « résolution de problème », alors il faut intégrer l'histoire des machines et des manières de faire dans une histoire des problèmes. Le problème est profondément – comme j'ai essayé de le montrer ailleurs[26] – un concept à la fois épistémologique et technique : il est ce avec quoi l'inventeur, l'ingénieur ou le praticien travaillent concrètement. Si *cadrer* est une opération technique, l'établissement d'une visée adaptée aux tâches et usages d'une caméra de cinéma a été – et reste – un problème technique important. Le couple viseur clair/dépoli en a été une forme de solution ; la visée reflex une autre ; le retour vidéo ou ses avatars numériques une autre encore. Lignées et problèmes ne se recouvrent concrètement que partiellement. Le problème de la visée reflex a été résolu avec des prismes dans la Bolex, mais aussi en adossant un miroir à l'obturateur, solution massivement adoptée depuis la Arriflex de 1937. Ce sont deux logiques différentes, redevables de lignées techniques distinctes. Chaque solution révèle un cadre épistémologique spécifique, qui fut la structure dans laquelle le problème concret a été envisagé, travaillé et construit. La solution change lorsque le problème change, et celui-ci évolue avec l'*épistémè* qui le soutient. La visée ne pose pas les mêmes problèmes dans le cadre numérique que dans un système analogique.

Dans la perspective d'une histoire des techniques, les machines Bolex seront donc considérées comme archives par une analyse technologique où elles apparaîtront comme nœuds de réseaux d'opérations, et par une analyse épistémologique par laquelle elles seront perçues comme agencement de solutions partielles de divers problèmes. Ces deux niveaux permettent d'articuler ensemble appareils, manières de faire et compréhension des enjeux propres de la pensée opératoire, tout en préservant l'autonomie relative et dialectique du niveau technique, et ainsi la complexité réelle des relations historiques entre le technique et la culture. C'est de cette façon, me semble-t-il, qu'une compréhension de la mutation numérique contemporaine pourra se jouer.

[26] Benoît Turquety, *Inventer le cinéma : épistémologie : problèmes, machines*, Lausanne, L'Âge d'homme, 2014.

Voyages aériens en images : sources et objets pour une histoire du cinéma utilitaire[1]

Stéphane TRALONGO

Tout un pan du patrimoine cinématographique est lié à l'association du plaisir visuel et de la force productive des films[2]. Introduite récemment dans le champ de la recherche en cinéma, la notion d'« utilité »[3] peut permettre d'appréhender des films qui s'attachent en priorité à exercer un travail, sans qu'en soit forcément exclue toute dimension divertissante ou toute recherche esthétique. Cette notion ouvre en même temps l'histoire des techniques cinématographiques à une variété de dispositifs de projection qui ont été peu considérés jusqu'à présent, en comparaison de la salle de cinéma vouée à l'exploitation commerciale. Appliquant les procédures méthodologiques qui ont été développées à partir d'objets périphériques tels que les projections domestiques, les appareils d'amateurs ou les films publicitaires, cette étude s'efforce de réfléchir au cinéma sous l'angle d'un « éclatement » des usages, amenant l'historien à explorer les relations que le cinéma n'a cessé d'entretenir avec d'autres secteurs industriels et culturels. L'abandon plus ou moins complet du support pelliculaire n'est pas complètement étranger à l'essor d'investigations dans cette direction, puisque les choix de conservation et les projets de numérisation ont poussé la recherche à redéfinir ses objets et ses problématiques. Face aux processus actuels de dissémination et d'individualisation des écrans qui

[1] Ce texte s'inscrit dans le cadre du projet de recherche « Liaisons aériennes : aux croisements industriels du cinéma et de l'aviation » soutenu par l'Université de Lausanne au sein de la Collaboration UNIL+Cinémathèque suisse.

[2] Un article comme « Utilisons le cinéma » paru dans *Lectures pour tous* (n° 132, 15 septembre 1917, p. 1666–1671) fait par exemple état des applications possibles du cinéma dans le domaine industriel, « surtout à l'usine et combiné à la méthode Taylor » suivant les préceptes de Frank B. Gilbreth.

[3] Voir Haidee Wasson et Charles R. Acland, « Introduction: Utility and Cinema », dans Charles R. Acland et Haidee Wasson (dir.), *Useful Cinema*, Durham, Duke University Press, 2011, p. 1–14.

déterminent notre rapport aux images, on doit aussi se demander si, au lieu de débuter avec les appareils numériques, ces processus ne prolongent pas plutôt des modes d'exploitation et de consommation des films fondés sur la « portabilité », l'« automatisme » ou la « miniaturisation » du matériel cinématographique[4].

Issus d'une liaison ancienne mais souvent jugée compromettante avec le monde industriel, films de formation, d'information, de prévention et de promotion ont tous en commun d'avoir été conçus pour l'accomplissement d'une tâche qui oblige à considérer ensemble le spectaculaire et l'utilitaire. « Un autre cinéma », telle est l'expression qui qualifie cette production multiple et éparse dans la revue *L'Avant-scène cinéma*, alors qu'elle s'aventure exceptionnellement sur le territoire du « film d'entreprise » pour son numéro spécial de janvier 1978, non sans l'avoir préalablement relié aux noms de ces illustres cinéastes que sont Georges Franju, Jean-Luc Godard et Alain Resnais[5]. Or « l'altérité » de ce cinéma est certainement à rechercher du côté des compétences extra-cinématographiques qu'il mobilise, étant donné que les films, mais aussi les discussions, les publications et les manifestations qui leur sont associés, se situent pour une bonne part à la lisière ou franchement en dehors des espaces consacrés du cinéma. Constatant l'intrication du documentaire et de l'industrie dans les années d'après-guerre (1946–1955), Michèle Lagny a décrit des démarches investigatrices qui doivent surmonter un double obstacle, d'une part celui du jugement dépréciatif, du « faible statut culturel » des films, et d'autre part celui de la rareté des sources qu'« [i]l faut chercher dans les entreprises concernées, dans la mesure où elles conservent ou archivent cette production »[6]. Toutefois, les rapports entre cinéma et industrie à cette époque (et, plus largement, entre art et industrie), sont d'une fécondité telle qu'on ne saurait rejeter les « films industriels » du côté de l'utilité et du promotionnel sans occulter les définitions qu'on en donne ou les usages qu'on en fait alors.

[4] La question est posée par François Albera relativement au développement du matériel à destination de l'amateur dans son texte « Le cinéma amateur "projette" le numérique », dans Valérie Vignaux et Benoît Turquety (dir.), *L'amateur en cinéma, un autre paradigme : histoire, esthétique, marges et institutions*, Paris, AFRHC, 2016, p. 56–73.

[5] *L'Avant-scène cinéma*, n° 199–200, 1–15 janvier 1978.

[6] Michèle Lagny, « Documentaire et commandite : conséquences pour le cinéma ouvrier », *Cahiers de la Cinémathèque*, n° 71, décembre 2000, p. 38.

Plus qu'avec d'autres secteurs industriels, le cinéma semble avoir été en constante interaction avec le milieu de l'aviation et surtout avoir « travaillé » à plein dans le sens de l'expansion du domaine du voyage aérien commercial au lendemain de la guerre. Cette étude s'intéresse ainsi à la possibilité de documenter l'histoire de ces échanges par des sources dont beaucoup semblent lointaines par rapport au cinéma, tout en dégageant certaines des questions qui peuvent guider la recherche à travers les méandres de l'utilitaire. Autrement dit, il s'agit d'éprouver une méthode basée sur le « décentrement » en faisant se croiser discours, films et technologies autour de la problématique des contacts entre industrie et cinéma. Nous localiserons d'abord, à l'extérieur du milieu du cinéma de cet après-guerre, un espace éditorial où utilité et spectacle ont été envisagés en complémentarité plutôt qu'en opposition autour de l'idée dc « cinéma fonctionnel ». La localisation de ces sources, en dehors des revues de cinéma les plus répandues, n'est pas la moindre des difficultés que pose la question de l'utilité, mais la recherche peut aboutir à la découverte d'une production journalistique d'une ampleur insoupçonnée. Puis nous nous pencherons sur la notion de « prestige » en interrogeant l'hybridité propre aux films du secteur industriel de l'aéronautique, qui font alors l'objet de manifestations de valorisation calquées sur le modèle des festivals de cinéma. Le caractère spectaculaire de ces films, ayant pour certains connu une distribution dans les salles, nous amène à réintégrer dans la réflexion la fonction promotionnelle des images. Nous considèrerons enfin l'une des impulsions extérieures que le monde industriel a données dès les années 1950 au cinéma de divertissement pour qu'en soient renouvelés les espaces et les techniques d'exploitation. L'installation de projecteurs de format « substandard » à bord des avions de ligne relève ainsi d'un processus de conversion des moyens de transport en espaces de divertissement qui mérite d'être questionné à l'aune de la « mobilisation » progressive des appareils mécaniques puis électroniques.

Hors du cinéma : l'extériorité des discours sur les films industriels

Depuis le début des années 1950, l'intégration du cinéma au monde industriel s'est intensifiée, tant dans les services de la recherche et du développement que dans ceux de la communication où il a pris place au côté de l'affiche, de la photographie et du diaporama. Si certaines revues spécialisées en cinéma s'intéressent aux films dits « utilitaires » ou

« fonctionnels »[7], les questions économiques, esthétiques et juridiques soulevées par cette production sont davantage débattues à l'extérieur du milieu de l'industrie cinématographique, dans des organes adressés à un lectorat d'entrepreneurs, d'ingénieurs et de publicitaires. Il nous faut donc faire un pas de côté pour repérer les sources révélant ce contexte d'intermédialité dans lequel le film se trouve incorporé aux « moyens audiovisuels » à la disposition de l'industrie. Ainsi le cinéma se présente-t-il comme un objet de réflexion pour une presse corporative qui lui ouvre des rubriques : à compter de 1958, *Le Miroir de l'information, de la publicité et des relations publiques* accueille régulièrement des « Nouvelles du film d'information ». De nouvelles revues, telles que le périodique *Cinéma-TV-Promotion* créé en 1959, sont en outre fondées pour en promouvoir activement les applications industrielles, commerciales et publicitaires. Allant dans le sens d'une professionnalisation du secteur de la production de films d'entreprise, cette presse favorise la prise de contact des entrepreneurs avec des sociétés cinématographiques, mettant en garde les commanditaires contre une méconnaissance qui a abouti, selon l'état des lieux de *L'Usine nouvelle*, à des « films abusivement chers », des « films de conseil d'administration », des « films d'amateurs »[8]. À l'écart des manifestations cinéphiles mais sans renoncer au prestige culturel acquis par le cinéma, d'autres discours s'élaborent dans cet espace éditorial « extérieur », faisant s'articuler logiquement des enjeux industriels et commerciaux avec des éléments de technique et d'esthétique des films.

Dans les organes où apparaît cette considération pour la portée utilitaire du cinéma, on fait d'abord la part belle aux discours instructifs, capables d'éveiller le monde industriel à tous les aspects de la production et de la distribution d'un film. Pour le rendre sensible à ce que l'on peut nommer, à la suite de Frank Kessler et Sabine Lenk, la « polyvalence »[9] du médium, les rédacteurs se livrent

[7] Voir notamment Jean-Pierre Coursodon, « Une intéressante métamorphose de genre : le film documentaire est devenu "fonctionnel" », *Le cinéma chez soi*, n° 33, mars 1961, p. 70–72.

[8] S. a., « La production de films d'information industrielle », *L'Usine nouvelle*, s.n., janvier 1965, p. 119.

[9] Frank Kessler et Sabine Lenk, « Quelles perspectives pour l'historiographie du cinéma ? », dans Alberto Beltrame, Giuseppe Fidotta et Andrea Mariani (dir.), *At the Borders of (Film) History: Temporality, Archaeology, Theories*, Udine, Forum, 2015, p. 128.

à un exercice périlleux de définition, qui passe par l'élaboration de typologies cherchant à embrasser la totalité des fonctions que les films sont appelés à remplir en ce domaine. Dans son article de fond sur le « film d'information », *Le Miroir de l'information* aborde frontalement la question de la pluralité des usages du film : « [e]ntre le film de propagande et le film publicitaire » est ainsi décrit un spectre étendu de films fonctionnels allant du « film d'éducation sociale et civique » au « film de diffusion commerciale », sans omettre le « film technique et professionnel »[10]. Aux différents usages possibles du film correspondent des circuits de distribution variés. Les écrans du « cinéma utilitaire »[11] peuvent être des installations éphémères pour une diffusion interne dans les usines aussi bien que les équipements standards des salles commerciales, où les films industriels les plus ambitieux sont profitablement couplés « avec un Jean Gabin » ou « un film de Brigitte Bardot »[12]. Comme la frontière entre information et promotion est plutôt flottante, on peut encore compter sur une diffusion parallèle dans le circuit de l'éducation, dans la mesure où le « catalogue de l'IPN [Institut pédagogique national] » regroupe quantité de films qui « entrent dans la catégorie des films "d'entreprises" »[13]. Par ces discours qui unifient sous la bannière de l'« utilité » une production pour le moins hétérogène et dispersée, il ne s'agit pas uniquement de convaincre les entrepreneurs des bénéfices que peut apporter le cinéma dans tous les services d'une société, mais aussi de mettre en place les conditions propices à une rencontre avec les producteurs de films ou les fabricants d'appareils.

[10] S. a., « Le film d'information va-t-il connaître en France un important développement ? », *Le Miroir de l'information, de la publicité et des relations publiques*, n° 45, 13 septembre 1958, p. 14.

[11] Nous renvoyons ici à la notion telle qu'elle a été développée dans l'ouvrage de Charles R. Acland et Haidee Wasson, *Useful Cinema, op. cit.*

[12] S. a., « La distribution commerciale dans les salles de cinéma », *Relations publiques actualités*, n° 146, avril 1966, p. 19–22.

[13] Henri Marc, « De l'information à l'éducation. 1600 films pour l'Enseignement public », *La Technique, l'exploitation cinématographique*, n° 270, janvier 1966, p. 18, souligné dans le texte.

Figure 1. La presse corporative des publicitaires s'empare de la question du film d'« information » au moment où sont fondées les Journées internationales du film technique, industriel et agricole à Rouen (*Le Miroir de l'information, de la publicité et des relations publiques*, n° 45, 13 septembre 1958).

Les revues corporatives participent dans le même temps à un processus de valorisation du cinéma utilitaire, qui fait entrer dans le débat des considérations stylistiques. Bien qu'ils œuvrent principalement dans un contexte extra-cinématographique, ceux qui sont favorables à l'essor d'un tel cinéma ne voient pas d'incompatibilité fondamentale entre la qualité fonctionnelle d'un film et son intérêt esthétique. Que l'utilitaire et le spectaculaire soient plutôt en corrélation, voilà qui n'est pas incohérent pour les lecteurs d'une revue publicitaire française de référence comme

Vendre. Dès 1932, à l'occasion de l'inauguration de sa « Semaine de la publicité par le cinéma », la société Dam-Publicité avait invité le pionnier Georges Méliès à narrer la fabrication de ses « vues-réclame » du début du siècle, plaçant ainsi les films à vocation promotionnelle sous le patronage du spécialiste des trucages[14]. Faisant preuve d'érudition cinéphile, *Le Miroir de l'information* présente encore, en 1958, Méliès en « précurseur inattendu du film d'information » mais s'appuie aussi sur l'exemple des cinéastes Robert Flaherty, John Grierson et Georges Rouquier, pour défendre l'idée que l'utilité a été depuis le début un moteur de la création en cinéma : « Le rôle du cinéma, selon ce groupe [formé par John Grierson], est non de <u>doubler</u> le théâtre ou le roman, mais de "servir", de traiter des sujets utilitaires. »[15] Dans l'étude en plusieurs livraisons sur le « film d'information industrielle » qu'elle fait paraître en 1965, la revue *L'Usine nouvelle* ne transige pas sur la nécessité d'insuffler de l'art à cette production, en dépit de l'austérité des objectifs de démonstration ou d'explication qu'elle se fixe : « il semble qu'à l'extrême limite, il faille donner raison à l'homme de l'art, car même le film industriel le plus sérieux et le mieux condensé doit rester un spectacle »[16].

Par-delà le divertissement : l'utilité du film dans l'industrie aéronautique

L'identification d'un corpus plus ou moins homogène de textes sur le cinéma utilitaire nous conduit à nous interroger ensuite sur la mise en œuvre des propositions adressées aux industriels. Toutefois, la localisation des films de l'industrie aéronautique nous oblige là aussi à effectuer un effort supplémentaire de décentrement, en investiguant le territoire des productions qualifiées par les archivistes d'« orphelines »[17]. En l'occurrence, l'idée de voyage en images autour de laquelle s'était organisée

[14] Georges Méliès, « Quelques souvenirs du créateur de la publicité filmée », *Vendre*, n° 106, septembre 1932, p. 119–121.

[15] S. a., « Le film d'information va-t-il connaître en France un important développement ? », *Le Miroir de l'information, de la publicité et des relations publiques*, *op. cit.*, p. 17–18.

[16] S. a., « La production de films d'information industrielle », *L'Usine nouvelle*, *op. cit.*, p. 121.

[17] Voir Paolo Cherchi Usai, « Are All (Analog) Films "Orphans"? A Predigital Appraisal », *The Moving Image*, vol. 9, n° 1, printemps 2009, p. 1–18.

toute une part du cinéma des premiers temps[18] persiste durablement
à travers les films des compagnies aériennes. Cité en exemple dans le
débat sur l'exploitation du cinéma dans le monde industriel, le secteur du
voyage aérien commercial fait un usage extensif du film dans les années
1950, à tel point que l'on peut se demander, comme Nico de Klerk, si
la diffusion de films ne relève pas d'une volonté d'*anticipation* des désirs
et des besoins en matière de vol intercontinental[19]. La projection de
films promotionnels dans les salles de cinéma comme au sein des salons
aéronautiques prend la forme de tours d'avion *virtuels*[20], précipitant les
spectateurs dans un espace longtemps associé à l'instabilité des éléments
plutôt qu'à la régularité d'une force qui les traverse sans encombre. En
réaction à la publication de l'étude sur le cinéma dans *Le Miroir de
l'information* en 1958, Jean Chitry, le « [c]hargé de propagande d'Air-
France », rappelle à juste titre que l'aéronautique avait précocement usé
du film comme moyen de promotion, ayant lui-même contribué « avec le
concours de Saint-Exupéry » à la production d'*Atlantique-Sud*, « très beau
documentaire de 40 minutes (1935) »[21]. Lorsqu'elle dresse le bilan des
usages du film chez Air France depuis le début des années 1950, la revue
France Aviation décrit une série de films réalisés par la compagnie ou avec
son appui sous l'angle de leur valeur fonctionnelle, les associant chacun
à un problème qui pouvait être résolu sur le plan de la représentation
cinématographique du voyage aérien[22]. De la familiarisation pédagogique
avec une machine qui suscite la méfiance sinon l'angoisse jusqu'à la
distinction technique de la flotte aérienne française, les promoteurs de
l'aviation commerciale ont travaillé le rapport de leurs potentiels clients
à l'aéronautique. Aux films sur les trajets hasardeux des pionniers de
l'aéropostale qui cherchaient avant tout à faire la démonstration de la

[18] Tom Gunning, « "The Whole World Within Reach": Travel Images without
 Borders », dans Jeffrey Ruoff (dir.), *Virtual Voyages: Cinema and Travel*, Durham,
 Duke University Press, 2006, p. 25–41.

[19] Nico de Klerk, « Dream-Work: Pan Am's *New Horizons* in Holland », dans Bo
 Florin, Nico de Klerk et Patrick Vonderau (dir.), *Films That Sell: Moving Pictures and
 Advertising*, Londres, British Film Institute, 2016, p. 131–144.

[20] Voir Jeffrey Ruoff, « The Filmic Fourth Dimension: Cinema as Audiovisual Vehicle »,
 dans Jeffrey Ruoff (dir.), *Virtual Voyages: Cinema and Travel*, *op. cit.*, p. 1–21.

[21] S. a., « Nouvelles du film d'information », *Le Miroir de l'information, de la publicité et
 des relations publiques*, n° 53, 8 novembre 1958, p. 35.

[22] G. M., « Photo, cinéma et aviation commerciale », *France Aviation*, n° 133,
 15 décembre 1965, p. D-E.

possibilité du voyage intercontinental (*Atlantique-Sud* fait encore partie de ceux-là en 1935), vont ainsi succéder des films donnant aux futurs passagers l'assurance de la rapidité et de la sécurité du transport aérien commercial à l'ère des *jets* (*Caravelle*, en 1959, suivra clairement cette orientation).

Si la lecture des revues corporatives et promotionnelles de l'industrie aéronautique facilite l'établissement d'outils filmographiques, elle dirige aussi l'attention sur des définitions et des catégorisations des films qui sont propres au cinéma utilitaire. À l'intérieur de la catégorie des « films d'information », ceux qui sont spécialement conçus à destination des services de « relations publiques » se situent dans une zone trouble, à la croisée de la vulgarisation des techniques de navigation aérienne et de la promotion de l'industrie aéronautique nationale. Contrairement aux films ouvertement qualifiés de « publicitaires », ce répertoire-là englobe des films « de prestige » dont la dimension promotionnelle est plus nuancée, allusive, impure, bref, diluée – comme le résume la revue *Relations publiques actualités* – dans « un certain caractère de *spectacle et d'information sereine* »[23]. Chez Air France, la recherche d'une forme hybride pour les films de prestige est déléguée à des sociétés de production cinématographique coopérant avec le service des « relations extérieures » qui, selon la revue d'entreprise *Kodéco*, « poursuit un but identique : faire aimer l'avion » mais « use de tactiques différentes », « ne pousse pas le public dans la carlingue »[24] à la manière d'un film publicitaire. Les procédés ostensibles de persuasion dont se sert la publicité cèdent ici le pas à des références discrètes à la marque, comme celles que, « dans un esprit de relations publiques », le film *Caravelle* s'applique à formuler « sans que le nom de la compagnie nationale soit seulement prononcé »[25]. Produit par Pathé-Cinéma en 1959, ce film célèbre la mise en service de l'avion à réaction français fabriqué par Sud-Aviation, mais il donne aussi à Air France l'opportunité de véhiculer, par quelques plans montrant l'intérieur de la cabine et intercalés à sa demande, l'idée que l'avion est devenu un espace de silence, de détente et de plaisir[26]. Apothéose

[23] P. Herbin et Ph. Gaumont, « L'utilisation du film de 16 mm dans les entreprises », *Relations publiques actualités*, n° 157, avril-mai 1968, p. 72 – c'est nous qui soulignons.

[24] R. Seube, « Air France et le cinéma », *Kodéco*, n° 166, novembre 1970, p. 20.

[25] G. M., « Photo, cinéma et aviation commerciale », *France Aviation*, *op. cit.*, p. D.

[26] *Caravelle*, Jean-Jacques Languepin, Pathé-Cinéma, 1959, 35 mm, couleur, sonore, français, 450 m, Gaumont Pathé Archives.

spectaculaire, le finale de ce film en couleur repose sur l'alignement de l'avion depuis lequel s'opère la prise de vues avec une Caravelle dont les hublots sont successivement traversés par les rayons du soleil couchant. Acrobatie aérienne et technique cinématographique s'enrichissent ainsi mutuellement.

La notion de « prestige » accolée à un film voué à décrire un processus de fabrication industriel est évocatrice du statut ambivalent des films d'information. Lors de la deuxième édition des Journées internationales du film technique, industriel et agricole, le film *Caravelle*, sélectionné dans la catégorie « Films de prestige de relations publiques », est récompensé par un « Oscar d'or »[27], la plus haute distinction décernée dans ce festival, mais une distinction ambigüe accentuant encore le balancement du film entre l'utile et l'agréable. Fondées à Rouen en 1958, ces Journées empruntent, en effet, autant au salon industriel qu'au festival de cinéma, dans la mesure où elles reconduisent les règles cérémonielles de célébration des films distribués dans le circuit commercial, mais rassemblent en leur jury et leur public des entrepreneurs, des publicitaires et des techniciens venus évaluer une production à vocation utilitaire. Si les questions techniques les plus sèches sont exposées par les spécialistes qui s'y sont déplacés en nombre, le festival cherche aussi à faire rejaillir sur les films de sa sélection le prestige des premières fastueuses, en accueillant « [l]es vedettes et metteurs en scène » d'un film de long métrage présenté lors de « soirées de gala » aux cinémas Éden, Omnia et Normandy[28]. Dans la conférence de clôture de l'édition de 1959, Rémy Tessonneau, le directeur de l'IDHEC, formule, en outre, une conception du cinéma « fonctionnel » – le choix de l'adjectif est éloquent – qui fait écho aux réflexions contemporaines en architecture ou en esthétique industrielle, voyant dans « l'agencement d'une maison moderne », « la ligne d'une auto » ou « l'ordonnance des sièges d'un avion » « une beauté de dépouillement *dont le canon est l'adaptation à l'usage qu'on en doit faire* »[29]. La valorisation des films industriels tient aussi à l'idée qu'une « beauté » peut naître des formes des

[27] S. a., « Journées internationales du film technique, industriel et agricole à Rouen 1959 », *La Technique cinématographique*, n° 203, novembre 1959, p. 276.

[28] S. a., « Dernières informations avant le programme complet des Journées internationales du film technique, industriel et agricole », *Le Miroir de l'information, de la publicité et des relations publiques*, n° 98, 26 septembre 1959, encart non paginé.

[29] Rémy Tessonneau, « Les significations d'un cinéma fonctionnel », *Le cinéma chez soi*, n° 33, mars 1961, p. 73 – c'est nous qui soulignons.

productions les plus utilitaires allant de la chaise tubulaire jusqu'à l'avion à réaction[30].

Au cœur de la technique : la productivité des appareils de cinéma aériens

La multiplication des applications industrielles du cinéma encourage les entreprises à ne pas simplement adopter un matériel standard, mais à stimuler la recherche, à impulser des modifications techniques, à pousser au développement d'appareils hybrides. Entre le bricolage d'appareils existants et la fabrication de prototypes adaptés à ses objectifs, l'industrie aéronautique suscite une constellation d'objets utilitaires qui dépassent l'« instrumentalisation » des appareils de cinéma. En même temps qu'elle fait apparaître la pérennité d'une multitude d'usages, la redécouverte de tels objets force à repenser la consommation de films en dehors de la salle de cinéma. C'est ce double enjeu d'une histoire du cinéma utilitaire articulée avec une histoire des techniques que nous souhaitons illustrer à présent par des cas concrets. À la fin des années 1950, le « casque-caméra » pour l'enregistrement de performances acrobatiques est déjà une réalité dans le domaine de l'étude et de l'enseignement du parachutisme, où d'intrépides hommes volants n'hésitent pas à s'harnacher d'un équipement d'appareils portatifs mais encore lourds à supporter à la seule force du cou[31]. Au-delà des usages strictement sportifs et militaires, les casques-caméras épousant le point de vue des parachutistes captent des images sensationnelles, si bien que le cinéma ne tarde pas à se les approprier dans des films spectaculaires tels que *L'Homme de Rio* (Philippe de Broca, 1964). Engagée dans une campagne de sensibilisation des entrepreneurs à l'utilité des appareils cinématographiques de format substandard[32], la firme suisse Paillard ne craint pas, pour sa part, de montrer l'une de ses caméras Bolex H8 Reflex transformée en machine à inventorier et à

[30] Ces deux objets techniques sont précisément juxtaposés dans le texte de Jean Pellandini, *Kodéco*, numéro spécial « La photographie révélatrice des choses de notre temps », janvier 1960, p. 12–23.

[31] Joseph Garrec, « Créé pour les besoins de la "chute libre", le casque-caméra apporte au cinéma un nouveau point de vue », *Le cinéma pratique chez soi*, n° 51, mars-avril 1964, p. 51–54.

[32] S. a., « Votre caméra au service de votre entreprise », *Vendre*, n° 351, mai 1959, p. 36–37.

contrôler les pales d'un réacteur pour la compagnie aérienne Swissair[33]. Soumise à une utilisation répétitive d'enregistrement image par image, la caméra est ainsi garante, au même titre que d'autres instruments de vérification, du bon fonctionnement de l'avion à réaction. Installé dans le secteur « Transports et communications » de l'Exposition nationale suisse en 1964, le dispositif de projection à triple écran de la section « Aviation » active enfin une fonction simulatrice du cinéma. Si le film de cette section a des vertus éducatives, en exposant « toutes les opérations que nécessite le décollage d'un multiturbines au long cours », il vise aussi à familiariser les visiteurs avec les conditions de vol à bord d'un long-courrier pendant « le trajet Suisse-Japon »[34].

Dans la lignée de ces objets utilitaires, les appareils de projection dont on a entrepris en France l'exploitation régulière en cabine dès la fin des années 1950 dépendent, à différents égards, ainsi qu'a pu le démontrer Stephen Groening par rapport au contexte américain[35], d'une logique de *persuasion*. Pionniers en matière d'appareils de projection « embarqués », les Transports aériens intercontinentaux (TAI) se présentent, dans un fascicule de 1958, comme la compagnie aérienne avec laquelle « le septième art a fait son baptême de l'air »[36], avant de s'imposer comme spectacle durable pendant ses vols long-courriers. Pour mettre en conformité le matériel audiovisuel avec l'environnement technique de la cabine, la compagnie souligne que faute d'appareils adaptés au vol, elle a dû impulser le développement d'un « projecteur à double objectif [qui] diffuse le film simultanément sur deux écrans, l'un en première classe, l'autre en classe touriste »[37]. En se rapprochant de l'industrie cinématographique, et en l'occurrence de la firme Pathé[38], la compagnie entraîne la production d'un appareil de projection conçu pour s'adapter aux conditions du vol – turbulences, bruit, exiguïté –, et faire ainsi corps

[33] *Caméra Bolex H16. Applications*, s. d., 16 mm, couleur, sonore, français, 166 m, Cinémathèque suisse.

[34] Ernest Naef, « Une vision instructive, éducative et frappante : les ailes suisses à l'Expo nationale 1964 », *Feuille d'avis de Lausanne*, n° 99, 29 avril 1964, p. 52.

[35] Stephen Groening, « Airborne Cinema: The Emergence of Inflight Entertainment », *Cinema Beyond Territory: Inflight Entertainment and Atmospheres of Globalisation*, Londres, British Film Institute, 2014, p. 65–108.

[36] Compagnie de Transports aériens intercontinentaux, *TAI The Sign of The Winged Gryphon*, Paris, TAI, 1958, p. 11 – c'est nous qui traduisons.

[37] *Ibid.*

[38] *Informations UTA*, n° 18, 1er trimestre 1969, s. p.

avec l'avion dans lequel il n'est plus tout à fait une « pièce rapportée » mais plutôt déjà un *prolongement* de la machine volante. Si elle compte ces appareils de cinéma au nombre des équipements qui garantissent à sa clientèle un service à bord « de qualité », la compagnie aérienne mise aussi sur la fonction distractive du cinéma pour promouvoir le voyage aérien intercontinental, au moment où en aviation commerciale la sensation de traversée de l'espace laisse de plus en plus la place au sentiment de l'écoulement du temps. L'allongement de la durée de vol sans escale est donc en partie compensé par des projections de films de divertissement, mais aussi par des films touristiques de la compagnie « vendant » les destinations qu'elle dessert[39].

Figure 2. Le voyage aérien de l'Europe vers l'Amérique du Nord est aussi la familiarisation avec un équipement audiovisuel anticipant sur la découverte des écrans de l'Expo 67 à Montréal (*Feuille d'avis de Lausanne*, n° 53, 4–5 mars 1967, p. 20).

[39] S. a., « Showings Aloft as TAI Pionneers the Theatre-in-the-Sky », *Business Screen*, vol. 21, n° 6, octobre 1960, p. 41.

D'une forme localisée de l'exploitation, certaines compagnies vont faire un enjeu majeur pour l'établissement de leurs lignes long-courrier. Témoins de « Joutes (publicitaires) aériennes »[40] en 1964, les analystes des campagnes de promotion signalent que la compagnie américaine TWA cherche à se distinguer de la concurrence par l'exclusivité de son service de projection de films pendant les vols transatlantiques, en faisant entrer dans son iconographie publicitaire la symbolique de la technique de cinéma avec une image de « clap », par exemple. Contrainte de s'aligner sur la concurrence américaine, la compagnie Air France opte en 1966 pour une réplique ambitieuse[41] autant sur le plan technique que sur celui de la communication, articulée autour de l'idée de *festivité* que l'on retrouve dans un slogan comme « Air France vous offre en plus… Festival en plein ciel »[42]. Confrontée aux problèmes techniques et sociaux que pose l'installation d'un matériel additionnel dans l'espace confiné de la cabine, Air France opte non pas pour la standardisation complète avec le système de projection Inflight Motion Picture, mais pour une solution mixte en équipant une partie de sa flotte de télévisions reliées à des magnétoscopes. Lorsqu'il vante la conversion d'« une cabine de Boeing » en « salles de cinéma »[43], le discours publicitaire cherche surtout à effacer l'idée d'un avion en espace de nécessaire contrainte du corps pour lui substituer celle d'un espace de décontraction recherchée, ou même dans ce cas de plaisir artistique que l'avion, mieux que la salle de projection « terrestre », serait en mesure de faire goûter. Si le modèle privilégié de ces « distractions à bord » est la salle de cinéma commercial où les films paraissent sur écran large, la conversion de la cabine en lieu de projection semble dépendre autant de l'industrie du voyage aérien que de l'industrie du cinéma, dont l'alliance aboutit à des objets techniques hybrides. Dans la perspective d'une histoire de la portabilité des appareils, on saisit l'intérêt de retrouver ces objets fondés sur des critères de mobilité et d'automatisme, transportant le cinéma hors des salles, transformant d'autres lieux en espaces de consommation des images.

La mise à l'épreuve d'une approche « décentrée » du cinéma permet en fin de compte de tirer certains enseignements pour la suite des recherches

[40] L'agent de publicité de service, « Joutes (publicitaires) aériennes », *Le Journal de la publicité*, n° 444, 4 décembre 1964, p. 2.

[41] C. L., « Festival en plein ciel », *France Aviation*, n° 139, 15 juin 1966, p. A.

[42] *Feuille d'avis de Lausanne*, n° 53, 4–5 mars 1967, p. 20.

[43] *Ibid.*

sur le cinéma utilitaire. Loin de l'étanchéité présumée entre les différentes catégories de films, un détour par la presse corporative des entrepreneurs et des publicitaires nous apprend ainsi que les films industriels, ou à tout le moins les plus prestigieux d'entre eux réalisés à des fins de relations publiques, ont pénétré les salles commerciales comme les circuits éducatifs et associatifs, où se confondent vulgarisation des techniques et glorification des industries. À l'opposé aussi de l'idée d'une frontière infranchissable entre utilitaire et spectaculaire, les définitions émanant de spécialistes de la technique du film industriel reconnaissent que le regard des cinéastes peut donner aux films consacrés au monde de l'entreprise une forme artistique qui en fait des objets également appréciables en dehors de leur valeur promotionnelle. S'ils servent assurément des objectifs de développement du voyage aérien, les objets – filmiques ou techniques – générés en nombre par l'industrie de l'aviation civile croisent en fin de compte la trajectoire du cinéma commercial, attiré par ce que l'avion offre comme nouvelles possibilités d'exploitation. Que ce soit avec un long métrage de fiction tel que *L'Homme de Rio* ou au cours d'une conférence sur l'aviation civile agrémentée de films promotionnels d'Air France, nombreux sont en tout cas les spectateurs qui, au tournant des années 1960, font leur baptême de l'air en toute sécurité à l'intérieur d'une salle de projection. Écrire l'histoire du cinéma utilitaire implique donc aussi bien de situer des points de contact entre spectacle et utilité que de retracer des usages des images qui, depuis les « vues animées » des premiers temps, lient indissociablement cinéma et industrie.

La manufacture mondialisée de l'animation : *Motion Makers*, ouvriers et petites mains de l'intervalle

Dominique WILLOUGHBY

> Si le temps c'est de l'argent,
> alors les animateurs sont les gens les plus pauvres
> du monde.
>
> Alexandre Alexeïeff[1]

S'il est une branche du cinéma où les liens entre esthétique et technique sont les plus visiblement interdépendants et économiquement déterminants, c'est bien le domaine de l'animation graphique. Au-delà des approches critiques et analytiques fondées sur l'analyse des films d'animation et de leur esthétique, il n'est pas inutile de considérer les motivations et les contraintes qui en sous-tendent les qualités particulières et en déterminent des formes spécifiques de création artistique, ainsi que d'organisation du travail et de la production. Nous proposons, dans cet article, un rappel historique, suivi d'un bref état des lieux de la question du travail de l'animation industrielle et de sa main d'œuvre, à l'heure de la mondialisation et des mutations numériques qui ont transformé et diversifié les pratiques sans réduire le besoin de main d'œuvre. Nous nous appuyons sur notre propre expérience pratique de création, sur des travaux de recherche sur l'histoire et l'esthétique de l'animation, sur différentes sources professionnelles et syndicales récentes, ainsi que sur la mémoire de quelques visites de studios

[1] Dans le film documentaire de Norman McLaren et Grant Munro, *L'Écran d'épingles* (*Pinscreen*), prod. ONFC, Canada, 1973. DVD « Alexeïeff : le cinéma épinglé », Cinédoc Paris Films Coop, Paris, 2005.

d'animation en différents lieux et époques. Nous avons également porté nos recherches sur les paroles d'animateurs, interviews, commentaires, sites et blogs non institutionnels consacrés à l'animation, qu'ils soient le fait de fans, de critiques ou d'animateurs, locaux ou expatriés, dans lesquels on peut trouver, avec un peu de patience, un certain nombre d'informations et de témoignages éclairants sur la réalité du travail et de l'art de l'animation aujourd'hui, distincts des discours institutionnels et des récits médiatiques.

L'animation ou le cinéma fait main

Les particularités du cinéma d'animation sont connues : chaque image doit en être pensée et dessinée ou construite manuellement, tandis qu'en prises de vues réelles les images s'inscrivent mécaniquement et instantanément au fil du tournage. Quelle qu'en soit la méthode, la réalisation des films d'animation demande beaucoup plus de temps qu'en prises de vues réelles. Ce fait détermine l'équation particulière qui relie l'esthétique, la technique et l'économie. Les différents équilibres entre temps d'exécution, nombre d'exécutants, qualités esthétiques, méthodes et procédés techniques sous-tendent l'organisation matérielle et humaine du travail de l'animation tout au long de son histoire et déterminent ses diverses options esthétiques et économiques. Du point de vue esthétique et technique, les variables interdépendantes en sont la complexité ou la qualité de chaque image, de leurs mouvements selon les changements d'images dont découle leur plus ou moins grande fluidité, et les procédés techniques employés. Du point de vue pratique, les solutions consistent en différentes modalités de séparation du fixe et du mouvant, de division et de hiérarchisation du travail, de choix entre qualité et quantité, la recherche et l'invention constantes de techniques plus rapides. De l'animateur solitaire aux grands studios mondialisés, les positions de l'artiste et de l'exécutant, de l'inventeur et du technicien, du producteur-entrepreneur cinématographique se confondent et s'opposent tour à tour, parfois incarnés dans les mêmes personnes.

Petite histoire de l'animation industrielle et de son organisation

Industrie de l'animation : la manufacture du mouvement animé

Près de deux siècles après l'invention des dessins animés par une petite poignée de savants européens, sous formes de jouets d'optique, et plus d'un siècle après leur réinvention cinématographique en 1908 par Émile Cohl, des milliers d'heures d'animation sont désormais visionnées chaque année par des spectateurs de tous âges sur une prolifération d'écrans de toutes sortes. Elles sont produites par une industrie mondialisée, à flux tendu, fabriquées manuellement par des milliers de « travailleurs de l'intervalle », ou *Motion Makers*, répartis dans des studios et officines spécialisées disséminés sur pratiquement tous les continents. On peut méditer un instant sur cette vertigineuse et laborieuse manufacture mondiale du « temps de vision animée », distraction alimentée quotidiennement par des cohortes invisibles de petites mains au prix d'un travail méticuleux et parfois harassant.

L'animation graphique industrielle, issue du dessin animé et se prolongeant via les méthodes numériques d'animation graphique en 2-D et 3-D[2], associe le travail artistique du dessin et de l'animation à des modalités manufacturières du travail de production, selon une combinaison qui la rattache d'un côté, aux savoir-faire artistiques et à l'esthétique cinématographique et de l'autre, aux industries fondées sur une main d'œuvre importante, à l'instar du textile ou de l'électronique. Cependant, là où les industries manufacturières produisent des séries d'objets identiques, celles de l'animation produisent des séries de différences entre les images du film, ressort des qualités de leurs mouvements à l'écran, ce qui explique les limites de ses possibilités d'automatisation et la nécessité d'une expertise humaine spécialisée à toutes les phases de la production. Et surtout, pour toute une partie de ses employés, les motivations ne sont pas qu'alimentaires mais artistiques, ce qui constitue un facteur particulier de ses ressources humaines, à l'instar de nombreuses professions artistiques.

[2] À la différence des techniques de *stop motion*.

Origines de l'animation industrielle

Au cours des années 1910, les premiers studios apparaissent aux États-Unis, alors que les deux pionniers du dessin animé Émile Cohl et Winsor McCay sont encore actifs, et sous l'impulsion du succès de leurs films – dont les qualités sont dues autant à leur expérience et compétences d'artistes complets du dessin et de l'animation graphique qu'au fait qu'ils en dessinent eux-mêmes toutes les phases. Ces studios instaurent la division du travail pour des résultats très médiocres, suscitant la première crise, entre mercantilisme et attractivité, dans le secteur naissant des dessins animés ou *moving cartoons*.

Cette nouvelle production qui s'accompagnait d'innovations techniques (*slash system*[3], celluloïd et tous systèmes visant à séparer le mouvant du fixe pour diminuer le travail de dessin et le temps de production), fut vivement critiquée par McCay, et de manière plus feutrée par Cohl, qui exerça sa carrière d'animateur solitaire dans les grandes sociétés de production françaises de l'époque, de Gaumont à Éclair, et constatait que « les premiers films » – qui ne pouvaient être que les siens et ceux de McCay – « avaient le mérite d'être extrêmement souples à la vision ; la douceur de mouvement des personnages crayonnés était remarquable : aucune saccade, aucun heurt malencontreux ; c'est que les croquis avaient été très étudiés… il se dégageait dans l'ensemble un moelleux qu'on a dû sacrifier un peu plus tard, lorsqu'on a voulu économiser le temps nécessaire à la confection des dessins »[4].

La leçon de cette première faillite esthétique et industrielle est ainsi tirée par l'historien de l'animation américaine Michael Barrier : « Il n'y a rien de plus inefficace que la production efficace d'un produit dont pratiquement personne ne veut »[5]. Surmenage et faillites de studios

[3] Le *slash system* a été mis au point par Raoul Barré au début des années 1910. « Afin d'éviter de redessiner les décors à chaque image, les artistes découpaient leurs dessins » pour insérer les parties qui changeaient par-dessus ou par-dessous le décor. Voir Charles Solomon, « Les pionniers du dessin animé américain », Paris, Dreamland, 1996, p. 49 et 113.

[4] J. B. de Tronquières (pseudonyme d'Émile Cohl), *Les dessins animés*, Larousse Mensuel, août 1925.

[5] « There is nothing so inefficient as the efficient production of a product that hardly anyone wants. » Michael Barrier « Hollywood Cartoons. American Animation in its Golden Age », Oxford University Press, New York 1999, p. 10 (ma traduction).

Figure 1. Studio Paramount, NY, *circa* 1920. Dans Michael Barrier, *Hollywood Cartoons. American Animation in its Golden Age*, Oxford University Press, New York 1999, p. 8.

indépendants en furent les conséquences. Cependant, la plupart des grands studios des États-Unis avaient créé leur département de dessins animés. Michael Barrier décrit ainsi une photographie d'un studio d'animation de la Paramount dans les années 1920 :

> Les photographies, remplies de jeunes hommes solennels (pas beaucoup de femmes) en costumes et cravates, auraient pu être prises dans n'importe quel building de bureaux de New York des années 1920 ; elles ne suggèrent aucune entreprise artistique. C'est seulement à cause des papiers placés devant ces honnêtes tâcherons que ces bureaux sont identifiables en tant que studios d'animation plutôt que de compagnies d'assurances. Le nombre de ces gens s'élevait à quelques centaines au maximum, une toute petite fraction des milliers qui constituaient l'industrie cinématographique.[6]

[6] *Ibid.*, p. 9 (ma traduction).

Description qui pourrait encore convenir à bien des studios contemporains de sous-traitance de l'animation de par le monde, aux codes vestimentaires et aux ordinateurs près. Une autre photo, prise dans les années 1920 au studio de Pat Sullivan, qui produisait la série à succès *Félix le chat*, montre un alignement d'animateurs à leurs pupitres par ordre décroissant de compétences, d'Otto Messmer, le véritable artisan de la série, aux simples encreurs. Cette photo matérialise aussi bien la nouvelle hiérarchisation du travail que la congruence industrielle de l'alignement des employés avec celle des innombrables dessins sur les photogrammes du ruban cinématographique, technique qu'au même moment les Russes baptisent éloquemment *Multiplikatzia*.

Figure 2. Studio Pat Sullivan, NY, *circa* 1925. Dans John Canemaker, *Felix the Twisted Tale of the World's most Famous Cat*, Pantheon Books, New York, 1991, p. 93.

À l'opposé et au même moment en Europe, les photos des ateliers de Ruttmann ou Fischinger montrent des hommes seuls animant leurs images sur des bancs-titres et dispositifs de leur conception, initiateurs

d'une lignée d'artistes et artisans animateurs, bricoleurs et inventeurs inspirés, finançant leurs œuvres grâce aux films publicitaires animés, et dont Alexandre Alexeïeff sera en France l'un des continuateurs les plus conséquents, en même temps qu'un théoricien et chroniqueur, des années 1930 à 1980[7].

Division du travail et métiers de l'animation

La nouvelle division du travail de l'animation – qu'accentuent le son, la couleur et les longs métrages – instaure une chaîne de nouveaux métiers : producteur, réalisateur, scénariste, *story boarder*, *lay out*[8], animateur, assistant animateur, intervalliste ou *in betweener*, encreur, gouacheur, auxquels s'ajoutent le décor, le son, la musique, les voix ou les prises de vues au banc-titre. Le cœur du savoir-faire et le nerf de l'attractivité des dessins animés inventée par l'équipe de Disney à partir des années 1920 ont porté sur le développement de l'acteur animé, du *cartoon acting*, ou *character animation*, grâce aux talents d'animateurs comme, entre autres, Ub Iwerks, Fred Moore, Art Babbit ou Bill Tytla. Les animateurs sont les acteurs de leurs personnages animés en ce sens qu'ils expriment graphiquement ses postures et expressions selon une forme d'empathie projetant leurs propres expressions faciales et corporelles sur les représentations dessinées en s'aidant de miroirs, que l'on trouvait toujours (et encore aujourd'hui) à côté de leur table à dessin, afin d'observer leurs propres mimiques, postures et gestes et de les transposer en phases d'animation.

La division des compétences et du travail se situe alors entre la « création » des réalisateurs, scénaristes et animateurs, et « l'exécution » des assistants animateurs, intervallistes et du département *Ink and Paint* essentiellement féminin, situé dans un bâtiment séparé. La forte pression

[7] Voir *Alexandre Alexeïeff : écrits et entretiens sur l'art et l'animation (1926–1981)*, Saint-Denis, Presses universitaires de Vincennes, 2016.

[8] « Le *layout* est l'étape qui suit le *storyboard*. Le *layout man* va dissocier les plans du *storyboard* en éléments indépendants : décors, personnages, éléments fixes… accompagnés d'informations précises pour faciliter le travail des animateurs par exemple. Il détermine tout ce qui composera une image et sous quelle forme. Plusieurs éléments entrent donc en compte : les décors, tous les éléments fixes de la scène, la position de personnages, les actions et les dialogues, le cadrage et les mouvements de caméra… » (voir <https://www.lesmetiersdudessin.fr/layout-man/>).

productiviste sur les exécutants, ces nouveaux prolétaires de l'intervalle, a suscité quelques grèves notoires au sein de différents studios, chez les frères Fleischer en 1937, Disney en 1941, majoritairement menée par les assistants animateurs et les intervallistes, ou encore au Japon à la Toei en 1964, et de nouveau aux États-Unis dans les années 1970 et 1980, cette fois-ci contre l'externationalisation, la sous-traitance ou la délocalisation de leurs emplois[9]. L'organisation actuelle du travail de l'animation commerciale et industrielle reste fondée sur ce modèle pour les raisons esthétiques et techniques évoquées précédemment. Cependant, le contexte économique et technologique a considérablement évolué à partir du milieu du XXe siècle, entraînant une division accrue du travail, désormais à l'échelle mondiale.

Évolutions technologiques et économiques

Si les débuts de l'animation industrielle, principalement aux États-Unis, étaient fondés sur des séries de courts métrages produits par différents studios de dimensions variables, Disney a créé avec le long métrage animé une nouvelle formule, plus hollywoodienne, de cette branche du cinéma, caractérisée par des temps de production très longs (quatre années en moyenne) et des coûts très élevés, avec des risques financiers et des recettes potentielles en proportion. Cette formule des longs métrages à succès, faisant eux-mêmes aujourd'hui l'objet de suites et de séries dérivées pour la télévision, constitue toujours le fonds de commerce des quelques grands studios en activité, principalement aux États-Unis. À titre indicatif, juste avant la grève de 1941, le studio Disney comptait plus de 1 100 employés, pour retomber à 530 fin novembre de la même année[10]. En 2016, son lointain héritier Pixar emploie environ 1 000 personnes travaillant sur trois longs métrages simultanément.[11]

La massification de la télévision à partir des années 1950–1960 dans les pays dits développés a généré une renaissance des séries animées et la segmentation des publics et du marché, avec notamment l'invention de la catégorie de l'animation pour enfants et autres jeunes publics. Cette

[9] En anglais, *outsourcing, offshoring, runaway production.*
[10] Voir M. Barrier, *op. cit.,* p. 307–309.
[11] Bernard Génin, « La souris qui accoucha d'une montagne », *La grande vague du cinéma d'animation,* Télérama hors série, Paris, 2016, p. 19.

nouvelle demande a suscité l'apparition de nombreux studios d'animation, de toutes tailles, avec des durées de vie plus ou moins longues, dans les pays disposant d'un secteur cinématographique et télévisuel, notamment les États-Unis, l'Angleterre et le Japon. Esthétiquement, ces nouvelles séries furent réalisées selon des techniques d'animation dite « limitée » au graphisme et aux mouvements simplifiés pour des raisons de productivité, les studios devant fréquemment produire plusieurs dizaines de minutes hebdomadaires, là où un long métrage d'un peu plus d'une heure demandait quatre années de production en moyenne. Du traitement original de cette contrainte a parfois émergé une esthétique renouvelée de l'animation, du studio United Productions of America[12] aux États-Unis à partir des années 1950 aux séries japonaises des années 1960, qui eut des conséquences jusque dans les longs métrages.

Outre des changements esthétiques, l'accroissement de la demande et de la production a suscité des transformations de l'organisation du travail de l'animation, ainsi que des recherches techniques pour tenter d'accélérer ou de simplifier celui-ci. Si le milieu de l'animation indépendante et expérimentale a toujours été le plus inventif de ce point de vue, pour ce qui concerne l'industrie, la technique du celluloïd et son organisation du travail se sont maintenues jusqu'à l'apparition du numérique au cours des années 1990.

Effets des technologies numériques

Les développements des méthodes électroniques puis numériques ont affecté aussi bien la diffusion que la production de l'animation, la demande que l'offre. Pour la demande, la multiplication des canaux de télévision, l'apparition de la vidéo domestique (VHS et DVD), puis Internet, ont revigoré la production tout en créant de fortes tensions autour de la qualité et de la main d'œuvre et ses prestataires, entraînant à partir des années 1970 le phénomène de la délocalisation de certaines tâches vers des pays à plus faibles devises et/ou niveaux de salaires, ainsi que l'internationalisation des productions.

Du point de vue technique, le recours à l'informatique, expérimenté à partir des années 1960 pour automatiser certaines tâches routinières, n'aura au final pas produit les effets escomptés sur le plan de l'amélioration

[12] Plus connu sous son sigle UPA.

de la productivité, en termes de temps de travail et de main d'œuvre, sinon à la marge. En revanche, l'informatique a fini par susciter des nouvelles esthétiques et catégories au sein de l'animation à partir des années 1990. Elle n'a cependant pas supprimé le travail manuel du dessin, qui reste toujours au cœur de la création, qu'il soit sur papier ou sur support numérique. Deux méthodes principales coexistent désormais : d'une part l'animation dite 2-D, où la majeure partie du travail est encore effectuée manuellement sur papier, notamment au Japon, et de l'autre l'animation en 3-D fondée sur la modélisation numérique des personnages et du décor en trois dimensions, dont Pixar est le parangon, technique aujourd'hui quasiment exclusivement utilisée pour les longs métrages animés aux États-Unis. Si la première repose toujours sur la division du travail héritée de l'argentique (à l'exception de la colorisation, ainsi que de la prise de vues désormais dévolue aux scanners et au *compositing*), la seconde permet la réalisation graphique et l'animation par les mêmes personnes, en raison de sa forte technicité et de la concentration de ces fonctions dans un même outil logiciel. Ce qui explique que le processus d'animation 2-D reste plus segmenté et donc plus facilement délocalisable que la 3-D.

La production industrielle actuelle se subdivise donc entre longs métrages et séries, avec des impératifs de quantité et de qualité[13] distincts, catégories elles-mêmes subdivisées entre réalisation en 2-D ou 3-D, avec des possibilités de délocalisation de main d'œuvre différentes. Le long métrage d'animation constitue sans doute aujourd'hui l'objet ou l'œuvre artistique « faite main » la plus onéreuse qui soit. Il faut également signaler l'apparition de domaines connexes tels que les effets spéciaux numériques, les jeux vidéo, certains secteurs de la post-production audiovisuelle et du design, pour la télévision et Internet, qui requièrent des compétences artistiques et techniques proches ou dérivées de l'animation. Enfin, les techniques numériques jouent également un rôle dans la délocalisation du travail, en ce qu'elles permettent, dans certains cas, plus d'échanges à distance entre les équipes par vidéoconférence, ainsi que la circulation par Internet de certains éléments numériques des films et séries entre les pays et continents.

[13] Avec, par exemple, l'apparition récente de la catégorie dite *pré-school*, au graphisme et à l'animation des plus minimales, destinée comme son nom l'indique aux enfants d'âge préscolaire.

L'animation industrielle aujourd'hui : États-Unis, Japon, France

États-Unis : exportation et importation de la main d'œuvre mondiale

Si l'on considère les trois nations actuellement estimées comme les plus productives en matière d'animation, les États-Unis et la France sont celles qui internationalisent le plus la main d'œuvre, tandis que le Japon ne le fait qu'à une échelle plus limitée. Tout comme dans les autres industries, les délocalisations font débat au sein de la profession, tant en termes d'efficacité, de qualité, que de défense de l'emploi par les syndicats – à l'instar de l'Animation Guild de Burbank[14]. Si les raisons en sont le plus souvent économiques, les paramètres en sont divers, des taux de change et niveaux de salaires, en passant par les questions de langage, de distance, de fuseaux horaires, les niveaux professionnels, technologiques et artistiques des différentes nations en la matière, liés éventuellement à leurs formations et écoles spécialisées, jusqu'aux législations en matière de coproduction, notamment en Europe, ainsi qu'aux avantages fiscaux mis en place par différents pays dans le but de préserver ou de développer l'emploi et l'industrie sur leur sol. Nous conclurons par quelques observations relatives à la délocalisation des séries d'animation dans les trois principaux pays producteurs d'animation.

Au cours des années 1980–1990, les États-Unis délocalisent tout d'abord au Japon en raison de la qualité de sa main d'œuvre et d'un taux de change avantageux, puis passent à la Corée du Sud. Les travaux délocalisés sont considérés comme les plus subalternes : dessins des intervalles (*in betweening*), encre et peinture. Si aux studios Disney de Burbank ces tâches étaient réalisées dans un bâtiment séparé, elles le sont désormais sur un autre continent. Aujourd'hui, ces délocalisations s'étendent à la Chine, la Thaïlande, les Philippines, le Vietnam et certains pays dits émergents d'Asie tels que la Malaisie. Pour la 3-D, une grande partie du travail est effectuée aux États-Unis, qui importe en partie sa main d'œuvre en attirant les animateurs du monde entier[15], et en

[14] The Animation Guild, IATSE Local 839 (International Alliance of Theatrical Stage Employees).

[15] « Trente-huit nationalités différentes chez DreamWorks », selon Kristof Serrand, directeur de l'animation des studios DreamWorks à Los Angeles, propos recueillis par Guillemette Odicino dans *La grande vague du cinéma d'animation, op. cit.*, p. 66–68.

délocalisant beaucoup au Canada voisin (qui pratiquait des réductions fiscales importantes), mais aussi en Inde (où l'on parle bien anglais) ainsi qu'en Chine et un peu en Corée du Sud[16]. Plus récemment, la France est devenue pour la 3-D américaine une destination de délocalisation, avec Paramount et Disney dans la foulée d'Universal réalisant chez Mac Guff *Moi, moche et méchant* (Chris Renaud et Pierre Coffin, 2010) :

> Les studios ont été alléchés par une combinaison d'incitations fiscales généreuses et un vivier grandissant de talents... derrière cela on trouve les réalités financières du marché de l'animation aujourd'hui. Quand Pixar et DreamWorks ont démarré dans les années 1990, ils ont livré des films frais à un marché sous-alimenté, et presque tous leurs titres furent des gros succès. Maintenant, les consommateurs sont saturés d'offre, et les studios remâchent leurs titres phares et dérivés qui finissent par cannibaliser leurs publics respectifs. Les studios d'animation ont dû réduire leurs budgets de production (DreamWorks Animation a réduit ses sorties à deux titres par an en 2015), et trouver des économies, incluant la délocalisation vers des pays moins chers.[17]

La délocalisation de l'animation américaine, en dépit d'une industrie très forte, cherche un nouvel équilibre entre économies et qualité dans un contexte de réduction des budgets. Selon Éric Miller qui, après avoir travaillé longtemps pour les grands studios, a fondé le sien :

> Les plus grands studios comme DreamWorks et Disney délocalisent eux aussi beaucoup de travail d'animation. Pour les séries TV animées ils font souvent la pré-production aux États-Unis, mais délocalisent ensuite toute la production... Il y a des choses que vous devez regarder en face quand vous avez un marché global. Il y aura toujours quelqu'un qui peut le faire plus vite, mieux et moins cher que vous. Même avec toute la délocalisation l'animation U.S. est plus forte que jamais... mais ce n'est pas toujours une question d'argent. Avoir une grande expérience du métier est un facteur important. Il y a un point de bascule où les économies ne suffisent pas à vous faire renoncer à travailler avec quelqu'un à côté de chez vous, ou au moins dans le même fuseau horaire[18].

16 Voir Justin Sevakis « Why Isn't American Animation Outsourced To Japan? », *Anime News Network*, 2 novembre 2015, <http://www.animenewsnetwork.com/answerman/2015-11-02/.94920>.

17 John Hopewell & Elsa Keslassy, « French Animators Lure U.S. Studios with Tax Rebates, Diverse Talents », *Variety*, 14 juin 2016, <http://variety.com/2016/film/global/disney-sends-animation-projects-to-france-1201795423/> (ma traduction).

18 Éric Miller, blog : <http://blog.milleranimation.com/2015/10/14/here-or-there-outsourcing-of-animation/> (ma traduction).

Figure 3. Arena Animation, studio de sous-traitance pour Disney en Inde dans les années 2000. Source : <https://www.justdial.com/photos/arena-animation-anna-nagar-chennai-animation-training-institutes-1u4qa3q-pc-7107656-sco-20mhrxvc> (consulté le 05/09/2018).

Y a-t-il de l'animation en France ?

Si la France, actuellement considérée comme la troisième nation productrice d'animation[19] après les États-Unis et le Japon, devient une terre d'accueil pour les délocalisations en provenance des États-Unis, elle a ses propres pratiques et problèmes de délocalisation. Un certain nombre d'animateurs formés en France s'expatrient aux États-Unis, au

[19] D'après une étude du RECA (Réseau des écoles françaises de cinéma d'animation) en 2011 : « l'animation française produit en moyenne plus de 300 heures de programmes de télévision par an (355 heures en 2011), et de 3 à 10 films de long métrage (10 en 2011). Elle compte une petite centaine d'entreprises de production, dont environ les deux tiers ont exercé une activité régulière dans la période récente. Elle emploie aujourd'hui quelque 5 000 personnes, dont 80 % sous le statut de salarié intermittent » (<http://www.reca-animation.com/le-secteur-de-lanimation/quelques-chiffres>, consulté le 25 octobre 2016). Cette étude s'appuie en partie sur celle du groupe Audiens, « La production de films d'animation et d'effets visuels » : <http://www.audiens.org/fileadmin/Images_et_documents/Groupe_Audiens/Etudes/Etude-Audiens-films-animation-2015.pdf>, consultée le 11/12/2016. NB : le total des emplois dans le secteur ne correspond pas uniquement à celui des animateurs, qui en constituent cependant la majeure partie.

Japon ou ailleurs, ce qui est parfois paradoxalement présenté comme un succès de l'animation française. La production y a toujours été aléatoire pour les longs métrages et est majoritairement orientée vers les séries TV. La délocalisation est pratiquée depuis les années 1970, notamment vers les pays de l'Est, puis à partir des années 1980 en Corée du Sud, puis du Nord, la Chine et les pays asiatiques (Philippines, Taïwan, Birmanie, Thaïlande, Vietnam) et enfin, au cours des années 2000, vers l'Ukraine, la Roumanie et l'Inde. Cependant, le contexte de baisse des financements a accentué ce mouvement, ce dont s'inquiète un rapport réalisé en 2003 pour le CNC[20] :

> Appelé aussi « cœur du métier », l'animation, c'est la vie. En matière de série, « la vie est ailleurs » : en Corée du Nord ou du Sud, en Chine, en Inde peut-être. L'Europe de l'Est n'est plus guère une option. Activité à forte intensité laboristique [*sic*], l'animation se fixe là où les coûts de main d'œuvre sont les plus bas. Le constat est ancien mais clair : hors certains produits courts et certains nouveaux produits vectoriels, il n'y a pas d'animation en France… Il s'ensuit évidemment des pertes d'emplois, mais aussi de savoir-faire, dommageables à court terme, y compris dans la perspective, hautement souhaitable, de la constitution d'une industrie française du long métrage d'animation.

On est loin des cocoricos médiatiques récurrents sur la fameuse *French Touch* en animation, qui pourtant font écho à une culture et à des pratiques de l'animation des plus anciennes et non des moins passionnées, de Reynaud et Cohl au Festival d'Annecy, avec une pléthore d'écoles d'animation et de diplômés qui en sortent chaque année. Mise à part la 3-D, qui reste majoritairement produite en France, le même rapport regrette la perte de savoir-faire et d'emplois que constituent les délocalisations de la production, qui par ailleurs sont considérées comme incontournables : « S'agissant de la prestation asiatique, l'évidence est économico-artistique. Il n'y a pas d'alternative à la sous-traitance de l'animation : l'animation française est économiquement inaccessible, l'animation asiatique est très accessible et de bonne qualité. »[21] Le souci

[20] « La production de séries d'animation », mai 2003, site du CNC, <http://www.cnc.fr/web/fr/etudes/-/ressources/19859;jsessionid=4CEF11759351F89993E28EDBC9 02F393.liferay>, p. 25.

[21] *Ibid.*, p. 43.

des délocalisations concerne aussi les pertes de productivité et de qualité, suite au manque de contrôle qu'engendrent les distances, les langues, les changements de prestataires, dans un domaine très complexe et pointu techniquement et esthétiquement, malgré la présence de superviseurs délégués sur place par les productions. Généralement passés sous silence de manière pudique, on peut cependant trouver quelques témoignages de ces problèmes.

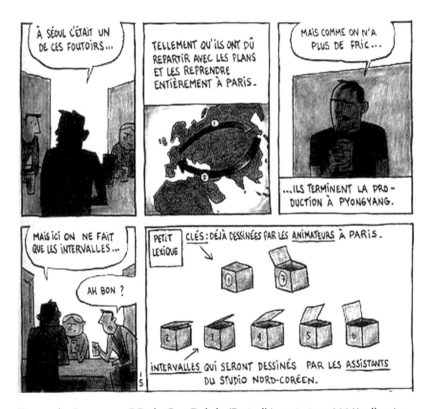

Figure 4. *Pyongyang*, BD de Guy Delisle (Paris, l'Association, 2003), d'après son expérience de superviseur d'animation en Corée du Nord.

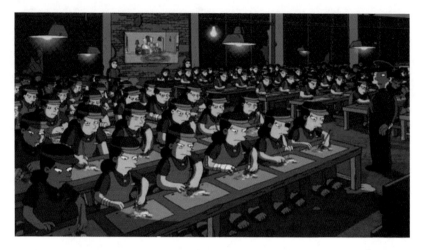

Figure 5. *How a Simpson Cartoon is made*, séquence d'ouverture de la série des Simpson réalisée avec la collaboration du grapheur anglais Banksy. Source : <https://www.youtube.com/watch?v=XEki-IBdop8> (consulté le 05/09/2018)

Japon : surproduction locale à flux tendu

La production de l'animation au Japon compte 419 studios dont 365 concentrés dans quelques quartiers de Tokyo, la plupart de petite taille[22], avec des conditions de travail très dures, mais que nourrissent une véritable passion, quasiment un culte, pour cet art. Les salaires y sont les plus bas et les temps de travail les plus élevés[23]. Ainsi, les animateurs débutants qui réalisent les intervalles (*douga*), quand ils ne sont pas délocalisés, travaillent-ils 12 heures par jour 7 jour sur 7 pour un salaire entre 300 et 500 euros, tandis que les assistants de production – une des voies pour devenir réalisateur – doivent être disponibles jour et nuit pendant les périodes de production pour des salaires d'environ 1 200

[22] Outre le regretté studio Ghibli, qui constitue une exception remarquable à méditer, fondé et animé par deux cinéastes séminaux, Hayao Miyazaki et Isao Takahata.

[23] Cependant, les temps de travail réels des autres pays sont souvent sous-estimés et sous-payés. Voir en ligne <http://www.cartoonbrew.com/>. Un rapport alarmant sur l'industrie de l'Animation de Vancouver révèle des rémunérations très faibles et des pratiques de dépassements horaires non payés. (<http://www.cartoonbrew.com/artist-rights/vancouver-animation-industry-survey-reveals-alarming-low-wages-unpaid-overtime-practices-142847.html#disqus_thread>, consulté le 9 février 2016).

euros, tout ceci dans des locaux exigus, comme le décrit Thomas Romain, un animateur et réalisateur français expatrié à Tokyo :

> Les conditions ne sont pas bonnes, étant donné le niveau de développement et le niveau de vie au Japon. Bien sûr, il faut savoir garder mesure, les animateurs japonais sont moins à plaindre que des mineurs de charbon ou des travailleurs à la chaîne dans des usines déshumanisantes. Ils exercent un métier qu'ils ont choisi par passion et qui leur offre beaucoup de satisfaction. Mais malgré tout, ramené au taux horaire, la plupart gagnent moins que ce qu'ils gagneraient en faisant n'importe quel *baito* (petit job).[24]

On touche ici à une des spécificités de l'insertion professionnelle dans l'animation et au statut de ses petites mains dans les pays à niveaux de vie élevés, qui sont prêtes à accepter des conditions de travail difficiles par passion pour cet art. Au Japon, cela constitue une forme de sélection, fondée sur une culture du travail et de l'art spécifiques :

> À mon arrivée au Japon en 2003, j'ai été frappé par de nombreux aspects de la production d'animation, tellement différente de celle en cours en France. Le statut précaire des animateurs, le dévouement total des équipes, la capacité d'entraide et le peu de rivalité entre les sociétés, les résultats incroyables obtenus avec parfois des temps de production et des budgets dérisoires etc. Il s'agit d'un milieu très exigeant et rude, mais absolument fascinant.[25]

Si le Japon délocalise, c'est surtout dans la sphère asiatique voisine et plus par pénurie de main d'œuvre ou manque de temps que pour des raisons strictement économiques ou de profit comme aux États-Unis ou en France, dans un contexte de surproduction :

> La troisième expansion de l'animation japonaise au milieu des années 1990 a vu le marché exploser et l'industrie a bénéficié d'une quasi-bulle jusqu'au milieu des années 2000. Le marché s'est rétréci de 2007 à 2008 après l'explosion de cette bulle qui a semblé être la fin de la croissance économique de l'animation japonaise. Cependant, l'animation elle-même ne perdait pas de sa popularité. En 2010, l'industrie croissait à nouveau et atteignait presque un record en 2013.[26]

[24] « L'industrie de la japanime en 2015 », Interview de Thomas Romain sur le site *Mangamag* : <http://www.mangamag.fr/dossiers/interview-thomas-romain-lindustrie-de-japanime-2015/>, consulté le 7 février 2017.

[25] *Ibid.*

[26] *Report on Japanese Animation Industry 2015*, The Association of Japanese Animation, <http://aja.gr.jp/english/japan-anime-data>.

Figure 6. Studio d'animation à Tokyo. Publié le 13/07/2012 sur le blog d'un employé japonais d'une société d'animation[27]. Source : <http://yaraon-blog. com/archives/42856>

Face à la compétition internationale et à une certaine surproduction de films et séries animées, les studios et producteurs industriels transfèrent la pression financière des réductions de budgets sur les prestataires et en bout de ligne sur les petites mains ouvrières de l'intervalle, la délocalisation étant considérée comme inévitable, tout comme pour n'importe quelle industrie manufacturière. Ce qui à terme menace la possible existence d'une industrie du long métrage produit nationalement, notamment en France, par la perte de savoir-faire et d'entreprises spécialisées. On note cependant une différenciation des pratiques selon les pays producteurs, et également selon les deux principales techniques actuelles : dessin manuel en 2-D et modélisation-animation en 3-D. Encore une fois la nature de la technique et des outils employés, au-delà des différenciations

[27] Cette photo accompagne un texte très critique sur les conditions morales et financières du travail dans l'industrie tokyoïte de l'animation.

esthétiques évidentes qu'elles constituent (pour simplifier, la différence entre un film du studio Ghibli et du studio Pixar) induisent différents modes d'organisation du travail. Le numérique de ce point de vue joue dans les deux sens : il fluidifie de façon générale la délocalisation, tandis qu'il la limite pour l'animation en modélisation 3-D en particulier, tout le travail étant concentré dans un seul outil et opérateur. Or la résilience du dessin manuel, ou résistance à l'esthétique du tout numérique, notamment au Japon, pour des raisons tant culturelles qu'industrielles, s'inscrit par ailleurs pour le long métrage dans une pratique d'auteur, qui avec le *e-konte*[28] tend à concentrer scénarisation et *lay out* selon un travail individuel de dessin (notamment avec Miyazaki et feu Satoshi Kon), tandis que l'industrie américaine repose sur un travail collectif et plus anonyme (le grand public ignore généralement les noms des réalisateurs des films américains d'animation), fondé sur un long développement du scénario et de façon quasi exclusive sur la modélisation-animation numérique en 3-D.

L'animation industrielle, art mondialisé ?

La question transversale de l'important travail de main d'œuvre se résout de différentes façons et selon différents modèles artistiques et économiques selon les pays et les techniques, et selon qu'il s'agit de séries ou de longs métrages. On peut imaginer que les motivations et le statut d'un intervalliste nord ou sud-coréen, canadien, japonais, malaisien, français ou indien sont assez différents. Cependant, on constate que la pression financière et productiviste tend à perpétuer, sous toutes les latitudes, des formes d'exploitation et de précarisation – temps de travail, salaires, contrats – des exécutants des tâches considérées comme les moins qualifiées. En réalité, ces dernières ne sont pas simplement de répétition quasi mécanique d'un même geste et objet, à l'instar des autres industries manufacturières. Sur ce travail reposent les qualités esthétiques ultimes des productions d'animation. Il existe de fait plusieurs types de délocalisation, de celle des intervalles et de la colorisation à celle de toute l'animation proprement dite, des séries aux longs métrages. Mais comme le cœur de l'art de l'animation reste précisément… l'animation, c'est donc bel et bien l'art de l'animation qui s'est mondialisé dans la mesure

[28] Proche du *storyboard* ou scénarimage.

où la majeure partie de son exécution – à quelques rares exceptions près – passe par les mains et le savoir-faire d'une multiplicité d'animateurs et d'exécutants de multiples nations et continents. Au-delà du constat d'une exploitation mondialisée de la main d'œuvre, qui est loin d'être propre au cinéma d'animation, il resterait à en évaluer plus précisément les conséquences. Ceci notamment en regard des thèses et des discours relatifs à des spécificités nationales telles qu'elles ont pu effectivement exister auparavant et se transforment aujourd'hui dans la concurrence mondialisée de différents modèles esthétiques et techniques, mais bien entendu également économiques, devenus affaires d'États. S'il faut rappeler que l'industrie du cinéma a été d'emblée mondialisée, dès le XIX^e siècle, celle de l'animation industrielle, de par ses coûts de production, eux-mêmes fonction de l'importante main d'œuvre qu'elle nécessite, a toujours visé un public mondial, et une esthétique mondialisée du regard, à laquelle répond aujourd'hui en grande partie une manufacture artistique et technique mondialisée.

Norman O. Dawn, créateur d'effets spéciaux : de la technique au métier

Réjane Hamus-Vallée

Dans différents ouvrages[1], Norman O. Dawn est systématiquement présenté comme l'inventeur de la peinture sur verre au cinéma[2] et l'un des premiers à avoir expérimenté la transparence[3]. Sa longue carrière – de 1907 au tout début des années 1950, des États-Unis à l'Australie, en passant par des films réalisés en Alaska ou en Bolivie – et ses multiples rôles – producteur, réalisateur, technicien des effets spéciaux – en font un personnage intéressant pour comprendre comment les pionniers du cinéma ont tâtonné afin d'inventer tant des techniques de trucages que les métiers associés.

Cet article se demande ainsi ce qu'apportent les archives personnelles de Dawn à la compréhension de sa place dans l'histoire des techniques. En quoi les schémas et anecdotes, rédigés souvent *a posteriori*, rentrent-ils en phase avec les éléments directement sortis des tournages, dessins préliminaires et morceaux de pellicules ? Quels enjeux méthodologiques cette étude de cas comporte-t-elle dans une réflexion plus large sur les enjeux de la recherche en histoire des techniques et des métiers, en

[1] Richard Rickitt, *Special effects, the History and Technique*, New York, Billboard Books, 2000 ; John Brosnan, *Movie Magic: the Story of Special Effects in the Cinema*, New York, Plume, 1974, ou encore Pierre Hemardinquer, *Technique des effets spéciaux pour le film et la vidéo*, Paris, Dujarric, 1993.

[2] D'abord du *glass shot* puis du *matte painting*, technique d'extension de décor par une peinture réalisée sur verre soit sur le plateau de tournage directement (*glass shot*) ou en post-production en utilisant un cache et contre-cache noir pour réintégrer cette extension dans la scène filmée originale (*matte painting*, peinture de cache). Voir Mark Cotta Vaz et Craig Barron, *The Invisible Art: the Legends of Movie Matte Painting*, San Francisco, Chronicle Books, 2002.

[3] En anglais, *rear* ou *back projection*, technique permettant de projeter par transparence, à travers un écran placé derrière un acteur, un film en tant que décor de fond.

particulier des effets spéciaux ? Si Norman O. Dawn occupe une position privilégiée dans l'histoire des techniques – à la différence de nombreux pionniers peu ou pas étudiés –, c'est principalement en raison des travaux qu'il a lui-même contribué à produire, relayés par l'universitaire et réalisateur américain Raymond Fielding. En 1963, Fielding se propose, dans un article primordial[4], de faire « le point, très superficiellement, sur la carrière et les contributions de Norman O. Dawn dans le champ des effets spéciaux », en utilisant des échanges épistolaires et des interviews menés pendant une dizaine d'années avec Dawn. Il y reprend une petite partie des archives de Norman O. Dawn, déposées dans les années 1970 au Harry Ransom Center de l'Université du Texas, à Austin. Accessible en ligne[5], la collection comporte 164 « cartes explicatives »[6], créées par Dawn en personne, illustrant une partie des 861 effets réalisés tout au long de sa carrière, selon son propre décompte. Comme Dawn l'explique à de nombreuses reprises dans les écrits de ses cartes à la troisième personne, elles sont :

arrangées et montées à partir des dossiers et enregistrements personnels de Norman Dawn. En raison de la grande quantité de matériel, tout ne peut pas être montré – mais toujours les objets principaux, comme les esquisses originelles à l'huile, puis un photogramme et enfin des élargissements et le rapport caméra. Quand il y a assez de place, une photo peut être ajoutée. Leurs formes sont variées autant que possible afin d'éviter la monotonie d'une collection aussi grande.[7]

[4] Raymond Fielding, « Norman O'Dawn: Pioneer Worker in Special-Effects Cinematography », dans Raymond Fielding (dir.), *A Technological History of Motion Pictures and Television: an Anthology from the Pages of the* Journal of the Society of Motion Picture and Television Engineers, Los Angeles, University of California Press, 1983, p. 142–149 (originellement publié dans le *Journal of the SMPTE*, janvier 1963, vol. 72). Raymond Fielding utilisera aussi des éléments, photos, schémas et explications pour l'édition et les rééditions de son ouvrage classique, *The Technique of Special-Effects Cinematography*, New York, Focal Press, 1965, maintes fois réédité.
[5] Voir en ligne : <http://hrc.contentdm.oclc.org/cdm/landingpage/collection/p15878coll15#nav_top>.
[6] On y trouve aussi une partie de la correspondance entre Fielding et Dawn de 1961 au début des années 1970.
[7] Carte 325 consacrée à *The Daring Miss Jones* : <http://hrc.contentdm.oclc.org/cdm/compoundobject/collection/p15878coll15/id/473/rec/1#nav_top>. Notre traduction, ainsi que pour toutes les autres citations extraites de ces archives.

Figure 1. Cette carte de la collection est consacrée à l'effet n° 6, *Missions of California*, 1907. Dawn y décrit son premier usage du *glass shot*, et mélange articles, peintures et dessins, schéma technique, quelques lignes de souvenir dans un patchwork assez représentatif de l'ensemble de ses cartes, toutes de mêmes dimensions (16 pouces sur 20, soit environ 40 x 50 centimètres).

Ces cartes lèvent donc le voile, très rapidement, sur le travail de l'auteur. Mais comme de nombreux professionnels des effets spéciaux, Dawn revendique aussi une forte part d'invisibilité, qui sera étudiée dans la première partie de cet article. Nous verrons ensuite en quoi le lien entre Dawn et son invention clé, la peinture sur verre, a pour conséquence de passer sous silence une part tout aussi importante de ses techniques. Enfin, nous nous demanderons comment Dawn a participé à l'essor d'un métier qui ne cesse de se réinventer depuis la naissance du cinéma : celui de spécialiste en effets spéciaux, qu'on l'appelle opérateur spécialisé ou superviseur des effets visuels.

Un inventeur invisible

La plupart des premiers films sur lesquels est intervenu Norman O. Dawn sont considérés, au début du XXIe siècle, comme perdus. Il en est ainsi de *Missions of California* de 1907, sur lequel Dawn aurait expérimenté pour la première fois la technique du *glass shot* au cinéma, après l'avoir utilisée, toujours selon ses déclarations, dès 1905 en photographie. Non seulement le film n'existe plus, mais la peinture effectuée un jour de mai 1907 sur une vitre en verre a depuis longtemps disparu. En effet, à l'issue d'un film, la peinture n'avait plus d'usage et le verre était nettoyé pour être recyclé dans une nouvelle production. La fragilité de la vitre, la difficulté de faire tenir dans le temps une peinture ou un pastel sur du verre, et le peu d'enjeu artistique, souvent revendiqué en tant que tel par Dawn et les peintres sur verre[8], expliquent la non-conservation de ces éléments. À cela s'ajoute le manque d'intérêt pour l'archivage des éléments filmiques à travers le monde, quand les éléments servant à la réalisation d'un film – décors, costumes, accessoires – sont le plus souvent dispersés, revendus ou détruits à la fin d'un tournage. La peinture a ici un seul objectif, celui d'agrandir un décor pour proposer une image plus significative, sur les plans esthétique et narratif. Dès que l'image est finalisée, la peinture qui a permis sa création perd alors toute utilité.

Quand bien même le film est conservé et visible, l'œuvre de Dawn demeure difficilement perceptible. En effet, travaillant sur des films d'aventures, des documentaires, souvent réalisés – en théorie – en décor extérieur, il est difficile de se rendre compte que tel plan de *Lure of the Yukon* de 1924 est en fait une combinaison de deux lieux différents, unis sur une même pellicule par la technique du cache/contre-cache : « Ce n'était pas une scène spectaculaire, mais cela montre bien comment, de temps en temps, beaucoup de temps et d'argent étaient économisés en liant ensemble en une séquence, par l'usage d'un plan de cache, deux lieux réels situés à des kilomètres d'écart. »[9]

[8] Par exemple sur la carte dédiée à *Gypsy Love*, 1909 : « Le lecteur notera que (ces peintures) n'avaient aucune technique artistique. Elles étaient faites pour essayer de créer une illusion de réalité dans un film. C'était fait pour des *businessmen* qui n'auraient rien accepté d'autre que de produire la réalité. De ce fait, la moindre once d'imitation d'un style artistique n'avait aucune place ici. » Source : <http://hrc.contentdm.oclc.org/cdm/compoundobject/collection/p15878coll15/id/38/rec/1#nav_top>.

[9] Carte pour *Lure of Yukon*, 1924 : <http://hrc.contentdm.oclc.org/cdm/compoundobject/collection/p15878coll15/id/501/rec/1#nav_top>.

Le travail de Dawn est donc voué à rester imperceptible, en suivant la typologie établie par Christian Metz concernant les trucages au cinéma[10]. Il en va de la réussite du trucage qui, chez Dawn, sert le plus souvent à mettre les acteurs en position de danger (au bord d'un précipice, près d'animaux sauvages...) ou à faire croire que le tournage s'est déroulé dans un pays lointain. « On doit bien se rappeler que pendant plusieurs années, la plupart de ces plans n'ont reçu AUCUNE PUBLICITÉ – la publicité aurait uniquement conduit à en diminuer leur valeur. »[11] Même un spécialiste peut avoir du mal à repérer des plans truqués par Dawn, qui emploie de nombreuses astuces, à peine évoquées ici, pour produire une illusion parfaite. De l'usage d'un pied spécial à la mise au point d'une caméra à la prise de vues motorisée pour une meilleure stabilité, les documents étudiés regorgent de détails exposant le souci du réalisme et de la perfection technique derrière le travail de Dawn.

Par conséquent, ces trucages sont non seulement inconnus du grand public mais aussi de la profession en soi, qui mettra de longues années avant de les considérer, en particulier les *matte paintings*, comme des outils efficaces. Une carte de la collection[12] montre bien les efforts de Dawn pour convaincre Griffith d'utiliser sa technique de décors miniatures au lieu de construire des décors géants, *a priori* ceux d'*Intolérance*. Tout au long de sa carrière, il aura besoin d'utiliser des esquisses à l'huile en couleur, non pour préparer le tournage, mais plutôt pour convaincre les réalisateurs et les producteurs de l'efficacité de sa méthode :

> Le lecteur n'oubliera jamais que le but original de ces esquisses était de permettre aux dirigeants et à leurs associés de visualiser ce que je proposais de réaliser à chaque fois. Bien sûr, tous les premiers films étaient en noir et blanc, mais cela ne m'empêchait pas de les réaliser en couleur puisque c'était plus efficace pour vendre une idée. Ils n'avaient aucune prétention artistique – mais une utilité pratique. La plupart d'entre eux étaient réalisés en une heure, et jamais plus de deux.[13]

[10] Christian Metz distinguait les trucages visibles en tant que tels (fondus enchaînés), les trucages invisibles mais perceptibles (homme invisible où l'on sait qu'il y a un truc, sans voir la technique) et les trucages imperceptibles, où le spectateur ne sait pas qu'il y a eu usage d'une technique de trucage. (« Trucage et cinéma » dans *Essais sur la signification au cinéma (tome 2)*, Paris, Klincksieck, 1972, p. 173–192).

[11] Carte dédiée à *The Drifter*, 1913 : <http://hrc.contentdm.oclc.org/cdm/compoundobject/collection/p15878coll15/id/119/rec/1#nav_top>.

[12] Carte intitulée *Griffith / Offenbach* : <http://hrc.contentdm.oclc.org/cdm/compoundobject/collection/p15878coll15/id/211/rec/20#nav_top>.

[13] *Gypsy Love*, 1909, *op. cit.*

Le technicien Dawn relève donc d'une invisibilité à plusieurs niveaux : vis-à-vis du public, des professionnels et du résultat de son travail[14], dont il ne reste que des traces, souvent tardives. Il peut donc être difficile de définir son rôle exact dans l'invention des techniques qu'il déclare utiliser, même si ses archives mettent en avant les passages qui semblaient exister entre inventeurs et entre pays, avant l'industrialisation du cinématographe à partir des années 1910.

Une technique qui occulte les autres

Clairement, l'association du nom Dawn avec le *glass shot* et le *matte painting* reste extrêmement forte dans les ouvrages précités[15]. Mais même pour lui, cette paternité n'est pas évidente et il reviendra à plusieurs reprises dans ses cartes sur l'impossibilité de déterminer le premier usage des différents trucages évoqués ici :

> Comme la plupart des autres, je ne savais pas grand-chose sur ce que j'étais en train de faire. Je ne pense pas que j'ai été le premier à faire cette sorte de chose ; cependant, dans ces premiers temps, il y avait tellement de secret et d'huile sur le feu jetée par les nouveaux arrivants du *show business* qu'on ne pourra jamais vraiment en être sûr.[16]

Non seulement cette paternité est à relativiser mais elle aura aussi un effet secondaire fort, celui de passer sous silence la part la plus importante du travail de Dawn, que ce soit la double puis la triple exposition, omniprésente dans ses différents films, à base de caches et contre-caches. Cependant, pour ce dernier cas, la paternité de l'invention ne peut lui être attribuée. C'est une technique photographique, abondamment utilisée dans le milieu du XIX^e siècle, en particulier pour intégrer des

[14] Néanmoins, la réalisation des cartes signale un désir de s'extraire de cette « invisibilité ». Il semblerait que cette opération date de la rencontre entre Raymond Fielding et Norman O. Dawn à la fin des années 1950, à travers une correspondance fournie, conservée dans les archives Dawn.

[15] Le plus souvent l'association est telle qu'elle n'est pas discutée ou nuancée, par exemple : « L'opérateur américain Norman O. Dawn invente la peinture sur verre pour les besoins du film *Missions of California* (1907) », Pascal Pinteau, *Effets spéciaux : un siècle d'histoires*, Genève, Minerva, 2015, p. 27.

[16] Carte consacrée à *Missions of California*, 1907 : <http://hrc.contentdm.oclc.org/cdm/ compoundobject/collection/p15878coll15/id/7/rec/1#nav_top>.

nuages dans un paysage[17], que Dawn a lui-même expérimentée dans son jeune âge en tant que photographe amateur. Adapté à la prise de vues cinématographique en France dès 1902 (*Flirt dans un train*, film Pathé) et aux États-Unis dès 1903 (*L'Attaque du grand rapide* de Edwin S. Porter), le cache/contre-cache fut donc naturellement employé par Dawn au moins dès juin 1907 pour *Poem in Pictures*, film Edison.

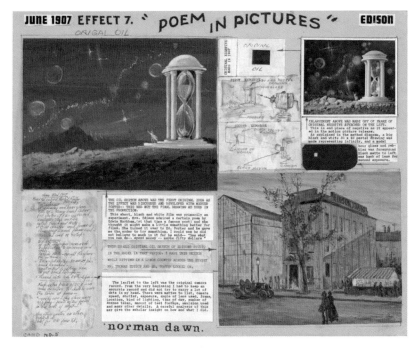

Figure 2. L'effet n° 7, réalisé pour le film Edison *Poem in Pictures,* comporte l'usage d'un cache, ici inséré sur la fiche, ainsi qu'un morceau du négatif original. Un schéma explique les différentes prises de vues nécessaires à la réalisation du trucage, dont un photogramme expose le résultat.

Dans cet effet, le septième réalisé par Dawn selon son décompte personnel, il utilise un cache inséré entre l'objectif et le corps de la caméra, afin de combiner sur un même plan une peinture de paysage

[17] Voir par exemple Édouard Belin, « La retouche des clichés de paysage », *L'Objectif,* vol. 4–5, octobre 1899-décembre 1900, p. 168–170 et p. 174–175. Voir aussi dans ce même numéro « La retouche et l'obtention des nuages », p. 30–32.

lunaire, filmée étonnamment en première exposition, avec un avant-plan comprenant un sablier et des cailloux pour plus de naturel, puis une seconde prise de vues avec une actrice sur fond noir, vue à travers un cache noir pour protéger le plus possible la prise initiale. Dès 1911, Dawn réalisera aussi les caches noirs en les peignant sur une vitre, placée devant la caméra, surtout utilisée pour des découpes particulièrement complexes à réaliser car le cache inséré derrière l'objectif devra être réalisé en petite taille et inversé (haut bas et gauche droite) pour suivre la prise de vues sur pellicule. Notons néanmoins que le cache peint et le cache découpé cohabitent dans le travail de Dawn, même si le cache découpé apparaît très fréquemment avec la constitution d'une « réserve » de caches dans une boîte dédiée[18]. Grâce à sa maîtrise de la technique, Dawn réussit à faire déambuler une araignée dangereuse sur le visage d'un acteur (*The Fire Cat*, 1921), ou permet à un comédien interprétant deux rôles de « s'auto-embrasser » (*The Right to Happiness*, 1919).

Dans le cas de *Poem in Pictures*, Dawn combine une scène réelle avec une peinture, même si le plus gros de son travail consistera par la suite à mixer ensemble deux prises de vues directes, ce qui constitue de son point de vue la meilleure technique possible. « De par mon travail, rien ne peut surpasser deux images naturelles sur un seul négatif original, ce qui sera plus réel que n'importe quel autre trucage – et je les ai tous vus et essayés, bien avant qu'ils ne soient brevetés. »[19] Dans ses cartes, en effet, on trouve référence à toutes les techniques de trucage existant à cette période. Il peut les mettre en place seules ou en les combinant. Outre le *glass shot* et le *matte shot*, avec ses différentes déclinaisons (cache avec peinture ou avec double exposition), Dawn évoque une caméra modifiée pour créer un des premiers *travelling matte* en 1914[20], puis en 1921 pour *Thunder*

[18] Voir le dessin qu'il en fait dans la cinquième carte consacrée à *Oriental Love* en 1916, à partir du moment où il bénéficie de la caméra Bell and Howell avec contre-griffe, autorisant une stabilité absolue de la prise de vues : <http://hrc.contentdm.oclc.org/cdm/compoundobject/collection/p15878coll15/id/173/rec/6#nav_top>.

[19] Carte pour *The Last Warning* : <http://hrc.contentdm.oclc.org/cdm/compoundobject/collection/p15878coll15/id/80/rec/1#nav_top>.

[20] Le *travelling matte*, dit cache mobile, est une technique qui permet de créer automatiquement un cache de la forme et mouvement d'un corps, par exemple placé sur un fond vert, bleu ou noir, pour ensuite l'intégrer dans un décor autre. Voir la carte pour *Two Men of Tinted Butte*, 1914 : <http://hrc.contentdm.oclc.org/cdm/compoundobject/collection/p15878coll15/id/133/rec/1#nav_top>.

Figure 3. À l'occasion de l'explication des effets 33 à 35 pour *Man of the West*, 1912, Norman O. Dawn évoque un trucage à base de miroir en haut à gauche, proche de ce que sera l'effet Schüfftan, à qui il est ici reproché d'avoir obtenu indûment un brevet pour ce procédé.

Island. Le *stop motion* est utilisé pour filmer en studio des *matte paintings*, photographiés image par image pour éviter les écarts potentiels provenant de sautes de pellicule, possibles avec les caméras non contre-griffées. Il met aussi en place un dispositif de rétroprojection[21] qu'il dessine pour *Ghost of Thunder Moutain* en 1912[22] avec une projection fixe, puis animée pour

[21] Voir l'article de Caroline Renouard, « Naissances, mort et renaissance(s) de la transparence », *Cahier Louis Lumière*, n° 10, décembre 2016, en ligne : <http://www.ens-louis-lumiere.fr/formation/recherche/cahier-louis-lumiere/cahier-10.html>.

[22] Encore ici, Dawn explique que « de nombreux opérateurs avaient joué avec l'idée bien avant qu'elle ne soit réellement praticable », carte *Ghost of the Thunder Moutain* : <http://hrc.contentdm.oclc.org/cdm/compoundobject/collection/p15878coll15/id/91/rec/1#nav_top>.

The Drifter en 1913. Il utilise des miniatures à de nombreuses reprises, y compris avec la technique de la maquette suspendue pour étendre un plafond, comme dans *The Vermillion Pencil* en 1921. Ici encore, cette technique lui semble très ancienne : « mon premier souvenir de cette technique est une version utilisée par Georges Meleis [*sic*] dans son studio de Paris, quand j'étais étudiant en art en France. Donc je n'ai pas inventé cette pratique et je l'ai surtout utilisée ici pour prouver au directeur artistique Robertson Cole qu'elle était réalisable. » Enfin, c'est même avec une forme de colère, visible par l'usage de lettres capitales, qu'il évoque l'effet Schüfftan[23]. Il déclare y avoir recours dès 1912 pour *Man of the West* sous le nom de « plan à miroir » :

> Une méthode que j'ai vu faire par Meleis [*sic*] et les Lumière. Matt Handschiegl insista pour que je le fasse et une fois fini, il dut admettre que cette méthode est délicate et bien longue entreprise pour faire un effet. [...] Des années plus tard, un Allemand du nom de Schüfftan a breveté cette idée. IL N'AURAIT JAMAIS DÛ POUVOIR LE FAIRE.[24]

Dawn estime ainsi que le brevet n'est jamais synonyme d'invention technique, y compris pour le propre brevet qu'il déposera finalement pour le *matte painting* et qui sera validé en 1918, à la suite et avec les images d'*Oriental Love*. Au même moment, des techniques identiques se retrouvent sous la main de différents opérateurs. Les passages se font de la photographie au cinéma, d'un opérateur à l'autre. Il explique ainsi avoir repris de Porter[25] une idée de boîte de développement express, nécessaire pour tester ses caches directement sur le plateau de tournage. En France, son contemporain Walter Percy Day pense avoir aussi inventé le *matte painting*, et Wilcké et Minine la maquette suspendue. « De nombreux hommes ont caressé cette idée et c'est surprenant de voir à quel point la

[23] Eugen Schüfftan est un chef opérateur allemand, qui a notamment travaillé sur *Metropolis* de Fritz Lang en 1926 et a déposé une demande de brevet pour le procédé qu'il aurait inventé et qui porte son nom ; le brevet américain n° US 1606482 A a été déposé le 27 février 1925 et publié le 9 novembre 1926.

[24] *Man of the West*, deuxième carte : <http://hrc.contentdm.oclc.org/cdm/compoundobject/collection/p15878coll15/id/104/rec/1#nav_top>.

[25] Carte *The Great Barrier*, 1908 : <http://hrc.contentdm.oclc.org/cdm/compoundobject/collection/p15878coll15/id/22/rec/2#nav_top>.

plupart d'entre eux continuent de croire qu'ils ont trouvé quelque chose de nouveau. »[26] Les liens entre ces différents protagonistes se complexifient au tournant des années 1920. Si des échanges et passages techniques se font dans les premières années du cinéma, à l'image de Dawn rendant hommage à Méliès et aux opérateurs Lumière, la multiplication de professionnels au fur et à mesure que l'industrie reconnaît la nécessité d'user de trucages rend la concurrence plus dure. Plus les techniques sont connues, plus elles se standardisent. Le métier se crée peu à peu à Hollywood et partout dans le monde, ce qui paradoxalement met en difficulté le pionnier et le touche-à-tout Dawn.

Un inventeur de métier ?

Sa longue carrière a conduit Dawn à travers différentes époques clés du cinéma. Il est d'abord un pionnier, quand il travaille pour Gaumont, pour les Hale's Tours, pour la Keystone, Ince, Edison, Selig… Puis, lors de l'organisation et la mise en place des *majors* et des *minors*, il travaille principalement pour le studio Universal et pour la MGM, tout en partant régulièrement réaliser ses propres films en Australie. Au cours de cette seconde période, Dawn oscille entre truqueur, particulièrement en effets optiques, et réalisateur (et parfois producteur). Comme l'explique Raymond Fielding :

> En tant qu'opérateur, Dawn avait le plus grand mal à vendre aux réalisateurs les avantages de ses effets pour leurs productions. À cette époque, et encore de nos jours, de nombreux réalisateurs ne comprenaient pas grand-chose aux techniques compliquées des effets spéciaux et hésitaient à dépenser de l'argent dans des séquences qui étaient nécessairement retirées du contrôle immédiat du réalisateur. Dawn décida que la seule façon d'exploiter la technologie qu'il avait développée était de devenir lui-même producteur et réalisateur. [27]

La place de Dawn est, à ce titre, atypique. Il est davantage crédité en tant que réalisateur qu'en tant que créateur des effets spéciaux, à une époque où seul le chef du département d'effets apparaît aux génériques. Ainsi, *Le Pays du dauphin vert* (Vincent Saville, 1947), sur lequel il a réalisé différents *matte painting*[28], ne le crédite pas et seuls Warren Newcombe

[26] Deuxième carte pour *Man of the West*, à propos de l'effet miroir, *op. cit.*

[27] Raymond Fielding, *op. cit.*, p. 143.

[28] Voir la carte consacrée à *Green Dolphin Street* : <http://hrc.contentdm.oclc.org/cdm/compoundobject/collection/p15878coll15/id/479/rec/2#nav_top>.

et Arnold Gillespie recevront l'Oscar, pour les meilleurs effets spéciaux en 1948. Sa double casquette lui permet néanmoins de développer, dans ses propres réalisations, de nombreux trucages. Les cartes consacrées à ses films sont ainsi les plus fournies, proposant un exposé clair des talents de Dawn : *Tundra* (1935) compte cinq cartes, tout comme *The Story of Andes* (1911). Cette double casquette est aussi liée à son parcours atypique et son goût pour la nature et les voyages. De fait, alors que son homologue Walter Percy Day multiplie en France dans les années 1920 des peintures pour créer ou étendre des plafonds de salle de bal et d'intérieurs bourgeois, comme dans *Nana* de Jean Renoir en 1926, Norman O. Dawn n'en exécute que très peu, développant au contraire des paysages de montagnes, de cascades ou de glaciers. Ses relations avec ses différents supérieurs, qu'il évoque régulièrement dans ses écrits[29], en font un personnage inclassable, cumulant différentes tâches avec un regard mi-artistique, mi-technique. La diversité de studios avec lesquels il collabore et la multiplicité des lieux de tournage achèvent d'exposer les particularités de Norman O. Dawn, qui est finalement un superviseur d'effets spéciaux, bien avant que le métier ne soit créé en tant que tel au début des années 1990[30], avec l'essor des effets numériques au cinéma. Or, la double casquette réalisateur/truqueur est néanmoins assez rare, les différents techniciens ayant le plus souvent opté pour l'un ou l'autre des métiers au passage des années 1920.

L'étude des archives de Norman O. Dawn, et en particulier des 164 cartes déposées dans ce cadre, permet d'exposer des difficultés méthodologiques courantes en histoire des techniques et métiers des effets spéciaux. D'une part, si cette ressource est passionnante, elle ne comble pas le manque de sources et d'images, liées aux débuts du cinéma, mais aussi à ce type de technique, vouée à l'invisibilité et au secret. L'héritage des prestidigitateurs est proche et la non-divulgation (non-débinage) des éléments précis est une règle standard tant pour éviter la concurrence que pour conserver l'illusion totale aux yeux des spectateurs. D'autre part, la perfection de la plupart des trucages les rend indétectables, sans ressources externes aux films, sur lesquelles aucune communication ne filtre jusque dans les années 1930. D'abord utilisées avec parcimonie, les informations techniques ne sont vraiment médiatisées qu'à partir des années 1980, et

de manière systématique avec les effets numériques du XXI^e siècle. Enfin, les traces laissées par ces techniciens sont, pour la plupart, rétroactives. Dans le cas des archives Dawn, seuls les enregistrements caméra, peu lisibles, et les esquisses peintes pour convaincre les producteurs sont contemporains de la réalisation des films. Il est clair que Dawn s'autorise ces confidences car les films cités ne sont quasiment plus exploités, l'enjeu étant moindre. Certaines anecdotes sont racontées plus de soixante années après, comme les apports de « Méleis » (*sic*) à son travail, difficiles à établir précisément. En effet, rien dans la filmographie existant de Méliès ne permet d'accréditer l'idée que le magicien de Montreuil aurait utilisé des miniatures suspendues ou des effets de miroir, comme le soutient pourtant Dawn dans différentes cartes. Si Méliès prestidigitateur connaît immanquablement les possibilités des vitres et miroirs par son expérience scénique, Méliès cinéaste ne semble pas les avoir adaptées au cinéma, du moins dans les éléments subsistant à ce jour[31]. Soit la mémoire de Dawn est imprécise sur ces deux points, soit elle permettrait de renouveler la recherche mélièsienne, sans avoir pour autant d'autres éléments corroborant ces dires… Enfin, la fonction de ces cartes est clairement pédagogique. Ce souci explicatif permanent est à la fois utile pour comprendre le travail de Dawn, mais le contraint à faire des choix dans ses explications qui vont rarement jusqu'au bout des détails techniques. Il est en tout cas éclairant sur le besoin de reconnaissance flagrant dont témoigne ici Dawn, et la difficulté, en fin de carrière, de continuer à « rester dans l'ombre » – et ce d'autant qu'il possède aussi un parcours de réalisateur et une formation artistique. C'est pourtant une part importante du cinéma que ce technicien hors pair permet d'éclairer différemment, à la fois d'un point de vue organisationnel que professionnel, technique et esthétique.

D'un strict point de vue méthodologique, les archives Dawn sont *a priori* uniques, mettant en relief les outils principaux disponibles en histoire des techniques et des métiers. Elles concentrent, en effet, les principales difficultés rencontrées dans ce type de travail : comment gérer à la fois autant d'informations (164 fiches, une petite centaine de films) et aussi peu d'éléments (une large part des copies n'existe plus, aucun élément technique complémentaire) ? Il est donc indispensable de travailler ici à la fois par récurrence et par exception : analyser les

[31] Je remercie ici Jacques Malthête pour son expertise sur ce sujet.

fiches une à une (éléments présentés, distinction entre éléments originaux et éléments *a posteriori*), puis identifier les fiches les plus originales en lien avec les fiches qui répètent inlassablement les mêmes techniques, les mêmes outils. Dans un second temps, les éléments présentés sont à confronter avec le peu d'informations fiables édités par ailleurs (ouvrages spécialisés, en particulier ceux de Fielding, films disponibles actuellement). Enfin, afin de comprendre la place du métier dans ce cadre précis, la comparaison avec des professionnels contemporains permet de cerner les spécificités de Dawn dans son approche et ses pratiques, tant techniques qu'organisationnelles. Les relations qu'il évoque à de nombreuses reprises avec les autres professionnels, en particulier producteur et réalisateur, sont éloquentes sur sa difficulté majeure de faire reconnaître son travail et le métier qui l'accompagne. C'est cette invisibilité des métiers des effets spéciaux en général qui implique ce croisement des sources pour arriver à faire la lumière sur ce métier de l'ombre, et en particulier sur le moment où il s'invente en tant que tel – tout en devant accepter qu'une part de ce voile, avec les outils et données actuels, ne pourra certainement jamais être levée…

Deuxième partie

Les métiers du cinéma et leurs évolutions

Décors et décorateurs de cinéma : approches et méthodes

Alexandre Tsekenis

Depuis que la « révolution » numérique s'est mise en marche, il y a environ vingt ans, l'attention des critiques et du public se porte plus volontiers sur le décor, notamment dans le cas de films aux partis pris esthétiques affirmés, aux décors à grande échelle ou offrant des images inédites. Nul doute que le décor bénéficie également de la curiosité des spectateurs pour les coulisses du cinéma, comme de l'intérêt suscité par les nouvelles techniques d'effets spéciaux et de trucages, aujourd'hui démystifiées et facilement accessibles. La technologie numérique s'est imposée au décor, notamment dans l'art de la simulation, amenant avec elles des changements au sein d'une profession jusque-là inégalement habituée, en France, à l'utilisation de trucages. Nullement figées, les nouvelles pratiques se sont suffisamment stabilisées pour pouvoir être identifiées, pour analyser les récentes mutations et les enjeux auxquels sont aujourd'hui confrontés les décorateurs du cinéma français.

Les décorateurs aujourd'hui : définition et enjeux

Profils et parcours

Tenter de définir une typologie de profils s'avère délicat. L'hétérogénéité de la profession reflète celle des demandes en termes de décors d'un film à l'autre, elles-mêmes variant considérablement en fonction des scénarios et des budgets. Cette diversité des profils est à la fois la cause et la conséquence de l'assouplissement, puis de l'abandon de règles strictes qui ont longtemps encadré la profession, un système fondé sur l'obtention de cartes professionnelles délivrées par le CNC. De solides études artistiques – peinture, architecture, parfois prolongées par l'Institut des hautes études cinématographiques (IDHEC) – étaient la formation la

plus courante au cours de l'après-guerre. Les années 1980 ont marqué une rupture, avec l'arrivée d'un grand nombre de jeunes décorateurs et techniciens aux parcours atypiques, venus du milieu de la mode, du design ou du film publicitaire, de même que des autodidactes se formant sur les tournages, des « super bricoleurs », comme ils se plaisent eux-mêmes à se décrire.

Photo, design industriel, arts appliqués... toutes les formations autour de l'image, de l'objet ou de l'aménagement de l'espace semblent conduire au décor de cinéma, parfois sans être menées à terme puisque aucun diplôme n'est requis pour entrer dans une équipe décoration et *a fortiori* pour accéder à son sommet. Si la tendance aux longues études semble actuellement en recul, on observe parallèlement le renforcement de la formation « officielle » et spécifique au décor de cinéma. En 2012, La Fémis a doublé l'effectif de son département décor avec quatre étudiants dont chacun aura effectué au total au moins six années d'études. Entre le premier poste occupé au sein d'une équipe décoration et le premier long métrage en tant que chef décorateur, souvent une production à petit budget tournée en décors naturels, la période est très variable. Généralement de trois à cinq ans, elle s'étend jusqu'à une bonne dizaine d'années pour ceux qui suivent la voie hiérarchique traditionnelle : stagiaire, second puis premier assistant. Un parcours parfois ignoré puisque certains décorateurs en activité aujourd'hui ont précédemment occupé les postes d'ensemblier, d'accessoiriste, de régisseur d'extérieur ou de constructeur. Au sein de la profession, nombreux sont ceux qui exercent, par choix ou par nécessité, des activités dans d'autres domaines que le cinéma, le plus souvent celui de l'audiovisuel (téléfilm, film publicitaire), mais aussi l'architecture intérieure, l'événementiel, le théâtre, la scénographie d'exposition ou les arts plastiques.

Regroupement et mobilisation de la profession

En l'absence d'une quelconque plateforme d'échanges et de rencontres, l'Association des chefs décorateurs de cinéma (ADC) est née en 2005, encouragée en cela par l'apparition – ou l'amplification – de mutations technologiques affectant la pratique du métier, de phénomènes au sein de l'industrie cinématographique la mettant en danger. L'ADC regroupe aujourd'hui environ quatre-vingt membres, soit la plus grande partie de la profession, ayant tous à leur actif au moins trois longs métrages de cinéma. L'augmentation de la part numérique des décors a incité les

décorateurs à redéfinir leur champ d'action et les responsabilités qui sont les leurs « depuis la première lecture jusqu'à l'encadrement des travaux de postproduction et la maîtrise des images virtuelles », de façon à garantir la continuité scénographique de l'œuvre. Dans sa charte, l'ADC s'affirme « le garant de la place et de la qualité de notre expression artistique au sein de la chaîne de production du cinéma français »[1]. Il s'agit bien de défendre la place du décor au sein de la création cinématographique, les savoir-faire de ses différents métiers et leurs conditions d'exercice, par exemple dénoncer les dispositions d'une nouvelle convention collective de 2012, jugées néfastes à l'organisation de la branche décoration.

Les délocalisations des tournages et leur progression annuelle régulière se trouvent au cœur des débats, comme l'atteste la boutade lancée par le décorateur Thierry Flamand à l'occasion du César qu'il reçut en 2015 pour les décors « d'un film français, *made in Germany* », le remake par Christophe Gans de *La Belle et la Bête*. L'éloignement des tournages augmente le chômage des équipes de techniciens et d'ouvriers en même temps qu'il fragilise les fournisseurs spécifiques au décor, parmi lesquels les loueurs d'accessoires et de mobilier. Suite à la mobilisation de l'ADC et de divers acteurs du secteur du cinéma et de l'audiovisuel, le crédit d'impôt sur les tournages en France a été relevé en 2016, facilitant leur retour sur le territoire. De façon similaire, un combat collectif contribua à empêcher la fermeture des studios de Bry-sur-Marne en 2014. Le milieu du cinéma et les pouvoirs publics furent sensibilisés à la disparition annoncée de ce site qui, à ce jour, poursuit son activité et offre un outil que les décorateurs considèrent comme indispensable[2].

Pour une histoire du métier de décorateur : sources et méthodes

Les archives de la Cinémathèque française : comment les « faire parler »

Les fonds d'archives de décorateurs sont d'un nombre très limité. Celui de Lucien Aguettand, qui couvre la période de 1932 à 1977,

[1] Voir : <https://www.adcine.com/qui-sommes-nous>.

[2] Suite au rachat des terrains des studios de Bry-sur-Marne par un groupe immobilier en 2017, l'ADC et d'autres professionnels du cinéma sont à nouveau mobilisés pour la poursuite de l'activité audiovisuelle sur le site.

témoigne largement de son activité de membre de la branche décoration du Syndicat des techniciens et membre de la Commission supérieure technique. Le fonds retrace ainsi l'histoire d'une profession et révèle quelle était, dans le contexte de l'après-guerre, la vision dominante du décor sur le plan technique et esthétique, grâce aux textes de conférences sur l'art du décor de cinéma. Si les décorateurs écrivent peu, leurs dessins sont nombreux et riches d'enseignements. La collection de la Cinémathèque est constituée d'esquisses, de maquettes dessinées, de plans et autres documents techniques qu'il s'agit chaque fois de « faire parler ».

Que disent ces documents sur le style du décorateur, sur son talent qui l'apparente plus au peintre ou à l'architecte ? Sur le parti pris stylistique du film, sur la façon – trucage ou maquette – dont un décor a été réalisé ? Des plans peuvent préciser les dimensions et l'équipement d'un plateau sur lequel un décor a été implanté, et par là-même renseigner sur l'état d'un studio à un moment donné. D'autres, dès lors qu'ils indiquent les axes de caméra ou le format d'image, témoignent d'une étroite collaboration entre décor et mise en scène. Ils peuvent mettre en lumière une méthode de travail, telles les perspectives opérées[3] par Jacques Colombier ou Max Douy. La confrontation de dessins, de storyboards ou de maquettes conservées dans la collection Costumes et objets avec des photogrammes du film peut révéler un grand écart avec la version retenue, et permettre d'imaginer les différentes étapes de la conception.

Pour décrypter ces documents, le regard du professionnel peut se révéler précieux. S'il s'avère impossible de faire commenter un dessin par son auteur, un collaborateur peut apporter son témoignage, comme le fit François de Lamothe pour des maquettes de Serge Pimenoff dont il fut l'assistant, à l'initiative du programme de recherches ANR Cinémarchives[4]. De leur côté, un décorateur contemporain proposera un regard extérieur, un spécialiste du cinéma replacera le dessin dans une perspective historique et permettra d'identifier des documents non indexés. Différentes collections peuvent être croisées, par exemple les photos de repérages de Pierre Guffroy pour *L'Insoutenable Légèreté de l'être* (*The Unbearable Lightness of Being*, Philip Kaufman, 1988) avec les maquettes en volume réalisées pour le même film. D'autres fonds

[3] Image d'un décor obtenue par sa mise en perspective à partir de plans et d'élévations, en tenant compte du format d'image du film et de la focale utilisée.

[4] Voir : <https://cinemarchives.hypotheses.org/category/serge-pimenoff>.

d'archives peuvent comporter des notes d'intentions de réalisateurs, des scénarios annotés, des plans de travail indiquant les lieux de tournage, tel le fonds Sylvette Baudrot, scripte sur plusieurs films de Roman Polanski avec Guffroy au décor. De nombreux documents liés au décor sont également conservés par la fondation Jérôme Seydoux-Pathé et le musée Gaumont, par la BnF (département des Arts du spectacle) et bien entendu par les décorateurs dans leurs propres archives.

Autres types de sources

Écrites ou audiovisuelles, de provenance universitaire, journalistique ou promotionnelle, des sources d'origines diverses se présentent aux chercheurs qui doivent alors cibler non plus seulement les décorateurs, mais les réalisateurs et les films. Les différents ouvrages consacrés à Alain Resnais[5] et Jacques Demy[6] évoquent longuement leur collaboration avec respectivement Bernard Evein et Jacques Saulnier. Des films aux univers stylisés, ceux de Jean-Pierre Jeunet ou de Michel Gondry, voient leurs décors largement commentés. Outre le style et les options visuelles, les processus de fabrication sont racontés, tels des secrets révélés au public, parfois par les décorateurs eux-mêmes, dans les revues professionnelles ou même généralistes, sur des sites consacrés au cinéma et dans des bonus d'éditions DVD. Les *making-of* conçus par les sociétés de post-production montrent les étapes de l'intégration de décors numériques aux prises de vues réelles, par exemple celui de la société Mikros Image réalisé pour *Faubourg 36* (Christophe Barratier, 2008) et qui fut présenté dans l'exposition de la Cinémathèque, « Profession : chef décorateur » (décembre 2014 – juin 2015). Si les monographies de décorateurs sont rares, les plus renommés d'entre eux ont fait l'objet de films documentaires, comme récemment *Les Ciels d'Alexandre Trauner* (2016) de Vincent Dumesnil. Au sein des écoles de cinéma, des activités de recherche ont été créées depuis quelques années et constituent elles aussi de nouvelles sources. Les entretiens filmés de techniciens (décorateurs, chefs opérateurs…) menés par les étudiants de La Fémis, dans le cadre de leur cursus, sont la preuve d'un intérêt renouvelé pour la mémoire des

[5] François Thomas, *Alain Resnais, les coulisses de la création*, Paris, Armand Colin, 2016, 511 p.

[6] Jean-Pierre Berthomé, *Jacques Demy et les racines du rêve*, Nantes, l'Atalante, 2014 [1982], 508 p.

techniques. Encouragés par la facilité de publication qu'offre le support internet, les documents audiovisuels se multiplient. Citons l'exemple de l'Académie des arts et techniques du cinéma qui, dans un contexte relevant cette fois de l'évènementiel, réalise et met en ligne chaque année des entretiens avec l'ensemble des techniciens nommés aux César[7].

La pratique du décor aujourd'hui

Le décor à l'heure du numérique

Depuis le premier *matte painting* numérique utilisé dans un film français, réalisé par Jean-Marie Vivès[8] en 1993 pour le film *Une époque formidable* (Gérard Jugnot, 1991), la technique s'est progressivement généralisée au cours des années 2000. Citons *La Cité des enfants perdus* (Marc Caro et Jean-Pierre Jeunet, 1995), premier film utilisant cette technologie à grande échelle et un tournant dans l'histoire du décor en France. De l'absence de trucages dans *Les Amants du Pont-Neuf* (Leos Carax, 1991) à la contribution de plus en plus importante du numérique dans deux autres films recréant eux aussi un grand paysage parisien, *Peut-être* (Cédric Klapisch, 2000) et *Faubourg 36* (2008), la nature hybride des décors, mélange de parties construites et d'extensions à présent numériques, s'est progressivement imposée aux producteurs et aux réalisateurs, du moins sur les projets les plus ambitieux.

Pour les décorateurs, appréhender un décor sous sa forme dématérialisée constitue le premier des défis. Appartenant à la génération entrée dans la profession avant l'apparition du numérique, Jean Rabasse a tenu à se former aux logiciels 3-D dès le début des années 1990, afin de s'assurer la même qualité de dialogue avec un infographiste qu'avec un peintre ou un sculpteur, et suivre ainsi le travail de création numérique jusqu'à la dernière patine. Concernant la préparation, le mode de fabrication et la gestion des décors, la pratique du métier a connu des changements notables, comme la modification de l'espace-temps du décor. Celui-ci n'est plus lié au lieu et à la durée du tournage, mais se trouve fragmenté, dispersé entre le plateau et les sociétés de post production. En conséquence, le superviseur d'effets visuels est un nouveau collaborateur qui rejoint le trio

7 Voir : <http://www.academie-cinema.org/images/videos/paroles-nommes,2018,4502,. html>.

8 Auteur de nombreux *matte paintings* numériques pour le cinéma entre 1990 et 2004.

réalisateur/chef opérateur/chef décorateur. Aux solutions alternatives du tournage en studio ou en décors naturels s'ajoute à présent une troisième option : l'extension numérique d'un décor ou son incrustation dans un univers étranger. Ce lien entre le décor et la post-production, d'abord difficile à mettre en place, est aujourd'hui communément établi.

Au sein des équipes

Comme dans les agences d'architecture, les bureaux décoration ont remplacé le calque d'étude et la planche à dessin par les tablettes et les ordinateurs. Pour les décorateurs et leurs assistants, la maîtrise, sommaire ou approfondie, des logiciels de dessin et de traitement d'image est désormais une évidence. L'outil informatique est systématiquement utilisé par les plus jeunes, et ce dès la phase de recherche. Pour les esquisses, pour les dessins d'ambiance ou pour les visuels finalisés, il permet un large éventail de styles de rendus qui souvent mêlent plusieurs techniques : dessin à la main, dessin informatique et retouche de photos. L'équipe décoration compte à présent de nombreux infographistes, une fonction officiellement entrée dans les métiers de la production cinématographique, chargés entre autres de tous les documents imprimés, qu'ils soient typographiques ou décoratifs. Concernant les équipes d'ouvriers et artisans, la technologie a, dans une certaine mesure, pénalisé les métiers de la peinture, en remplaçant les découvertes peintes par leurs équivalents numériques. De nouvelles méthodes de fabrication industrielle, comme la découpe numérique de matériaux, ont ainsi transféré vers des sociétés extérieures des tâches jusque-là réalisées par les équipes de construction.

De nouvelles pistes pour la recherche

Le dessin renouvelé

Qu'il s'agisse de dessin artistique ou technique, comment l'informatique a-t-elle remplacé la gestuelle naturelle de la main ? Le nouvel outil a renouvelé le style, introduit de nouveaux effets, montré des influences venues de de la bande dessinée ou de l'illustration contemporaine. Louée pour ses performances et sa précision, sa rapidité à varier les points de vue, à modifier couleurs et textures, l'informatique n'en est pas moins critiquée pour sa rigidité et sa moindre capacité à

suggérer l'émotion. Il n'est pas anodin que certains décorateurs préfèrent, pour des projets spécifiques, intégrer au processus de conception les supposées imperfections du dessin traditionnel : c'est le cas de Françoise Dupertuis pour le film *Astérix et Obélix : au service de Sa Majesté* (Laurent Tirard, 2012). Une autre problématique est celle de la conservation et de l'archivage des documents de nature numérique et donc reproductible. Si un dessin peut être signé de son seul auteur, le partage des fichiers fait qu'il est à présent détenu par plusieurs personnes.

L'évolution des studios

Depuis les années 1960, le paysage des studios de cinéma a connu une histoire mouvementée. La fermeture de l'important complexe d'Arpajon en 2012, moins de vingt-cinq ans après sa création, est retracée dans le documentaire *Les Studios d'Arpajon, la fabuleuse histoire d'un hangar à pommes,* de Sabine Chevrier et Gaëlle Girard-Marchandise (2013). De la disparition de sites historiques à la construction de nouveaux plateaux aux dimensions réduites, à partir des années 1980 et sous l'effet des tournages de films publicitaires, quelle est la typologie des plateaux en France et de leur infrastructure (piscine, cyclorama, terrains extérieurs) ? Quels sont les éléments favorisant aujourd'hui l'utilisation des studios (les effets spéciaux et les tournages sur fond vert, le succès de nouveaux formats télévisuels comme les séries qui comportent des décors récurrents) ?

Les associations de professionnels

Sans doute encouragées par la création de l'ADC, de nouvelles associations proches du décor ont vu le jour entre 2009 et 2015, rassemblant les créateurs de costumes (AFCCA[9]), les accessoiristes de plateau (AFAP[10]), les métiers associés du décor de cinéma et de l'audiovisuel (MAD[11]) et les repéreurs (Association des repéreurs[12]). Simples forums d'information et de réflexion ou acteurs de l'évolution de leur profession, ces regroupements de professionnels montrent un besoin

[9] Association française des costumiers du cinéma et de l'audiovisuel : <http://www.afcca.fr/>.

[10] Association française des accessoiristes de plateau : <https://www.afap.fr/>.

[11] Métiers associés du décor : <https://mad-asso.com/>.

[12] Association des repéreurs : <http://www.asso-repereurs.fr/>.

de reconnaissance du statut et de la fonction. Sur ce point, la création d'une nouvelle carte professionnelle a été évoquée au cours de débats.

En conclusion

Le décor est souvent abordé par son aspect le plus « glorieux » et spectaculaire. Sa visibilité, sur l'écran comme dans les études qui lui sont consacrées, est forte à l'occasion de projets ambitieux ou de nouvelles prouesses techniques. Elle occulte cependant une réalité plus diversifiée, une profession et des pratiques régulièrement fragilisées, sans cesse amenée à se transformer pour s'adapter aux évolutions techniques et économiques. Déjà au cours de la période de l'après-guerre, les décorateurs s'étaient trouvés confrontés aux mutations de l'industrie du cinéma, aux transformations parfois brutales de leur métier, au sort incertain des studios délaissés par les productions. Ardents militants au sein d'organisations syndicales et professionnelles, ils pouvaient faire preuve d'un esprit corporatiste. Leur vision quelque peu dogmatique, celle du recours systématique – ou presque – au studio, n'est plus partagée. Il est cependant un point essentiel sur lequel ils sont rejoints par les générations suivantes, c'est leur conviction intime que le décor est un élément majeur contribuant à la qualité artistique des films. La création de l'ADC, les revendications et les actions menées pour la défense d'une profession – et sa reconnaissance au sein de l'industrie cinématographique – peuvent être rapprochées des remises en question et des combats qui ont marqué les décennies précédentes. Les mutations du décor ne sont qu'un éternel recommencement.

À travers les collections de la Cinémathèque française

Jacques Ayroles

Suite à l'exposition « Profession : chef décorateur » qui s'est tenue à la Galerie des donateurs de la Cinémathèque française de décembre 2014 à juin 2015, nous avons dressé un panorama des collections de maquettes de décors que nous conservons. Cette exposition concernait uniquement le travail des chefs décorateurs installés en France et avait pour bornes chronologiques les années 1945–2014. Cependant, la collection des maquettes de décors de la Cinémathèque concerne bien la période de 1910 à aujourd'hui. Nous avions laissé de côté la très riche collection sur le cinéma muet allemand. Cette collection, qui fut rassemblée par Lotte Eisner, a été l'objet d'un catalogue et d'une exposition[1]. Nous avons également écarté à regret les chefs décorateurs anglais (je pense aux 430 maquettes d'Alfred Junge ou à celles de Hein Heckroth). Il faut également mentionner les dessins du Japonais Hiroshi Mizutani (le chef décorateur de Kenji Mizoguchi), dont certaines maquettes ont été présentées dans l'exposition « L'écran japonais » de septembre 2016 à juin 2017.

[1] Laurent Mannoni et Marianne de Fleury (dir.), *Le cinéma expressionniste allemand : splendeurs d'une collection*, Paris, La Martinière, 2006.

Figure 1. Affiche de l'exposition « Profession : chef décorateur », d'après un dessin de Jacques Saulnier. © Renée Saulnier/Cinémathèque française.

Georges Méliès (1861–1938) a longtemps utilisé la toile peinte mais a aussi inventé de nombreuses machineries qui donnent chez lui une « profondeur » au décor qui n'existe pas dans les années 1900–1910. C'est pourtant sous l'impulsion du mouvement de l'Art déco, dans les années 1920, que le décor au cinéma se renouvelle et s'exprime enfin, de manière évidente, avec l'arrivée des Russes qui, en s'installant à Montreuil, créent une nouvelle esthétique du décor[2]. Boris Bilinsky (1900–1948) et Ivan Lochakoff (1877–1942) sont des représentants de cette époque de grande création.

Le Polonais Lazare Meerson (1900–1938), à la vie brève, travaille principalement pour deux réalisateurs, René Clair et Jacques Feyder. C'est pour ce dernier qu'il signe les décors d'un film qui marquera le cinéma français pour de longues années, *La Kermesse héroïque* (1935). Pour ses

[2] Voir François Albera, *Albatros, des Russes à Paris (1919–1929)*, Paris/Milan, Cinémathèque française/Mazzotta, 1995.

maquettes, il utilise beaucoup la technique de l'estompe[3]. L'essentiel des archives de ce décorateur est conservé à la Cinémathèque et l'Association française de recherche en histoire du cinéma (AFRHC) lui a consacré une courte plaquette[4]. Meerson forme le Hongrois Alexandre Trauner. Il lui transmet le même art de l'estompe et du crayon mêlé. Peintre de formation, Trauner ajoute sa patte et multiplie souvent les points de vue dans ses dessins.

Figure 2. Ivan Lochakoff, *Geheimnisse des Orients* (*Schéhérazade*), Alexandre Volkoff, 1928. © Cinémathèque française.

[3] L'estompe est une technique utilisée dans le dessin pour atténuer le passage d'une couleur à une autre (ou d'un gris à un autre). À partir d'un petit papier buvard, on effectue des mouvements circulaires afin que les grains des couleurs (pastel ou fusain) se mélangent doucement.

[4] *Lazare Meerson (1900–1938)*, dossier réalisé sous la responsabilité de Michel Warren, Fédération des cinémathèques et archives de films de France (FCAFF), sans date [*circa* 1994], 44 p.

Figure 3. Lazare Meerson, *La Kermesse héroïque*, Jacques Feyder, 1935.
© Cinémathèque française.

Georges Wakhévitch (1907–1984), né à Odessa, introduit dans le
décor de cinéma une vraie parenté avec le décor de théâtre. Il retrouve
dans *Les Visiteurs du soir* (Marcel Carné, 1942), dont il signe les décors
avec Trauner, une forme très stylisée propre aux arts de la scène. André
Andrejew (1887–1967), né en Russie, après avoir beaucoup travaillé
pour le cinéma allemand, saura produire pendant la Seconde Guerre
mondiale, avec peu de moyens, des décors qui utilisent au maximum
les jeux de l'ombre et de la lumière. Eugène Lourié[5] (1903–1991), né à
Kharkov en Russie, accompagne Jean Renoir sur plusieurs de ses grands
films des années 1930 (*Les Bas-Fonds*, 1936 ; *La Grande Illusion*, 1937 ;
La Bête humaine, 1938 ; *La Règle du jeu*, 1939). Il le suit aux États-Unis
et réalisera les décors de *L'Homme du Sud* (*The Southerner*, 1944) et du
Journal d'une femme de chambre (*The Diary of a Chambermaid*, 1946). Les
191 maquettes dessinées de Lourié soulèvent un problème : la plupart
d'entre elles ne sont toujours pas indexées à des films. Les dons faits à la
Cinémathèque ont parfois été réalisés de manière « rapide » et il n'a pas
toujours été possible d'indiquer au dos du dessin le nom du film voire
du réalisateur. On ne saurait trop recommander à tous les archivistes et

[5] Eugène Lourié, *My Work in Films*, San Diego/New York/Londres, Harcourt Brace
Jovanovich, 1985.

documentalistes du monde de l'art d'accomplir ce geste essentiel qui consiste à noter la source du document, au plus près de celui-ci.

Léon Barsacq (1906–1969), au dessin minutieux, devient au sortir de la guerre un des représentants d'un certain décor à la française. Chaque élément nécessaire à la construction du décor y est inscrit. C'est le premier décorateur, dès 1970, à écrire un livre sur son métier[6]. Une partie de ses archives se trouve à la Bibliothèque nationale de France, une autre à la Cinémathèque française. Serge Pimenoff (1895–1960) devient, de 1945 à 1960, un des chefs décorateurs les plus demandés, travaillant avec Jean Delannoy, Julien Duvivier ou Jean-Paul Le Chanois. À sa mort en 1960, il aura travaillé sur plus de 70 films et aura formé de nombreux décorateurs comme François de Lamothe[7]. La Cinémathèque détient 845 de ses maquettes dans la collection.

Jean d'Eaubonne (1903–1971) est connu pour sa collaboration avec Max Ophuls. Son savoir-faire lui permettra de travailler avec plusieurs réalisateurs américains qui tournent en Europe dans les années 1950. Il utilise souvent le pastel et formule une représentation de l'espace qui reste esthétique. Max Douy (1904–2007), à la très longue carrière, savait remarquablement parler de son travail et finit, comme Barsacq, par écrire un ouvrage[8], après avoir collaboré avec Claude Autant-Lara (ancien chef décorateur lui-même) et Henri-Georges Clouzot. Avec plus de 100 films à son actif, René Renoux (1904–2000) a su pleinement utiliser les studios pour construire des décors. Il forme avec Jean Delannoy un tandem parfait et le point d'aboutissement de son travail reste les décors gigantesques qu'il réalise pour *Notre-Dame de Paris* (1956).

Maurice Colasson (1911–1992) travaille de concert avec Wakhévitch sur plusieurs films dont *Dédée d'Anvers* (Yves Allégret, 1948) et *Mayerling* (Terence Young, 1967). Excellent dessinateur, il laisse une empreinte subtile dans le décor de cinéma à la française. Ces dernières années, les dons de Pierre Guffroy (1926–2010), de Jacques Saulnier (1928–2014) et de François de Lamothe (1928–2011) ont permis à la Cinémathèque de compléter les fonds de chefs décorateurs qui travaillèrent beaucoup

[6] Léon Barsacq, *Le décor de film (1895-1969)*, 2ᵉ édition, préface de René Clair, Paris, Veyrier, 1985.

[7] Site internet du programme de recherche ANR Cinémarchives consacré à Serge Pimenoff : <http://www.cinematheque.fr/sites-documentaires/pimenoff/index.php>.

[8] Max Douy et Jacques Douy, *Décors de cinéma : les studios français de Méliès à nos jours*, Paris, Le Collectionneur, 1993.

avec des réalisateurs des années 1960 qui ont largement développé le tournage des films en décors naturels. Guffroy, architecte de formation, savait alterner décors de studio et décors naturels avec beaucoup de savoir-faire, un de ses actes de bravoure fut de repeindre la « nature » de *Tess* de Roman Polanski (1979). Saulnier, *alter ego* d'Alain Resnais, a construit la plupart des décors des films de ce dernier.

Grâce à l'exposition consacrée aux chefs décorateurs, nous avons pu enrichir le fonds des maquettes de décors avec les dons de Jean-Jacques Caziot, de Jacques Bufnoir, de Jean-Marc Kerdelhué et d'Olivier Raoux, ou encore de Jean Rabasse, chef décorateur du film de Marc Caro et Jean-Pierre Jeunet *La Cité des enfants perdus*, d'Anne Seibel, professeure à La Fémis, et de Thierry Flamand. La plupart des fonds sont catalogués et numérisés, mais certains, comme ceux de Guy-Claude François, de Katia Wyszkop ou de Laure Lepelley-Monbillard, récemment arrivés, sont encore en cours d'inventaire et seront accessibles ces prochaines années.

Truquer les décors de cinéma en France : quelle visibilité des métiers et des techniques, d'hier à aujourd'hui ?

Caroline Renouard

En juin 2016 est paru un rapport du Centre national du cinéma et de l'image animée (CNC) consacré à la *Fabrication d'effets spéciaux numériques en France*. L'auteur, Jean Gaillard, y distingue trois types d'effets visuels développés au sein de l'activité industrielle : les « VFX Univers » (la construction d'un univers visuel imaginaire crédible), les « VFX Support » (la reproduction imitative et/ou la simulation créative nécessitées par la dramaturgie) et les « VFX Réparation » (l'amélioration visuelle, la correction ou la réparation). Il est précisé, dans cette dernière catégorie, que « d'une manière ou d'une autre, pratiquement tous les films (et fictions) y ont recours »[1]. Cette typologie évoque en lointain écho la catégorisation émise par Christian Metz dans « Trucage et cinéma », qui se place du côté de la réception et qui différencie les trucages imperceptibles des trucages invisibles (mais perceptibles[2]). Les « VFX Support » se trouveraient donc à cheval sur les deux catégories de Metz, les « VFX Univers » se situant dans la catégorie des trucages invisibles mais perceptibles et les « VFX Réparation » dans celle des trucages imperceptibles.

Si l'on reprend la distinction de Metz, la plupart des trucages présents dans les films français sont imperceptibles : ce sont des effets qui ne se voient pas en tant que tels sur l'écran. Les décors sont artificiellement prolongés sans que le spectateur le devine, et ces trucages discrets sont

[1] Jean Gaillard, *La fabrication d'effets spéciaux numériques en France*, mission réalisée pour le CNC, juin 2016, p. 25–26.

[2] Christian Metz, « Trucage et cinéma », dans *Essais sur la signification au cinéma* (tome II), Paris, Klincksieck, 1972, p. 173–192.

liés aux récits dominants du cinéma français. Les participations de leurs concepteurs sont rarement perceptibles… et donc rarement créditées aux génériques de ces films[3]. Pourtant, et contrairement aux idées reçues, le cinéma français regorge d'effets spéciaux – notamment de décors truqués – dès ses débuts et tout au long de son histoire. Ce qui prédomine dans les productions, ce sont majoritairement les effets visuels « support » et « réparation », c'est-à-dire des trucages imperceptibles. On l'observe encore parfaitement aujourd'hui à la lecture du rapport de Jean Gaillard :

> Les besoins en « VFX Support » couvrent une large gamme de besoins qualitatifs et quantitatifs. Les besoins quantitatifs vont de quelques séquences (par exemple simulation d'effets naturels, foules, explosions, etc.) à l'intégralité du film (par exemple films historiques). Les besoins créatifs vont de la simple extension de décor ou découverte à des personnages synthétiques interagissant avec des acteurs réels. Une variété de techniques sont mises en œuvre : simulation, fond vert, synthèse, *matte painting*, *compositing*, etc. Les méthodes et techniques sont banalisées dans une certaine mesure. L'image finale résultant d'un *compositing*, la coordination avec les VFX au moment du tournage est essentielle. Cette coordination ne présente en théorie d'autre difficulté qu'organisationnelle, décisionnelle ou pratique. La présence et les besoins techniques de l'équipe VFX sur le plateau doivent être prévus, rendus possibles et respectés. Les besoins en « VFX Réparation » sont plus utilitaires que créatifs. Il s'agit essentiellement de remédier à des problèmes pratiques liés au tournage : effacement de câbles, petites extensions de décors, suppression d'éléments dans le champ de la caméra, ré-incrustations d'images dans des écrans, etc. Ces travaux sont fréquemment assimilés à la post-production. D'une manière ou d'une autre, pratiquement tous les films (et fictions) y ont recours.[4]

Au cinéma, de manière générale, les chefs décorateurs disent souvent qu'un décor réussi est un décor qui ne se remarque pas. Il en est de même pour les trucages imperceptibles. Ainsi, quand on souhaite entreprendre une recherche scientifique sur un objet d'étude tel que les trucages imperceptibles intégrés dans des décors réussis – dont on ne perçoit seulement à l'écran qu'une certaine qualité esthétique globale –, on peut atteindre rapidement

[3] Voir Réjane Hamus-Vallée et Caroline Renouard, « Du *visual effects supervisor* au superviseur des effets visuels, un rapport au collectif différent ? », dans Bérénice Bonhomme, Isabelle Labrouillère, Paul Lacoste (dir.), *La création collective au cinéma*, n° 1, novembre 2017, p. 59–82.
En ligne : <https://creationcollectiveaucinema.files.wordpress.com/2017/11/cccn-1.pdf >.

[4] Jean Gaillard, *op. cit.*, p. 26.

une limite du regard, de la compréhension et, par conséquent, de la réflexion elle-même. Il s'agit alors de trouver les traces, souvent imperceptibles elles aussi, de ceux qui ont conçu ces décors truqués, pour mieux appréhender leur travail dans les films, les techniques employées, les effets esthétiques recherchés, les relations entretenues avec le reste de l'équipe technique et artistique… L'objet de cette contribution est donc d'interroger une des techniques phares des « trucages imperceptibles » et des « VFX Support » : celle des techniques d'extension de décor, en se focalisant sur les témoignages des métiers, nouveaux et disparus, qui y sont liés.

Une nouvelle visibilité des effets imperceptibles ?

Depuis Georges Méliès, les décors du cinéma français se sont développés en relation étroite avec les trucages, mais avec une certaine discrétion. Les techniques de trucage décor sont ainsi passées d'un mode de production artisanal et relativement ponctuel à des outils intégrés à la production même des films. Les principaux décors truqués, constitués de découvertes peintes, photographiques ou en volume, ont trouvé leurs équivalents numériques, avec la même quête de perfection qui prédominait du temps de l'âge d'or des décors en studio. Les décors truqués des films français restent de l'ordre de l'artisanat jusque dans les années 1990, avec un ou quelques professionnels convoqués pour un film, sous la houlette le plus souvent du chef décorateur ou du directeur de la photographie. Si le numérique a bouleversé les métiers liés aux décors en proposant dès les années 1990 des extensions numériques, il semble qu'en France la rupture liée à la perte de ces métiers soit intervenue bien avant l'arrivée des premiers ordinateurs. Cette problématique de la perte de technique ou de la disparition de métiers n'est donc pas particulièrement nouvelle dans le trucage décor. En effet, en avril 1966, le décorateur Lucien Aguettand déplorait déjà « L'oubli des leçons de Méliès » dans *La Technique cinématographique* : « Il existe en France des techniciens habiles et très au courant des trucages optiques et photographiques ; d'autres conservent encore le souvenir de la pratique du trucage-décor qui permettait avant la guerre de 1939, d'augmenter ou de modifier, sans trop de frais, les lieux et décors, trucages oubliés dans notre pays, mais fortement employés en URSS ou aux USA[5] ».

[5] Lucien Aguettand, « L'oubli des leçons de Méliès », *La Technique cinématographique*, n° 273, avril 1966, p. 13. Nous renvoyons aussi à la version manuscrite de l'article (et

Alors que le trucage décor apparaissait comme un simple souvenir pour quelques anciens professionnels dans les années 1960, il est intéressant de constater que l'apport des technologies du numérique a permis de remettre au cœur de la création cinématographique cet enjeu technique, afin « d'augmenter ou de modifier, sans trop de frais, les lieux et décors ». *Amour* de Michael Haneke (2012) ou *Bird People* de Pascale Ferran (2014) ne sont que quelques exemples récents de films aux décors truqués par des découvertes extérieures réalisées en image de synthèse et tournés sur fond vert en studio. Ces films nous permettent de présenter aussi les typologies des sources les plus fréquentes que l'on utilise quand on travaille sur les effets numériques aujourd'hui :

- des interviews dans la presse spécialisée comme *Cinefex* ou *SFX*, ou des entretiens avec des professionnels donnés dans le cadre de conférences comme celles de Paris FX, devenues Paris Image Digital Summit ;
- des revues corporatives comme celle de l'Association française des directeurs de la photographie cinématographique (AFC) ;
- des entretiens menés sous la forme d'enquête sociologique afin de comprendre les enjeux de la pratique professionnelle et les enjeux de création[6] ;
- des conférences ou des tables rondes avec des professionnels, organisées dans le cadre de séminaires ou de journées d'études[7] ;
- les *promo reels*, *making-of* et autres « avant-après » que mettent en ligne les sociétés d'effets ou de post-production ou qui complètent le film dans les éditions DVD.

ses brouillons) présente dans le fonds Lucien Aguettand conservé à la Cinémathèque française, cote AGUETTAND137-B8.

[6] Voir notamment les travaux de Bérénice Bonhomme sur les chefs opérateurs et les webdocumentaires sur les métiers de l'audiovisuel produits par la Commission nationale paritaire pour l'emploi et la formation et le centre Pierre Naville de l'Université Évry-Val-d'Essonne, réalisés par Réjane Hamus-Vallée et Caroline Renouard, disponibles en ligne : <http://www.cpnef-av.fr/films/>.

[7] Citons, entre autres exemples, le cycle de conférences du Conservatoire des techniques de la Cinémathèque française ; les séminaires de recherche du GRÉCA organisés par Laurent Creton, Kira Kitsopanidou et Ana Vinuela (Université Sorbonne Nouvelle - Paris 3) ; les colloques et les séminaires de recherche Hist3D ; la journée d'étude « Le lexique des techniques d'illusion : quelles définitions des effets spéciaux visuels ? » organisée par Caroline Renouard le 7 avril 2016 à l'ENS Louis-Lumière dans le cadre du projet de recherche « Les arts trompeurs, machines, magie, médias ».

Les *making-of,* surtout lorsqu'ils sont commentés, sont devenus indispensables pour rendre visible une profession qui travaille en grande partie à rendre invisible son travail. Malgré des contrats avec les productions qui limitent leur parole pour un temps plus ou moins déterminé – comme les magiciens, ils peuvent être tenus au secret –, ils sont aussi nécessaires pour défendre leur société dans un secteur hautement concurrentiel. Une parole est donc davantage donnée aux professionnels grâce au numérique et à l'essor de nouveaux métiers et de nouvelles sociétés liés au développement de l'industrie créative des effets visuels. Cette parole met souvent en avant l'organisation du travail collectif entre l'équipe de production et les sociétés indépendantes qui sont recrutées spécialement pour travailler sur les effets visuels d'un film.

Prenons l'exemple du *making-of* de *Faubourg 36* (Christophe Barratier, 2008) dont les décors ont été réalisés par Jean Rabasse. Les effets visuels ont été dirigés par Arnaud Fouquet pour L'Étude et la supervision des trucages (L'EST) et supervisés par Hugues Namur pour Mikros Image. Dans le *making-of* présent dans l'édition DVD[8], on comprend que les extensions numériques prolongent et complètent avec souplesse et une relative rapidité un décor existant, en « dur », construit en studio et en *backlot*[9]. Les extensions numériques approfondissent les perspectives, apportent du mouvement, du dynamisme dans l'image. Un travail de *compositing*[10] permet d'incruster dans ce décor réel un décor virtuel photoréaliste, malléable à l'infini, qui peut provenir de différentes sources (infographie, peinture, sculpture, photographie, film), de différentes villes, de différentes époques, qui donneront l'illusion d'un espace unique et unifié. Il s'agit bien de ne pas le remplacer entièrement par de l'image de synthèse, mais de prolonger ponctuellement un décor déjà présent au tournage. Les décors de Jean Rabasse et leurs extensions numériques s'inspirent ouvertement des décors du cinéma français des années 1930, qui incarnent une esthétique bien connue, proposée par des architectes décorateurs comme Lazare Meerson, Serge Pimenoff ou Alexandre Trauner. Tout comme les ajouts numériques au décor construit permettent de recréer un Paris en trompe-l'œil (un Paris fantasmé

[8] *Making-of* réalisé par Thomas Lautner (54 min), dans l'édition DVD du film *Faubourg 36* (Pathé vidéo, sortie le 25 mars 2009).

[9] Décors extérieurs adjacents à un studio de cinéma.

[10] Assemblage dans un seul plan de sources visuelles différentes (images et effets), à l'aide de logiciels spécifiques.

d'avant-guerre en 2008 dans *Faubourg 36*), des extensions de décor par le biais des divers trucages participaient déjà à la conception d'un Paris populaire idéalisé dans les années 1930[11].

Figures 1. Captures d'écran « avant-après » de *Faubourg 36* de Christophe Barratier, 2008 (plan composite avec extension de décor numérique).

[11] On le voit très bien dans les premiers films parlants de René Clair, dont les décors sont déjà critiqués à leur époque car non représentatifs du Paris de 1930 (*Sous les toits de Paris*, 1930, et *Le Million*, 1931, seront des succès partout dans le monde, participant à l'imaginaire de ce Paris « carte postale » qui sera décrié dans *Le Fabuleux Destin d'Amélie Poulain* de Jean-Pierre Jeunet, 2001, ou dans *Faubourg 36*).

Figures 2. Photogrammes du plan d'ouverture du *Million* de René Clair, 1931 (maquette volume en perspective forcée).

Les trucages de décors dans le cinéma français des années 1920 à 1950 : omniprésence et invisibilité d'une technique

Dans sa thèse consacrée au décor de film en France entre 1929 et 1939, Lydia Lorilleux présente tout un chapitre sur le décor truqué, expliquant d'emblée que « le détail des procédés employés demanderait beaucoup trop de temps pour que je puisse vraiment le développer ici »[12]. Cette remarque synthétise tout le problème d'une recherche sur les trucages de décors : les ouvrages français spécialisés dans les décors et ceux spécialisés dans les trucages consacrent, pour les premiers, un chapitre aux décors truqués reprenant toujours les mêmes types de techniques et, pour les seconds, un chapitre consacré aux décors truqués, qui expose superficiellement ces mêmes éléments d'information, c'est-à-dire : le Dunning[13], le procédé Schüfftan[14], la transparence[15], le Pictographe d'Abel Gance[16] et le Simplifilm d'Achille

[12] Lydia Lorilleux, *Le décor de film en France entre 1929 et 1939*, mémoire soutenu à l'École supérieure de journalisme, 1984, p. 153.

[13] Technique d'incrustation (plan composite) pour les films tournés en noir et blanc, utilisée entre la fin des années 1920 et la fin des années 1930.

[14] Trucage utilisant un miroir incliné à 45° par rapport à la caméra, afin de mêler dans une même prise de vues des maquettes, des décors de taille réelle et éventuellement des acteurs.

[15] Rétroprojection d'un décor sur un écran translucide devant lequel est filmé un premier plan.

[16] En 1938, Abel Gance et l'opticien Pierre Angénieux mettent au point le procédé du Pictographe, dans le but d'obtenir une netteté de toute l'image sans avoir à utiliser de véritable profondeur de champ. Cette illusion était créée en plaçant une maquette ou une photographie devant l'objectif de la caméra équipé d'une lentille compensatrice (constituée de demi-lentilles additionnelles), alors que simultanément

Dufour[17]. Même si ces techniques demeurent assez rarement utilisées dans le cinéma français, elles sont *remarquables* donc elles sont mises en avant, mais ce sont toujours les mêmes exemples de films qui sont mentionnés (quand des titres de films sont seulement associés à ces techniques). Les « maquettes Day » (*matte painting*[18]) sont parfois décrites, mais pas de manière automatique[19]. La découverte ou le fond photographique sont des procédés répandus, banalisés, mais pas toujours correctement évoqués, tout comme l'autre technique phare des trucages qui est la maquette relief, peu évoquée, hormis dans certains ouvrages spécialisés[20]. Pourtant, le travail des maquettes dans le trucage décor était primordial dans le cinéma français, et plusieurs artistes autodidactes se développèrent dans cette discipline, dépassant le seul métier de maquettiste pour se spécialiser pleinement dans les effets spéciaux, travaillant étroitement avec le chef décorateur mais aussi le chef opérateur. Les noms de ces spécialistes sont peu connus puisque leurs participations n'étaient pas créditées aux génériques des films, du moins jusque dans les années 1950. Ceux qui n'ont pas été complètement oubliés sont les Assola père et fils, ainsi que les Russes blancs Nicolas Wilcké et Paul Minine, qui travaillèrent ensemble dès leur rencontre en France en 1921. Chacun incarne bien une organisation du travail spécifique au trucage décor dans cette période des années 1920 et 1930, entre artisanat et industrie.

les acteurs jouaient leur scène au loin. L'ensemble de l'image apparaissait à la prise de vues parfaitement net, du premier plan truqué jusqu'au lieu d'action des personnages (arrière-plan).

[17] Mis au point par Achille Dufour et perfectionné par Henri Mahé, ce dispositif optique permet, comme le Pictographe, de filmer simultanément une photo découpée et une scène animée, de telle façon que cette dernière donne l'illusion de se dérouler dans le cadre de la maquette photographique.

[18] Technique de peinture sur cache placée devant la caméra, permettant de créer artificiellement des extensions de décor. Walter Percy Day est un des artistes emblématiques de cette technique à partir des années 1920.

[19] Réjane Hamus-Vallée, *Peindre pour le cinéma : une histoire du* matte painting, Villeneuve-d'Ascq, Presses universitaires du Septentrion, 2016, p. 62.

[20] Nous renvoyons notamment au cours de l'IDHEC de Hugues Laurent : « La technologie du décor de film » (accès réservé à la Bibliothèque de la Cinémathèque française) et au cours de Lucien Aguettand sur le décor de cinéma et de télévision, 4ᵉ leçon : « Découverte et trucage » (accès réservé à la Bibliothèque de la Cinémathèque française) ; à l'ouvrage de Léon Barsacq, *Le décor de film (1895–1969)*, 2ᵉ éd., Paris, Veyrier, 1985, p. 39 et p. 177.

Charles Assola, un des précurseurs de la technique du cache/contre-cache[21] en France, dirigea l'atelier des maquettes chez Pathé Cinéma, dans les studios de Joinville. Jusqu'en 1940, son atelier produisait tous les trucages nécessaires aux productions Pathé, grâce à une équipe de menuisiers, électriciens, peintres et d'autres corps de métiers spécialisés, rigoureusement sélectionnés par Assola pour réaliser les trucages, lui-même certainement supervisé par le chef du service décoration[22]. Avec la mort de Charles Assola en 1940, l'atelier cessa d'exister, selon les propos de son fils Henri, lui aussi maquettiste[23]. Henri Assola travailla comme assistant de Nicolas Wilcké après la mort de Minine en 1938[24] et celle de son père. Wilcké a œuvré, entre le début des années 1920 et la fin des années 1950, à 363 films officiellement répertoriés (et sans doute à d'autres). La technique phare développée par Minine et Wilcké était celle de la maquette suspendue[25]. Wilcké et Minine présentent l'autre facette de l'organisation de la profession des spécialistes en effets spéciaux, puisque après avoir été engagés à leurs débuts en France dans les studios Albatros, puis à Billancourt par la société des Films Abel Gance, ils créent leurs propres sociétés spécialisées dans les décors truqués. Suite à la mort de Minine et après quelques années passées au service de la Continental Films, Wilcké exige par contrat que la mention « Nicolas Wilcké : effets

[21] Il s'agit d'une des méthodes les plus simples et les plus anciennes du cinéma pour combiner deux images dans le but d'en créer une nouvelle. Lors d'une première prise de vues, une seule partie du cadre est exposée, la partie non désirée de l'image étant marquée par un cache (en carton par exemple) placé devant la lentille. La pellicule est ensuite rembobinée et une nouvelle scène est filmée sur la précédente, cette fois-ci la section précédemment exposée est masquée par un autre cache : le contre-cache. Le résultat révèle l'assemblage des deux scènes sur le même morceau de pellicule.

[22] Morgan Lefeuvre, « Les travailleurs des studios : modalités d'embauches et conditions de travail (1930–1939) », *1895, revue d'histoire du cinéma* n° 65, AFRHC, 2011, mis en ligne le 1er décembre 2014, consulté le 10 novembre 2017. URL : <http://1895.revues.org/4439>.

[23] « Qui êtes-vous, Henri Assola ? », propos recueillis par Henriette Dujarric, *Le Technicien du film,* n° 36, février-mars 1958. Voir aussi Hugues Laurent, « La technologie du décor de film », *op. cit.,* p. 55 : « après la mort de cet ami que j'avais connu tout enfant, j'ai été pressenti en 1947 pour remonter cet atelier, projet qui n'eut aucune suite. Hélas ! Tous les trésors provenant du travail d'Assola ont été dispersés. »

[24] Avant Assola fils, Wilcké et Minine formèrent Eugène Lourié, russe émigré lui aussi, qui deviendra par la suite un chef décorateur reconnu à l'international. Lourié travailla à partir des années 1950 avec Henri Assola.

[25] Technique d'extension de décor reposant sur un principe proche de celui du *matte painting*, ayant recours à des miniatures en relief, placées devant la caméra.

spéciaux » soit présente au générique, généralement après le nom du chef décorateur, imposant ainsi sa marque sur le film lui-même.

Figures 3. Captures d'écran du générique et du plan d'ouverture de *Barbe-Bleue* de Christian-Jaque, 1951 (plan composite avec maquette suspendue).

On retrouve dans la presse spécialisée quelques mentions de leurs maquettes[26] mais leur travail est plus souvent attribué au chef décorateur. À la fin de la guerre, Wilcké a une expérience exceptionnelle de son métier qu'il a lui-même inventé. Selon un contemporain :

> Il est tellement maître de sa technique qu'il parvient à faire des travellings sur des décors, maquettes et constructions grâce à une plateforme spéciale : son invention géniale est tombée dans le domaine public, plusieurs ont été construites, copiant servilement son prototype, mais il n'en a cure, estimant que personne ne saura l'utiliser véritablement, ce en quoi il a raison. Wilcké, poursuivant sa carrière, plafonne des centaines de décors, il représente des toitures par milliers, devenant ainsi le plus grand constructeur de villes, [...] et aucun spectateur n'a réellement vu son travail, tant la perfection de l'image donne l'impression du vrai.

Wilcké décède en 1961. Par la suite :

> Le cinéma exécutera encore des maquettes, mais l'on peut dire que jamais plus certains travaux exécutés par lui seul, conçus, réalisés, éclairés et tournés par un seul homme, ne seront faits. Le cinéma français a perdu sans paraître s'en apercevoir un de ses atouts majeurs : l'homme qui reculait les limites du possible.

Ces deux dernières citations sont tirées d'une copie dactylographiée de sept pages d'un article intitulé « Le truquage dans le cinéma

26 Voir par exemple Lucie Derain, « Avec les pirates dans le Yunnan niçois », dans *Ciné-France*, 22 octobre 1937. Reportage sur le tournage du film *Les Pirates du rail* de Christian-Jaque (1938), dans les studios de la Victorine. Elle écrit « le maquettiste Wikie ».

français ». Aucun auteur, aucune information de publication, aucune date n'est référencé[27]. Ce texte est le document qui présente, à ce jour, les informations les plus complètes sur Wilcké et Minine, depuis leur vie en Russie jusqu'aux derniers mois de Wilcké. Alors que son statut scientifique est particulièrement faible, cet article incarne toute la teneur et le paradoxe du fonds d'archives consacré à Wilcké et Minine se trouvant à la Cinémathèque française, entre la richesse de la documentation et la pauvreté de l'identification des documents.

Au-delà d'un fonds d'archives

Le fonds d'archives consacré à Wilcké et Minine, inédit et partiellement inventorié et catalogué[28], a été repéré par Giusy Pisano alors qu'elle travaillait entre 2008 et 2011 sur le fonds Serge Pimenoff[29]. L'ensemble du fonds, malgré les difficultés d'identification des documents et le peu de réponses qu'il apporte sur les méthodes de travail de Wilcké et Minine dans leur quotidien, dresse un portrait d'artisans autodidactes et touche-à-tout, les photographies de tournage se mêlent aux reproductions dessinées ou peintes en tout genre, notamment les dessins préparatoires (maquettes) conçus par les chefs décorateurs avec lesquels ils travaillèrent, aux documents administratifs, aux devis et aux factures, aux correspondances diverses et aux souvenirs personnels et intimistes (vacances à la plage, pique-nique campagnard…).

Lenny Borger, historien du cinéma, journaliste et consultant, spécialiste des Russes blancs[30] a effectué un travail d'enquête auprès des

[27] « Le truquage dans le cinéma français », Cinémathèque française, Fonds Wilcke, dossier « Devis, factures : ciné. – pub », cote BIFI/INV/00390.

[28] Voir Giusy Pisano et Caroline Renouard, « Une archéologie de l'extension de décor : les maquettes suspendues de Wilcké et Minine », dans Thomas Carrier Lafleur et Jean-Pierre Sirois-Trahan (dir.), *L'archéologie des effets spéciaux : histoire, ontologie, dispositifs,* Sesto S. Giovanni, Mimésis, 2017.

[29] Il en a résulté un site internet présentant l'intégralité de la recherche sur ce chef décorateur, dans le cadre du programme ANR Cinémarchives : <http://www.cinematheque.fr/sites-documentaires/pimenoff/index.php>.

[30] Il a participé à la redécouverte et à la restauration du *Monte-Cristo* de Henri Fescourt (1928–1929), film aux décors de Boris Bilinsky et aux effets spéciaux de Wilcké et Minine. Voir Lenny Borger, « From Moscow to Montreuil: Russian Emigrés in Paris, 1920–1929 », *Griffithiana*, n° 35–36, octobre 1985 ; Lenny Borger, Catherine Morel, « L'angoissante aventure : l'apport des Russes de l'entre-deux-guerres », *Positif*, n° 323, janvier 1988, p. 36–42.

descendants de Nicolas Wilcké et Paul Minine : Eugénie et Maurice Chauvet (aujourd'hui disparus). Il a pu obtenir ainsi un document précieux : la filmographie de 363 titres évoquée, accompagnée de notices biographiques correspondant à chacun des deux maquettistes, établies par Eugénie Chauvet, fille de Minine et belle-fille de Wilcké[31]. Ce document est indispensable à la compréhension du fonds d'archives tout en illustrant l'omniprésence des deux hommes dans l'industrie cinématographique française, sur près de trente-cinq ans. Cette recherche « de terrain » impulsée par Lenny Borger est primordiale dans cette étude de cas et dépasse le seul cadre d'une histoire de techniques et de métiers : il s'agit de comprendre les êtres humains derrière les papiers, derrière les photogrammes de film, avec leurs personnalités et leurs histoires personnelles, afin de trouver de nouvelles sources, de nouveaux témoignages à recouper et, ce faisant, de chercher à se fabriquer une meilleure connaissance de l'objet selon une myriade de facettes et de périodes. Il paraît alors nécessaire de porter sur cet objet un regard oblique, attentif aux éléments qui pourraient sembler d'un premier abord périphériques. Cet objet est ici protéiforme et multiple, et se présente tout autant comme un fonds d'archives difficile à inventorier, un métier disparu, des inventions oubliées, une création collective souvent ignorée par l'histoire du cinéma, etc. Cet objet pose davantage de questions qu'il n'offre de réponses sur des trajectoires humaines complexes et sur l'apport des immigrés à l'industrie du cinéma français, sur les « secrets » de fabrication des trucages imperceptibles, sur l'importance des décors truqués dans le cinéma français et sur le peu de considération qu'ils ont néanmoins suscitée jusqu'à l'arrivée des différents métiers des effets visuels numériques.

En gardant comme angle de vue les circulations des techniques, les savoir-faire, les survivances des pratiques au gré des innovations technologiques, on constate une certaine ritournelle entre les traces indiciaires[32] des techniques et des métiers du temps de Wilcké et Minine et les traces, plus nombreuses celles-ci, des métiers des effets visuels d'aujourd'hui, bien que l'on passe d'une maquette volume en bois à une maquette 3-D générée par ordinateur. Ce début de compréhension des pratiques de Wilcké et Minine permet de mieux mettre en perspective les témoignages des professionnels d'aujourd'hui, et inversement : étudier les

[31] Wilcké épousa la veuve de Minine.

[32] Carlo Ginzburg, *Mythes, emblèmes, traces : morphologie et histoire*, édition revue et augmentée, Paris, Verdier, 2010.

techniques et les métiers d'aujourd'hui permet d'apporter un éclairage nouveau sur l'apport fondamental des extensions de décors dans le cinéma français depuis les années 1920. La maîtrise des perspectives, des échelles, des lignes de raccord entre le décor réel et le prolongement artificiel, les éclairages, les textures, etc., sont les mêmes problématiques traitées par les artistes-techniciens, que l'on soit sur une production de 1931 ou sur une production de 2008. Il y a donc à la fois une rupture technologique et une continuité technique entre la fabrication du Paris du *Million* par Lazare Meerson, Nicolas Wilcké et Paul Minine et celle de *Faubourg 36* vu par Jean Rabasse, Arnaud Fouquet et Hugues Namur. Prendre en considération les apports de ces artistes-techniciens est donc essentiel car rares sont les études à s'intéresser à ces collaborateurs qui demeurent dans l'ombre de la caméra et d'un cinéaste. Ces relations de coopération sont pourtant significatives quant aux formes esthétiques et méthodes employées dans la création et la fabrication d'un film. Les archives font état de cette bataille menée pour la reconnaissance, qu'elles se présentent comme des documents épars dans des cartons emmagasinés dans les institutions patrimoniales, des bonus de *making-of*, des entretiens dans la presse spécialisée ou dans des webdocumentaires. Tant d'autres pistes sont encore à creuser, pour mettre en lumière cette facette trop méconnue du cinéma français[33].

[33] Les recherches pour ce texte ont été en partie réalisées en 2011 dans le cadre de la bourse d'études Jean-Baptiste Siegel de la Cinémathèque française et reprises entre 2015 et 2016 grâce au contrat de post-doctorat accordé par le Labex Arts-H2H, pour le projet « Les arts trompeurs : machines, magie, médias », dirigé par Giusy Pisano et Jean-Marc Larrue. L'auteur remercie vivement pour leurs précieux renseignements et conseils Joël Daire et Jacques Ayroles de la Cinémathèque française, Giusy Pisano et Lenny Borger.

Le regard des opérateurs nord-américains sur la pellicule panchromatique dans sa période d'expérimentation (1917–1923) : que nous apprend la presse technique et corporative ?

Priska MORRISSEY

Cet article dans lequel j'observerai la phase d'expérimentation de la pellicule panchromatique du point de vue de ses premiers utilisateurs, les chefs opérateurs, prolonge mes travaux sur l'histoire du métier d'opérateur de prise de vues et sur la panchromatique, deux sujets que j'ai abordés jusqu'ici sous l'angle du cinéma français[1]. En 2016, lors d'un séjour de recherche financé par le groupe de recherche *Technès* et l'Université de Montréal, j'ai consulté à Rochester, dans l'État de New York, les archives de la George Eastman House ainsi que la Kodak Historical Collection déposée à l'Université de Rochester. J'ai pu y trouver de nombreuses informations concernant la période d'invention de la panchromatique au début des années 1910, mais les archives permettant de reconstituer l'adoption progressive de cette pellicule, quelques années plus tard, par les opérateurs et les studios sont au contraire extrêmement rares. Tout au long des années 1920, un nombre sans doute important de films a été tourné partiellement en orthochromatique, partiellement en panchromatique : il faudrait accéder aux négatifs des films concernés ou à leurs archives de production, pour tenter de déterminer la part respective des deux pellicules. En attendant de pouvoir réaliser un tel travail, je me

[1] Voir ma thèse *Naissance d'une profession, invention d'un art : l'opérateur de prise de vues cinématographiques de fiction en France (1896–1926)*, Université Paris 1 Panthéon-Sorbonne, 2008, et mon article « De Coissac à Mitry : réflexions historiographiques sur le passage à la panchromatique en France », dans André Gaudreault et Martin Lefebvre (dir.), *Techniques et technologies du cinéma*, Rennes, Presses universitaires de Rennes, 2015, p. 143–162.

suis orientée vers la presse, vers les témoignages écrits, les entretiens et mémoires d'opérateurs pour mieux comprendre les enjeux de cette lente période de transition. La presse d'époque constitue la source principale de mon étude[2], même si je m'appuierai aussi par moments sur des témoignages postérieurs. Les ressources numériques disponibles sur Media History Digital Project m'ont permis de compléter le dépouillement systématique que j'avais effectué quelques années auparavant notamment pour *American Cinematographer* et une partie du *Journal of the Society of Motion Picture Engineers*. Ces sources ont été très utiles pour repérer la réception critique de tel ou tel film dans la presse spécialisée ou la carrière des techniciens.

La pellicule panchromatique a été imaginée au début des années 1910 pour pallier l'incapacité des pellicules orthochromatiques à photographier l'intégralité du spectre des couleurs. En effet, si l'émulsion orthochromatique – du grec ancien *orthos* : droit, juste – était censée donner un rendu correct des couleurs, elle était en réalité très sensible aux lumières bleues et vertes et très peu sensible aux lumières rouges et orangées. De fait, sur une copie positive, un élément bleu paraissait blanc tandis qu'un élément rouge pouvait paraître presque noir. La pellicule panchromatique – du grec *pan* : tout – visait un meilleur rendu de la gamme complète des différentes longueurs d'onde et notamment des lumières rouges. Cette fidélité était indispensable au développement des procédés de prise de vues bichromes et trichromes comme le Chronochrome qui reposait sur la sélection d'informations par l'usage de filtres rouges, verts et bleus. En 1923, la pellicule cinématographique panchromatique devient un produit régulier d'Eastman Kodak. Le marché visé était toujours celui du tournage en couleurs mais aussi et surtout du tournage en noir et blanc puisque cette pellicule, sensible à toutes les longueurs d'onde, contribue à un rendu plus fidèle des valeurs. Cependant, la pellicule panchromatique d'Eastman Kodak circule avant sa commercialisation officielle. Elle est connue et testée par des chefs opérateurs américains, généralement des techniciens chevronnés dont le parcours témoigne

[2] Une grande partie de la presse nord-américaine spécialisée est aujourd'hui accessible. Elle offre de très larges possibilités de recherche et de croisement des informations. Voir l'ensemble des collections numérisées disponibles sur <http://mediahistoryproject. org> (dernière consultation le 13 janvier 2017).

d'une propension à innover. Certains d'entre eux deviennent des experts en panchromatique et, en cette qualité, viennent assister des collègues. Dès 1917, un film est partiellement tourné sur panchromatique. Or entre cette date et 1923, la panchromatique est très peu mentionnée dans la presse et même dans les discours des chefs opérateurs, pourtant dotés depuis 1919 d'une revue prestigieuse, *American Cinematographer*, qui rend compte des nouveautés et des expérimentations dans leur domaine. Durant cette période, plusieurs façons d'aborder la panchromatique se dessinent au sein de la profession, depuis la spécialisation qu'on imagine enthousiaste jusqu'au silence généralisé qui s'explique peut-être par les difficultés rencontrées avec cette pellicule, en passant par des expérimentations individuelles, ponctuelles et qui préparent l'adoption de la panchromatique dans la seconde moitié des années 1920.

Carl Louis Gregory et Glen Gano, promoteurs isolés de la panchromatique

Selon l'historien du cinéma Richard Koszarski, le premier usage de la panchromatique pour une prise de vues en noir et blanc daterait de 1917[3]. Il s'agirait de scènes tournées en extérieur de *La Reine de la mer* (*Queen of the Sea*), féerie aquatique avec Annette Kellerman, mise en scène par John G. Adolfi, produite par Fox et photographiée par Frank D. Williams et Carl Louis Gregory. Koszarski raconte que la durée de vie de l'émulsion ne dépassait alors pas plus de deux mois et que la pellicule devait être commandée spécialement par lots de 8 000 pieds, soit 2 438 mètres. Williams comme Gregory sont d'excellents techniciens spécialistes des prises de vues sous-marines. Williams, « the wizard of Hollywood », est un des pionniers du *traveling matte*[4].

[3] Richard Koszarski, *History of American Cinema 3 : An Evening's Entertainment. The Age of the Silent Feature Picture, 1915–1928*, New York, Scribner, 1990, p. 140.

[4] Carl York, « How They Do It ! », *Photoplay*, vol. 29, n° 5, avril 1926, p. 28–31, p. 28.

Figure 1. Annette Kellerman dans *La Reine de la mer*. Source : *Motography*, 6 avril 1918, p. 659.

Peut-être le recours à une pellicule panchromatique pour *La Reine de la mer* est-il lié à la nécessité de prises de vues sous-marines ou encore, tout simplement, comme l'expliquera le chef opérateur Alfred Gilks à propos de *Vaincre ou mourir* (*Old Ironsides*, James Cruze, 1926), au souci de photographier correctement les visages burinés par le soleil se détachant sur un ciel et une mer bleus[5]. En tous les cas, s'il est difficile de savoir si Williams a expérimenté la panchromatique avant ce tournage, il n'en est pas de même pour Gregory[6]. Âgé de trente-cinq ans en 1917, ce dernier est membre de l'illustre Royal Photographic Society of Great Britain (exceptionnel honneur pour un Américain, à plus forte raison pour un opérateur de cinéma de l'époque) et de deux associations new-yorkaises, l'American Chemical

[5] Anonyme, « "Sea-Going" Cameras for *Old Ironsides* », *American Cinematographer*, vol. 7, n° 6, septembre 1926, p. 7–8 et p. 16.

[6] La carrière de Gregory est notamment retracée dans un article anonyme : « Carl Louis Gregory », *Journal of the SMPTE*, vol. 57, août 1951, p. 176–177, p. 177.

Society et le Camera Club. Après des études de pharmacie et de chimie à Ohio State University, il devient photographe avant de se diriger vers le métier d'opérateur et de metteur en scène, chez Edison en 1909 puis pour la Thanhouser Company en 1910. Connu pour sa maîtrise des trucages, il devient le premier opérateur à prendre des vues sous-marines en dirigeant et photographiant en 1914 aux Bahamas pour les frères Williamson le documentaire *Thirty Leagues under the Sea*. Surtout, depuis 1915, il est engagé par Technicolor pour effectuer des recherches et, en février 1917, la presse le présente comme *chief photographer* de cette firme[7]. Or Technicolor utilise une pellicule panchromatique. Gregory a donc déjà expérimenté ce type d'émulsion lorsqu'il tourne *La Reine de la mer*.

Nous savons aussi par ses articles que Gregory connaît cette pellicule. Gregory est un des rares opérateurs à évoquer la question de la panchromatique dans la presse avant 1923. En effet, depuis 1915, il tient dans *The Moving Picture World* la rubrique « Motion Picture Photography » où il répond aux questions que lui adressent des amateurs comme des professionnels de l'image. Dès 1916, il donne des indications soulignant les contraintes de la panchromatique, notamment son absence de stabilité. Interrogé sur la sensibilité des pellicules, il estime l'orthochromatique potentiellement aussi sensible que la panchromatique (utilisée sans filtre), mais il prévient :

> En règle générale, l'émulsion panchromatique ne conserve pas sa sensibilité aux couleurs sur de longues périodes et toute pellicule qui n'est pas fraîche doit être testée avant utilisation. L'auteur de ces lignes a utilisé une pellicule Eastman vieille de deux ans et a obtenu de bons résultats, mais celle-ci avait été soigneusement conservée dans un endroit frais et sec. Par ailleurs, la pellicule neuve mais ayant subi un climat tropical humide devient insensible à certains endroits et ne saurait être utilisée compte tenu des grandes taches transparentes qui défigurent l'émulsion du fait de l'action combinée de la chaleur, de l'humidité et des potentielles moisissures[8].

[7] Anonyme, « Carl Gregory Marries Myrta Strong », *The Moving Picture World*, vol. 31, n° 6, 10 février 1917, p. 852.

[8] Carl Louis Gregory, « Comparative Speed of Cine Film », *The Moving Picture World*, vol. 29, n° 1, 1er juillet 1916, p. 96 (ma traduction).

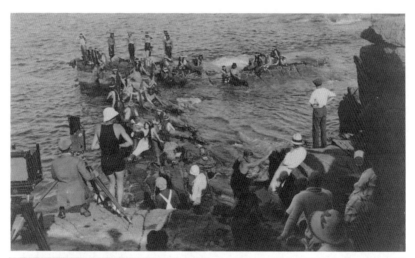

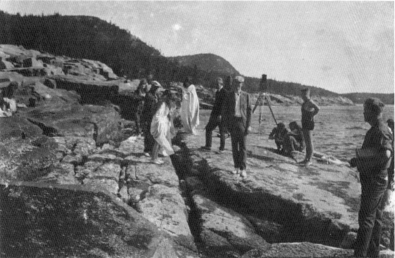

Figures 2 et 3. Tournage de *La Reine de la mer*. Source : Jonathan Silent Film Collection (2005.002r ; F-5-18 et F-15), Frank Mt. Pleasant Library of Special Collections and Archives, Chapman University, CA, USA), Photograph courtesy Chapman University.

Dès lors, on comprend mieux pourquoi Robert Flaherty serait parti tourner, d'avril 1923 à décembre 1924, *Moana* sur panchromatique dans les chaudes îles de Samoa contre l'avis d'Eastman Kodak. En 1916 et 1917, Gregory mentionne de temps en temps la panchromatique, rappelant ses propriétés et préconisant son emploi pour les duplications de films teintés ou virés[9]. Il donne également de petits conseils pratiques comme celui de faire la mise au point à travers la pellicule avant de placer son filtre de couleur car celui qu'on utilise avec la panchromatique peut se révéler très dense, ce qui rend l'image moins lisible[10]. Ces indices laissent à penser que des opérateurs et employés de laboratoire expérimentent et qu'ils ont accès à ce type de pellicule. En 1920, lors des rencontres de la Society of Motion Picture Engineers (SMPE) à Philadelphie, Gregory donne une conférence avec Gerald J. Badgley, ancien employé de la Thanhouser Company et inventeur en 1914 d'une caméra pour amateurs. Cette conférence, intitulée « Attachments to Professional Cinematographic Cameras », est l'occasion de définir le chef opérateur « moderne » qui doit savoir réaliser de magnifiques effets de nuages, maîtriser le rendu des valeurs, utiliser des écrans colorés et… la pellicule panchromatique[11]. Les deux auteurs associent l'emploi de cette dernière à la possibilité de distinguer les lointaines montagnes bleutées et rappellent qu'un chef opérateur, en combinant la panchromatique à un filtre jaune, peut rendre une actrice « aussi blonde qu'il le désire et réduire les taches de rousseur et les imperfections du visage à leur minimum »[12].

[9] Voir par exemple sa réponse à Dark Room, qui lui écrit de New York, dans Carl Louis Gregory, « Motion Picture Photography », *The Moving Picture World*, vol. 30, n° 6, 11 novembre 1916, p. 855, ou Carl Louis Gregory, « Making Dupe Negative », *The Moving Picture World*, vol. 32, n° 9, 2 juin 1917, p. 1438.

[10] Carl Louis Gregory, « Focusing with Color Filters », *The Moving Picture World*, vol. 32, n° 8, 26 mai 1917, p. 1283.

[11] Carl Louis Gregory et Gerald J. Badgley, « Attachments to Professional Cinematographic Cameras », *Motion Picture News*, vol. 21, n° 8, 14 février 1920, p. 1737–1738, et vol. 21, n° 9, 21 février 1920, p. 1965.

[12] *Ibid.*, p. 1965 (ma traduction).

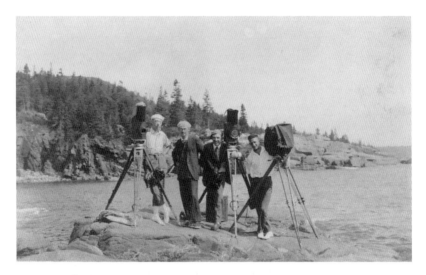

Figure 4. Équipe image de *La Reine de la mer*. Gregory est le second en partant de la gauche. Le troisième est probablement Williams. Source : Jonathan silent film collection (2005.002.r, F-5-13), Frank Mt. Pleasant Library of Special Collections and Archives, Chapman University, CA, USA), Photograph courtesy Chapman University.

Au tout début des années 1920, un jeune chef opérateur de moins de trente ans, Glen Gano, se signale par une série d'articles parus dans *The Exhibitor's Trade Review*. Si Gregory pouvait mentionner la panchromatique au détour d'un autre sujet, Gano lui consacre hardiment un « traité », visant l'amélioration de la photographie du film[13]. Il raconte vouloir répondre à un collègue qui l'aurait accosté de cette manière :

> J'ai entendu dire que tu étais un de ces « fous de couleur » qui utilisent du film panchromatique exclusivement pour les extérieurs. On m'a dit que c'était seulement sensible au rouge. Tu peux me dire comment tu arrives à bien photographier les arbres et l'herbe alors qu'ils sont verts ?[14]

[13] La numérisation des numéros d'*Exhibitor's Trade Review* débute en septembre 1921, ce qui nous prive des trois premières parties du traité. Voir Glen Gano, « Science in Photography : A Treatise on Panchromatic Film for Betterment of Motion Picture Photography », *Exhibitor's Trade Review*, vol. 10, n° 17, 24 septembre 1921, p. 1212, 1214 ; vol. 10, n° 18, 1er octobre 1921, p. 1280, 1282 ; vol. 10, n° 19, 8 octobre 1921, p. 1349–1350.

[14] *Exhibitor's Trade Review*, vol. 10, n° 17, 24 septembre 1921, p. 1212.

L'anecdote révèle, même si probablement de manière caricaturée, la manière dont la panchromatique était perçue et peut-être mal comprise par certains opérateurs. L'objectif de Gano est clairement établi : par une démonstration scientifique allant jusqu'à définir la dimension spectrale de la lumière, il souhaite pallier l'ignorance de ses collègues opérateurs.

Figure 5. Portrait de Frank D. Williams. Source : *Motion Picture News*, 5 juillet 1919, p. 360.

Figure 6. Portrait de Glen Gano. Source : *Exhibitor's Trade Review*, 8 octobre 1921, p. 1349.

Le temps des expérimentations : une presse bien silencieuse

Cette ambition ne semble pas partagée par les membres actifs au sein de la revue de l'American Society of Cinematographers (ASC), étonnamment et longtemps silencieuse sur cette innovation. En 1921, un seul article, reproduisant un journal de tournage tenu par un opérateur, préconise de ne pas oublier, en extérieurs, ses nombreux pieds et trépieds, son film panchromatique et ses filtres[15]. La panchromatique n'est pas citée en 1922, sauf pour mentionner l'expérience de Joseph A. Dubray en photographie fixe[16]. S'il est fait état de tests en 1923, *American Cinematographer* ne mentionne qu'une seule fois la pellicule en 1924, dans son numéro d'octobre, à l'occasion du recrutement d'un nouveau membre, Len H. Roos. Celui-ci est présenté comme un as de la manivelle, rompu aux pratiques du laboratoire et spécialiste de la panchromatique[17]. C'est en vertu de cette spécialisation qu'il collabore à plusieurs films, non cités, de Reginald Barker et qu'il assiste le chef opérateur Karl Brown pour des films de James Cruze produits par Paramount[18]. Ainsi, nous voyons qu'il existait des opérateurs ou spécialistes de la panchromatique qui pouvaient – peut-être sur les conseils d'Eastman Kodak – assister un tournage. En dehors de cette mention qui dévoile la spécialisation que requiert son emploi, la panchromatique n'est donc que très peu citée dans la revue de l'ASC au début des années 1920. Quant aux articles publiés par la SMPE, en 1922, le procédé y est encore surtout relié tantôt à la photographie fixe tantôt aux procédés de tournage en couleurs. La SMPE annonce la sortie de la nouvelle pellicule en 1922 et, en 1923, elle évoque des tests et la question des filtres. Surtout, lors des rencontres de la SMPE

[15] Anonyme, « The Log of a Great Picture : Daily Record of the Filming of a Famous Feature from the Diary of the Cameraman Who Shot It », *American Cinematographer*, vol. 2, n° 20, 1ᵉʳ novembre 1921, p. 10.

[16] Anonyme, « Joseph A. Dubray », *American Cinematographer*, vol. 2, n° 26, 1ᵉʳ février 1922, p. 22.

[17] Anonyme, « Len H. Roos New as ASC Member », *American Cinematographer*, octobre 1924, vol. 5, n° 7, p. 23 et 26.

[18] Rappelons que Karl Brown signe en 1923 la photographie, encore aujourd'hui admirée, de *The Covered Wagon* (*La Caravane vers l'Ouest*) de James Cruze. Contrairement à ce qu'on peut lire dans certains ouvrages, où l'on s'étonne parfois de la beauté de la photographie à une époque où la pellicule panchromatique n'aurait pas été disponible, il est plus que probable que certaines scènes aient justement été tournées sur panchromatique avec l'aide de Roos.

en mai 1923, il est fait mention du problème que pose cette pellicule au moment de son développement, à savoir l'impossibilité de la développer à la lumière rouge. On voit ici poindre l'un des facteurs expliquant la difficile adoption de la pellicule. L'autre problème soulevé est la faible sensibilité de la panchromatique, même si sont rappelés les efforts mis en œuvre pour accroître cette sensibilité[19].

Si la pellicule semble faire partie des outils potentiels du chef opérateur en extérieurs dès le début des années 1920, la panchromatique est donc fort peu commentée par les opérateurs à cette époque. Pourtant, nous savons qu'elle était déjà expérimentée avec succès par certains d'entre eux. Citons par exemple Charles Van Enger qui l'emploie pour tourner des plans en extérieurs dans la Bear Valley et le parc de Yosemite du *Dernier des Mohicans* (*The Last of the Mohicans*, 1920) de Maurice Tourneur et Clarence Brown, cela à la demande de Jules Brulatour, tout-puissant responsable des ventes d'Eastman Kodak et lui-même producteur[20]. De son côté, Virgil E. Miller photographie *Tu ne tueras point* (*The Trap*, Robert Thornby, 1922), avec en vedette Lon Chaney. Ce dernier, séduit par les gros plans de ce film, impose l'année suivante Miller à la photographie de certains plans du *Bossu de Notre-Dame* (*The Hunchback of Notre Dame*, Wallace Worsley, 1923)[21]. Rapidement passionné par ce que permet cette pellicule, Miller imagine des combinaisons qui inaugurent le *day for night* (nuit américaine) et invente même en 1923 un « filtre panchromatique » destiné à cet effet[22]. Ce nouveau filtre inventé par Miller est cité dans la presse, mais le chef opérateur ne mentionne pas les films sur lesquels il a expérimenté la panchromatique. Le chercheur qui s'intéresse aux débuts de cette nouvelle pellicule s'étonne de voir à quel point les premiers films qui l'ont employée mettent peu en avant cette innovation dans leurs

[19] Anonyme, « Report of the Committee of Films and Emulsions », *Transactions of the Society of Motion Picture Engineers*, n° 16, mai 1923, p. 269–277, notamment p. 270.

[20] Richard Koszarski, « Career in Shadows : Interview with Charles Van Enger », *Film History*, vol. 3, n° 3, janvier 1989, p. 275–290, p. 281 ; Charles Van Enger, « A Letter from Charles J. Van Enger », *Griffithiana*, n° 32–33, septembre 1988, p. 243–244.

[21] George Turner, « A Silent Giant : *The Hunchback of Notre Dame* », *American Cinematographer*, vol. 66, n° 6, juin 1985, p. 34–43, p. 39. La photographie du film est signée Robert S. Newhard. Miller, non crédité, affirme avoir pris en charge la quasi-totalité des gros plans de Chaney et avoir tenu la seconde caméra lors des grandes scènes.

[22] Anonyme, « Miller Perfects Filter », *Exhibitor's Trade Review*, 8 décembre 1923, p. 13 ; Virgil E. Miller, « Filters-Factors for Daytime Night-Effects », *American Cinematographer*, vol. 23, n° 3, mars 1942, p. 106–107.

discours de promotion. Les revues professionnelles et techniques auraient pu être des espaces de choix pour évoquer ces questions, mais elles n'en font rien.

Figure 7. Portrait de Len H. Roos. Source : *American Cinematographer*, octobre 1924, p. 23.

Figure 8. Portrait de Virgil E. Miller. Source : *American Cinematographer*, février 1922, p. 23.

En 1917–1918, l'utilisation de la panchromatique pour *La Reine de la mer* n'est pas documentée dans la presse, ni au moment des prises de vues ni à la sortie du film. Le tournage des extérieurs durant l'été et une partie de l'automne 1917 sur l'île des Monts-Déserts (dans l'État du Maine) est pourtant bien couvert par les journalistes, mais les articles décrivent surtout le bouleversement que connaît alors la petite ville de Bar Harbor, les prouesses sportives d'Annette Kellerman, son attrayante vedette, et, lorsqu'il est question du chef opérateur Williams, c'est pour évoquer le procès intenté à Fox par ce dernier qui s'estime propriétaire du système d'aquarium et des techniques d'éclairage spéciales pour prises de vues sous-marines du film. Ce silence, peut-être imposé par Eastman Kodak en raison du côté expérimental des premiers essais pas toujours réussis, domine les premières années de son usage.

Dans la presse, j'ai trouvé seulement deux articles, en 1922, associant un film avec la panchromatique. En mars 1922, l'*Exhibitors Herald* évoque des plans tournés en intérieurs sur film panchromatique pour le film *Pageant Nebraska*, mis en scène par H.F. Chenoweth et destiné aux écoles d'Omaha[23], tandis qu'en juin 1922 une critique de *Néron* (*Nero*, J. Gordon Edwards), tourné en Italie et photographié par Horace G. Plimpton, Jr., attribue l'inhabituelle splendeur de la photographie au film panchromatique et au teintage[24]. Or cette même année 1922 sort sur les écrans *The Headless Horseman*, mis en scène par Edward D. Venturini et photographié par Ned Van Buren. Ce film est généralement présenté dans les histoires du cinéma comme la première production ayant largement recours à la panchromatique, voire comme le premier film entièrement tourné sur cette pellicule. Si, dans la presse, les critiques font l'éloge de la photographie avec ses splendides effets de nuages et de silhouettes, sa capacité à figurer un ciel tourmenté, si Van Buren est bien cité, il n'est jamais fait état de l'usage novateur de la panchromatique. Ce silence n'est pas imputable au manque de reconnaissance de son opérateur, alors en pleine ascension professionnelle. Van Buren préside depuis 1921 la Motion Picture's Photographers Association, équivalent new-yorkais de l'ASC. Il donne en janvier 1921 avec Carl Gregory une conférence consacrée à l'usage des filtres en couleurs. En novembre 1923, quelques mois après la sortie de *The Headless Horseman*, il est intronisé au sein de

[23] H.E. Nichols, « Travelling through Nebraska with H.E. Nichols », *Exhibitors Herald*, 11 mars 1922, p. 69.

[24] Fritz Tidden, « *Nero* », *The Moving Picture World*, vol. 56, n° 5, 3 juin 1922, p. 498.

l'ASC, alors qu'il vit encore à New York. Il est présenté dans *American Cinematographer* en décembre 1923 comme un grand chef opérateur, bénéficiant d'une longue expérience en laboratoire, mais, contrairement à Len H. Roos l'année suivante, il n'est point fait mention de son usage pionnier de la panchromatique[25]. On peut émettre des hypothèses sur les raisons expliquant le maintien de ce silence : le désintérêt général pour cette pellicule trop contraignante dont on n'imagine sans doute pas l'avenir glorieux, la volonté des opérateurs de garder secrètes leurs recettes, ou encore un potentiel veto d'Eastman Kodak, peu vraisemblable tant les résultats obtenus dans ce film devraient inciter la firme à utiliser l'œuvre comme vecteur promotionnel[26]. Ce sera d'ailleurs largement le cas à la fin des années 1920, tant du côté de DuPont, l'autre grand fabricant américain de pellicule, que du côté d'Eastman Kodak ou du fabricant de produits de maquillage Max Factor, chacun énumérant dans ses publicités respectives les films ayant utilisé leurs produits « panchromatiques ». Cette situation se poursuit en 1923 avec *Romola*, réalisé en Italie par Henry King et photographié par Roy Overbaugh avec l'aide de Gustav Dietz. Ce dernier est alors considéré comme un spécialiste des questions techniques liées à la photographie. Originaire de l'État de New York, il est l'auteur dans les années 1910 de plusieurs brevets de photographie consacrés à l'amélioration des obturateurs et viseurs et est responsable, pour *Romola*, des travaux au laboratoire[27]. À la sortie du film, la panchromatique n'est toujours pas évoquée, ni par le chef opérateur ni par les critiques. En revanche, King soulignera son emploi en 1926, dans les pages d'*American Cinematographer*, à un moment où la panchromatique se généralise et fait des émules, affirmant même avec fierté que *Romola* serait le premier film entièrement tourné sur panchromatique[28].

[25] Anonyme, « Ned Van Buren Chosen for ASC Membership », *American Cinematographer*, vol. 4, n° 9, décembre 1923, p. 17.

[26] Barry Salt mentionne d'ailleurs qu'Eastman Kodak aurait financé le film, produit par Carl Stearns Clancy, mais je n'ai pas trouvé confirmation de cette information. Voir Barry Salt, *Film Style and Technology: History and Analysis*, Londres, Starword, 1992 [1983], p. 148.

[27] Dietz met au point en 1925 avec André Barlatier un procédé de développement de la pellicule pour faciliter les tournages en panchromatique à la fois en extérieur et en intérieur. Voir Anonyme, « Some Inventions of 1925 : Cameramen Invent New Film Process », *Film Daily Year Book*, 1926, p. 441. On retrouve Dietz en 1930 à la tête d'une société de lampes spéciales pour film panchromatique.

[28] Anonyme, « Harold Hurrey and Film Expert Speak before ASC Open Meeting », *American Cinematographer*, vol. 6, n° 2, mai 1925, p. 24.

Lorsque la panchromatique est mentionnée, cela reste donc généralement à propos de ses emplois cantonnés aux extérieurs et habillés de filtres. On s'étonne de voir à quel point la nouvelle pellicule est peu voire jamais associée à un film précis qui pourtant aurait pu servir de démonstration de son potentiel. Dans quelle mesure ce silence traduit-il une volonté de discrétion d'Eastman Kodak durant cette phase exploratoire ou les réserves des opérateurs ? Le mutisme des opérateurs, à peine compensé par un Gano, un Gregory ou un Miller, rend compte d'une probable résistance à l'égard d'une pellicule certainement mal comprise, encore très peu sensible, coûteuse, qui pose d'innombrables problèmes de raccord quand elle est employée avec l'orthochromatique et qui, enfin, est loin d'être également sensible à toutes les longueurs d'onde. Sans même rentrer dans des considérations impliquant l'éclairage des studios désormais obsolète, ces défauts expliquent en partie la lente adoption d'une pellicule qui divise encore les professionnels de l'image à la fin des années 1920.

Vers l'hégémonie

Le renversement des discours, amorcé en 1925, ne s'établit vraiment qu'en 1926, lorsque l'offensive commerciale d'Eastman Kodak se conclut par la réduction du prix de la panchromatique et que l'engouement des opérateurs s'étend. On constate ainsi que le statut de la pellicule panchromatique au sein du mensuel *American Cinematographer* évolue de manière significative à partir de 1926, tant du point de vue quantitatif (nombre de citations) que du point de vue qualitatif (plaidoyer en faveur de l'émulsion). En 1925, on compte quatre articles (et quelques mentions au sein des publicités Goerz). Ces articles rendent compte des travaux de la SMPE, de projections organisées à l'ASC par Gustav Dietz de tests sur pellicule panchromatique (mai 1925) et évoquent une démocratisation de son usage au sein des studios. En 1926, dans la même revue, la pellicule fait l'objet de développements et d'un discours de promotion dans huit articles (et une dizaine de publicités Kodak). Il y est notamment question de Joseph A. Dubray *panchromatic expert*, d'un éloge de la pellicule par des réalisateurs, de son usage sur un tournage pour réaliser une nuit américaine tandis qu'une longue étude scientifique (en deux parties) analyse l'emploi de désensibilisateurs au moment de son développement. On voit notamment Daniel Bryan Clark, président de l'ASC entre 1926 et 1928, porter en étendards des films comme *Vaincre ou mourir*, déjà

mentionné, et *La Conquête de Barbara Worth* (*The Winning of Barbara Worth*, Henry King, 1926), photographié par George Barnes, pour promouvoir la pellicule à laquelle il prédit une formidable destinée. Il aura donc fallu attendre neuf ans après *La Reine de la mer* et quatre ans après *The Headless Horseman* pour que l'argument d'une photographie réussie soit enfin utilisé. Puis, avec le parlant et le remplacement d'un éclairage devenu trop bruyant par des lampes à incandescence, la panchromatique s'impose comme la pellicule professionnelle par excellence et il n'est bientôt plus besoin de mentionner la différence entre panchromatique et orthochromatique, cette dernière disparaissant définitivement.

Questionner le passage au numérique : la vision du chef opérateur. Approches méthodologiques

Bérénice Bonhomme

Depuis 2012, je me suis interrogée sur le passage au numérique de la chaîne de production cinématographique, et plus particulièrement du dernier bastion qui résistait au numérique : la caméra image. Après le son, le montage, la post-production, le tournage image a, en effet, été frappé par la vague numérique. Dans cette perspective, je me suis concentrée sur celui qui, en France, est le responsable de l'image tout au long du trajet de fabrication du film : le chef opérateur. Je vais tenter de faire le point ici sur cette recherche, cette contribution étant l'occasion de dresser un bilan de parcours et de revenir sur des éléments de méthode comme le choix du corpus ou la mise en place d'entretiens en tentant de répondre aux questions suivantes : quelles sont les conséquences d'un changement d'outil et de support aussi important ? Comment une innovation technique telle que celle-ci s'impose-t-elle et se stabilise-t-elle ? Dans un second temps, en m'inspirant cette fois de ce que propose la sociologie de la traduction et en articulant parole de la fabrique et modélisation théorique, je mettrai en exergue la constitution de « la boîte noire numérique », puis je tenterai de montrer comment se sont imposées la technologie numérique et les stratégies d'adaptation qui en découlent.

Ainsi, à l'origine, il y a deux interrogations principales : comment s'installe une mutation technologique dans le monde de la création cinématographique ? Quelles sont les influences sur le métier de chef opérateur ? Deux questionnements qui sont d'ailleurs liés, puisqu'on ne peut pas séparer la dimension technique et la dimension sociale de l'innovation. Ces deux interrogations sont associées à ce que je pourrais qualifier d'hypothèse de travail : à savoir que la technologie induit des comportements, qui ont une influence sur la création. Je ne voulais pas exclure le versant esthétique de cette recherche mais bien au contraire en faire un point d'ancrage. Cela me semblait être imposé par mon objet

d'étude, le métier de chef opérateur proposant un versant technique, économique, social (chef d'équipe) et artistique. Deux perspectives méthodologiques ont soutenu ma réflexion. Tout d'abord, l'histoire des métiers et des techniques cinématographiques, un champ en pleine expansion, a accompagné ma recherche. Par ailleurs, en m'écartant du champ disciplinaire du cinéma proprement dit, les propositions de la sociologie de la traduction, faites par Madeleine Akrich, Michel Callon et Bruno Latour, m'ont aidée à mieux comprendre les interactions socio-techniques et la mise en place de la « boîte noire numérique » au fil des associations et des actions collectives. Bien évidemment, les objets d'étude ne sont pas du tout les mêmes (EDF, les médicaments) mais en postulant une théorie de l'innovation au plus près des acteurs, et en mettant au même niveau ce qui est de l'ordre du technique, de l'économie et du social, ces textes sont particulièrement éclairants en ce qui concerne le passage au numérique que je qualifierai de « machination socio-technique ». La place de l'utilisateur comme acteur de l'innovation y est également interrogée.[1]

De l'usage de l'entretien : le recueil de données

Avec un tel objet de recherche, la question des sources s'est très vite posée. Il s'agit d'une étude sur une mutation en cours, une construction en train de se faire. Selon Michel Callon et Bruno Latour, cette place pour le chercheur est un avantage, permettant de « s'installer là où le contrat est passé, là où se traduisent les forces, là où l'irréversible devient réversible »[2], là où finalement la pellicule devient capteur. Mais cela entraîne un certain nombre de difficultés et, en particulier, cela limite les sources exploitables. Pour cette raison, je me suis appuyée sur trois corpus différents.

Un premier ensemble de sources est constitué par les entretiens, billets d'humeur et analyses publiés par les chefs opérateurs eux-mêmes dans la presse et sur Internet. Ainsi, la lettre de l'Association française des directeurs de la photographie (AFC) permet de suivre mois par mois

[1] Une place de l'utilisateur qui, dans le cadre de ma recherche, est celle du chef opérateur.

[2] Michel Callon et Bruno Latour, « Le grand Léviathan s'apprivoise-t-il ? », dans Madeleine Akrich, Michel Callon, Bruno Latour (dir.), *Sociologie de la traduction, textes fondateurs*, Paris, Les Presses des Mines, 2006, p. 32.

l'évolution des perspectives. À cela s'ajoutent les forums professionnels et les entretiens publiés dans les revues de cinéma (ou certains ouvrages). *A priori*, je voulais exclure les publications étrangères puisque je souhaitais me concentrer sur le point de vue du chef opérateur français. Mais je me suis rendue compte que, de toutes façons, plusieurs chefs opérateurs français travaillaient aux États-Unis et lisaient la presse professionnelle en anglais, et qu'il n'était pas très pertinent de laisser de côté *The American Cinematographer* tout comme *Film and Digital Times*. Les mémoires de recherche d'étudiants de l'ENS Louis-Lumière, pour l'essentiel apprentis chefs opérateurs, sont également des sources précieuses. Les documentations techniques font aussi partie du corpus : publications techniques des constructeurs, mais aussi publicités (les deux sont souvent confondues), sites et salons professionnels comme le micro-salon. Enfin, j'ai mené tout au long de ces trois ans des entretiens avec des chefs opérateurs et d'autres techniciens. Il s'agit d'entretiens longs de plus d'une heure, entretiens suivis de correspondances et qui ont parfois été doublés. Pour l'instant, j'ai interrogé 17 chefs opérateurs et 16 techniciens ayant d'autres spécialités (*Digital Imaging Technician*, maquillage, étalonneurs, effets visuels). Ce sont des entretiens sur leurs formations, leurs choix professionnels et techniques et la question du passage au numérique. Je tiens d'ailleurs à remercier ici toutes les personnes qui ont pris le temps de répondre à mes questions. En ce qui concerne le choix de la période étudiée, j'ai tenté de remonter jusqu'en 2008[3], le moment où la problématique des modifications des pratiques professionnelles s'institutionnalise, même si les éléments à ma disposition sont plus riches à partir de 2012, date du début de ma recherche.

J'ai fait le choix de me concentrer sur l'analyse de la parole des chefs opérateurs. Ce choix méthodologique, qui était guidé par le souci de faire du socle de ma recherche le point de vue de chef opérateur, a structuré mon étude et ses étapes. Au-delà des publications professionnelles, j'ai pensé qu'il était important d'interroger directement des chefs opérateurs sur leur rapport au numérique. Un premier dépouillement des revues professionnelles m'a permis de relever les éléments qui semblaient récurrents ou qui étaient au contraire éludés, et cela m'a permis d'élaborer ce que l'on peut appeler un questionnaire, mais qui est davantage une carte de route pour la conversation, pour ne rien oublier et pour pouvoir

[3] Voir le rapport de l'Observatoire des métiers de l'audiovisuel en 2008 (<http://www.cpnef-av.fr/cpnef-audiovisuel/l-observatoire-des-metiers>).

comparer les réponses entre elles. Les questions ne sont pas destinées à être posées telles quelles, ce sont des jalons placés dans le but avant tout de stimuler la parole et le questionnement. Comme je voulais que la parole soit libre, je précise dès le début de chaque entretien que je ne citerai pas ce qui est dit sans l'accord de chaque interviewé.[4]

Après quelques entretiens, mon travail est devenu beaucoup plus aisé. J'ai pu ajouter quelques questions. Plus important encore, j'ai commencé à avoir des points de comparaison et de réflexion. Plusieurs éléments m'ont permis de rendre les entretiens plus riches et exploitables comme par exemple de choisir de se concentrer sur des éléments concrets. Parler du passage au numérique en général n'est pas très pertinent et donne lieu à des déclarations peu précises. Ainsi le plus souvent, la première réaction des chefs opérateurs était de commencer par déclarer que le passage au numérique n'avait « rien » changé à leur façon de travailler. Une réponse, qui pour être très signifiante, en ce qui concerne la perception professionnelle de cette modification technologique, méritait pourtant d'être approfondie et précisée autour de cas concrets. Ainsi, le retour sur des films récents, la description minutieuse de situations de tournage et de post-production permettent de mettre au jour d'autres éléments, comme un rapport différent à la caméra, l'abandon d'outils symboliques comme la cellule, ou encore la modification de la construction de l'éclairage, le capteur numérique étant très sensible. J'ai également précisé ma problématique. Le passage au numérique est une question très large, et le positionnement autour de questions esthétiques, comme le rendu de la peau, permet de structurer chaque élément (éclairage, contraste, utilisation des objectifs, rapport avec les autres corps de métiers, perspectives offertes par la post-production) autour d'une problématique commune au cœur du travail des chefs opérateurs : comment filmer un visage ? Il apparaît que poser la question du rapport inter-professionnel est très fécond. Par exemple, la problématique des effets visuels, qui influe sur la lumière et le cadre, sans pourtant faire partie de l'équipe du chef opérateur, a permis de révéler l'importance de la maîtrise de la création.

Construire un travail comparatif a, par ailleurs, beaucoup enrichi ma réflexion. Au bout d'un certain nombre d'entretiens, des positions communes émergent assez vite. Il devient plus aisé de pointer les

[4] J'envoie avant publication à chaque professionnel mentionné les citations qui lui sont attribuées afin qu'il me dise s'il est d'accord ou non avec leur contenu.

différences et les nuances. Prenons un exemple qui semble faire plus ou moins consensus chez les chefs opérateurs que j'ai rencontrés. Le choix des objectifs avec le passage au numérique est sans doute devenu encore plus crucial que dans les tournages argentiques, permettant de modifier l'image. Ainsi, il y a une mode de l'objectif ancien, plein d'aberrations. Cela va dans le même sens que le retour du Cinémascope qui, avec les aberrations qu'il propose, « fait plus cinéma ». Cette question de l'objectif va revenir de manière très régulière, mettant en lumière des réflexions profondes telles que : qu'est-ce qui, dans une image numérique, est gênant ? Qu'est-ce qui fait « cinéma » ? Quels outils sont encore à la disposition du chef opérateur ? D'un autre côté, un élément clivant est aussi très intéressant – il en est ainsi du rapport aux caméras numériques et à leur réglage. Certains chefs opérateurs considèrent que ce n'est pas leur travail de connaître parfaitement le fonctionnement des caméras numériques, leurs menus, codecs et réglages. Pour cette raison, ils préfèrent se reposer sur leur assistant, parfois sur un DIT. D'autres chefs opérateurs se sont extrêmement bien documentés techniquement et refusent de laisser la main sur ces réglages. Les deux perspectives laissent deviner l'importance du rapport à l'outil.

Cette recherche a enfin posé une difficulté évidente mais centrale, qui est celle de mon propre rapport à la technique et de mes connaissances sur le numérique. Au début de mon parcours de recherche, je pensais que, comme je voulais travailler non pas sur la technique numérique à proprement parler mais sur la perception qu'en avaient les chefs opérateurs, mes connaissances techniques seraient suffisantes. Mais le passage à un *workflow* numérique entraîne un véritable changement de paradigme qui m'a demandé une plus grande précision technique. Finalement, le fait de devoir m'informer a été un élément structurant de ma propre recherche, me permettant de faire l'expérience des réseaux d'informations sur le numérique et de la difficulté récurrente d'obtenir une information fiable et claire.

Ce travail d'entretiens m'a permis de faire émerger des convergences autour de questionnements récurrents que l'on peut classer ici de façon très schématique, même si chaque élément est interdépendant : qu'en est-il de ce qu'on pourrait qualifier de résignation progressive au passage au numérique ? Qu'est-ce qui l'explique et y a-t-il des résistances ? Un autre point est celui de la formation aux outils : comment s'effectue-t-elle et quelle est la documentation disponible ? D'autres éléments convergent autour de stratégies d'adaptation à l'outil et aux évolutions

des méthodes de travail (sensibilité, immédiateté de l'image, VFX).
On voit aussi apparaître un questionnement sur la qualité de l'image
(la définition élevée, les couleurs) et des possibilités de détournement
de l'outil (demandes aux constructeurs, optiques particulières). Enfin,
de nouvelles dynamiques de tournage, faisant évoluer la place du chef
opérateur et le contrôle de l'image sont mises en évidence.

Je ne développerai pas ici le questionnaire complet que j'ai mis au
point et me concentrerai sur quelques questions mettant en évidence des
problématiques différentes qui participent de ma recherche. Quelle est
votre formation initiale ? Quel est votre premier long métrage comme
chef opérateur ? Quel est votre premier film en numérique ? Ces trois
premières questions posent le cadre et permettent de situer la carrière
du chef opérateur interrogé dans le temps. Un des enjeux de cette
recherche est de vérifier si les chefs opérateurs plus jeunes s'adaptent plus
facilement au numérique et si la notion de *digital native* a une quelconque
pertinence à ce sujet. Pour l'instant, j'ai rencontré principalement des
chefs opérateurs qui ont fait une longue carrière en pellicule avant de
passer au numérique. Cette constatation permet de pointer un élément
de recherche important : le choix du panel. Jusqu'ici, j'ai interrogé des
chefs opérateurs appartenant à l'AFC, par commodité et parce qu'il s'agit
d'un critère de légitimation inter-professionnelle (ils sont donc reconnus
par leurs pairs comme chefs opérateurs). Par ailleurs, ce sont donc des
professionnels installés, ayant une carrière conséquente derrière eux et
ils ont une perspective particulière. Ce choix méthodologique est donc à
questionner et à assouplir.

Une autre série de questions tourne autour du basculement en
numérique : pourquoi passer au numérique ? Avez-vous eu des réticences
avant de tourner en numérique et si oui pourquoi ? Pensez-vous tourner
de nouveau en pellicule ? Les réponses mettent en évidence le tournant
qu'a constitué le passage des salles en projection numérique, ou encore
l'arrivée de caméras « acceptables » comme l'Alexa[5]. La dernière question
est assez éclairante. En effet, en 2010, dans le cadre d'une recherche
différente sur la notion d'équipe de film, j'avais rencontré quatre chefs

[5] L'Arri Alexa est une caméra numérique destinée au cinéma, produite par Arri et qui
 est sortie dans sa première version en avril 2010. Il existe plusieurs modèles dont
 l'Alexa Mini, l'Alexa XTX, ou encore l'Arri Alexa 65. Rappelons également ici
 l'importance des mises à jour, qui font évoluer les caméras en permanence. Voir le site
 <http://www.imageworks.fr/> qui présente les nouveautés d'Arri.

opérateurs. Par curiosité, je leur avais demandé ce qu'ils pensaient du numérique : à cette époque-là, ils envisageaient avec beaucoup de scepticisme de tourner, sauf cas très particuliers, un film entièrement en numérique. Inversement, en 2013–2015, tous les chefs opérateurs que j'ai rencontrés ne pensaient pas retourner encore en pellicule, ou dans le cas d'un projet très particulier, un peu comme quand on tournait en noir et blanc dans les années 1990.

D'autres questions se concentrent sur l'adaptation à l'outil et le choix du matériel, par exemple. À la question : « Avez-vous suivi une formation pour le numérique ? », la réponse dominante est « non ». Plusieurs stratégies de formations ont été élaborées : on peut pointer l'importance des essais, le rôle de tournages longs comme les séries télévisées, ou encore les tournages publicitaires. Certains ont travaillé avec des fabricants de caméra et ont testé leurs produits. À la question « Quels sont vos critères de choix de matériel ? », l'idée du film comme prototype original est affirmée. Chaque film demanderait une configuration technique spécifique. On remarque cependant des critères de choix récurrents comme l'ergonomie et également le degré de ressemblance entre les caméras numériques et les caméras argentiques, ce qui facilite l'adaptation. Trois fabricants sont mis en avant : Arriflex, Red et Sony, autour de questions variées comme la maniabilité, le *workflow*, le rendu des couleurs, la sensibilité, le prix… Le choix de la caméra est un bon exemple d'arborescence mêlant technique, esthétique, économique et social (habitude de travail). Le passage au numérique force les chefs opérateurs à réfléchir de façon plus consciente à ce qu'ils attendent d'une caméra.

Certaines questions s'intéressent davantage au rapport esthétique/technique et économique.

« Y a-t-il une perte d'émotion avec le tournage numérique ? » Lorsqu'on parle d'émotion, les chefs opérateurs parlent « grain » de la pellicule, associant spontanément un fait technique au registre de l'émotion. Deux autres éléments sont souvent mentionnés : la platitude de l'image numérique mais aussi, pour certains, l'attachement qu'ils avaient pour la pellicule, son bruit de défilement dans la caméra, le plaisir de bricoler l'outil et donc la peine qui découle de cette perte.

« Selon vous le numérique coûte-t-il moins cher que la pellicule ? » La réponse est presque unanimement « non ». Il s'agit d'un point de vue mais pas forcément de la réalité. La présentation du numérique comme plus économique est souvent dénoncée comme une erreur en ce qui

concerne les tournages professionnels – les « gros films ». Cela va de pair avec l'idée d'un numérique plus léger, demandant moins de matériel. Certes, les caméras sans accessoires sont plus légères mais si on veut des retours moniteur (et on en souhaite), cela alourdit considérablement la configuration. De même, le processus d'enregistrement est devenu plus lourd, demandant des sauvegardes permanentes. En revanche, l'illusion d'un numérique moins cher aurait participé de la bascule vers cette technologie. De plus, maintenant que la chaîne a basculé, l'argentique est devenu moins fiable et plus cher.

La problématique des modifications des méthodes et habitudes de travail ainsi que le rapport au *workflow* est également au cœur de cette recherche : le numérique a-t-il changé votre manière de travailler ? Quels sont les nouveaux métiers du numérique et qu'en pensez-vous ?

Un mot est devenu central avec le numérique, c'est le *workflow*, c'est-à-dire le trajet de l'image de la pré-production à la post-production, un *workflow* difficile à maîtriser dans son ensemble et qui parfois semble un mot vide de sens, comme un *mantra* permettant de conserver une certaine illusion de maîtrise. Le numérique pose la question du contrôle de l'image, le chef opérateur pouvant se sentir dépossédé : nouveaux métiers du numérique (*Digital Imaging Technician*, par exemple), présence envahissante des moniteurs sur le plateau, fragilisation technique, importance de la post-production avec une image modifiable à l'infini.

Ainsi se dessine un dernier champ d'exploration : le statut du chef opérateur. Une seule question dans mon enquête aborde frontalement l'évolution du statut du chef opérateur, mais c'est une interrogation qui sous-tend une grande partie du discours des chefs opérateurs. La problématique du statut professionnel met en évidence une autre difficulté de ma recherche, celle de la construction d'une image professionnelle. L'AFC est une association professionnelle qui défend une certaine vision du métier de chef opérateur. Ma recherche doit prendre en compte cet aspect et tenter de conserver une certaine distance et un regard critique sur ces questions.

Modélisations théoriques : la « boîte noire » numérique

À partir du recueil de toutes ces données et de leur dépouillement, j'ai tenté d'articuler modélisations théoriques et paroles de la fabrique (c'est-à-dire le discours de ceux qui participent à la fabrication des films). J'ai

ainsi développé des recherches sur l'évolution du métier de chef opérateur, sur le rendu de la peau en numérique, sur le rapport entre émotion et numérique, sur les dynamiques interprofessionnelles entre chef opérateur et VFX, sur le chef opérateur en tant qu'auteur[6]. Ces différentes directions de recherche étaient liées entre elles par la volonté de rendre compte le plus justement possible de la transition numérique du point de vue du chef opérateur. Je voudrais proposer rapidement ici deux modélisations théoriques qui s'inspirent de la sociologie de la traduction et sur lesquelles je travaille actuellement. J'évoquerai la constitution de la « boîte noire numérique », puis je tenterai de comprendre comment se sont imposées la technologie numérique et les stratégies d'adaptation qui en découlent. Bien sûr, il ne s'agira ici que d'une esquisse.

La notion de « boîte noire » est un concept utilisé par la sociologie de la traduction, et plus particulièrement Bruno Latour et Michel Callon qui l'associent à l'idée de l'acteur réseau. La « boîte noire » – un terme particulièrement suggestif quand on parle de cinéma – contient une série d'actions collectives émanant d'un ensemble socio-technique. Il s'agit d'un ensemble d'opérations et de connaissances fonctionnant d'elles-mêmes et qui rend possible une action sans que l'on ait à réfléchir à tout le dispositif comme un réseau socio-technique. Michel Callon prend l'exemple de l'automobile :

> L'autonomie du conducteur tient paradoxalement au fait que l'automobile n'est qu'un élément dont le fonctionnement est dépendant d'un large réseau socio-technique. Il faut des infrastructures routières avec leurs services de maintenance, des sociétés d'exploitation des autoroutes, l'industrie automobile, le réseau des garagistes et des distributeurs d'essence, une fiscalité spécifique, des auto-écoles, un code de la route, des agents de la circulation,

[6] Voir les articles : « Le directeur de la photographie en France et la révolution numérique », dans Réjane Hamus-Vallée et Caroline Renouard (dir.), *Les métiers du cinéma à l'ère du numérique*, CinémAction, n° 155, Condé-sur-Noireau, éditions Charles Corlet, 2015, p. 20–30 ; « Le numérique, une image froide : points de vue du chef opérateur », dans Martin Barnier, Isabelle Le Corff et Nedjima Moussaoui (dir.), *Penser les émotions : cinémas, séries, nouvelles images*, L'Harmattan, « Champs visuels », 2016, p. 183–199 ; « Le numérique, "dur avec la peau" ? », dans Priska Morrissey et Emmanuel Siety (dir.), *Filmer la peau*, Rennes, Presses universitaires de Rennes, 2017, p. 207–220 ; « Le chef opérateur, la lumière et les effets visuels en France », *La création collective au cinéma*, n° 1, <https://creationcollectiveaucinema.wordpress.com/revue-01/>, revue en ligne sous la direction de Bérénice Bonhomme, Isabelle Labrouillère et Paul Lacoste, 2017, p. 83–103.

des centres techniques pour contrôler la sécurité des véhicules, des lois, etc… L'automobile de Monsieur Martin est au centre d'un tissu de relations liant des entités hétérogènes, d'un réseau qui à nouveau peut être qualifié de socio-technique puisqu'on y trouve des humains et des non humains.[7]

L'automobile est un artefact qui met en boîte cette action collective, « lorsque l'automobile se met en mouvement, c'est tout le réseau qui se met en mouvement ». La caméra argentique pourrait être décrite de la même façon. Quand on crie « moteur » sur un plateau et que la pellicule commence à être entraînée dans le magasin, c'est tout le réseau qui se met en mouvement : fabricants de pellicules et de caméras, laboratoires de développement, formation et rôle du chef opérateur, organisation de la production et de la post-production, type d'éclairage… tout un réseau très complexe qui rendait possible la fabrication de l'image d'un film. Or Michel Callon fait remarquer que c'est durant

> la constitution de ces réseaux socio-techniques, c'est-à-dire durant la conception, le développement et la diffusion de nouveaux artefacts techniques, qu'apparaissent le plus clairement, avant la mise en boîte noire, les inévitables négociations et ajustements entre actants humains et non humains.[8]

Le passage au numérique a précisément mis en difficulté la « boîte noire argentique ». Ce constat ouvre sur deux dynamiques de recherche. Tout d'abord, on a assisté à une ouverture brutale de la « boîte noire argentique », ce qui a rendu possible plusieurs travaux pour préserver les « savoir-faire et les connaissances menacés de disparition avec la fin de l'argentique »[9]. On a aussi assisté à la constitution d'une nouvelle « boîte noire », qui n'est pas encore complètement refermée aujourd'hui et qui est encore en négociation. Dans la lettre de l'AFC de janvier 2016, le chef opérateur Sébastien Bunchman note ainsi à propos du film qu'il vient de tourner en numérique :

> J'aurais aimé faire ce film en 35 mm, je préfère le redire car à maintes reprises, on me demande : « ah bon, les chefs op' préfèrent l'argentique ? ».

[7] Michel Callon, « Sociologie de l'acteur réseau », dans *Sociologie de la traduction : textes fondateurs, op. cit.*, p. 270.

[8] *Ibid.*, p. 271.

[9] Texte de cadrage du colloque « Métiers et techniques du cinéma et de l'audiovisuel : approches plurielles (objets, méthodes, limites) », organisé à Paris les 12 et 13 février 2016 par Hélène Fleckinger, Kira Kitsopanidou et Sébastien Layerle.

J'ai l'impression que c'est une évidence mais il semble que non. Le son a eu son Cantar, l'image l'attend encore. On me dit que je suis nostalgique. Je ne crois pas l'être plus que ceux qui bataillent pour trouver des optiques vintages en numérique. Je pense simplement que l'image dans l'univers numérique n'a pas encore trouvé l'outil qui mettra tout le monde d'accord, je l'attends.[10]

Cette « boîte noire » se structure entre les fabricants de caméra, les caméras, les laboratoires numériques, les producteurs, les loueurs, les réalisateurs, les chefs opérateurs, les écoles de cinéma (qui ne forment plus à l'argentique), etc. La constitution de la « boîte noire » numérique nous amène à un deuxième point : comment la caméra numérique s'est-elle imposée sur les tournages ? Comment le numérique est-il devenu incontournable ? Michel Callon et Bruno Latour expliquent comment se constitue un Léviathan en prenant l'exemple d'EDF et de la voiture électrique :

> Il s'insinue dans chaque élément sans faire aucune différence entre ce qui est de l'ordre de la nature – catalyse, texture des grilles de la pile à combustible –, ce qui est de l'ordre de l'économie – coût des voitures à moteurs thermiques, marché des autobus – de l'ordre de la culture – vie urbaine, *homo automobilis*, peur de la pollution – et il lie tous ces éléments épars d'une chaîne qui les rend indissociables et force à les parcourir comme si l'on déroulait un raisonnement ou si l'on développait un système ou appliquait une loi.[11]

Dans les années 1970, EDF a construit une réalité, dans laquelle Renault était condamné à disparaître comme acteur autonome dans les prochaines années, une réalité où la voiture électrique s'imposait. De même, une réalité du cinéma numérique s'est progressivement construite et elle semble rendre inévitable son avènement. Trois éléments sont pointés par les chefs opérateurs comme ayant eu raison de leur résistance. Le premier élément concerne les aides de l'État pour que les salles de cinéma soient équipées de projecteurs numériques. Une fois que la projection est en numérique, il est difficile de justifier une caméra pellicule. Non seulement une caméra numérique permet d'avoir un *workflow* entièrement numérique, ce qui est plus facile mais certains chefs opérateurs pointent également le fait qu'il ne sert plus à rien de se battre pour des raisons esthétiques pour utiliser de la pellicule, puisque de toute façon le film sera

[10] Sébastien Buchmann, au sujet du film *Le Grand Jeu* (2015) de Nicolas Pariser, *Lettre de l'AFC*, n° 260, janvier 2016, p. 15.

[11] Michel Callon et Bruno Latour, « Le grand Léviathan s'apprivoise-t-il ? », *op. cit.*, p. 22.

projeté en numérique. Cette logique de chaîne s'est encore accentuée avec la fermeture de nombreux laboratoires photochimiques. Un deuxième facteur tient à l'arrivée de caméras numériques « acceptables », de « vraies caméras », avec une bonne dynamique, fonctionnant comme une caméra argentique. Il s'agit de caractéristiques techniques et esthétiques mais aussi culturelles, liées aux habitudes de travail. La sortie de l'Alexa semble une étape essentielle, rassurante de par son ergonomie et le savoir-faire Arri qui connaît bien le cinéma professionnel. Le contexte économique imposerait ce choix technique constitue un troisième motif d'explication. Les producteurs ont cru que le numérique permettrait de faire baisser les coûts. Même si ce n'était pas forcément vrai, cette croyance est devenue vérité. Avec le basculement de la chaîne, la pellicule est devenue plus chère et moins sûre que le numérique.

Le Léviathan ne fait aucune différence entre la taille des acteurs, entre le réel et le rêve, entre le nécessaire et le contingent, entre le technique et le social[12]. Ainsi se déploie un système qui semble rendre inéluctable le passage aux caméras numériques et finit par convaincre les chefs opérateurs, un système que l'on pourrait brosser à grands traits ainsi : de toute façon, toute la chaîne est en numérique, la logique de chaîne est toujours la plus forte. De plus, les fabricants ont fait beaucoup d'efforts et les caméras sont devenues acceptables.[13] Le numérique coûte maintenant réellement moins cher que la pellicule. À cela s'ajoute qu'un chef opérateur qui ne travaille pas en numérique ne peut plus trouver de travail et que finalement, il est assez facile de tourner en numérique, s'adapter à l'outil n'est pas si compliqué et il n'est pas forcément nécessaire d'approfondir la partie technique pour pouvoir travailler. Pour résumer, « le numérique est l'avenir du cinéma, même si je suis attaché à la pellicule, je suis obligé de travailler en numérique et je ne sais pas si je retournerai un jour en pellicule. Il faut s'adapter à l'outil puisque, quoi qu'il en soit, je n'ai pas le choix ». Ainsi les chefs opérateurs s'emparent-ils de l'outil et proposent-ils des adaptations, phénomène d'assimilation et d'adaptation qui est au cœur de ma recherche actuelle. Cependant, il me semble que le débat n'est pas totalement clos et que la controverse gronde toujours. Le monde argentique riposte progressivement. Michel Callon et Bruno Latour décrivent comment Renault a fait, dans les années 1970, un travail de dissociation des associations d'EDF, remettant en cause

[12] « Le grand Léviathan s'apprivoise-t-il ? », *op. cit.*, p. 24–25.
[13] Même si l'image numérique est globalement moins appréciée que l'image argentique.

le modèle proposé et transformant la filière de la pile à combustible en
« oubliette » : « Comme ces fleuves chinois qui changent brutalement
de lit, les nécessités et les filières techniques sont ainsi détournées. La
société industrielle coulait vers le tout électrique, elle poursuit sa course
majestueuse vers la voiture individuelle à moteur thermique amélioré. »[14]

De même, le Léviathan argentique se relève, des réalisateurs américains
mettent en avant les qualités de l'argentique, un accord est signé entre six
grands studios d'Hollywood et Kodak pour sauver la pellicule, les forums
professionnels bruissent de l'espoir que la pellicule n'est pas morte, les
chefs opérateurs insistent sur ses qualités, à la fois esthétique et pratique,
les conservateurs mettent en avant sa pérennité, la production de films en
argentique a un sursaut et augmente… Cependant, on peut se demander
si l'argentique parviendra à détourner le fleuve de la filière cinéma, ou
s'il se transformera en un format de niche élitiste, qui ne pourra être vu
que par quelques privilégiés, comme la projection en 70 mm du film de
Quentin Tarantino, *The Hateful Eight* (*Les Huit Salopards*, 2015). Ainsi
la persistance (ou non) du format argentique pose la question du type de
film sur ce support (genre, mode de production), des raisons de ce choix
(désir du réalisateur ?), ainsi que du discours qui les accompagne (films
plus « authentiques » ?).

[14] « Le grand Léviathan s'apprivoise-t-il ? », *op. cit.*, p. 24.

Changement technique et geste artistique : Questionner le passage au son numérique à travers l'œuvre de Walter Murch

Violette LIBAULT

> Pour une raison que je ne m'explique pas entièrement, je suis profondément ému par l'espace qui entoure un son. Parfois, je me dis presque que je préfère enregistrer l'espace qui entoure un son plutôt que le son en lui-même dans cet espace.
>
> Walter Murch (1998)[1]

L'histoire du cinéma offre un extraordinaire point de départ pour penser l'enregistrement et le traitement du son à travers l'évolution des techniques. La mise au point des premiers microphones, l'invention de la triode[2], l'arrivée du parlant, l'apparition de la bande magnétique et du multicanal ont été autant de mutations technologiques invitant à reconsidérer sans cesse la nature des représentations filmiques. C'est donc sans surprise que l'audio-numérique nous ramène au passé tout en nous engageant à réfléchir aux conditions nouvelles de la « chasse aux papillons » des ondes sonores, celle-ci se faisant désormais à l'aide de grands filets informatiques composés de mailles 1 et 0.

Si l'étude du cinéma se rapporte d'abord à l'image, faite essentiellement de lumière, le son participe également à la construire – Michel Chion et de nombreux autres théoriciens l'ont démontré en établissant une véritable histoire critique de l'audio-vision[3]. Néanmoins, la lumière et le

[1] Tom Kenny, « Walter Murch, the search for order in sound and picture », *Mix Magazine*, avril 1998, p. 53.

[2] Premier dispositif amplificateur de signal électronique inventé par Lee De Forest en 1906.

[3] Michel Chion, *L'audio-vision,* Paris, Nathan, 1990.

son ont leurs propres problématiques, qu'il convient de poser dans des articles qui leur soient spécifiquement consacrés. C'est pour répondre à ce besoin que nous nous proposons ici d'étudier l'impact de l'audio-numérique dans le cinéma, et plus précisément dans l'univers de Walter Murch, concepteur son et mixeur américain oscarisé à trois reprises[4], mais aussi monteur image, scénariste et réalisateur. En tant que figure du Nouvel Hollywood, il est l'auteur des bandes sonores de *THX 1138* (George Lucas, 1971), *American Graffiti* (George Lucas, 1973), *Le Parrain* (*The Godfather*, Francis Ford Coppola, 1972, 1974, 1990), *Conversation secrète* (*The Conversation*, Francis Ford Coppola, 1974) ou encore *Apocalypse Now* (Francis Ford Coppola, 1979), chacun de ces films ayant témoigné à sa manière d'une profonde volonté de renouveau au cinéma. Mais son œuvre s'étend bien au-delà des années 1970. Sa carrière a été marquée par d'autres rencontres artistiquement fécondes, comme en témoignent ses nombreuses collaborations avec le réalisateur Anthony Minghella, par exemple : *Le Patient anglais* (*The English Patient*, 1996), *Le Talentueux Mr. Ripley* (*The Talented Mr. Ripley*, 1999) et *Retour à Cold Moutain* (*Cold Mountain*, 2003). Bien d'autres bandes sonores jalonnent encore sa filmographie, oscillant entre succès populaires – *Ghost* (Jerry Zucker, 1990) ou *Jarhead* (Sam Mendes, 2005) – et projets plus personnels – les retrouvailles avec Francis Ford Coppola pour *L'Homme sans âge* (*Youth Without Youth*) en 2007, puis pour *Tetro* en 2009. Afin d'illustrer notre propos d'exemples précis, nous voyagerons à travers les voix, les ambiances, les bruits et les musiques de quelques-uns de ces films et chercherons à saisir une certaine évolution des formes entre une première période analogique (1969–1993)[5] et une seconde, numérique (1994–2009)[6].

[4] Oscar du meilleur mixage pour *Conversation secrète* (*The Conversation*) en 1975 et *Apocalypse Now* en 1980 de Francis Ford Coppola et en 1997 pour *Le Patient anglais* (*The English Patient*) d'Anthony Minghella.

[5] Cette première période va de *Les Gens de la pluie* de Francis Ford Coppola (*Rain People*, 1969), premier film mixé par Walter Murch en mono à *Romeo Is Bleeding* de Peter Medak (1993), mixé en Dolby Stereo Spectral Recording.

[6] Cette deuxième période s'étend du film de Charles Shyer *Les Complices* (*I Love Trouble*, 1994) mixé en Dolby Digital à *Tetro* de Francis Ford Coppola, dernier film mixé par Walter Murch à ce jour.

La numérisation du signal sonore

En 1962, Thomas Stockham, professeur au *Massachusetts Institute of Technology* (*MIT*) et père de l'audio-numérique, commence ses recherches sur les premiers enregistreurs numériques à bande, avant de fonder en 1975 la société Soundstream qui sera la première à commercialiser ces appareils aux États-Unis. En 1972, au moment de l'affaire du Watergate, Thomas Stockham est chargé d'enquêter sur « le trou de dix-huit minutes » des bandes remises par l'administration présidentielle de Richard Nixon, partiellement effacées. Deux ans plus tard, *Conversation secrète* reçoit la Palme d'Or au Festival de Cannes. Le film retranscrit avec une sombre mélancolie les méandres psychologiques et sentimentaux du détective-ingénieur Harry Caul, chargé d'enquêter sur des bandes sonores au cœur de l'Amérique moderne, toile hitchcockienne toujours plus sombre où s'entremêlent complots, grandes affaires et secrets de chambres. Fasciné par la naissance de la technologie numérique, Walter Murch « imagine » alors les sons produits par ces appareils ultra-sophistiqués de laboratoire et livre une partition de maître dès l'ouverture du film, où les interférences et les bruits électroniques des machines se mêlent aux chants des musiciens qui remplissent la place, puis à la conversation d'un couple mis sur écoute. Le miracle du « numérique » opère : les micros canons des espions, pourtant placés à vingt-cinq mètres du sol, reçoivent la parole d'un seul homme et d'une seule femme qui marchent dans la foule, entourés de chanteurs des rues. Aujourd'hui encore, un tel enregistrement relèverait de la prouesse technologique.

On comprend bien comment le contexte politique dans lequel est né l'audio-numérique a pu inspirer un tel film et nourrir l'imagination de Walter Murch. Si cette magistrale entrée en matière possède des qualités cinématographiques indéniables, elle nous permet également de revenir un instant sur la dimension technique de notre sujet en posant la question suivante : l'audio-numérique a-t-il véritablement représenté une rupture, voire une révolution, dans l'histoire du cinéma ? Une première réponse consisterait à répondre « oui », dans la mesure où l'arrivée de l'informatique a d'abord constitué un nouveau système d'écriture : en convertissant les variations d'amplitude des ondes en valeurs binaires, il est devenu possible de « dématérialiser » une partie de la chaîne du son, les étapes de l'enregistrement par microphones et la diffusion par haut-parleurs demeurant toutefois analogiques. L'écriture numérique a donc permis de transporter, stocker, traiter et manipuler

des informations différemment, « révolutionnant » ainsi les méthodes de travail des ingénieurs du son. Il faudrait pourtant apporter une seconde réponse, plus nuancée, si l'on examine de plus près les arguments avancés en faveur du progrès numérique. Les principales améliorations portées à la qualité de restitution du son ont toujours concerné quatre aspects fondamentaux : l'élargissement de la bande passante (soit la captation des fréquences, se situant entre 16 et 20 000 Hz pour l'Homme) ; l'augmentation de la dynamique (les sons forts étant réduits et les sons faibles augmentés par une opération de compression inhérente au support de l'enregistrement : cylindre, disque, pellicule, bande...) ; l'amélioration du rapport signal/bruit, c'est-à-dire la diminution du « souffle » produit par la bande ou par la pellicule, qui « réagissent » d'abord à l'enregistrement, puis qui s'abîment à force de manipulation, et finissent ainsi par être de plus en plus bruyantes ; et enfin, la réduction du taux de distorsion harmonique (les harmoniques jouant directement sur le timbre, ou sur la couleur, du son). Ces améliorations se sont succédées de manière progressive tout au long de l'histoire, beaucoup d'entre elles ayant été au cœur des travaux menés par le laboratoire Dolby depuis 1965.

En se fondant sur ces premières considérations, on peut effectivement constater que le son numérique répond à ces critères de qualités fondamentaux :

1) la bande passante, conditionnée par la fréquence d'échantillonnage, couvre toutes les fréquences audibles par l'oreille humaine ;

2) la dynamique, qui ne dépend plus des limites des supports ou des appareils, mais du nombre de bits utilisés pour la quantification du signal, couvre les limites de la perception humaine, le seuil de la douleur se situant à 130 dBspl ;

3) avec les supports analogiques, le « souffle » a disparu de la bande son, permettant ainsi la venue de véritables « silences numériques »[7] ; le pourcentage du taux de distorsion atteint, quant à lui, des mesures insignifiantes.

De ce point de vue, la finesse de restitution du son numérique va de pair avec le piqué de l'image numérique, celle-ci se faisant bien sûr au détriment du « grain » si cher aux amateurs d'images plus chaudes

[7] Michel Chion, *Un art sonore, le cinéma : histoire, esthétique, poétique*, Paris, Cahiers du Cinéma, 2003.

et de sons plus ronds (grain produit par l'interaction de la lumière avec les sels d'argent dans le cas de la pellicule, et du son avec les particules de limaille de fer dans le cas de la bande). On pourrait ainsi comparer la netteté du rendu sonore du froissement des ailes d'un papillon de nuit venant se heurter frénétiquement contre le verre d'une ampoule avec celle du très gros plan contrasté ouvrant le film *Tetro* (filmé avec une caméra Sony Haute Définition), ou encore louer la douceur duveteuse avec laquelle le vol de la colombe prisonnière de l'église de Cold Mountain résonne dans la mémoire d'Inman, ouvrier américain enrôlé durant la guerre de Sécession. Mais les légers cliquetis d'armes accompagnant l'évanouissement de Michael Corleone sur les marches de l'opéra de Palerme, enregistrés sur bande et mixés en Dolby Stéréo sur pellicule, nous rappellent que l'essentiel du travail de réduction de souffle et de précision avait déjà été pris en charge par le réducteur de bruit SR, lancé par Dolby en 1986. On pourrait même avancer que la supériorité du Dolby Stéréo sur le numérique tiendrait à sa capacité à combiner la précision du rendu avec la chaleur du grain : en témoigne l'ouverture d'*Apocalypse Now*, faisant surgir les détails sonores d'une jungle lointaine dans la moiteur d'une chambre d'hôtel en plein Saïgon. Trop de netteté ne nuirait-elle pas à cette séquence où le Capitaine Willard s'enfonce dans les brumes fiévreuses de son imagination ? Seule l'expérience de la projection du film en copie argentique permettrait au lecteur de se forger son opinion.

Toutefois, ces considérations d'ordre purement technique ne sont pas celles que l'on retrouve dans le langage commun des spectateurs de films vantant les mérites des bandes sonores actuelles : on entend plutôt parler de « puissance », de « précision », de « vitesse ». Derrière chacun de ces termes, se loge une parcelle de fascination pour ce que la technologie aurait de meilleur à offrir au monde – et donc au cinéma – moderne, et l'on peut aisément déceler dans ce discours enthousiaste autant de raisons empiriques que de facteurs idéologiques. Mais alors, que retenir de cette mythologie sonore ? Sans doute que la technique seule ne peut suffire à créer une impression, à toucher la corde sensible et infiniment complexe du spectateur humain. Si l'amélioration des quatre critères énumérés plus haut a certainement permis de donner plus de précision et de force aux bandes sonores des films, il ne faut pas sous-estimer le rôle du montage son ainsi que du mixage, c'est-à-dire du choix artistique.

Montage et mixage

Ces deux étapes de post-production déterminent le nombre de pistes mélangées dans un film et répondent à deux questions essentielles : combien et comment ? Elles sont globalement responsables de l'impression de « clarté » et de « densité » que nous donne une bande sonore. Walter Murch a écrit à ce propos un long article dans la revue *Transom* intitulé « Dense Clarity, Clear Density » dans lequel il invite les opérateurs à rechercher avant tout un point d'équilibre entre le vide et le plein et à respecter les limites naturelles du cerveau humain par rapport à sa capacité de traitement simultané de plusieurs informations de natures distinctes[8]. Il est aujourd'hui difficile de séparer ces deux étapes, l'une empiétant toujours plus sur le territoire de l'autre dans le flot continu de la fabrication d'un film, et leurs fonctions étant intrinsèquement liées. Ainsi, on peut très bien considérer que le montage serait principalement lié à la question du rythme, tandis que le mixage servirait à gérer les contrastes et le dynamisme du rendu sonore. Mais on sait également que l'impression de puissance, par exemple lors d'une explosion dans un film, n'est pas uniquement une affaire de fréquences et de décibels : elle est bien souvent reliée au « micro-montage » d'un petit silence placé juste avant l'explosion, venant ainsi renforcer l'impression d'impact sonore. Les logiciels utilisés dans les salles de montage et les auditoriums (*Pro Tools* et *Pyramix* par exemple) permettent donc non seulement de contenir des dizaines de pistes sur une même interface, mais aussi d'isoler des fragments minuscules afin de les traiter en jouant sur toutes leurs caractéristiques à la fois (intensité, hauteur et timbre). Devant cet éventail de possibilités, monteurs et mixeurs remplissent finalement des fonctions similaires : sélectionner, focaliser, hiérarchiser, filtrer.

Si nous comparons le rendu sonore de la célèbre séquence de l'attaque du village vietnamien par les hélicoptères du colonel Kilgore dans *Apocalypse Now*, celle de la bataille du Cratère ouvrant *Retour à Cold Moutain* et celle de l'attaque par erreur des Marines américains de *Jarhead* par leur propre aviation, ce ne sont pas tant les différences de qualité technique (bande passante, dynamique, souffle et distorsion) qui nous frappent que les similarités dans l'écriture de ces trois séquences : Walter Murch ménage systématiquement, par le biais de la bande son, des

8 Walter Murch, « A Conversation with Walter Murch », *Transom Review*, Vol. 5, avril 2005.

moments de pause qui invitent à la distanciation, à la prise de conscience de la réalité objective des scènes de guerre par le ressenti subjectif de ses personnages. Alors qu'il est délicat de ramener la musique à un rôle précis sans simplifier son effet (la « Chevauchée des Walkyries », tout comme le chant religieux « Idumea » interprété par des chœurs puissants de mormons, retentissent à la fois comme des hymnes épiques et des lamentations décalées), on peut affirmer sans détour que la douce cloche du village vietnamien tintant entre les voix des enfants et les aboiements lointains des chiens, le crépitement du feu brûlant le livre d'Inman dont le corps vient d'être enterré, le hennissement du cheval se relevant seul au beau milieu du charnier sudiste, ou la lente volée de sable que reçoit le soldat Swofford suite à l'explosion des bombes lancées en plein désert irakien, ne sont pas seulement des bruits illustratifs. Ils sont les mots permettant de créer le contraste, de produire des effets poétiques, voire d'ajouter des dimensions métaphoriques aux images.

Autre marque de fabrique liée davantage au style « murchien » qu'aux possibilités techniques de l'analogique ou du numérique : la multiplicité des plans sonores au sein d'un même espace. Comme Walter Murch s'en est expliqué à de nombreuses reprises, la création de l'espace entourant les sons est au cœur de son geste artistique et sert bien souvent d'écrin à la présence des personnages. Ainsi, comment isoler Harry Caul des bruits de travaux extérieurs s'infiltrant malgré lui jusque dans son appartement, et lui rappelant ainsi son incapacité à échapper à l'autre ? Comment détacher la terreur du jeune soldat de seize ans sudiste de la rumeur grandissante des armées yankees approchant de son camp ? Comment séparer le paysage toscan où sonnent au loin « les cloches du souvenir » (pour reprendre le titre du poème de Maurice Vaucaire) de László Almásy, le blessé amnésique du *Patient Anglais* ? Walter Murch utilise avant tout la profondeur de champ pour introduire des éléments plus ou moins flous, plus ou moins nets, au loin, au milieu et au-devant de la scène.

On pourrait croire que la création d'un espace sonore « dense et clair » pourrait être favorisée par le cumul des pistes numériques (leur nombre presque illimité ne posant plus de problèmes de souffle) ou par la possibilité d'un montage son toujours plus précis permettant aux éléments de s'agencer d'une manière parfaitement ordonnée (le placement des sons sur la barre temporelle pouvant être contrôlé au cent-millième de seconde près). Walter Murch remarque que la clef d'un tel équilibre repose d'abord sur la capacité du mixeur à distinguer les sons « codes » des sons « corps », c'est-à-dire des sons délivrant de l'information de ceux délivrant

de l'émotion, indépendamment de leur appartenance présumée à l'une ou l'autre de ces catégories (une pièce musicale pouvant par exemple être plus « froide » qu'une ligne bouleversante de dialogue) :

> Il y a des éléments musicaux qui s'intègrent parfaitement au discours parlé : pensez à la manière musicale dont telle personne peut s'exprimer. Vous pourriez très bien me dire si cette personne est heureuse ou triste rien qu'en écoutant le ton de sa voix, même si vous ne comprenez pas un mot de ce qu'elle raconte. Vous comprenez parfaitement ce que vous dit R2D2, grâce à la qualité musicale de ses bips et de ses bops, bien qu'il n'utilise aucun mot. Par contre, la voix informatisée de Stephen Hawking est parfaitement compréhensible, mais monotone (elle n'a que très peu d'intonation), ce qui concentre notre attention sur le contenu même de ce qu'il nous dit.
>
> De la même manière, il y a des éléments de langage dans n'importe quelle pièce musicale. Pensez à la difficulté que vous avez à écouter un opéra chinois si vous n'êtes pas chinois. Cela peut vous paraître étrange, mais c'est uniquement parce que vous n'êtes pas familier avec ce langage et tout ce qu'il implique. En fait, la plupart de vos goûts musicaux dépendent du nombre de langages musicaux avec lesquels vous êtes familiers, et de la difficulté interne à ces langages. Le code du *rock'n roll* est très basique et touche un public immense. Celui de la musique baroque est bien plus sophistiqué et touche un public plus expérimenté.
>
> Les effets sonores quant à eux peuvent aussi glisser du linguistique au musical. Pensez aux sons d'ambiances du film *Eraserhead*. On ne dira pas que c'est une musique car il n'a pas de mélodie à proprement parler, mais il n'empêche qu'il agira sur vous exactement comme de la musique. Et parfois, les bruits sont tellement signifiants qu'ils ont presque la valeur de mots. De telles distinctions n'ont comme fonction que de vous aider à classer, de manière théorique, les sons de votre film. Car de la même manière qu'un peintre agencera les différentes couleurs complémentaires du spectre de manière créative et équilibrée, il faudra que la bande-son de votre film apparaisse de manière tout aussi intéressante, en jouant sur l'agencement des couleurs sonores de votre propre spectre .[9]

Spatialisation du son dans les salles

Un autre argument avancé en faveur du son numérique au cinéma concerne cette fois la possibilité du *surround*, c'est-à-dire du mixage « enveloppant ». Bien que cette notion ait été inventée avec l'apparition

[9] *Ibid.*

du multicanal dans les années 1970 (et dont la popularité dut beaucoup à l'usage qu'en fit Walter Murch dans *Apocalypse Now*, qui mixa la version 70 mm du film avec le procédé Dolby Stereo 70 mm 6 tracks, ancêtre du format de mixage aujourd'hui noté 5.1), elle continue de se développer dans les salles à travers de nouveaux procédés, toujours plus fournis et plus ambitieux, comme le Dolby Atmos ou le Auro 3-D (reposant chacun sur une disposition de douze canaux combinant un axe horizontal et un axe vertical, avec la présence de haut-parleurs *tout autour* et *au-dessus* des spectateurs). Les normes internationales de diffusion du cinéma numérique (aussi connues sous le nom de « normes ISO ») établies par le Digital Cinema Initiatives (DCI : consortium réunissant les principaux studios hollywoodiens) spécifiant qu'un DCP peut contenir jusqu'à seize pistes (non compressées et pouvant aller jusqu'à une fréquence d'échantillonnage de 96 kHz 24 bits), on peut bien sûr imaginer la création prochaine de nouveaux formats de mixage utilisant davantage de canaux dans les salles de cinéma.

Les écrits de Murch sont clairs à ce propos : les principales « révolutions » techniques qu'il reconnaît dans l'histoire du cinéma sont d'abord celles qui servent le montage, l'arrivée du parlant ne pouvant à ce titre être catégorisée de la même manière que la couleur ou la 3-D. Or n'oublions pas que les nouveaux formats de mixage *surround* (aussi appelés « mixage 3-D ») furent d'abord développés pour la projection en relief, ce que nous rappelle le slogan même de l'Atmos : « Hear the whole picture ».

Revenons donc à la question de la spatialisation 5.1, inaugurée par Walter Murch, et devenue par la suite la norme incontournable du cinéma numérique. En effet, dès l'apparition des premiers procédés de son numérique entre 1991 (CDS Kodak) et 1994 (SDDS Sony), tous les fabricants proposèrent des solutions techniques permettant de loger quatre canaux (l'équivalent du Dolby Stereo lancé en 1975) ou six (répartis selon la disposition d'*Apocalypse Now* : trois frontaux, deux à l'arrière, plus un caisson de basse). Le multicanal 5.1 fut donc imposé « par » le numérique, l'augmentation du nombre de canaux dans les salles ayant sans doute été considérée comme synonyme de modernité, par opposition aux formats plus communs de l'analogique (le Dolby Stereo 70 mm 6 tracks reposant sur la lecture de pistes magnétiques couchées sur les bords de la pellicule, et donc lues par des projecteurs équipés de têtes magnétiques, était un procédé onéreux réservé à quelques salles).

L'approche novatrice du son multipiste dans *Apocalypse Now* suscita de nombreux commentaires, certains enthousiastes (« en sautillant d'un son à l'autre, en amalgamant plusieurs sons simultanés, le spectateur enveloppe, relie, désarticule, pour recomposer plus tard une matière sonore, dressant du coup un lieu sonore aux limites mobiles et aux dimensions variables »[10]) et d'autres plus dubitatifs :

> En les gardant bien enfoncés dans leur siège, totalement désincarnés pour l'occasion, car voyageant d'un plan à l'autre en ayant l'impression que l'action se déroule tout autour d'eux puisqu'ils repéreront des sources sonores provenant de leur gauche ou de leur droite, voire de derrière eux ou au-dessus de leur tête, le cinéma « narratif-représentatif-industriel », comme le nommait Claudine Eizykman dans les années soixante-dix, cherche moins à en mettre plein les oreilles aux gens dans la salle qu'à les maintenir à tout prix dans un pur univers de fiction qui les aliène chaque fois un peu plus.[11]

Il est intéressant de comparer ces critiques avec les explications données par Walter Murch sur le sens même de son travail, l'utilisation du mixage multicanal étant toujours chez lui au service de l'histoire, du rythme et de l'émotion, les trois piliers de son art. David Bordwell et Kristin Thompson nous indiquent par exemple que les sons de pales (d'hélicoptères et de ventilateur) ouvrant le film proviennent à la fois du devant et de l'arrière de la salle, afin de renforcer l'impression d'étourdissement ressentie par les spectateurs. Puis, quand Willard se lève pour aller à la fenêtre de sa chambre d'hôtel et regarder d'en haut la rue de Saïgon, les ambiances de la ville sont mixées à l'avant de la salle, dans les trois haut-parleurs frontaux, de manière à conserver un ancrage précis dans l'image tout en ouvrant vers le hors-champ. Enfin, lorsqu'il revient s'allonger et fumer une cigarette en repensant à son passé, les sons de Saïgon se transforment progressivement en ambiances de jungle, et le mixage, devenant alors monophonique, nous entraîne avec lui dans l'esprit de Willard[12]. On voit ici comment Murch tire parti de la spatialisation 5.1 pour plonger les spectateurs dans un ballet de sons réels et imaginaires, et promener les oreilles des spectateurs du film entre plusieurs strates de perception. On retrouvera

[10] Serge Cardinal, « Entendre le lieu, comprendre l'espace, écouter la scène », *Protée*, Chicoutimi, Université du Québec, automne 1995, p. 99.

[11] Pierre Rannou, « Du rôle et de la fonction de l'espace sonore au cinéma », *Inter : art actuel*, n° 98, 2008, p. 41.

[12] David Bordwell, Kristin Thompson, *L'art du film, une introduction*, Bruxelles, De Boeck, 2009, p. 432.

cette même approche du mixage multicanal dans de nombreux films de
sa période « numérique », faisant la part belle aux séquences fondées sur
l'enchevêtrement des temporalités et des sons. Dans *Conversations avec
Walter Murch*, Michael Ondaatje remarque que le mixage souligne les
transitions spatio-temporelles liées aux réminiscences de László Almásy :

> On entend ainsi le bruit du papier de verre sur la pierre avant de passer
> visuellement aux archéologues dans le désert ; le doux cliquetis du morceau
> de métal que lance Hana en jouant à la marelle se transforme peu à peu en
> musique berbère, et prépare le spectateur à un nouveau saut en arrière dans
> le temps.[13]

De même, le mélange de voix, de souffles, de musique, de tintements
aigus et de grincements plaintifs clôturant la séquence finale, presque
hallucinatoire, du *Talentueux Mr. Ripley* a sans doute bénéficié d'un
traitement multicanal. Dès lors, on peut se prendre à rêver au rendu
surround de certaines séquences monophoniques de *Conversation
secrète* ou de *Julia* (Fred Zinnemann, 1977). Comment Murch aurait-il
spatialisé la bande sonore du voyage onirique d'Harry Caul, perdu dans
une brume bleutée, habillée par l'étrange symphonie des sons de la ville
progressivement déformés par l'inconscient du rêveur (la cloche d'un
tramway lointain résonnant aux côtés des interférences « numériques »,
d'une cloche d'église, de klaxons et de nappes électroniques) ? Aurait-il
utilisé les différents canaux pour renforcer le sentiment de proximité
donné par la voix intérieure de la narratrice Lili, du sentiment de distance
créé par les voix fantomatiques de son passé, lui revenant sous forme
de leitmotivs obsédants et réverbérés ? On peut bien sûr considérer que
le changement technologique amené par l'arrivée du numérique a été
bénéfique à l'histoire du cinéma en termes de restitution sonore, bien que
les quatre critères énoncés plus haut ne puissent évidemment pas suffire à
définir de manière irréfutable ce qui ferait la qualité d'un enregistrement.
Cependant, en comparant quelques extraits de la filmographie de
Walter Murch à travers les décennies, on peut également constater que
l'importance de la technologie impliquée dans la création de ses bandes
sonores (analogique ou numérique) apparaît bien moindre que celle du
geste artistique, de la réflexion du concepteur son – qui, semblable en
cela au metteur en scène, ne cesse de relier le fond et la forme – et de la

[13] Michael Ondaatje, *Conversations avec Walter Murch*, Paris, Ramsay, « Cinéma »,
 2009, p. 18.

persistance de certains effets de style donnant à l'œuvre une cohérence toute personnelle. Les études consacrées aux travaux des concepteurs son nous rappellent enfin que la qualité de l'échange qu'un film réussit à faire naître entre un grand écran et ses spectateurs, soumis à leurs facultés de *projection* réciproques, tient pour beaucoup à la manière dont les images et les sons se mêlent, se succèdent, se complètent, se répètent, se contredisent, s'opposent, s'attirent ou se rejettent. Quelle que soit la technologie qui le fasse vivre, le cinéma demeure ainsi l'art des relations sonores et visuelles, puisqu'au croisement de nos perceptions sensorielles et de nos interprétations mentales, commencent encore et toujours de nouveaux voyages intérieurs.

Troisième partie

Faire l'histoire des techniques et des métiers

Le cinéma au prisme du magique, ou pour une réactivation de la figure du physicien-fantasmagore

Frédéric TABET

« Ce problème [les fantasmagories] se présente comme un nœud dans lequel l'histoire, la mémoire et l'imaginaire sont si fortement entremêlés qu'il a pu en paraître "gordien" »[1]. Gilles Chabaud introduit, par ces mots, une étude historique consacrée à la fantasmagorie. En écorchant au passage l'histoire du cinéma, il souligne que les inventions mises en œuvre par la fantasmagorie et son contexte d'apparition ne permettent en aucun cas de comprendre comment ces spectacles ont été reçus et, notamment, qu'il est délicat de les relier aux périodes de troubles et aux bouleversements associés à la violence révolutionnaire de la Terreur.

La fantasmagorie est un objet d'étude complexe : rangée du côté des belles lettres, les chercheurs ont assimilé sa forme à un spectacle populaire et mineur, excessif dans la mise en œuvre de ses effets ; rangée du côté de l'histoire des sciences, d'autres y ont vu l'une des formes les plus abouties du spectacle scientifique et l'accomplissement de la physique amusante mise en œuvre par les physiciens du XVIIIe siècle[2]. Les archives techniques décrivent une représentation immersive où tous les sens du spectateur sont sollicités. La projection lumineuse des plaques du Fantascope de Robertson est accompagnée d'effets acoustiques, visuels, olfactifs et tactiles. Tout concourt à rapprocher la représentation de la

[1] Gilles Chabaud, « Se faire peur avec le passé », *L'ennemie intime*, Rennes, Presses universitaires de Rennes, 2011, p. 47.

[2] Frédéric Tabet, Pierre Taillefer, « L'escamoteur de la baraque de foire au cabinet de physique : récit d'une illusion presque réussie », *Dix-huitième siècle, Une société de spectacle*, n° 49, Paris, La Découverte, juillet 2017.

Gesamtkunstwerk[3], l'œuvre d'art totale wagnérienne. Or, si ces effets tendent au spectaculaire, il est pourtant impossible de les concevoir sans convoquer l'impression produite sur le spectateur, cette dimension que Wagner place au cœur de sa réflexion[4]. Il s'agit de s'interroger sur *l'effet de l'effet*, et de dénouer les parts d'Histoire, de mémoire et d'imaginaire.

Les pratiques fondées sur l'application d'illusions – dont le cinématographe fait partie – relèvent de la même problématique. L'étude de ces objets illusionnistes ne peut se faire sans aborder simultanément leur archéologie, leur mise en œuvre et les horizons d'attente créés en amont de l'événement par les annonces et en aval par les commentaires. L'évolution de chacune de ces instances déplace les cadres de réception des effets et donc, la manière de concevoir l'événement. L'histoire des formes, des techniques et des appareils de la représentation illusionniste est sujette à de multiples déformations. Une méthode spécifique est à déterminer pour délimiter le champ de travail, la méthode historiographique et ses outils d'analyse.

Le cinématographe comme successeur « naturel » du spectacle illusionniste

Pourquoi l'illusionnisme – dont la forme emblématique se condense dans la figure du prestidigitateur – si présente à l'origine du cinéma, si régulièrement invoquée dans les différentes histoires, n'est-elle pas davantage abordée dans sa matérialité même ? Les effets illusionnistes, puisqu'ils fonctionnent, prouvent l'efficacité des principes de base : parce que « ça marche », il ne semble pas nécessaire d'analyser les fonctionnements. En cela, il est fréquent de concevoir une filiation évidente des relations entre magie et cinéma, souvent postulée comme point de départ. Par exemple, selon Paul Hammond, « Il est parfaitement naturel qu'une illusion d'optique supérieure comme le cinéma se trouve initialement dans les mains des magiciens,

[3] Richard Wagner, *Das Kunstwerk der Zukunft* (*L'œuvre d'art de l'avenir*), 1849, traduction de J. G. Prud'homme et Dr F. Holl., Paris, Éditions d'aujourd'hui, 1982. Nous suivons en cela l'analyse de Tom Gunning dans « Fantasmagorie et fabrication de l'illusion », *Cinémas*, vol. 14, n° 1, 2003, p. 73.

[4] Richard Wagner, « Lettre sur la musique », *Œuvre en prose*, vol. 4, Paris, Delagrave, 1910, p. 194–196.

qui souvent sont des mécaniciens experts, bien renseignés sur les trucages optiques »[5].

Cette évidence ne peut se concevoir que si l'on souscrit à un déterminisme technique. Utilisé comme un motif « repoussoir », le stade illusionniste dépassé, le cinéma se serait libéré pour devenir art. Or la première décennie d'exploitation du cinématographe constitue un laboratoire éblouissant de formes magiques. La comparaison des répertoires d'effets cinématographiques et scéniques est récurrente mais l'étude des principes de construction des illusions mises en œuvre montre que les images animées ont été pleinement investies par les illusionnistes de la Belle Époque, dans la parfaite continuité des écritures élaborées en scène. Seule la réévaluation de ces spectacles, à travers les traces qu'ils ont laissées, permet de saisir les influences, les zones de contact et de dépasser les points communément commentés. Cette « évidence naturelle » a constitué le déclencheur d'une exploration des principes illusionnistes. Des filiations peuvent être rapidement explorées du côté de la magie optique, acoustique ou cinétique, mais les ramifications des genres illusionnistes, la déclinaison des illusions, la variété des lieux et des discours ne permettent en rien de concevoir un schéma simple ni de percevoir clairement les contours d'une rencontre – qui se voudrait fortuite et éphémère – entre une forme de spectacle établie et des machines dont les évolutions restent, encore aujourd'hui, en devenir.

Dès les débuts, les images animées servent à créer des formes aussi diverses qu'étonnantes. La machine cinématographique a été employée de manière singulière par un ensemble d'acteurs du monde du spectacle. À la fin du XIXe siècle, Leopoldo Fregoli, Howard Thurston ou Harry Houdini l'ont utilisée. Plus récemment, Marco Tempest ou les duos Barry Jones/ Stuart MacLeod et Penn Jillette/Teller[6] ont repensé l'interaction entre images animées et illusions scéniques. La perte d'une « essence » – suivant de près les évolutions techniques – remet régulièrement en lumière un ensemble de pratiques considérées auparavant comme marginales ou stériles. L'étude de l'image animée, abordée à partir de pratiques connexes,

[5] « It is perfectly natural that a Superior Optical illusion like the cinema should find itself initially in the hands of conjurers, who are often experts mechanics, and are well acquainted with Optical trickery », Paul Hammond, *Marvellous Méliès*, Londres, Gordon Frazer, 1974, p. 94.

[6] Frédéric Tabet, « L'illusionnisme post-moderne », *Géopolitiques de la magie*, Paris, Presses universitaires de France (à paraître).

permet de comprendre autrement la constitution de ces formes, d'en saisir la spécificité, d'appliquer de nouvelles grilles d'analyse et de repenser tant l'histoire que la théorie du cinéma.

Ces études comparées et ces rapprochements de pratiques rassemblées en séries culturelles[7] peuvent cependant souffrir de décalages historiographiques. Les premières histoires du cinéma ont été réalisées sans avoir un accès aisé aux films. Ne disposant que de peu de documents, les historiens, parfois collectionneurs eux-mêmes, constituaient leurs propres archives[8]. Dans les années 1970, les films sont devenus plus accessibles, permettant des approches structuralistes. Les chercheurs ont tenté ainsi de faire des liens entre le texte et les films, en s'intéressant aux microstructures des films. Cette période a coïncidé avec ce que Laurent Le Forestier a nommé *source turn*[9], correspondant à une utilisation raisonnée de documents premiers, permettant ainsi une nouvelle écriture de l'Histoire. En replaçant le cinéma au sein d'une constellation de pratiques, notamment spectaculaires, nous assistons à une vague de recherche inédite : le cinéma devient l'un des éléments d'une macrostructure : ici, le spectacle illusionniste. Cette nouvelle appréhension coïncide avec un *digital source turn*, c'est-à-dire un accès apparemment libre aux archives digitalisées, ouvrant la voie, entre autres, à des approches statistiques. Or ces données numérisées et ces nouveaux outils de l'Histoire ne sauraient être adoptés sans une prise en compte de l'état historiographique des autres pratiques. Si l'étude du cinéma a effectué son *digital source turn*, l'historiographie de l'illusionnisme se trouve encore entre la première et la seconde vague[10].

Pour penser le cinéma illusionniste, il s'est agi de construire et d'établir un champ de travail, de défricher et d'explorer un domaine complexe, sans le considérer comme une sous-catégorie du théâtre sur lequel il a pu être rabattu. Au contraire, les contextes historiques ont modelé un

[7] Cette approche a été largement promue par André Gaudreault, dans *Cinéma et attraction. Pour une nouvelle histoire du cinéma*, Paris, CNRS éditions, 2008, p. 110–114.

[8] Nous pensons, entre autres, à Will Day ou Jacques Deslandes.

[9] Laurent Le Forestier, « L'approche "gender" au prisme de l'historiographie du cinéma. Noël Burch et Geneviève Sellier, *Le cinéma au prisme des rapports de sexe* », *1895, revue d'histoire du cinéma*, n° 60, Paris, AFRHC, 2010, p. 194–201.

[10] Nous reprenons ici des éléments avancés initialement dans Frédéric Tabet, « Les Archives de l'art magique, ou pour en finir avec le mythe de la source secrète », *L'archive-forme : création, histoire, mémoire*, Paris, L'Harmattan, 2014, p. 287–296.

objet hybride qui entrecroise différentes pratiques pour générer des catégories de formes, qui sont plus complexes que des emprunts et plus denses que des combinatoires. Le détressage de ces influences mène à explorer diverses périodes historiques et divers domaines disciplinaires pour accéder à la compréhension du spectacle illusionniste.

L'art magique, son identité, ses influences et ses courants

La première des précautions a été de concevoir l'objet avec circonspection, tant son identification et son rapport à l'Histoire sont problématiques, y compris dans les termes avec lesquels les acteurs se définissent et décrivent leurs pratiques. La plupart des spectacles d'illusionnisme contemporains proposent des représentations attendues que les critiques considèrent comme un art mineur. Malgré la diversité des espaces de représentation et l'attrait des publics, ce phénomène culturel n'a généré que peu d'intérêt. Tout en démontrant une forte influence sur la culture du XXe siècle[11], Simon During souligne cette différence : « L'Art peut être noble et profond alors que la magie est triviale et légère. L'Art peut générer un immense capital culturel, alors que la magie n'en produit aucun. »[12] Cependant, « le charme persistant de l'illusionnisme »[13], pour reprendre les propos du magicien Teller, tend à démontrer le contraire. La fascination pour ce genre de spectacle explique, entre autres, l'existence de numéros « sans le moindre souci de présentation ni d'originalité », mais malgré cela, « le "concept" reste attrayant »[14]. L'illusionnisme résiste ainsi à toutes les remises en cause qui lui sont régulièrement portées. Cette efficacité opérante réside dans son essence même. Si l'illusionniste

[11] Simon During, *Modern Enchantments: The Cultural Power of Secular Magic*, Cambridge/Londres, Harvard University Press, 2002, p. 1–42.

[12] Simon During, « A Resonant Moment in the Twinned Histories of Art and Magic », *Magic Show*, Londres, Hayward Publishing, 2009, p. 66.

[13] Joseph Stromberg, « Teller Speaks on the Enduring Appeal of Magic », *Smithsonian Magazine*, février 2012, disponible en ligne : <http://www.smithsonianmag.com/arts-culture/teller-speaks-on-the-enduring-appeal-of-magic-97842264>, consulté le 15 mars 2017.

[14] Stephen Thompson, « Penn & Teller Part 1 », *A.V. Club*, 27 juin 1998, disponible en ligne : <http://www.avclub.com/article/penn-and-teller-part-1-13534>, consulté le 15 mars 2017.

produit de manière réaliste des événements impossibles[15], perçus à la fois comme des phénomènes réels et irréels, l'illusion magique reposerait sur une *unwilling suspension of disbelief*, sur le refus de la suspension de l'incrédulité[16]. Le spectacle illusionniste « célèbre un mensonge partagé entre le magicien et son spectateur »[17] conscient, consentant, et qui en est averti. La scène doit ainsi adopter une esthétique hyperréaliste afin de dépasser un « seuil de crédibilité » à partir duquel l'illusion à l'œuvre est ressentie réelle[18]. Dès lors, le mensonge devient vertueux et merveilleux[19]. L'effet magique naît alors de l'écart entre le perçu et le su. Forme ironique et paradoxale, l'illusionnisme met en doute les limites de la représentation, jouant en dissonance entre la perception d'une situation et la connaissance du spectateur et de son incapacité à ne pas être crédule. Le spectacle illusionniste ne trompe pas puisque sa spécificité tient à son artificialité avérée. À travers le temps, il serait donc vain de concevoir un objet pré-construit et prédéterminé, au contraire, il semble nécessaire de le délimiter par le regard du spectateur, ce regard qui se sait à demi-trompé.

Pour concevoir l'évolution esthétique, une mise à distance des termes est nécessaire. Sur les périodes étudiées, de nombreux mots font leur apparition. Les illusionnistes font ainsi preuve d'une volonté de rupture. Or mettre en lumière des filiations permet d'en occulter d'autres. Les processus de différenciation dissimulent les liens de continuité ; inversement, les filiations revendiquées construisent de nouvelles origines. Les termes utilisés définissent et informent autant qu'ils trompent ; ils dévoilent autant qu'ils voilent et induisent en erreur. Une fois repris, et sans critique historique, ces termes peuvent être à l'origine d'*a priori* linguistiques, dont l'une des conséquences trompeuses est de générer des raisonnements circulaires (prestesse du prestidigitateur, illusions de l'illusionniste, manipulation du manipulateur, mental du mentaliste...). Pour prévenir les interprétations anachroniques, une critique historienne

[15] Joseph Stromberg, « *Teller Speaks* », *op. cit.*

[16] *Ibid.*

[17] Traduction effectuée par nos soins, nous soulignons. « Penn & Teller », *The Amazing Meeting 2*, 15–18 janvier 2004, captation disponible en ligne : <https://www.youtube.com/watch?v=tXbJT9nQ8eU>, consultée le 15 mars 2017.

[18] Bruce Tognazzini, « Principles, Techniques, and Ethics of Stage Magic and Their Application to Human Interface Design », *INTERCHI*, Amsterdam, IOS Press, 1993, p. 361.

[19] Stephen Thompson, « Penn & Teller Part 1 », *op. cit.*

des termes, doublée d'une analyse des apports disciplinaires spécialistes, est nécessaire. Ensuite, l'inflexion du sens des termes est à rapporter à celle des formes : les glissements sémantiques sont à mettre en regard avec les changements de pratiques. Les termes devancent-ils les pratiques ? Sont-ils en phase ? En rupture ? Cette mise en corrélation révèle les stratégies d'utilisation des termes – données tant aux acteurs qu'aux effets présentés. Ce détour par les installations matérielles permet de comprendre l'enjeu des reformulations et de donner autant d'indices des pressions sociales à l'œuvre. L'abondante *littérature des secrets* donne ainsi un aperçu de la machinerie déployée et des protocoles à l'œuvre, aspects qui permettent d'identifier l'application de savoir scientifique et de technique novatrice. Par le recoupement de ces descriptions techniques et des discours, il devient possible de percevoir l'intégration de technologies aux processus de création de l'illusion, de saisir leur déploiement – visible ou dissimulé –, de comprendre l'articulation du discours illusionniste avec un imaginaire scientifique et de délimiter les médiations technologiques des performances et leurs effets sur l'expérience spectatorielle.

Parallèlement à la compréhension des spectacles, trois pôles critiques et esthétiques ont été identifiés. Le pôle virtuose place la main et le savoir-faire de l'opérateur au cœur de l'événement ; le pôle scientifique centre la performance sur l'ingéniosité des inventions ; le pôle théâtral conçoit le spectacle comme résultant d'une combinaison d'effets complémentaires. Ces trois pôles impliquent d'appréhender dès le départ une histoire décloisonnée. L'art magique est complexe à périodiser, il est plus aisé de considérer non pas des formes singulières, mais de prendre en compte des assemblages[20], amalgamant temporairement des pratiques telles que la ventriloquie, la marionnette, la jonglerie, le fakirisme, le spiritisme, le dressage d'animaux ou la projection d'images. Au fil du temps, ces différents assemblages ont su plaire à des publics hétérogènes. Leurs attentes ont produit de multiples discours, qui en retour ont fait évoluer l'équilibre de ces amalgames. De même, une histoire de l'illusionnisme, considérée comme une forme de divertissement, ne peut se faire qu'à partir du moment où l'on dégage le terme « magie » des racines qui le lient à la religion ou l'occultisme. Or cette sécularisation s'est accompagnée d'un cloisonnement artificiel entre des pratiques parallèles et autonomes. Des espaces ont accueilli des pratiques encadrées, voire aidées par les instances

[20] Simon During, *Modern Enchantments: The Cultural Power of Secular Magic*, *op. cit.*, p. 66.

de pouvoir. D'autres lieux, informels, ont vu se développer des pratiques spontanées, précaires, considérées comme suspectes et déviantes, car difficilement contrôlables. Le « psyfoclèptis » (le joueur de pierre) a côtoyé la machinerie théâtrale des théâtres grecs. Les escamoteurs de foire[21] ont côtoyé les tréteaux des mystères médiévaux puis de la *Salle des Machines*… jusqu'aux physiciens escamoteurs[22] du XVIIIe siècle dont les représentations entre science et illusion ont donné naissance au spectacle bourgeois du prestidigitateur de salon. Ce n'est qu'en reliant ces histoires parcellaires et en tentant de comprendre, au-delà du cloisonnement des espaces de représentations, les schémas directeurs ayant présidé à la réalisation de ces spectacles, qu'il est possible de comprendre comment les spectacles se sont modelés aux courants de pensées contemporains.

Pour une analyse médiatique par le prisme du magique

Dernier point, pour ne pas élire en modèle un détail historique, pour ne pas prendre des coïncidences pour des corrélations : un travail de fond a été réalisé dans la presse et les périodiques d'époque – menant à ce jour à une base de données de près de 10 000 entrées du XVIe au XXIe siècles. Cette collecte permet de pointer des « nœuds médiatiques » et en particulier de pointer des périodes où des découvertes dans le domaine de l'image et du son ont rencontré le spectacle illusionniste : période des fantasmagories, des spectres du professeur Pepper[23], des effets d'impressions lumineuses spirites, mais aussi aux effets d'entrée et de sortie de l'écran, au Théâtre Noir, aux personnages miniatures du Théâtre de Tanagra, aux *Spook-shows* des années 1940, aux techniques de projections sonores ou de *Whispering*[24]. De là, l'analyse des nœuds médiatiques permet d'accéder à ce

[21] Pierre Taillefer, « La figure de l'escamoteur de la Renaissance à nos jours », dans Patrick Le Chanu, Pierre Taillefer, Agnès Virole (dir.), Catalogue de l'exposition *Tours et détours de l'escamoteur, de Bosch à nos jours* (espace Véra, 2016), Musée municipal de Saint-Germain-en-Laye, 2016, p. 30–45.

[22] Frédéric Tabet et Pierre Taillefer, « L'Escamoteur de la baraque de foire au cabinet de physique », *Revue d'histoire du théâtre, op. cit.*

[23] Technique d'illusion d'optique utilisée dans les représentations scéniques, les châteaux hantés et certains tours de magie.

[24] L'ensemble de ces effets ou de ces techniques utilisent ou détournent des techniques que l'on retrouve à l'œuvre au cinéma, comme nous l'avons analysé pour le Théâtre noir dans « Entre art magique et cinématographe », *1895, revue d'histoire du cinéma*, n° 69, AFRHC, avril 2013, p. 26–43.

que Christian Fechner a nommé la « pensée magique »[25] : l'étude des *modi operandi* montre que les effets peuvent être réalisés de diverses manières selon de multiples possibilités qui ne dépendent pas exclusivement des objets choisis ni des espaces de représentation. Lorsqu'il élabore un effet, l'illusionniste détermine les moyens de sa réalisation. Si les mêmes effets sont sans cesse montés en scène, les sélections adoptées pour leur mise en œuvre relèvent d'une réécriture permanente, indépendante des applications technologiques mises en jeu. Partant de guides symboliques, pragmatiques ou techniques, les relations structurelles qu'entretiennent techniques, mises en œuvre et effets, identifient l'influence d'écoles et de courants de pensée par-delà les motifs apparents. Au choix de l'ordre des expériences présentées, de leur enchaînement et des applications scientifiques mises en œuvre, s'ajoute celui des principes de *mise en spectacle* et de leur esthétique propre. L'étude de la genèse de cette écriture permet de comprendre la « pensée magique » des créateurs et de saisir les principes qui la dirigent. Par exemple, le « principe d'égarement de l'esprit »[26] exploite la reconnaissance de schémas et de situation. Induit par les gestes et les conduites de l'artiste, par la dynamique du regard, et par la réalisation d'actions *en transit*, ce principe joue de la transparence et de l'opacité des dispositifs : il vise à altérer les identités ou à éviter la production d'un effet trop parfait. Le « principe d'indiscernabilité » exploite les limites perceptives. Il vise à créer des zones d'interpositions et des moments de tampon visuel et sonore, à jouer de la confusion entre les motifs et les fonds. Il reconstruit les cadres de l'expérience en élaborant de nouveaux hors-champs sonores et visuels qui modélisent les cadres de l'expérience. Le « principe de déplacement des solutions de continuité » induit continuités et discontinuités apparentes. Il peut se fonder sur la déliaison d'image et son, sur les césures ou enjambements rythmiques, stylistiques, ou protocolaires.

Ces outils déploient autant de nouvelles lectures de l'histoire des techniques cinématographiques : les notions d'indiscernabilité, d'égarement et de déplacement de solution de continuité, appliquées

[25] Christian Fechner, *La Magie de Robert-Houdin*, vol.3, Boulogne, Éditions FCF, 2002, p. 23 ; repris dans Christian Fechner, « La pensée magique de Robert-Houdin », *Revue de la prestidigitation*, n° 549, septembre 2005, p. 14–16.

[26] « On ne doit rien négliger de ce qui peut concourir à égarer l'esprit des spectateurs… », voir Jean-Eugène Robert-Houdin, *Les secrets de la prestidigitation et de la magie*, Paris, Michel Levy, 1868, p. 45.

au cinéma, permettent autant d'analyser les techniques de construction du conflit que celles d'effacements visuels et sonores. Nous pensons bien sûr aux effets spéciaux, mais aussi à une autre histoire du montage et des esthétiques narratives discursives ou de correspondance. Plus largement, les archives de l'art magique, traitées avec circonspection, nous semblent contribuer à enrichir l'étude des techniques médiatiques. Les outils illusionnistes fournissent ainsi de nouveaux angles d'analyse qui, appliqués aux usages de machines, aident à comprendre leurs effets de réel et d'imaginaire. En outre, appliqués de manière non ostentatoire, ces principes produisent un mode de « lecture magique », éphémère, qui subsiste jusqu'à ce que ces mêmes principes soient intégrés de manière plus « apparente » aux écritures médiatiques.

> C'est sous le règne d'une terreur trop réelle qu [e Robertson] s'était efforcé de détruire pour jamais, par des expériences de fantasmagorie, la terreur imaginaire des spectres et des visions ; si elle n'habitait plus dès lors au sein de la capitale, dans combien de départements n'est-elle pas encore vivante aujourd'hui ?[27]

Ainsi, si la magie est si présente à l'origine des médias, si régulièrement invoquée dans son histoire et son développement technique, c'est peut-être parce qu'elle a servi et s'est régulièrement pliée à de multiples discours. Le discours techniciste, moralisateur, a permis d'engager une pédagogie du désenchantement en focalisant les discours sur le pôle scientifique. Le discours virtuose a servi la cause du contrôle du corps érigeant l'abnégation du travailleur en modèle de discipline. Le pôle magie théâtrale a permis de servir un discours ludique qui prône l'artificialité de son espace laissant en creux la question de la coprésence à un théâtre plus « conventionnel »[28]. Mais de tout temps, ces trois discours ont aussi servi l'émancipation, la distanciation du spectateur en l'incitant à transpercer de son regard les terreurs imaginaires d'illusions trop parfaites.

[27] E. Roch, « Avant-Propos », *Mémoires récréatifs, scientifiques et anecdotiques du physicien-aéronaute E.G. Robertson*, Paris, Chez l'auteur, 1831, p. IV.

[28] Frédéric Tabet, « L'art magique, lieu de la co-présence médiatique », *L'autre co-présence, révélations des relevés de mise en scène*, Atelier scientifique international, Université de Montréal, 13 juin 2014 (non publié).

Les techniciens et ouvriers des studios dans les années 1930 : enjeux et limites d'une histoire générale des métiers de la production cinématographique

Morgan Lefeuvre

> Le métier d'opérateur est intimement lié à la cohésion d'une équipe technique et ouvrière, prouvant abondamment que la création d'un film est une œuvre collective dans laquelle l'amitié est l'indispensable ferment[1].
>
> Henri Alekan

Signant la préface des mémoires de l'opérateur Alain Douarinou, Henri Alekan insiste sur la dimension collective de la création cinématographique et sur l'importance des relations humaines dans l'exercice de ce métier. Loin de présenter l'opérateur comme un créateur isolé, sorte de démiurge de la lumière ayant tout pouvoir sur la réussite finale du film, il souligne au contraire la présence indispensable à ses côtés d'une équipe large et soudée qui englobe toutes les catégories professionnelles du studio. Si chaque métier possède ses propres règles et ses savoir-faire spécifiques, il n'en demeure pas moins que les professionnels de la production cinématographique inscrivent tous leur pratique dans une démarche collective. Par conséquent, le chercheur qui s'intéresse à l'histoire des métiers et techniques cinématographiques éprouve bien souvent des difficultés à établir les limites de son objet d'étude et se voit contraint de naviguer sans cesse du général au particulier, de l'œuvre collective à la pratique singulière. Comment s'intéresser par exemple à la naissance

[1] Henri Alekan, préface des mémoires d'Alain Douarinou, *Un homme à la caméra*, Paris, éditions France Empire, 1989.

du métier d'ingénieur du son, sans s'interroger sur l'aménagement des studios, sur l'évolution des décors ou du matériel d'éclairage et de prise de vues imposés par le film parlant ? Comment éluder la question de sa délicate intégration au sein des équipes de production et de ses relations souvent tendues voire conflictuelles avec le chef opérateur ? Chaque métier, chaque geste technique semble s'inscrire dans une chaîne de décisions et d'actions dont il est parfois délicat d'isoler les maillons.

Dans le cadre d'une réflexion théorique et méthodologique sur les différentes manières d'appréhender les métiers et techniques cinématographiques, il me paraît intéressant d'interroger la pertinence d'une approche globale de la question. En effet, les difficultés rencontrées dans l'étude isolée des différents métiers, ne doivent-elles pas nous inciter à proposer une lecture plus large et plus systémique des pratiques professionnelles ? Penser l'exercice de chaque métier en fonction d'un contexte économique, technique ou social plus vaste et faire de leurs interactions l'objet même d'une recherche ne permettrait-il pas d'en éclairer le fonctionnement et les spécificités ? C'est à ce questionnement heuristique que cette contribution propose d'apporter quelques réponses, en s'appuyant sur une recherche menée il y a quelques années sur l'histoire des studios français des années 1930[2]. En raison de la structure même du système des studios français durant cette décennie – système reposant sur une multitude de structures de différentes tailles entretenant des liens étroits entre elles – et de la porosité existant à cette époque entre les différents métiers de la production cinématographique, une approche large, englobant l'ensemble des métiers du studio, s'est rapidement imposée. En effet, comment, en travaillant sur l'histoire des studios, faire l'économie d'une approche globale des métiers de la production ? Sauf à réduire les studios à leur seule dimension matérielle et technique, comment justifier de privilégier l'étude d'un ou plusieurs métiers tout en excluant les autres ? Une étude complète et approfondie du système des studios français devait nécessairement considérer les aspects techniques, économiques et sociaux aussi bien que culturels et humains de la question et englober l'ensemble des métiers participant au fonctionnement de ces infrastructures. Ce choix s'est révélé d'autant plus pertinent qu'au fur et à mesure de mes recherches, la centralité des studios dans le système de

[2] *Histoire générale des studios de cinéma en France (1929–1939)*, thèse de doctorat sous la direction de Michel Marie, Université Sorbonne Nouvelle - Paris 3, soutenue en décembre 2013.

production français des années 1930 devenait de plus en plus évidente, les plateaux de tournage et leurs dépendances constituant l'unique territoire commun d'un milieu professionnel géographiquement dispersé et socialement très hétérogène, le point de convergence de tous les métiers de la production. Le studio est, pour les années 1930, le prisme idéal à travers lequel envisager les métiers et techniques cinématographiques dans leur acception la plus large.

L'objet de cette contribution n'est pas, on l'aura compris, de proposer un zoom sur un métier ou une technique en particulier, mais bien d'interroger la possibilité, les enjeux et les limites d'une approche globale des métiers de la production, en s'appuyant sur le cas précis des studios français des années 1930. L'idée d'une histoire générale des travailleurs de la production a-t-elle un sens et quels éclairages spécifiques peut-elle apporter à l'histoire des métiers et techniques cinématographiques ? Au-delà de cette interrogation sur les enjeux et limites d'une telle approche, il s'agira de se poser la question des sources et de leur traitement notamment par le recours à l'outil numérique.

Pertinence d'une approche globale des métiers de la production cinématographique

Indépendamment du cas spécifique d'une recherche sur les studios, la dimension collective de la production cinématographique, évoquée par Alekan en préambule de ce texte, me paraît justifier pleinement la pertinence d'une approche globale des métiers de la production. Sans vouloir aplanir toutes les responsabilités, minimiser le rôle des principaux collaborateurs de création (scénariste, réalisateur, chef opérateur, décorateur, etc.), il est un fait que la réalisation matérielle et effective d'un film est toujours un geste collectif. La notion « d'équipes créatrices » est une réalité particulièrement bien ancrée dans les pratiques professionnelles du début des années 1930, période marquée par une relative stabilité d'emploi qui permettait aux décorateurs, mais également aux opérateurs, ingénieurs du son ou réalisateurs de travailler avec les mêmes collaborateurs sur plusieurs productions. Le processus de création d'un décor, par exemple, s'inscrit dans une longue chaîne de discussions et de réalisations dont les responsabilités incombent à de nombreux métiers, du chef décorateur qui conçoit le décor au machiniste qui participe à son montage sur le plateau, en passant par les assistants décorateurs, maquettistes, chef menuisiers, staffeurs, tapissiers,

accessoiristes ou peintres, sans oublier le chef opérateur chargé d'éclairer
le décor avec l'aide du chef électricien et de ses équipes. C'est certes au
chef décorateur qu'incombera la responsabilité du résultat final : c'est
à lui que le réalisateur adressera ses compliments ou ses reproches au
moment du tournage, mais s'il en porte la responsabilité, il est loin d'être
l'unique artisan de la réussite ou de l'échec de ce décor. Étudier le métier
de décorateur en ignorant ces interactions multiples avec les autres corps
de métiers du studio conduirait de toute évidence à une vision biaisée
de la réalité. Par ailleurs, l'exercice du métier de décorateur diffère de
beaucoup d'un film à l'autre mais également d'un studio à l'autre. En
fonction des caractéristiques techniques et des équipements dont dispose
le studio (dimension des plateaux, mise à disposition ou non d'un stock
de décor, outillage de la menuiserie, etc.) mais également en fonction
de son organisation interne (le studio dispose-t-il ou non d'un service
de décoration et d'équipes fixes ?), le décorateur y occupera un rôle plus
ou moins central et son travail s'en trouvera modifié. Lazare Meerson
ou Pierre Colombier, tous deux directeur du service de décoration
d'un grand studio (Tobis à Épinay-sur-Seine pour le premier et Pathé à
Joinville-le-Pont pour le second) sont chargés – en plus de leur travail de
conception des décors de plusieurs grandes productions chaque année –
de superviser la construction et l'aménagement des décors de l'ensemble
des films tournés dans le studio[3], de gérer le stock et d'assurer le bon
fonctionnement d'équipes pouvant compter jusqu'à 200 ouvriers durant
les périodes de forte activité. La pratique de leur métier de chef décorateur
est difficilement comparable à celle de Marius Brouquier, chef décorateur
des studios Pagnol à Marseille dans lesquels ne sont tournés qu'un à deux
films par an et ne disposant pas d'équipes fixes. Cet exemple du métier
de décorateur met en évidence l'importance qu'il peut y avoir à replacer
le geste créatif dans un contexte plus large afin d'en comprendre plus
clairement la portée et les limites dans le cadre d'une création collective.

Enfin, la dimension collective de la production cinématographique ne
doit pas être entendue dans un sens restrictif en la réduisant au noyau des
collaborateurs de création les plus proches du réalisateur. Dans les années
1930, elle englobe plus largement l'ensemble des équipes des studios.
Avant la première convention collective de juin 1936, qui encadre de
manière plus stricte les horaires de travail dans la production, les équipes

[3] Soit entre 3 et 27 longs métrages par an, auxquels il faut ajouter les nombreux courts
 métrages, une dizaine minimum par an.

d'ouvriers et de techniciens sont soumises aux impératifs des producteurs qui, pour réduire la durée des tournages, n'hésitent pas à leur imposer des rythmes de travail harassants, de jour comme de nuit. Il n'est pas rare, en effet, que durant les tournages, le personnel de production soit contraint d'enchaîner les journées de 14 ou 15 heures et bien souvent de passer la nuit sur les plateaux ou dans les ateliers, ce qui en dépit de la fatigue occasionnée, resserre inévitablement les liens au sein des équipes. Dans les toutes premières années du parlant, les tournages des films de René Clair dans les studios Tobis d'Épinay[4] sont vécus par les équipes comme une véritable aventure collective, une expérience intense dépassant largement le cadre convenu de l'exercice de leurs métiers respectifs. Son assistant Georges Lacombe compare ainsi chaque tournage de René Clair à une expédition hors du temps, « une longue traversée entre ciel et mer » dans laquelle le réalisateur « s'embarquait avec toujours la même équipe »[5]. Durant le tournage, le réalisateur s'installait durant plusieurs semaines aux studios d'Épinay avec ses deux complices, le décorateur Lazare Meerson et le chef opérateur Georges Périnal (auxquels se joignait parfois le compositeur Georges Auric), ne regagnant que rarement Paris. Tous les témoignages évoquent les discussions collectives autour de la conception d'une scène, les nuits sans sommeil passées à concevoir ou construire un décor, les loges transformées en dortoirs pour les techniciens et l'atmosphère joyeuse qui régnait dans les ateliers et sur les plateaux[6]. Dans ce contexte, certes exceptionnel, il paraît difficile de déterminer avec précision le rôle des uns et des autres dans le processus de création et de comprendre la pratique d'un métier en ignorant les conditions particulières dans lesquelles il s'exerce. Moins souvent citées, les équipes ouvrières font elles aussi partie de cette aventure collective et René Clair ne manque pas de le souligner quand il déclare dans *Pour Vous* à la fin du tournage de *Sous les toits de Paris* :

[4] *Sous les toits de Paris, Le Million, À nous la Liberté !* et *14 Juillet,* tournés entre janvier 1930 et novembre 1932.

[5] Archives de la Cinémathèque française, fonds de la commission de recherches historiques, CHR 96 B5, séance non datée consacrée à René Clair, témoignage de Georges Lacombe.

[6] Voir en particulier Georges Charensol, René Régent, *Cinquante ans de cinéma avec René Clair,* Paris, éditions de la Table ronde, 1979, p. 83 et Archives de la Cinémathèque française, fonds de la Commission de recherches historiques, CHR 96 B5, séance non datée consacrée à René Clair, témoignage de Georges Auric.

Je ne termine jamais un film sans éprouver un sentiment de profonde reconnaissance envers les collaborateurs de toutes sortes qui m'ont permis d'accomplir ma tâche. Je crois qu'il m'est possible de faire un film passable sans « grandes vedettes », mais je ne crois pas pouvoir le faire si, par exemple, un bon accessoiriste et une bonne équipe de machinistes et d'électriciens me font défaut. Presque tous les travailleurs qui nous entourent dans les studios sont animés d'une sorte d'esprit sportif étonnant […] presque tous apportent à la collaboration commune une initiative, un désir de bien faire, un sens des responsabilités qui font mon admiration.[7]

Cette citation, et plus largement l'exemple des tournages de René Clair, mettent clairement en évidence l'imbrication très forte des différents corps de métiers dans la réalisation d'un film, confirmant pleinement l'intérêt et la pertinence d'une approche globale de ces métiers.

Indépendamment de son intérêt scientifique, le parti-pris choisi nécessite de préciser les contours de l'objet de recherche. Contrairement à une étude circonscrite à un métier spécifique, une analyse portant sur les « travailleurs des studios » pose quelques questions sur les limites du champ. De quels métiers parle-t-on ? Lorsque l'on évoque les métiers du cinéma, il s'agit principalement des métiers ayant une dimension technique ou artistique, éventuellement économique. Mais si personne ne mettra en doute la légitimité des chefs opérateurs, décorateurs, *script-girls*, ingénieurs du son ou monteurs à entrer dans la catégorie des « métiers du cinéma », le sort des secrétaires de production, des chefs comptables de studios ou des ingénieurs mécaniciens paraît plus incertain. Les standardistes ou les concierges des studios parisiens sont-ils des professionnels du cinéma ? Où arrêter la liste ? Dans le cadre d'une recherche sur les studios, ce sont les limites géographiques qui se sont imposées comme les plus pertinentes. Ont donc été pris en considération tous les professionnels qui travaillent dans l'enceinte des studios, qu'ils soient acteurs, figurants, techniciens, ouvriers, employés de la production ou des services administratifs, ce choix n'étant pas sans poser quelques difficultés et renoncements.

En effet, avec un panel aussi large de métiers, l'approche scientifique et la nature même des recherches ne peuvent être similaires à celles pratiquées dans le cadre d'une recherche sur un seul métier ou *a fortiori* sur une technique spécifique[8]. Il ne peut être question à une échelle aussi

[7] Nino Frank, « Quelques pas dans un jardin avec René Clair », *Pour vous*, n° 77, 8 mai 1930, p. 7.

[8] Voir dans cet ouvrage, les contributions de Réjane Hamus-Vallée et Caroline Renouard sur le *matte painting*.

vaste de proposer une étude approfondie des savoir-faire et pratiques professionnels de chacun des métiers concernés mais bien de s'intéresser aux conditions de travail d'un milieu professionnel dans sa globalité et aux interactions entre les différents métiers en question. Cette étude générale des professionnels de la production ne permet pas non plus de traiter avec la même précision l'ensemble des métiers du studio, certains d'entre eux n'ayant laissé que très peu de traces dans les archives. Si une telle recherche doit reposer sur des informations aussi riches et variées que possible et s'appuyer sur des études de cas précis, il ne s'agit pas de retrouver pour chaque métier la trace d'un geste technique mais bien d'éclairer le contexte dans lequel ce geste va se développer. On pourrait ainsi dire que cette approche globale s'apparente davantage à une histoire économique et socio-culturelle des professionnels de la production qu'à une histoire générale des métiers et techniques cinématographiques[9]. Il n'existe à mon sens aucune opposition entre ces deux approches, qui, bien au contraire, visent à se compléter. Le fait de varier les échelles d'analyse permet de mettre en perspective les métiers ou les techniques étudiés en les intégrant dans une réflexion plus large, de même que des études de cas pointues peuvent nourrir la réflexion et éclairer la compréhension du fonctionnement des studios.

L'histoire générale des studios : révélateur de la diversité des métiers de la production cinématographique et de leurs interactions multiples

Cette approche globale qui impose au chercheur quelques limites dans son appréhension des différents métiers, permet néanmoins d'éclairer certains aspects de la production cinématographique délaissés par les études plus spécifiques. Elle lui offre, tout d'abord, la possibilité

[9] Si les études d'histoire économique ou culturelle du cinéma ne s'intéressent à la question des métiers que de manière périphérique (voir notamment les travaux de Laurent Creton, *Histoire économique du cinéma français, production et financement 1940–1949*, Paris, CNRS éditions, 2004, de Jacques Choukroun, *Comment le parlant a sauvé le cinéma français : une histoire économique (1929–1939)*, Paris, AFRHC, 2007 ou de Dimitri Vezyroglou, *Le cinéma en France à la veille du parlant*, Paris, CNRS éditions, 2011), l'histoire des métiers, encore embryonnaire en dépit d'un intérêt grandissant depuis quelques années, reste dominée par une approche sectorielle (voir, par exemple, les travaux de Priska Morrissey sur les chefs opérateurs ou ceux de Martin Barnier sur les ingénieurs du son).

d'évoquer des métiers qui ne sauraient, faute de sources suffisantes, faire l'objet d'une étude à part entière mais qui sont pourtant indispensables au fonctionnement des studios et, par conséquent, à la production cinématographique. Analyser les conditions de travail et les parcours professionnels des employés administratifs des studios apporte ainsi des éclairages précieux sur les liens pouvant exister entre les différents métiers de la production cinématographique. S'il ne viendrait à personne l'idée d'entreprendre une recherche sur les standardistes ou les sténo-dactylo des studios français, il est pourtant intéressant de constater que certaines *script-girls* ont tout d'abord occupé ces emplois avant d'évoluer professionnellement et d'intégrer l'équipe des techniciens de la production[10]. Une attention portée aux employés des studios (dont l'activité n'est pas directement liée à la création cinématographique) permet également de mieux comprendre le fonctionnement interne des sociétés de production et, bien souvent, d'éclairer les conditions d'accès aux différents métiers du studio. Prenons le cas de Marcel Lathière qui, entré dans les studios de la rue Francœur à l'âge de 13 ans comme simple groom, occupe diverses fonctions administratives au sein du service des achats avant d'intégrer les services de la production jusqu'à devenir secrétaire général du groupe Franstudio après-guerre[11]. La lecture de ses mémoires centrées sur sa vie professionnelle chez Pathé offre d'innombrables données factuelles sur les rémunérations, les rythmes de travail ou l'organisation des services, mais permet également de deviner les liens et les tensions pouvant exister entre les différentes catégories professionnelles du studio. Des recherches sur les employés des services administratifs peuvent ainsi apporter un éclairage intéressant sur les possibilités de promotion au sein des studios, sur la formation et le parcours de certains techniciens.

Une histoire générale des studios permet notamment d'aborder la question centrale et complexe de la formation aux métiers du cinéma. Avant la Seconde Guerre mondiale et la création en 1943 de l'Institut des hautes études cinématographiques (IDHEC)[12], il n'existe en France

[10] C'est le cas par exemple de la scripte Jeanne Witta qui débute sa carrière comme secrétaire sténo-dactylo au service des scénarios des studios Paramount de Saint-Maurice avant de devenir rapidement une *script-girl* très appréciée des réalisateurs et producteurs.

[11] Le groupe Franstudio fondé en 1946 assurait l'exploitation des studios Pathé et Gaumont de Joinville, Francœur et Saint-Maurice, ainsi que les studios de Marcel Pagnol à Marseille et le petit studio de la place Clichy.

[12] Voir, dans cet ouvrage, l'article de Marie-Charlotte Téchené.

aucune structure d'apprentissage spécifique à ces métiers. À l'exception des opérateurs et décorateurs qui entrent pour certains avec quelques connaissances théoriques en optique ou en dessin (acquises à l'école de Vaugirard[13] ou aux Beaux-Arts), l'immense majorité des ouvriers et techniciens de la production entrent dans les studios sans connaissance théorique ni expérience pratique. Dans leur immense majorité, les métiers de la production cinématographique s'apprennent donc à « l'école du studio ». Il ne s'agit pas d'une formation organisée mais d'un apprentissage sur le tas, basé sur l'observation et la création spontanée de binômes « maître-apprentis », certains techniciens confirmés acceptant de prendre sous leur aile de jeunes assistants débutants. Cet apprentissage n'étant pas formalisé (aucun stagiaire ou apprenti n'est jamais signalé dans les archives de production des films ou dans la comptabilité des studios), ce n'est qu'en s'intéressant à l'activité des studios dans leur ensemble et à tous les corps de métiers qui s'y rattachent que cette question de la formation aux métiers de la production apparaît en filigrane. Cette approche globale permet également de prendre conscience de l'importance des réseaux et des recommandations dans l'accès à la profession. En multipliant les études de cas se rattachant à divers métiers ou catégories professionnelles (techniciens comme ouvriers), il apparaît nettement que les réseaux professionnels jouent un rôle fondamental dans l'accès aux métiers de la production. Les exemples de techniciens ayant fait leurs premiers pas dans la production cinématographique grâce à l'appui d'un ami ou d'une connaissance sont légion, à l'image de l'opérateur Alain Douarinou. En 1932, ce dernier entre pour la première fois dans un studio de cinéma en tant que second assistant du chef opérateur Willy Faktorovitch dont il avait rencontré fortuitement le cadreur (Nicolas Hayer), quelques semaines auparavant. Délaissant la monotonie de son métier d'employé de banque, il participe, sans aucune formation, à son premier tournage (un court métrage de Roger Capellani) pour 700 Francs par semaine[14]. Les modalités d'accès à une profession, la découverte d'un métier puis son apprentissage, sont des éléments déterminants dans la compréhension d'un parcours professionnel. Pourtant, ils ne peuvent être analysés qu'en

[13] L'École technique de photographie et de cinéma, alors située rue de Vaugirard à Paris, et qui deviendra par la suite École nationale supérieure Louis-Lumière, est fondée en 1926. Jusqu'en 1947, elle se consacre exclusivement au domaine de la prise de vues et de la projection.

[14] Alain Douarinou, *Un homme à la caméra*, op. cit., p. 17. Alain Douarinou précise que ce salaire hebdomadaire correspondait à son salaire mensuel comme employé de banque.

prenant en considération l'importance des réseaux de sociabilité qui dépassent largement les frontières d'un métier.

L'histoire des métiers à travers le prisme du studio permet également d'envisager la variété des pratiques et des parcours professionnels et d'évoquer certains métiers parfois difficiles à identifier avec précision. Si le cinéma a connu au fil des décennies une professionnalisation croissante, marquée par la mise en place de formations spécifiques et une définition de plus en plus précise des métiers, cela n'a pas toujours été le cas, loin s'en faut. Dans les années 1930, de nombreux professionnels ne semblent pas avoir de métier bien déterminé ou naviguent d'un métier à l'autre au gré des opportunités ou des besoins de la production. Si certains techniciens, à l'image du jeune Henri Alekan[15], démarrent leur carrière en étant parfaitement déterminés à devenir opérateur ou réalisateur, la plupart des professionnels franchissent les portes des studios sans volonté précise ni attirance pour un métier en particulier, mais avec le seul désir de pénétrer un milieu, « d'entrer dans le cinéma », comme on entrerait en religion. Une fois dans les lieux, toute place semble bonne à prendre, pourvu qu'elle assure au nouvel arrivant un salaire et lui permette de rester en contact avec ce milieu professionnel. En 1930, le journaliste et romancier André Lang est ainsi engagé par la société Pathé-Natan, dans un premier temps comme responsable éditorial d'un hebdomadaire cinématographique qui ne verra jamais le jour, avant d'être finalement promu « Directeur adjoint de la production de Pathé-Cinéma[16] ». Dans les années 1930 à 1935, André Lang semble participer de près à l'activité de cette société, sans que son rôle de directeur adjoint de la production ne soit clairement établi. Il est l'auteur des scénarios de quatre productions Pathé-Natan[17], mais également du *Voleur* (1933) de Maurice Tourneur, une production de Vandal et Delac, tournée dans les studios Pathé de Joinville. Durant cette même période, il signe la préface d'une biographie de Marcelle Chantal, actrice sous contrat chez Pathé et se trouve également crédité comme assistant réalisateur d'Anatole Litvak sur le film *L'Équipage* (1935), dernière production Pathé-Natan avant la mise en

[15] Henri Alekan, *Le vécu et l'imaginaire : chroniques d'un homme d'images*, Paris, La Sirène, 1999.

[16] André Lang, « Dans la cour des mirages. Joinville inconnu », *Pour vous*, n° 457, 19 août 1937, p. 8.

[17] *Ariane, jeune fille russe* de Paul Czinner (1931), *Les Croix de bois* de Raymond Bernard (1931), *Les Misérables* de Raymond Bernard (1931) et *Amok* de Fedor Ozep (1933).

faillite de la société. Apparaissant régulièrement sur les photos de tournage des productions Pathé de la période, il a indéniablement joué un rôle non négligeable dans la production cinématographique de la première moitié des années 1930 sans être clairement identifié comme directeur de production, scénariste ou assistant réalisateur. Dans les premières années de la décennie, les studios Paramount de Saint-Maurice étaient peuplés d'auteurs, assistants en tous genres ou aspirants cinéastes (au premier rang desquels Marcel Pagnol), auxquels le directeur des studios, Robert Kane, distribuait généreusement les titres de « superviseurs » sans que n'y soit attachée une fonction bien déterminée[18]. Le personnel moins qualifié n'échappe pas à ce flou qui entoure bien souvent les fonctions des professionnels du cinéma. Un peintre embauché comme ouvrier pour peindre des décors au pistolet et ponctuellement affecté à la réalisation d'une découverte ou d'un tableau pour habiller un décor doit-il être considéré comme un ouvrier ou un technicien ? Un simple exécutant ou un collaborateur de création au même titre qu'un assistant décorateur ? De même, comment établir la frontière entre le métier d'habilleuse, celui de couturière ou de costumière ? Certes, en théorie, les couturières et habilleuses sont embauchées directement par le studio et rétribuées à la semaine au tarif de la main d'œuvre ouvrière, tandis qu'une costumière est engagée par la production et rémunérée à la semaine ou au cachet pour sa création pour le film. Dans la pratique, la frontière est moins nette et les « ouvrières-couture » du studio sont bien souvent chargées de modifier, voire confectionner des costumes pour les figurants et les petits rôles, tandis que la costumière (ou le costumier) sera chargée de concevoir ceux des principaux acteurs.

Une recherche large, portant sur l'ensemble des activités des studios, offre également la possibilité de retracer des parcours non linéaires et de mettre en évidence les nombreuses passerelles qui existent entre les métiers de la production, permettant ainsi une meilleure compréhension des pratiques professionnelles de cette époque. La mobilité à l'intérieur des studios ne se fait pas uniquement en gravissant les échelons au sein d'un même corps de métier. Certes, les chefs décorateurs ont en général débuté comme dessinateur, puis assistant, puis décorateur avant d'obtenir la direction artistique d'une production, mais bien des réalisateurs ont

[18] Voir notamment le cas de l'acteur et réalisateur Charles de Rochefort qui évoque son passage dans les studios Paramount dans ses mémoires : Charles de Rochefort, *Secrets de vedettes : le film de mes souvenirs*, Paris, Société parisienne d'édition, 1943, p. 207.

pratiqué plusieurs métiers avant d'accéder à cette fonction et les passerelles sont nombreuses d'un métier à l'autre. Le cas du réalisateur Jean Devaivre est à ce titre assez éclairant. Formé aux Beaux-Arts, il est tout d'abord engagé par une société de distribution pour laquelle il crée des affiches et réalise des bandes annonces. Parallèlement à cet emploi, il décide de suivre les cours du soir « Ciné-photo-radio » de l'École nationale des arts et métiers (où il s'initie au montage) et se voit confier le remontage de certains films distribués par la compagnie de distribution qui l'emploie. Pourtant, c'est en qualité d'assistant décorateur qu'il participe à sa première réalisation (*Deuxième Bureau* de Pierre Billon tourné en 1935 à Épinay-sur-Seine), avant de devenir assistant réalisateur de Léon Mathot l'année suivante (pour le film *Les Loups entre eux*, 1936), tout en continuant ses travaux de montage pour la Compagnie française de distribution. Dans la même période, il supervise des travaux de doublage et sera ensuite embauché par Léo Joannon comme directeur de production et monteur de son film *Alerte en Méditerranée* (1938). Après avoir multiplié les expériences comme assistant-réalisateur pendant l'Occupation[19], il réalise enfin son premier film, *Le Roi des resquilleurs* en 1945[20].

Enfin, l'analyse socio-culturelle de ce milieu professionnel offre la possibilité d'évoquer les temps creux de la production, de s'intéresser aux à-côtés du métier, à ces lieux et ces temps de sociabilité durant lesquels se créent les réseaux professionnels et se nouent les amitiés dont dépendent bien souvent la carrière des professionnels du cinéma. En dressant un bilan précis, semaine après semaine, de l'activité des studios français et en mettant en évidence les variations d'activité on obtient une vision plus complète des pratiques professionnelles. Dans la première moitié des années 1930, l'exercice des métiers de la production ne se cantonne pas aux périodes de réalisation. Entre deux tournages, le personnel des studios est en effet affecté à l'entretien ou à l'amélioration du matériel. Entre deux films de long métrage, on procède à l'inventaire des stocks de décor, on répare ou on améliore les systèmes d'éclairage ou le matériel de prise de vues ; dans les plus grands studios décorateurs, opérateurs et ingénieurs-mécaniciens mettent au point de nouveaux équipements (ascenseurs, plateformes pivotantes, grues, etc.) Les tournages de courts métrages sont également l'occasion de tester du nouveau matériel ou de

[19] Il devient alors l'assistant de Maurice Tourneur, André Cayatte ou Richard Pottier sur des films produits par la société allemande Continental Films.

[20] Jean Devaivre, *Action !*, Paris, éditions Nicolas Philippe, 2002.

nouvelles techniques (nouvelles caméras, prises de vues sous-marines, film couleur). Cette partie du travail n'apparaît pas dans la filmographie d'un chef opérateur ou d'un décorateur, elle fait pourtant partie intégrante de son métier et ne peut être révélée qu'en consignant de manière minutieuse toutes les informations relatives à l'activité quotidienne des studios.

Écrire une histoire générale des métiers de la production : problèmes méthodologiques, bilan et perspectives

Aussi fructueuse soit-elle, cette démarche scientifique qui tend à élargir au maximum le spectre des métiers considérés, n'est pas sans poser quelques problèmes d'ordre méthodologique qu'il me paraît important d'évoquer ici. En ce qui concerne les sources, le chercheur oscille entre surabondance et profondes lacunes. L'approche retenue implique, en effet, d'avoir recours à un corpus extrêmement large de sources et de procéder à un dépouillement quasi exhaustif de la presse spécialisée et des archives de production de la période. La mémoire des studios se trouve disséminée en une multitude de fonds d'archives dont aucun, hormis dans les archives de la société Pathé, ne se rapporte explicitement aux infrastructures ou à l'activité d'un studio en particulier. Il s'agit donc pour le chercheur de dépouiller aussi bien les annuaires professionnels que les catalogues et répertoires de films de la période (afin d'établir des fiches techniques complètes pour chacun des films réalisés), des archives de production (en particulier les devis, contrats, plans de travail ou rapports de tournage), des fonds publics (pour tout ce qui concerne le droit du travail, l'application des lois sociales dans les studios ou la situation matérielle et financière des techniciens de la production), des archives syndicales que des mémoires ou témoignages. En dépit de l'abondance et de l'éclectisme des sources dépouillées, certains aspects de cette histoire générale des métiers de la production restent très peu documentés, tandis que les informations abondent sur certains sujets. On constate tout d'abord un déséquilibre géographique évident, le statut des travailleurs et les conditions de travail étant bien mieux documentés pour les grands studios parisiens que pour les petites structures ou les rares studios situés en province. Je n'ai ainsi obtenu aucune information de première main sur les travailleurs des studios de Saint-Laurent-du-Var, de Marseille ou les studios d'Émile Couzinet à Royan. Mais la taille des infrastructures ne suffit pas toujours à expliquer l'inégale représentation

des studios dans les archives. Exploités par des sociétés souvent éphémères et peu soucieuses de se constituer une mémoire, de nombreux studios actifs dans les années 1930 (comme les studios François 1er ou les studios de Neuilly) n'ont laissé aucune archive sur lesquelles s'appuyer pour retracer leur histoire. Il existe également un déséquilibre évident entre les catégories professionnelles. Si les techniciens sont relativement bien représentés dans les archives, les employés et ouvriers le sont beaucoup moins au début de la décennie. Toutefois, cet écart se comble quelque peu à partir de 1935–1936 avec le développement de l'activité syndicale dans les studios qui donne une plus grande visibilité (y compris dans la presse et dans les rapports officiels) aux catégories ouvrières. Au sein même des techniciens, il existe de grandes disparités de représentation. Le métier d'opérateur, ancien et doté d'un syndicat depuis 1919, est ainsi bien mieux documenté que celui d'ingénieur du son. En dépit de leur rôle central dans les studios au début du parlant, on ne sait finalement que peu de choses sur ces nouveaux-venus dans les équipes de réalisation, pour lesquels les archives ne livrent que de rares indices. Il en est de même pour les costumiers, les maquilleurs ou les peintres décorateurs qui n'apparaissent que rarement au générique des films et dont on ignore bien souvent le statut, le niveau de rémunération ou la durée des contrats.

La documentation n'en reste pas moins très importante et face à l'avalanche d'informations de toutes natures recueillies dans ces multiples sources, se pose inévitablement la question de leur traitement. Comment hiérarchiser, trier, organiser la multitude de faits, de chiffres, de dates et de noms extraits de ces documents ? Au-delà du travail de critique des sources et de recoupement des données indispensable et commun à toute recherche historique, le recours à l'outil numérique (plus précisément les bases de données) s'est rapidement imposé comme une étape indispensable afin de pouvoir mobiliser rapidement les informations mais également établir des comparaisons, des recoupements ou des statistiques. J'ai donc établi, de manière simple et sans mobiliser une expertise spécifique dans le domaine, plusieurs bases de données. La première – qui compte plus de 2 000 entrées – porte sur les tournages et recense pour chaque studio les films qui y ont été tournés en indiquant pour chacun les dates de tournage, la composition des équipes techniques et artistiques et toute information relative à la production (difficultés techniques, informations spécifiques sur le décor, sur la figuration, les tournages des extérieurs, etc). La deuxième – qui compte plus de 400 entrées – est centrée sur le personnel technique des studios. Pour chaque personnalité sont

consignées les informations relatives à leurs fonctions au sein des studios, mais également pour certains à leurs contrats et niveaux de rémunération. Enfin, une dernière base – comportant 2 250 entrées organisées en quinze thématiques – permet de consigner toutes les informations, tous les faits relatifs à l'organisation des studios, aux conditions de travail, à la vie associative ou syndicale des professionnels ou tout événement touchant de près ou de loin les travailleurs des studios (réception de presse, grève, innovation technique, construction d'un garage à vélo, accident du travail, incendie…). Ces bases de données m'ont ainsi permis de disposer d'informations inédites sur le fonctionnement de l'ensemble des studios français sur une décennie (nombre de films tournés, dates de tournage, variation d'activité, périodes de fermeture, etc.). Bien que leur exploitation se révèle extrêmement fructueuse, la réalisation de ces bases de données – qui requiert un minimum de savoir-faire technique – pose plusieurs difficultés au chercheur. La première, d'ordre pratique, tient au caractère chronophage de l'entreprise. Chaque article de presse, chaque témoignage ou chaque document d'archive dépouillé contient en général des informations multiples qui devront être réparties en fonction de leur nature dans les différentes bases. Un plan de travail pourra ainsi contenir des informations relatives aux personnes ayant participé au film (noms, adresse, fonction), des précisions sur le studio et les dates de tournage ou encore des informations sur le temps de construction des décors et le rythme de travail des équipes ouvrières. Effectuer cette lecture thématique et cette sélection des informations pour chaque document consulté implique de disposer d'un temps suffisamment conséquent ou de travailler en équipe avant de pouvoir récolter les fruits de ce travail minutieux. Au-delà de cet obstacle matériel, il n'est pas toujours évident de faire entrer des éléments d'information parfois complexes dans des catégories nécessairement réductrices. Certaines informations sont, en effet, rétives au classement. Quel métier ou quelle fonction associer au jeune Marcel Carné sur le tournage de *Sous les toits de Paris*, lui dont le nom ne figure pas au générique ? Engagé officiellement comme second assistant à la mise en scène, il indique dans ses mémoires avoir rempli les fonctions de *script-girl*, ce que confirme d'ailleurs Edmond T. Gréville[21].

[21] Marcel Carné, *La vie à belles dents*, Paris, éditions Jean-Pierre Ollivier, 1975, p. 31 et Edmond T. Gréville, *Trente-cinq ans dans la jungle du cinéma*, Lyon/Arles, Institut Lumière/Actes Sud, 1995, p. 90. Gréville avec lequel René Clair souhaitait travailler, avait été engagé comme acteur, le réalisateur n'ayant pu lui trouver un autre emploi sur ce film…

Quant à Denise Tual, évoquant le tournage du *Requin* (1930) d'Henri
Chomette, elle raconte y avoir été tout à la fois assistante de production,
apprentie monteuse et *script-girl*, sans que son nom n'apparaisse au
générique ni dans les fiches techniques du film publiées dans la presse
corporative[22].

En dépit des limites inhérentes à tout procédé de classement
des informations, le recours à l'outil numérique est l'unique moyen
d'exploiter cette multitude de renseignements et offre des perspectives
intéressantes pour faire progresser la recherche sur les métiers et
techniques cinématographiques. L'exploitation de ces bases de données
permet d'une part de retracer en détail des parcours de professionnels. De
faire apparaître – pour un individu ou un groupe de personnes – les
différentes fonctions qu'ils ont occupées, l'évolution de leurs statuts ou
de leurs rémunérations et de mettre en évidence la mobilité géographique
d'un technicien. Était-il attaché à un studio ou au contraire extrêmement
mobile ? Cela a-t-il évolué dans le temps ? Cette mobilité est-elle liée
à un réseau de proches collaborateurs ou est-elle seulement dictée par
les besoins de la production ? L'extraction rapide de données précises au
sein de ces milliers d'informations offre la possibilité au chercheur de
mieux comprendre les affinités qui se mettent en place entre réalisateurs,
producteurs et techniciens. Il arrive bien souvent que des professionnels
se rencontrent au sein des studios, en marge de leurs films respectifs ;
savoir que l'équipe de réalisation de telle production s'est trouvée dans
tel studio au même moment que telle autre équipe peut s'avérer utile à
la compréhension de certains rapprochements entre professionnels. Ces
bases de données permettent également d'établir des organigrammes des
services de production des studios en activité, qui ne peuvent être établis –
faute de documents d'archives plus complets – que par le recoupement
d'informations multiples provenant de différentes sources. L'outil
numérique offre enfin la possibilité d'introduire une dimension spatiale
à l'analyse des pratiques professionnelles. Outre les informations d'ordre
professionnel, j'ai consigné dans la base de données sur les personnalités
quelques 1 720 adresses personnelles de techniciens et ouvriers qui ont
permis la réalisation d'un travail de cartographie et d'analyse spatiale de
ces données. Par un travail de géolocalisation des studios et des adresses
des professionnels de la production, il est possible de visualiser sous
forme de cartes, les principaux studios ainsi que leur niveau d'activité

[22] Denise Tual, *Le temps dévoré*, Paris, Fayard, 1980, p. 58.

(et l'évolution dans le temps de cette répartition de la production), mais également l'existence ou non de bassins d'emploi autour des principaux studios.

Ce travail réalisé de manière artisanale et à un niveau individuel dans le cadre de mes travaux sur les studios français des années 1930, offre, me semble-t-il, des perspectives intéressantes tout en invitant les historiens du cinéma à une réflexion sur la nécessaire mise en commun des recherches effectuées dans ce champ. Empruntant aussi bien aux méthodes de l'histoire quantitative qu'à celles de l'histoire prosopographique, cette histoire générale des métiers de la production doit s'appuyer sur une masse de données fiables, collectées et répertoriées avec soin. Elle ne peut donc être, à l'image de la création cinématographique, qu'une œuvre collective.

Faire l'histoire du métier de scripte à partir de ses documents de travail

Lauren BENOIT

Comment, à partir des vingt-cinq fonds d'archives de scriptes conservés à la Cinémathèque française, tenter d'établir l'histoire d'un métier aux origines, aux fonctions et aux pratiques aujourd'hui encore obscures ? Un métier pour lequel les définitions mêmes semblent peu éclairantes car circonscrivant à grand peine la pluralité de tâches et le champ d'action qu'il embrasse. Parmi ces définitions, deux sont officielles. La première est celle de la Convention collective nationale des techniciens de la production cinématographique du 30 avril 1950 : « Auxiliaire du réalisateur et du directeur de production. Elle veille à la continuité du film et établit, pour tout ce qui concerne le travail exécuté sur le plateau, les rapports journaliers artistiques et administratifs ». La seconde est issue de la précédente, corrigée à l'initiative de l'association Les Scriptes Associés[1] (LSA) en 2006 : « Collaborateur direct technique et artistique du réalisateur. Responsable de la continuité, il veille à sa bonne mise en œuvre auprès des différents départements pendant la préparation et le tournage du film. Il suit le minutage et fait le lien entre le montage et la direction de production ». Dès lors, de quelles réalités du métier et de son évolution les divergences (et convergences) perceptibles entre ces deux définitions témoignent-elles ? Cette redéfinition récente nous permet de poser les jalons de notre recherche : prend-elle acte d'une mutation du métier au début des années 2000 ou bien est-elle l'expression de revendications « politiques » de la part d'une association professionnelle nouvellement constituée, en particulier celle de la reconnaissance d'une implication systématique du scripte dans la mise en scène (le passage du

[1] Voir le site de l'association : <http://www.lesscriptesassocies.org/>.

féminin au masculin étant lui-même porteur de la volonté de transmettre une autre image de la profession)?

Bien avant l'action de LSA, c'est Sylvette Baudrot – scripte à laquelle sont restés fidèles Alain Resnais, Roman Polanski et Costa-Gavras, pour ne citer qu'eux – qui a veillé à mettre en lumière cette profession par le biais d'entretiens et de dons à la Cinémathèque française. En effet, le grand attrait de l'étude des pratiques du métier en France réside dans le fait admis que c'est sur les tournages français que le rôle du scripte s'avère le plus riche. Il y occupe une place centrale sur le plateau, en lien avec tous les départements et au carrefour de la technique, de l'administratif et de l'artistique. Cette figure, jusqu'alors quasi exclusivement féminine, s'est vue affublée à juste titre du surnom de « mémoire du film » car elle est non seulement celle qui a acquis la plus intime connaissance du scénario, mais elle est aussi la plus grande productrice d'archives sur le plateau, et notamment de rapports qui forment aujourd'hui la trace la plus précise et la plus précieuse de la genèse des films. Il nous est donc permis d'espérer qu'en suivant le fil de ce très large éventail typologique de documents de travail, nous parviendrons à faire ressurgir les indices et subtilités de ces facettes plurielles et *in fine* à tisser une histoire du métier.

Cette histoire débute sur une béance, celle de près de vingt années de pratiques pour lesquelles nous ne pouvons déterminer ni l'étendue des fonctions du scripte ni les méthodes employées, et encore moins nous figurer les formes prises par ces documents. Car si nous pouvons considérer que le métier est apparu en France au début des années 1930, la Cinémathèque française ne possède pas d'archives antérieures à la fin des années 1940. En revanche, à partir des années 1950, il existe pléthore d'archives dont la richesse n'a d'égal que la complexité. Le scripte élabore, collecte et annote des documents classés en deux catégories : ceux servant au respect de la continuité et aux raccords et les rapports destinés à d'autres départements. De fait, les fonds recèlent des documents préparatoires actualisés sur le plateau (continuités chronologiques, dépouillements, etc.), des scénarios annotés, des rapports montage qui témoignent du travail de la mise en scène et des rapports production et horaire qui fournissent un compte-rendu quotidien de l'avancée du tournage par le biais d'indications techniques et de renseignements chiffrés. La mise en parallèle de ces fonds révèle, en premier lieu, que l'évolution du métier est rendue sensible par l'apparition de documents nouveaux, la modification ou la suppression d'autres, mais également que l'évolution des méthodes de travail des scriptes correspond souvent à leur adaptation

à de nouveaux outils. Il importe néanmoins de parvenir à distinguer ce qui relève de l'évolution du métier ou de son statut, de ce qui relève du parcours singulier de chaque scripte qui perfectionne ses méthodes au fil des expériences, et de ce qui concerne sa relation particulière avec le réalisateur. Or le degré d'implication du scripte dans la mise en scène dépend grandement de sa complicité avec le réalisateur et il est rare que les archives puissent l'expliciter. Ainsi, seul le témoignage du metteur en scène est susceptible d'exposer clairement les qualités d'observateur discret, de conseiller bienveillant et de diplomate du scripte.

Deux autres aspects sont à évoquer. Si le scripte est la mémoire du film, le film en revanche est une source difficilement exploitable dans l'établissement d'une histoire du métier. Cela tient au rôle même que le scripte joue dans la production : puisqu'il possède la vision globale du scénario et s'assure que des séquences tournées dans la discontinuité, pour des raisons logistiques et économiques, puissent être raccordées sans heurts au montage, il est logique que son travail ne transparaisse pas dans le film. *A contrario*, la compréhension de ces archives n'est rendue possible que par la mise en parallèle de tous les documents de scripte pour chaque film, par leur assemblage de manière à reconstituer le puzzle du tournage et surtout par leur confrontation avec le film achevé. Si nous tenons compte de la somme d'informations contenues dans une seule archive, nous entrevoyons le travail colossal que demande l'étude des fonds de scriptes. Le second aspect est que ces archives sont aussi porteuses d'autres histoires : celle du travail de tous les autres postes du plateau, des aléas rencontrés sur chaque film et de l'évolution des rythmes de tournage.

Les origines d'un métier

Pour pallier cette béance de plus de vingt ans, nous disposons de sources telles que les autobiographies, les annuaires professionnels et les périodiques. Les contradictions qui s'y repèrent ne nous autorisent qu'à former des hypothèses, tout en considérant que celles-ci peuvent nourrir une réflexion intéressante sur les causes et les conditions de l'émergence de ce métier et *a fortiori* sur son statut actuel. Les témoignages qui se heurtent le plus manifestement sont les autobiographies du réalisateur Henri Diamant-Berger et de celle qui est considérée comme la première scripte française : Jeanne Witta-Montrobert. Le premier s'attribue la paternité du métier, créé pour *Les Trois Mousquetaires* en 1921 : « J'y

ajoute, et c'est une innovation, une secrétaire, afin de prendre des notes sur les raccords des milliers de plans à tourner... Comme je suis libre de conduire le film à ma guise mais que pour les dépenses administratives, je suis soumis à un contrôle tracassier, j'affirme que ce poste existe aux États-Unis et je l'affuble d'un nom américain imaginaire : *script-girl*. Plus tard, les réalisateurs d'outre-Atlantique adopteront le procédé »[2]. Jeanne Witta raconte, quant à elle, qu'elle était chargée en 1931 de traduire les scénarios dans les diverses langues des membres du tournage au studio de Saint-Maurice possédé par la Paramount. Son patron décide de l'embaucher en tant que scripte sur le film *Mistigri* de Harry Lachman (1931) parce qu'elle en a tapé le scénario. Elle est formée par une scripte américaine et précise que c'était un « métier qui n'existait pas en France et que l'on doit aux Américains »[3]. Ces contradictions attestent du danger inhérent à tout témoignage oral à rebours. Les assertions de Vladimir Zederbaum dans son *Cours de technique générale du cinéma : six leçons complémentaires* (1931) abondent toutefois dans le sens de Jeanne Witta : « Le dialogue exact arrêté et enregistré pendant la prise d'une scène est sténographié exactement par une sténo-dactylo qui doit se trouver tout le temps sur le plateau. Cette sténographie du dialogue est indispensable pour pouvoir reprendre ou refaire une scène qui était mal enregistrée ou mal photographiée, pour faire des raccords, etc. Les Américains ont donné le nom de *script-girl* à cette dactylo qui s'occupe du dialogue et ce terme est adopté actuellement dans les studios français »[4]. Dès lors, nous pouvons supposer que le métier est issu, aux États-Unis, de la division du travail imposée par le système des studios qui engendre l'apparition d'un personnel nouveau afin d'atteindre la plus grande efficacité de production. En France, il en ressort que la féminisation du métier remonte à ses origines, que c'est la connaissance du scénario qui garantit l'efficience du scripte et enfin, que son apparition est liée au parlant. En effet, pour pallier l'immobilisme des acteurs imposé par le lourd matériel sonore et pour éviter les erreurs de textes entraînant un

[2] Henri Diamant-Berger, *Il était une fois le cinéma...*, Paris, Jean-Claude Simoën, 1977, p. 87.

[3] Jeanne Witta-Montrobert, *La lanterne magique : mémoires d'une script*, Paris, Calmann-Lévy, 1980, p. 39.

[4] Vladimir Zederbaum, *Cours de technique générale du cinéma : six leçons complémentaires*, Paris, École universelle par correspondance, 1931, p. 55.

gaspillage de pellicule, les scènes sont davantage découpées, multipliant de fait les raccords de gestes, textes et rythme.

Les périodiques et les annuaires accusent, quant à eux, un retard conséquent dans la prise en compte de l'émergence de ce métier : les scriptes ne font leur apparition dans les annuaires professionnels qu'en 1942. Les périodiques des années 1920 nous permettent d'en dresser un portrait en creux car le public y apparaît plus exigeant sur les problèmes de raccords. Mais sont alors incriminés les réalisateurs et les régisseurs en charge de la bonne place des accessoires de jeu. Dans les années 1940, en revanche, la scripte devient un personnage récurrent : individu féminin fantasmatique aux fonctions obscures, muni d'un chronomètre, de stylos et de lourds cahiers, elle est présentée aux côtés du réalisateur et des acteurs.

Les évolutions du métier depuis les années 1950

Autant l'histoire des origines du métier abonde en lacunes, autant la conscience patrimoniale qui anime les scriptes telle Lucie Lichtig, première donatrice à la Cinémathèque française en 1978, ouvre dès les années 1950 une pléthore d'archives. Si elles offrent un panorama très riche et précis des pratiques du métier, leur déchiffrement s'apparente néanmoins à une lente conquête, tant elles sont ardues, difficilement lisibles, techniques. Et ce en premier lieu parce que le scripte remédie au peu de temps qui lui est imparti en employant abréviations, codes et sténo, ce qui nous assure *de facto* de l'utilité de chacune des annotations. C'est pourquoi l'étude longue et méthodique de ces documents ne doit pas faire oublier le temps très restreint au cours duquel ils ont pris forme. Le chercheur est donc tenu de les replacer dans l'espace et le rythme du tournage, tâche quasiment impossible sans avoir fait l'expérience des conditions de travail du scripte sur le plateau. De fait, la valeur de ces archives réside également dans la temporalité qui s'en dégage : de l'urgence qui se ressent dans une écriture, des photos floues ou la détérioration des pages aux strates de temps qui s'entremêlent à la surface de documents actualisés au fur et à mesure du tournage. La temporalité propre à la production des films, perceptible dans les rapports, témoigne quant à elle du caractère profondément artisanal du travail en équipe sur le plateau. De la même façon, ces archives attestent de la capacité d'adaptation des scriptes aux impératifs propres à chaque film. On constate, en outre, pour chaque scripte une évolution de sa

méthode d'annotation qui tend à la fois vers un perfectionnement et une épuration, celui-ci éduquant progressivement son regard aux raccords et à leur hiérarchie. L'analyse des scénarios annotés comporte donc une part inévitable de subjectivité, le chercheur devant néanmoins éviter l'écueil de considérer que la qualité du travail du scripte s'évalue à la quantité de notes couchées sur le papier.

Ainsi, les annotations des scénarios qui rendent tangibles à la fois l'évolution du métier et celle des méthodes de chaque scripte correspondent avant tout aux indications de raccords nécessaires à la préservation de la cohérence du film. Les scénarios et leur découpage tendant à se complexifier au fil du temps, ces raccords se multiplient de manière concomitante. L'évolution la plus manifeste transparaît dans la comparaison d'un scénario découpé en plans (figure 1) et d'un autre découpé en séquences (figure 2). Les premiers demandent au scripte d'être principalement vigilant aux raccords de début et de fin de plan. Toutefois, la volonté affichée par les réalisateurs d'une plus grande liberté sur le tournage et au montage a imposé le découpage des scénarios en séquences, permettant de multiplier les axes sur le plateau. La quantité de raccords que le scripte doit mémoriser en cours de prise (actions, textes, accessoires, etc.) a donc augmenté de manière vertigineuse, exigeant de trouver au plus vite la méthode optimale d'annotation d'un scénario dont la forme ne se prête pas à un tel nombre d'indications. Pour l'instant, aucun logiciel n'a cependant pu se substituer à la rapidité de la prise de note sur version papier. Le numérique a accentué ce phénomène puisqu'il a entraîné une augmentation de la matière filmée, la généralisation des tournages à plusieurs caméras et que les rythmes de production de la télévision sont aujourd'hui adoptés par le cinéma. Or, dans l'effervescence du tournage, il apparaît essentiel que le scripte préserve un recul salvateur pour veiller aux intentions de mise en scène, ce qui nécessite l'abandon progressif de rapports laborieux à rédiger. De plus, d'après les scriptes, la multiplication des plans et les montages marqués de plus en plus par des ellipses rendent moins importants les raccords de base (costumes, accessoires) au profit de raccords plus complexes tels que le rythme. Tous ces bouleversements participent à faire du scripte l'interlocuteur principal du réalisateur. Ainsi, si nous reprenons l'hypothèse de départ selon laquelle la question des raccords a présidé à l'apparition du métier, ce rôle étant confié à des secrétaires de production, nous voyons que les tâches administratives dont il a hérité disparaissent au profit d'une implication grandissante dans la mise en scène.

Figure 1. Scénario de *Mon oncle* (Jacques Tati, 1957). Annotations et photos de Sylvette Baudrot. © Cinémathèque française/fonds Sylvette Baudrot-Guilbaud.

Figure 2. Scénario de *Toutes nos envies* (Philippe Lioret, 2010). Annotations et photos de Betty Greffet. © Cinémathèque française/fonds Betty Greffet.

Malgré une démultiplication des notes, nous ne pouvons qu'être saisi par les nombreuses similitudes entre des scénarios annotés dans les années 1950 et d'autres dans les années 2000. Ces ressemblances ne remettent pourtant pas en cause la valeur du travail des scriptes, au contraire, puisqu'elles sont révélatrices de deux facettes du métier. La première, comme évoqué précédemment, a trait à l'exigence de cette profession qui a nécessité d'établir très vite la méthode de travail la plus efficiente. La seconde est que le scripte produit des archives reconnaissables entre toutes et dotées d'une valeur esthétique indéniable. Sur la surface de ces documents se devine ainsi l'importance de la transmission des savoirs, telle la méthode de fléchage que Sylvette Baudrot a apprise de scriptes américaines lorsqu'elle était scripte seconde équipe sur les films américains tournés en France et qu'elle a transmise à ses nombreux assistants. Ce système, selon lequel chaque flèche correspond à un plan et vient couvrir la portion d'action et de dialogue concernés par le plan, permet d'évaluer en un coup d'œil si le montage possédera la matière suffisante pour chaque séquence. L'évolution du métier peut également être mesurée à l'aune des outils employés car ceux-ci ont un impact sur les formes prises par les archives.

Les outils (par ordre chronologique de production)

Le premier de ces outils à faire son apparition est le bout d'essai, soit quelques images de début ou de fin de prise prélevées sur le négatif. Il donne la valeur exacte du plan mais le format laisse dubitatif quant à sa possibilité de lecture. Viennent ensuite les photos de raccords pour lesquelles le photographe de plateau fut, dans les débuts, mis à contribution. Elles s'attachent à épouser le cadre adopté par la caméra mais accusent deux retards : le temps de pose des comédiens et le temps nécessaire au développement. Grâce au Polaroïd, qui n'exige ni développement ni tirage, le scripte peut indiquer immédiatement à quels plan et prise le cliché correspond. Cet appareil, créé fin 1940, devient incontournable en France à la fin des années 1970. L'appareil photo numérique est adopté aujourd'hui par la grande majorité des scriptes. Cet outil facile d'utilisation réclame néanmoins un temps de tri rébarbatif et incite le scripte à multiplier les photos au risque de ne plus pouvoir distinguer ensuite lesquelles immortalisent un bon raccord. De fait, si les raccords d'un long métrage nécessitaient

environ une centaine de Polaroïds, les scriptes font plus de mille photos aujourd'hui. Ils peuvent également photographier l'écran du *combo*, outil dont l'usage s'est généralisé dans les années 2000. Cet appareil diffuse en direct les prises tournées par les caméras et permet de les visionner à nouveau. Au vu de cette possibilité, certains professionnels ont remis en cause le caractère indispensable du scripte. Certes, la surveillance des raccords d'une séquence en train d'être tournée est facilitée, à supposer que le réalisateur sache exactement quelles prises il retient pour le montage. Mais qu'en est-il des raccords avec des séquences tournées il y a plusieurs semaines ou restant à filmer ? Les scriptes eux-mêmes sont partagés concernant son utilisation dans l'exercice de leur métier. Pour certains, pouvoir visualiser en direct le cadrage des plans permet de se faire une idée du montage et s'avère particulièrement pratique lors d'un tournage à plusieurs caméras. Pour d'autres, le combo fausse les perceptions de l'espace et des gestes des acteurs, il immobilise le scripte et l'éloigne du plateau, même s'il s'y trouve de fait aux côtés du réalisateur.

Traces flagrantes de l'évolution des techniques, ces photos méritent un examen approfondi tant le cadrage et l'attitude des comédiens – en train de poser, de jouer ou saisis à leur insu – sont révélateurs de la place physique du scripte sur le plateau et du temps que lui accordent les membres de l'équipe.

Les documents

L'avènement du numérique, qui permet l'enregistrement des métadonnées directement dans les fichiers de la caméra, simplifie, voire rend obsolète la réalisation de certains rapports, quand le rythme effréné pris par les tournages favorise leur abandon. Certaines informations qu'ils répertorient demeurent néanmoins essentielles et ont nécessité la création de nouveaux outils spécifiques au métier de scripte, à l'instar de l'application pour tablettes *ScriptE*. Adaptée des États-Unis par Aurore Moutier et Charles Jodoin-Keaton, elle permet surtout le cumul automatique des données sur les rapports et leur envoi instantané. Il est indéniable que les tablettes modernisent l'image du scripte, mais redéfinissent-elles son travail pour autant ?

Figure 3. Aurore Moutier utilisant *ScriptE*. © Nadir Telhaoui.

Concernant les documents préparatoires, la gestion de la continuité qui tend à devenir l'aspect primordial du métier ne rend que plus prégnante leur importance. Le LSA lutte donc pour qu'un minimum de neuf jours de préparation puissent leur être accordés. Un de ces documents nous apporte par ailleurs la preuve la plus éclatante de l'implication du scripte dans la mise en scène : la continuité chronologique. Ce document est primordial puisqu'il donne un aperçu immédiat des raccords à prévoir et forme un garde-fou précieux auquel le scripte peut se référer avant le tournage de chaque séquence. Élaboré à la suite de multiples lectures du scénario, il permet au scripte d'en mettre à jour toutes les erreurs et incohérences et d'en faire part au réalisateur en pré-production. Ces tableaux sont aujourd'hui des archives hybrides car réalisées sur informatique mais annotées tout au long du tournage en fonction des modifications survenues. De la même manière, le pré-minutage du scénario évalue au plus près la durée du film tel qu'il sera idéalement une fois monté et permet d'envisager la suppression de séquences en amont, évitant ainsi de perdre un temps précieux à tourner des scènes qui, pour des raisons de durée ou de rythme, devront être sacrifiées au montage. Réalisé plusieurs mois avant le tournage, il est un des exercices les plus

complexes que le scripte ait à effectuer, exigeant de mimer les actions, les dialogues et d'imaginer les temps de pause de chaque séquence.

Figure 4. Continuité chronologique élaborée par Laurence Couturier pour *Pour elle* (Fred Cavayé, 2007). © Cinémathèque française/fonds Laurence Couturier.

Le rapport montage fournit le détail de chaque plan tourné au montage et permet de distinguer les particularités de chaque prise : le scripte inscrit scrupuleusement l'avis du réalisateur et les différentes options envisagées. Ces observations sont aujourd'hui d'autant plus primordiales que le montage est réalisé parallèlement au tournage et que la matière filmée augmente. Mais puisque les rushes sont à présent aisément accessibles dans les chutiers des logiciels de montage, la description minutieuse du cadre, de l'action et des dialogues devient superflue. Quant aux rapports purement administratifs, il semble évident que la présence constante du scripte sur le plateau et sa place centrale dans l'équipe ont imposé ce dernier comme « œil de la production ». Grâce au rapport production, la production s'assure que le tournage n'a pas pris de retard par rapport au plan de travail et que les dépenses restent dans la limite du budget accordé. Les informations qui demeurent essentielles sont le cumul

des minutages et le nombre de plans et de séquences tournés, d'où la pertinence de l'utilisation de logiciels. Les *time code*, les numéros de carte et de clips ayant succédé à la gestion des stocks de pellicule et des bobines, la collecte de certaines informations est facilitée. Enfin, le rapport horaire fournit un compte-rendu détaillé heure par heure de la journée de tournage. Il liste les problèmes organisationnels ou de mauvais temps, les incidents survenus sur le plateau, il permet de déceler les lenteurs et d'aviser. Les scriptes apprécient peu ce document dont la rédaction s'avère particulièrement laborieuse en regard de son utilité. C'est pourquoi les informations cruciales sont de plus en plus reportées dans la case « divers » du rapport production.

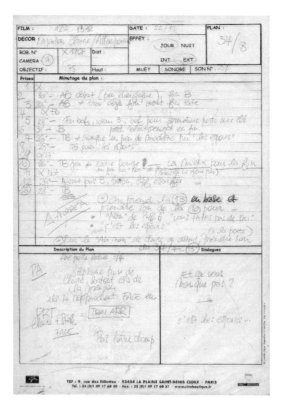

Figure 5. Rapport montage élaboré par Betty Greffet pour *Toutes nos envies* (Philippe Lioret, 2010). © Cinémathèque française/fonds Betty Greffet.

Figure 6. Rapport production élaboré par Suzanne Durrenberger pour *Le Nouveau Protocole* (Thomas Vincent, 2007). © Cinémathèque française/fonds Suzanne Durrenberger.

Quel avenir du métier de scripte envisager au vu de la raréfaction, de la dématérialisation et de l'appauvrissement de ces rapports ? Pour nombre de professionnels, la réduction des tâches administratives est l'opportunité de faire reconnaître cette implication dans le travail de mise en scène car la primauté accordée au respect des intentions du réalisateur valorise le métier. Qu'elle se fasse au détriment des documents techniques et administratifs est néanmoins profondément regrettable du point de vue de la recherche et du patrimoine archivistique. En effet, la véracité, la précision et la richesse des informations livrées par ces archives ne sauraient être mises en doute puisqu'elles divulguent les choix du metteur en scène – des plus infimes à ceux qui bouleversent

en profondeur l'architecture du film –, les solutions pragmatiques trouvées pour remédier à chaque aléa, le rôle joué par tous les membres du plateau et leurs interactions. Si les tablettes ont permis de préserver certains documents, quel est l'attrait de ces archives dématérialisées d'où ne se dégage plus aucune temporalité ? Ces documents posent en outre à l'heure actuelle à la Cinémathèque française la question fondamentale et encore irrésolue de leur conservation.

Aux origines de l'Institut des hautes études cinématographiques

De la création du Centre artistique et technique des jeunes du cinéma (CATJC) aux conférences de Jean Epstein à l'IDHEC (1941–1945)

Marie-Charlotte Téchené

En occupant la chaire d'esthétique de l'Institut des hautes études cinématographiques (IDHEC) durant l'automne 1945, le cinéaste et théoricien français Jean Epstein accompagna les premiers pas de ce qui deviendra l'École nationale supérieure des images et du son (La Fémis). Ainsi que nous le constatons dans notre thèse de doctorat consacrée à la pédagogie du cinéma selon Jean Epstein[1], cette expérience de « maître de conférences » à l'IDHEC dans l'immédiat après-guerre fut la seule qu'il connut dans une institution consacrée à l'enseignement. Mais elle inaugura dans sa pensée un moment à compter duquel ladite pédagogie du cinéma devint, en tant que telle, un nouvel objet théorique. Partant du principe selon lequel l'analyse de ces conférences ne pouvait se faire sans prendre en considération le cadre institutionnel dans lequel elles avaient été données, nous nous sommes penchée sur les travaux d'historiens tels que Jean-Pierre Bertin-Maghit, Fabrice Montebello, Jean-Antoine Gili ou encore Laurent Le Forestier consacrés à différents aspects de l'histoire de l'Institut[2]. Plusieurs interrogations subsistent cependant sur cette école

[1] Marie-Charlotte Téchené, *Des ondes pour nous imperceptibles. La pédagogie du cinéma selon Jean Epstein : création et rayonnement d'une œuvre des années 1920 aux années 1980*, thèse de doctorat en cours sous la direction de Sylvie Lindeperg, Université Paris 1 Panthéon-Sorbonne.

[2] Jean-Pierre Bertin-Maghit, *Le cinéma sous l'Occupation*, Paris, Olivier Orban, 1989 ; Fabrice Montebello, *Le cinéma en France depuis les années 1930*, Paris, Armand Colin, 2005 ; Jean A. Gili, « De l'Occupation à la Libération : Marcel L'Herbier et la naissance de l'IDHEC », dans Laurent Véray (dir.), *Marcel L'Herbier, l'art du*

créée sous l'Occupation (1943) : quel rôle le Centre artistique et technique des jeunes du cinéma (CATJC) a-t-il joué dans l'identité pédagogique, institutionnelle et idéologique de l'IDHEC ? Quelle était la nature des enseignements dispensés à l'IDHEC au moment de sa création ? S'agissait-il, à l'heure de la Révolution nationale prônée par Vichy, de former les étudiants à un esprit « français » du cinéma ? Ou encore, dans quelle mesure les lois d'exclusion antijuives furent-elles appliquées durant le processus de recrutement des étudiants à l'IDHEC en 1944 ?

Reposant sur un corpus de documents d'archives, cette contribution se propose de revenir sur la genèse de l'Institut des hautes études cinématographiques depuis la création de sa structure initiale (CATJC) en 1941 jusqu'à l'attribution, en 1945, de la chaire d'histoire et d'esthétique de l'IDHEC à Jean Epstein. Pour ce faire, nous nous appuierons sur des documents issus de différents fonds d'archives, sur une série de témoignages oraux réalisés dans le cadre de notre thèse et sur les films de fin d'étude des élèves du CATJC et de l'IDHEC : le fonds Jean et Marie Epstein de la Cinémathèque française ; le fonds de l'École nationale supérieure des métiers de l'image et du son[3]; le fonds Marcel L'Herbier, du département des Arts du spectacle de la Bibliothèque nationale de France[4]; les archives du ministère de l'Information[5] ; les archives de la Direction générale du cinéma[6] ; des témoignages d'anciens étudiants de l'IDHEC : Jacqueline Thiédot, Henri Lanoë, Annette Wademant et Jacqueline Moreau[7] ; des photographies de tournage du CATJC, collection privée Yannick Bellon[8].

 cinéma, Paris, AFRHC, 2007, p. 297–314 ; Laurent Le Forestier, « Entre cinéïsme et filmologie : Jean Epstein, la plaque tournante », dans *La Filmologie de nouveau*, *CiNéMAS*, Revue d'études cinématographiques, vol. 19, n° 2–3, Université de Montréal, Montréal, Canada, printemps 2009, p. 113–140.

[3] Conservé aux Archives nationales, Site de Pierrefitte-sur-Seine.

[4] Nous tenons à remercier Madame Marie-Ange L'Herbier qui nous a donné l'autorisation d'utiliser à des fins pédagogiques (projection pendant le colloque) d'une lettre émanant du Commissariat Général aux Questions Juives, conservée au sein du fonds Marcel L'Herbier (Lettre du Commissariat Général aux Questions Juives, 9 novembre 1943. Fonds Marcel L'Herbier. Cote 4-COL-198 (1638/1943).

[5] F 41, Archives nationales.

[6] F 42, Archives nationales.

[7] Entretiens menés et enregistrés par Arnaud Bruttin, Thibaut Bruttin ou Marie-Charlotte Téchené (2016).

[8] Nous tenons à remercier très chaleureusement Madame Yannick Bellon et Monsieur Éric Le Roy de nous avoir donné accès à la consultation d'un ensemble de photographies issues du fonds personnel de Madame Bellon couvrant la période de ses études au CATJC.

Cette contribution tend ainsi à révéler la multiplicité des sources à prendre en considération pour écrire l'histoire de la fondation de l'IDHEC : sources institutionnelles, éléments pédagogiques divers (manuscrits des conférences des enseignants et intervenants, notes de cours prises par les anciens élèves, publications de l'institut « Cahiers de l'IDHEC », comptes rendus des comités d'orientation et de perfectionnement, épreuves et résultats…), éléments de correspondance mettant en relation les différents membres de l'Institut, témoignages, films d'étudiants. Un croisement minutieux de ces multiples archives est rendu nécessaire par la nature même d'un projet dont les enjeux (pédagogiques, artistiques, idéologiques, institutionnels) sont aussi variés que complexes. C'est pourquoi, dans un premier temps, nous nous intéresserons à la création du CATJC en 1941, puis aux raisons qui ont conduit à lui substituer l'IDHEC. Enfin, nous nous focaliserons sur l'enseignement délivré par Jean Epstein au sein de l'institut en 1945, ce qui nous permettra de mettre en lumière un exemple concret du contenu des cours qui pouvait être délivré durant les premières années de l'école.

Le Centre artistique technique des jeunes du cinéma à l'origine de l'IDHEC

L'IDHEC trouve son origine dans une association qui lui préexistait : le Centre artistique et technique des jeunes du cinéma, fondé le 28 mars 1941 à Vichy, sous l'égide du Secrétariat général de la jeunesse. Le siège social du CATJC se trouve d'abord à Castellaras dans les Alpes-Maritimes, avant d'être officiellement transféré à Nice[9]. D'un point de vue administratif, le CATJC est une association de loi 1901 dont les buts sont, d'après ses statuts, de « Grouper des jeunes artistes, artisans et techniciens Français choisis parmi les meilleurs afin de créer un mouvement qui rénove la grande tradition de la qualité française en matière de cinéma[10] ; Créer un foyer d'études, de recherches artistiques

[9] Récépissé de déclaration de modification des statuts de l'association CATJC, 30 septembre 1943. Cote AN 20100344/20.

[10] Sur cette notion de « qualité française », nous renvoyons à la thèse de Guillaume Vernet intitulée *Aux origines d'un discours critique : la « tradition de la qualité » et la « qualité française ». La bataille de la qualité ou la mise en place du soutien de l'état aux films de qualité en France (1944–1953)*, sous la direction de Laurent Le Forestier, soutenue le 25 janvier 2017 à l'Université Rennes 2.

et techniques préparant à leur tâche les jeunes artistes et techniciens du cinéma ; Réaliser des productions artistiques et techniques remettant en honneur les véritables valeurs humaines et françaises »[11]. À l'origine, le CATJC devait produire ses films en collaboration avec l'association Jeune France[12]. Si ce projet est finalement rayé des statuts, les deux associations travailleront néanmoins de concert. Au premier bureau du CATJC siègent le président Paul Legros[13], le vice-président Maurice Cloche, le secrétaire général Louis Page[14] et le trésorier Tony Leenhardt[15].

Signe de l'omniprésence du gouvernement au sein même des structures décisionnelles de l'association, on trouve au conseil d'administration du CATJC plusieurs représentants du Secrétariat général de la Jeunesse tels que M. Desjardin, chef du service de la comptabilité ou encore Albert Dutruch, chef du service cinéma de la Légion. Plusieurs membres de l'association Jeune France y siègent également : M. Barbier, directeur du service dramatique, le pianiste Alfred Cortot, l'ingénieur Pierre Schaeffer et, enfin, le compositeur Yves Baudrier. On note également un très fort interventionnisme de Louis-Émile Galey, à la tête de la Direction générale du cinéma, qui participe très régulièrement aux assemblées générales du CATJC. Il est notamment l'auteur d'un texte redéfinissant les buts du Centre, le 15 décembre 1942, un mois après l'invasion de la zone sud par l'occupant allemand[16].

Moins d'un an après sa création, le CATJC est structuré en dix services parmi lesquels un service de « recherches et de formation des jeunes stagiaires »[17]. Y sont rattachés les stagiaires recrutés sur dossier et placés dans des projets de productions. Un rapport est établi sur chaque

[11] Statuts du Centre artistique et technique des jeunes du cinéma (CATJC), 28 mars 1941, p. 1. Cote AN 20100344/1.

[12] Créée en décembre 1940, l'association Jeune France a pour objectif de promouvoir l'idéologie de la Révolution nationale auprès des jeunes à travers une politique culturelle de création et de diffusion.

[13] Paul Legros est également directeur du CATJC au moment de sa création et le restera jusqu'à l'arrivée de Pierre Gérin en 1942.

[14] Louis Page est alors opérateur de prise de vues.

[15] L'ingénieur du son Tony Leenhardt siège également à cette époque au bureau d'études de l'association Jeune France.

[16] Ce texte sera approuvé à l'unanimité par les autres membres du conseil d'administration.

[17] Note de service pour les chefs de service du CATJC, décembre 1941. Cote AN 20100344/1.

stagiaire au bout d'un ou deux mois d'activité au sein du Centre afin que le directeur général décide de les diriger ou non sur une voie technique spécifique (prise de vue, son, montage, etc.). Parmi les premiers stagiaires recrutés par le CATJC, citons l'opérateur Henri Alekan. Ce dernier envoie une lettre de demande d'admission au CATJC avant même que l'association ne soit officiellement créée et joint à son courrier un *curriculum vitae*[18]. Outre le témoignage sur ses activités de combattant durant la guerre, ces documents montrent la nécessité d'être parrainé par au moins deux techniciens du cinéma pour postuler au CATJC[19]. Néanmoins, les modalités d'admission du CATJC vont évoluer puisqu'à partir de 1943, les postulants devront passer un concours. Celui-ci s'organise en deux épreuves : dans un premier temps, les candidats doivent répondre à un questionnaire sous la forme d'un dossier écrit qu'ils doivent adresser au CATJC par courrier. Parmi les dix questions du formulaire : « Pourquoi aimeriez-vous travailler dans le cinéma ? » ; « De quelle nature est la satisfaction que vous procure le cinéma et quel est son rôle dans la société ? » ; « Liste des 10 films que vous avez préférés (muets ou sonores) ? » ; ou encore « Qu'est-ce qui peut-être, à votre avis, amélioré dans le cinéma actuel ? »[20]. Dans un second temps, les candidats ayant réussi cette première épreuve écrite sont convoqués au CATJC pour cinq épreuves pratiques et orales : « culture générale », « arts plastiques et musique », « histoire du cinéma », « technique » et « travaux pratiques »[21]. Yannick Bellon figure parmi les cinq stagiaires admis au cours de l'année 1943 et poursuivra sa formation à l'Institut des hautes études cinématographiques, à Paris, dès le mois de janvier 1944[22].

L'enseignement dispensé aux stagiaires en 1942 comporte un cours de montage, un cours sur le son (séances théoriques et pratiques), un cours organisé par le service financier du CATJC (séances théoriques consacrées à l'apprentissage de notions administratives, de comptabilité

[18] Lettre et *curriculum vitae* d'Henri Alekan, 10 décembre 1940. Cote AN 20100344/5.

[19] Henri Alekan est parrainé par Louis Page et Philippe Agostini.

[20] Questionnaire de l'examen du concours d'entrée au CATJC, 28 mars 1943. Cote AN 20100344/11.

[21] Ces cinq épreuves sont respectivement supervisées par Messieurs Gérin, Lods, Damas, Sanlaville et Gudin. Tableau des épreuves au concours d'entrée du CATJC, 18–19 juin 1943. Cote AN 20100344/11.

[22] Yannick Bellon n'obtiendra pas de diplôme de l'IDHEC puisqu'elle interrompra sa formation dès la fin de l'année 1944.

et des séances pratiques consacrées à la tenue d'un livret de comptabilité d'un régisseur), un cours de production et enfin, un cours sur la prise de vue (théorie et travaux pratiques)[23]. Cet enseignement est complété par une série de cours portant sur l'histoire du cinéma et d'un cycle de conférences mensuelles données par des membres du CATJC lors des réunions de son « Cercle d'études »[24]. Concernant les productions du CATJC, nous pouvons distinguer des films « techniques », c'est-à-dire des films ayant une finalité didactique[25] ; des reportages photographiques[26] et bien entendu, les films réalisés par les stagiaires[27].

Nous pouvons constater une nette convergence des thématiques abordées dans les films produits par le CATJC avec les thématiques et les valeurs promues par le régime de Vichy : accent mis sur la jeunesse, la notion d'effort, le monde paysan, la valeur du travail, l'ancrage régional, l'artisanat, l'exhortation à la solidarité. Citons par exemple le film *La Ronde des toits* réalisé en 1943 par les techniciens du CATJC sous la direction de Maurice Cloche, dont Jean-Pierre Bertin-Maghit montre, dans son ouvrage *Les documenteurs des années noires*, qu'il est un pur film de propagande[28]. Il convient également de signaler que le CATJC

[23] Cours dispensés aux stagiaires du CATJC. Cote AN 20100344/11.

[24] Bulletin périodique d'information n° 12, 22 septembre 1942. Cote AN 20100344/20.

[25] Par exemple, celui que le Collège national d'Antibes commande au CATJC en 1942. Il s'agit d'une série de petits films sonores de 400 mètres environ qui ont pour sujet l'éducation sportive. Ces films devaient compléter l'enseignement sportif dispensé au sein du collège et être diffusés au sein de diverses associations sportives régionales. Rappelons à ce sujet que le sport fit l'objet d'une récupération idéologique très appuyée par le régime de Vichy. Voir à ce propos l'ouvrage dirigé par Georges Bensoussan, Paul Dietschy, Caroline François et Hubert Strouk : *Sport, corps et sociétés de masse : le projet d'un homme nouveau*, Paris, Armand Colin, 2012.

[26] Citons un reportage consacré aux « Artisans vannier, charron et bourreliers » en 1942, AN 20100344/19.

[27] Le bulletin d'information n° 15 du CATJC rend compte des difficultés rencontrés par René Clément sur le tournage de son film *Ceux du Rail* : « La machinerie du cinéma insérée dans la machinerie des chemins de fer a souvent des ratés. Faire coïncider un plan de travail avec les horaires ferroviaires n'est pas un jeu d'enfant, non plus que de tourner en équilibre sur un tender ou suspendu à un câble le long des flancs d'une Pacific en marche. Quoi qu'il en soit, René Clément et son directeur de production, M. Prevot, ont franchi tous les obstacles et le film sera bientôt au montage », Bulletin d'information n° 15, 5 février 1943. Cote AN 20100344/20. Dix films produits par le CATJC sont conservés aux Archives françaises du film du CNC dont *Chefs de demain* (1941), ou encore *Ceux du Rail* (1942) de René Clément.

[28] En dressant le portrait d'une famille prise en charge par le Secours national, le film vise à amener les spectateurs à souscrire à des bons de solidarité. Il s'agit ainsi

organise régulièrement la présentation officielle de ses films à Vichy pour des représentants du Maréchal Pétain[29].

Pourquoi et comment est-on passé du CATJC à l'IDHEC ?

Depuis de nombreuses années, Marcel L'Herbier caressait le projet d'un grand Conservatoire des arts nouveaux dont « L'École préparatoire du cinématographe devait constituer la première des cinq sections (Cinéma, Radio, Music-hall, Jazz, Disque) ». Les notes personnelles de L'Herbier contiennent même les grandes lignes du programme pédagogique qu'il souhaitait mettre en œuvre pour la section cinéma : « A- Mise en Film / B- L'Acteur de Film / C- Le décor du film / D- Technique Sonovisuelle / E- Technique Appliquée / F- Support Intellectuel du Film / G- Histoire du Cinéma »[30]. Parmi les intervenants envisagés par L'Herbier figurent les noms d'Henri Langlois pour le cinéma muet et de Jean-Georges Auriol pour le cinéma parlant. Il est également prévu d'organiser des projections en « puisant dans le répertoire de la Cinémathèque Française ». Or, en décembre 1942, se trouvant à Nice pour le tournage de son film *La Vie de bohème* (1945) dans les studios de la Victorine, Marcel L'Herbier prend contact avec le CATJC, pensant trouver l'appui nécessaire à la réalisation de son projet de conservatoire. C'est à cette occasion qu'il rencontre Pierre Gérin, président du CATJC depuis 1942. Si ce premier projet devait rester lettre morte, la rencontre des deux hommes allait cependant jeter les bases de l'IDHEC. Dès le mois de février 1943, Louis-Émile Galey commande à ses services un rapport sur le fonctionnement du CATJC.

d'affirmer la mise en place par le gouvernement de structures et d'actions d'assistance et de soutien de la population, d'affirmer la vocation fédératrice du cinéma d'État. Voir Jean-Pierre Bertin-Maghit, *Les documenteurs des années noires*, Paris, éditions Nouveau Monde, 2004.

[29] « En présence de la Maréchale Pétain et du colonel Chapuis, représentant le Maréchal, Chef de l'État, Chef de la Légion, de M. Raymond Lachal, directeur général de la Légion, M. Pierre Gérin accompagné de MM. Maurice Cloche et René Clément a présenté les dernières réalisations du C.A.T.J.C en collaboration avec le service cinématographique de la Légion. *La Grande Pastorale* de René Clément et *Bel Ouvrage* premier volet du triptyque de Maurice Cloche *La France au Travail* ont remporté un vif succès devant cette assistance de choix. », Bulletin d'information n° 15, 5 février 1943. Cote AN 20100344/20.

[30] Pièces importantes relatives à la fondation de l'IDHEC. Bibliothèque nationale de France, Département des Arts du spectacle, Fonds Marcel L'Herbier, IDHEC, 1943. Cote 4-COL-198 (1636).

La conclusion des rapporteurs est très claire : « un tel Centre ne peut exister qu'à Paris ».

C'est à la suite d'une assemblée générale extraordinaire tenue le 4 septembre 1943 à Nice que le CATJC devient l'IDHEC[31]. Par conséquent, l'IDHEC n'est que le nouveau nom d'un CATJC dont les statuts ont été modifiés. En effet, la création de l'IDHEC consiste à l'origine en « un projet d'extension de l'activité du CATJC »[32] que Pierre Gérin présente comme « une sorte d'université ou d'école des Beaux-Arts du Cinéma, où les futurs réalisateurs, décorateurs, ingénieurs du son, directeur de production, régisseurs, etc. apprendront leur métier, soit en suivant des cours, soit en suivant des travaux pratiques ». Le Centre, installé à Paris, deviendrait un « foyer de recherches et d'études ». Le projet est soumis à la Direction générale de la Cinématographie nationale qui l'accepte, et avec qui il est convenu que Marcel L'Herbier coordonnera les efforts requis par ce projet d'extension[33]. Les premières modifications importantes concernent le changement de nom de l'association et les buts de celle-ci. Ainsi, Pierre Gérin propose d'ajouter aux trois objectifs préexistants (CATJC) la formation des « futurs techniciens et artistes de la corporation cinématographique » et la propagation de la « culture cinématographique dans le grand public »[34]. En effet, l'IDHEC a pour ambition de proposer « un enseignement supérieur de l'art cinématographique ». Il ne s'agit plus seulement de former des techniciens et des réalisateurs comme le proposait le CATJC, mais aussi d'élaborer une véritable « culture cinématographique » à travers un programme ambitieux de conférences sur des thèmes historiques et esthétiques.

[31] Compte-rendu de l'assemblée générale extraordinaire du CATJC, tenue à Nice le samedi 4 septembre 1943, à 21 heures. Cote AN 20100344/2.

[32] *Ibid.*

[33] Il est intéressant de souligner que la raison principale présidant à la modification des statuts du CATJC n'est pas tellement « le projet lui-même », comme l'indique le compte-rendu de l'assemblée générale du 4 septembre 1943, mais « un vœu de la commission budgétaire indiquant qu'il était préférable de rattacher le Centre Artistique et Technique des Jeunes du Cinéma à la Direction générale de la Cinématographie Nationale », Compte-rendu de l'assemblée générale extraordinaire du CATJC, tenue à Nice le samedi 4 septembre 1943, à 21 heures. Cote AN 20100344/2.

[34] De fait, la modification des buts de l'association entraîne une modification de ses moyens d'actions puisque au cours de cette assemblée générale est également votée la création d'un centre de formation d'artistes et de techniciens pour le cinéma (*ibid.*).

Un concours d'admission est organisé en Sorbonne les 20 et 30 septembre 1943 : 150 candidats se présentent, la première promotion est composée de 34 étudiants (25 reçus au concours, 5 élèves issus de l'école technique de photographie et de cinématographie de Vaugirard et 4 stagiaires de Nice, dont Yannick Bellon). Au moment de sa création, l'Institut comprend quatre sections : réalisation-production ; ingénieur du son ; décorateurs ; opérateurs[35]. Il semblerait que les étudiants se spécialisent seulement à partir de la deuxième année (le cycle d'études est alors de trois ans pour la section réalisation-production et de deux ans pour la section son)[36]. Le dossier relatif aux conditions d'admission à l'IDHEC et aux modalités d'inscription au concours d'entrée fait mention de treize épreuves pour les postulants à la section réalisation-production parmi lesquelles cinq épreuves écrites et huit épreuves orales[37]. Parmi les élèves qui passeront, en octobre 1944, l'examen du cours de création cinématographique, l'un d'eux, qui s'illustrera par la suite, s'attire cette appréciation peu amène de Marcel L'Herbier : « Monsieur Resnais : N'a pas suivi les cours. Semble avoir été trop souvent malade. Répond médiocrement. Note : 9 »[38].

Conformément à la législation antijuive du régime de Vichy, le bulletin d'inscription au concours d'entrée exige de chaque étudiant qu'il stipule pour chaque membre de sa famille s'il est juif ou non[39]. Si les étudiants juifs n'ont pas été totalement exclus de l'enseignement

[35] Dossier indiquant les conditions d'admission à l'IDHEC et les modalités d'inscription au concours d'entrée, septembre 1943, p. 1. Cote AN 20100344/19.

[36] Nous renvoyons ici aux entretiens d'anciens étudiants de l'IDHEC tels que Jacqueline Thiédot, Annette Wandemant ou encore Maurice Delbèze, réalisés par Arnaud et Thibaut Bruttin en 2016.

[37] Les épreuves écrites : « épreuve d'imagination » ; « composition de littérature générale dans ses rapports avec le cinéma » ; « composition d'histoire et de géographie dans leurs rapports avec le cinéma » ; « composition d'esthétique » ; « épreuve d'organisation ». Les épreuves orales : « étude critique de deux films après projection » ; « littérature française »; « histoire de l'art, art plastique » ; « histoire et géographie » ; « orientation professionnelle » ; « culture cinématographique » ; « sens pratique » (plusieurs anciens étudiants de l'IDHEC mentionnent une « épreuve de débrouillardise ») ; littératures étrangères et langues vivantes (facultatif).

[38] Pièces importantes relatives à la fondation de l'IDHEC : Bibliothèque nationale de France, Département des Arts du spectacles, Fonds Marcel L'Herbier, IDHEC, 1943. Cote 4-COL-198 (111).

[39] Bulletin d'inscription au concours d'entrée, septembre 1943, p. 9. Cote AN 20100344/19.

supérieur (contrairement aux enseignants et à l'ensemble des membres de la fonction publique), la loi du 21 juin 1941 les soumet néanmoins à un *numerus clausus* de 3% dans les universités[40]. D'autre part, ce bulletin pose la question de l'appartenance « raciale » jusqu'à la génération des grands-parents car le statut des Juifs du 3 octobre 1940 définit comme Juif tout individu dont trois grands-parents au moins sont de « race juive » ou bien deux grands-parents seulement, si le conjoint est lui aussi juif. Notons que cette fermeture de l'accès à l'enseignement supérieur est alors justifiée par le régime au nom de l'inutilité pour les Juifs d'obtenir un diplôme ouvrant à des professions qu'il leur est désormais interdit d'exercer. En témoigne la réponse négative catégorique donnée par le Commissariat général aux questions juives à la demande de Pierre Gérin qui souhaitait savoir si l'Institut pouvait admettre des élèves juifs[41]. Les cours de la première promotion commencent en janvier 1944 au 8, rue de Penthièvre, Paris VIII^e.

Les métiers auxquels forme l'IDHEC au moment de sa création sont présentés dans un livret distribué aux candidats afin qu'ils anticipent leur spécialisation en deuxième année[42]. Chaque métier y est présenté sous le double aspect des connaissances techniques à acquérir et des qualités morales à solliciter[43]. Onze métiers y sont représentés dont « l'écrivain de l'écran », « le metteur en film », « l'assistant metteur en film », « le directeur de production », « l'architecte-décorateur », « le chef opérateur », « l'opérateur », « l'assistant-opérateur », « l'ingénieur du son ». À une jeune femme souhaitant intégrer la section mise en scène en 1944, Marcel L'Herbier répond : « On me communique votre lettre, et sans vouloir vous décourager, je suis forcé de vous signaler que je ne vois pas la mise

[40] Nous renvoyons à ce sujet à l'ouvrage de Claude Singer, *Vichy, l'Université et les Juifs*, Paris, Les Belles Lettres, 1992.

[41] Lettre du Commissariat Général aux Questions Juives, 9 novembre 1943. Fonds Marcel L'Herbier. Cote 4-COL-198 (1638/1943).

[42] « L'Institut des Hautes Études Cinématographiques prépare aux divers métiers du cinéma. Il importe que les candidats aient une notion claire de ces divers métiers et qu'ils puissent d'eux-mêmes faire un choix conforme à leurs aptitudes, leurs talents et leurs goûts ». Livret « Les métiers du cinéma », 1943, p. 1. AN 20100344/19

[43] Ainsi, le metteur en film est présenté comme « un ARTISTE doublé d'un TECHNICIEN, triplé d'un CHEF. Sa responsabilité est écrasante, sa compétence doit être quasi universelle, son autorité incontestée […] Les qualités exigées du metteur en film sont celles de l'artiste : goût, imagination créatrice – de l'homme d'action : clarté, sang-froid, autorité, efficacité – de l'homme d'affaires : bon-sens, prévisions justes, pondération et hardiesse ».

en scène cinématographique comme un métier de femme ». En effet, la majorité des étudiantes de l'IDHEC intégraient les sections montage ou *script-girl*. Jacqueline Thiédot, élève de la deuxième promotion (section montage) mentionne l'obligation d'effectuer un stage et évoque la méfiance des professionnels à l'égard des étudiants de l'IDHEC[44]. Parmi ses professeurs de l'IDHEC, elle se souvient particulièrement de Georges Sadoul, de Jean Mitry et de Jacques Becker. Elle évoque aussi les cours de Jean Epstein comme « de la culture bonne et difficile, inutilisable à des fins cinématographiques », jugement partagé alors par nombre d'étudiants. Mais quel en était exactement le contenu ?

Les conférences de Jean Epstein à l'IDHEC (1945)

En novembre 1945, Jean Epstein se demande en ouverture de son cours inaugural : « Qu'est-ce que le cinématographe ? ». Il répond d'emblée à cette question par une « lapalissade », en déclarant : « Le cinéma n'est pas aujourd'hui ce qu'il était hier ; il n'est pas non plus, ce qu'il sera demain. Le cinématographe n'est pas, mais il devient, il diffère continuellement de lui-même »[45]. Ce n'est donc pas à travers la recherche de son essence (ce qu'il aurait de fondamental, de fixe, d'immuable) qu'Epstein choisit d'enseigner le cinéma, mais depuis l'affirmation de son devenir. Son projet pédagogique consiste moins à « refaire encore une histoire du cinéma, après tant d'autres » qu'à déterminer, comme il le formulera par la suite, « la place et le rôle du cinéma dans l'histoire, dans l'évolution

[44] « À la fin des deux ans d'études, il fallait faire un stage. Ça n'était pas facile d'en trouver un car on ne connaissait personne et cela ne fonctionnait que par connaissance. Pour les monteurs, il fallait faire un stage en laboratoire : c'était très ennuyeux et ça embêtait tout le monde. Pour devenir assistant monteur, il faut normalement faire un stage en labo et trois stages sur des tournages. Mais à l'IDHEC, on pouvait devenir assistant monteur en ne faisant uniquement qu'un stage sur le tournage d'un long métrage. […] Quand on sortait diplômé de l'IDHEC, on n'était pas favorisé : les gens ne voulaient pas de nous dans le métier. Quand j'ai fait mes stages et mon premier film en tant qu'assistante, toutes les monteuses étaient très désagréables avec moi. Elles me disaient : "on sait bien que vous n'avez rien appris à l'IDHEC". C'était un peu vrai, en tout cas, du point de vue du montage », Entretien avec Jacqueline Thiédot réalisé par Arnaud Bruttin, Thibaut Bruttin et Lucas Marchina, le 7 novembre 2015 à Montmorency.

[45] Première conférence de Jean Epstein à l'IDHEC, version annotée et corrigée par Jean Epstein, 1945, feuillet 1, Collection La Cinémathèque française, Fonds Jean et Marie Epstein. Cote EPSTEIN238-B60.

intellectuelle générale de l'humanité »[46]. En guise de préalable à la réflexion – pour le moins ambitieuse – qu'il souhaite mener avec sa classe, Jean Epstein développe un bref récit des différentes phases de l'évolution du cinématographe. Son cours vise à mettre au jour les étapes ayant conduit le cinéma à se transformer successivement en « amusement de laboratoire », « phénomène de foire », « art du spectacle », « langage visuel international », « mentalité », « école d'irrationalisme », « philosophie ». Dans cette trajectoire historique, la philosophie apparaît ainsi comme le *telos* vers lequel s'oriente inévitablement le cinéma.

Évoquant le rôle que le cinéma joue dans notre culture, Epstein met en avant le fait qu'il est à la fois un instrument de recherche scientifique et un puissant moyen d'enseignement professionnel. À l'instar d'inventions telles que la lunette astronomique ou le microscope, le cinématographe, en tant qu'outil offrant une « représentation particulière de l'univers », pourrait être lui aussi à l'origine d'un nouveau courant de pensée. Il constitue en effet, selon Epstein, la seule « machine à faire voir le temps », nous donnant la possibilité d'en éprouver la plasticité grâce aux procédés d'accéléré, de ralenti et de projection à rebours. Epstein affirme également l'existence d'une « mentalité cinématographique » qui serait le produit des « habitudes sentimentales et intellectuelles que le cinématographe impose à son public ». Il envisage même l'éventualité d'une importance historique du cinéma un jour comparable à celle de l'imprimerie – à cette différence près que le cinéma constitue pour lui une « école d'irrationalisme », par opposition à la raison classique véhiculée dans les livres par un *logos* auquel échappe précisément le langage en images du cinématographe[47]. L'observation de ce monde dont les phénomènes

[46] Jean Epstein, « Le rôle du cinématographe dans la culture humaine ». Collection La Cinémathèque française, Fonds Jean et Marie Epstein. Cote 97B24.

[47] Cette conception de l'irrationalisme du cinéma envisagée sous un angle positif renvoie aux préceptes de la pensée futuriste énoncés dans le texte du manifeste intitulé *La Cinématographie futuriste*, publié à Milan le 11 septembre 1916 par six des membres du groupe. Comme le rappelle Dimitri Vezyroglou, à la même époque, Ricciotto Canudo s'interroge lui-aussi sur les nouvelles approches cognitives permises par le cinématographe : « Le "septième art" (Canudo), arrivant après tous les autres et venant du monde de la technique, doit les englober et les dépasser pour engendrer une expression artistique nouvelle, fondée sur une synesthésie régénératrice et opposée à la rationalisation sclérosante du Verbe. Par ailleurs, le cinéma est susceptible, plus que toute autre forme d'expression, de court-circuiter la pensée raisonnante pour s'adresser directement à la sensibilité, de susciter un choc émotionnel et psychique, et d'offrir grâce à sa capacité simultanéiste, une

étranges nous sont dévoilés par la machine-cinéma pourrait dès lors, parce qu'elle bouscule nos catégories de pensée, conduire à l'élaboration d'une philosophie proprement cinématographique qu'Epstein s'efforcera à définir et à expérimenter au fil des séances suivantes.

L'enseignement du cinéma, tel qu'il est pratiqué par Epstein, ne saurait être exclusivement théorique. Il prévoit également un atelier de montage au sein de son cours et des projections d'extraits visant à démontrer le bien-fondé de ses hypothèses sur le cinéma comme machine à faire voir le temps (séquences accélérées et ralenties, variété d'échelles de plans sur une même personne, mouvements de caméra, etc.). Néanmoins, cet enseignement est jugé beaucoup trop théorique par les étudiants qui, trouvant que Jean Epstein parle de tout sauf de cinéma, se mettent à déserter le cours. Dans un premier temps, le cinéaste-théoricien demande à ce que son cours devienne facultatif avant de quitter définitivement son poste[48]. Pourtant, bien que cette expérience se soit soldée, de l'aveu même d'Epstein, par un échec, les cours donnés à l'IDHEC inaugurent un moment à compter duquel l'enseignement du cinéma devient pour lui un objet de réflexion à part entière.

Outre son projet de livre *Méthode du cinéma*[49], véritable somme où se cristallise l'ensemble de ses recherches pédagogiques, il envoie, quelques années plus tard, à Jean Benoit-Lévy un manuscrit intitulé *Le rôle du cinéma dans la culture humaine* (1950). Il présente lui-même ce

forme neuve d'aperception et d'intelligibilité du monde ». Dimitri Vezyroglou, « Futurisme », dans Antoine de Baecque et Philippe Chevalier (dir.), *Dictionnaire de la pensée du cinéma*, Paris, PUF, 2012, p. 315–317.

[48] Nous pouvons néanmoins constater la perpétuation des liens entre le cinéaste et les membres de l'école avec qui il entretiendra des liens malgré l'interruption de ses conférences au cours de l'année 1945. Il reçoit notamment une lettre de Mademoiselle A. Viala, chargée de la Section « Cinéma » à l'Évolution Musicale de la Jeunesse et bibliothécaire de l'IDHEC, lui faisant part, le 23 mars 1948, de son souhait d'organiser une séance autour de son film *Le Tempestaire* au Palais de la Mutualité : « Je souhaiterais vivement, au cours de la quatrième séance de la saison qui aura lieu le 15 avril prochain […] projeter le film "Le Tempestaire" que j'ai eu l'occasion de voir à l'Institut il y a quelques mois. Je suis très attachée aux recherches que vous poursuivez et j'estime que les jeunes doivent être mis au courant des réalisations nouvelles », Lettre de Melle A. Viala à Jean Epstein, 23 mars 1948, Collection La Cinémathèque française, Fonds Jean et Marie Epstein. Cote B92. Par ailleurs, les notes prises par Louis Malle pour le cours intitulé « Écrits et doctrines du cinéma » témoignent de l'analyse de l'œuvre théorique d'Epstein au programme de l'IDHEC en 1952.

[49] Jean Epstein, *Méthode du cinéma* (s.d.). Collection La Cinémathèque française, Fonds Jean et Marie Epstein. Cote EPSTEIN98-B24.

texte comme le « schéma d'ensemble d'un enseignement qui pourrait être découpé en tranches ». S'inscrivant dans la continuité de ses cours à l'IDHEC, cette synthèse dénote une démarche intellectuelle toujours aussi ambitieuse : « On a beaucoup expliqué comment le cinéma a été inventé et perfectionné. Mais, il faut aussi se demander pourquoi le cinéma été créé et développé ; pourquoi il est devenu un équipement si important de la civilisation. » Parmi les quinze sections qui composent ce projet pédagogique, certaines d'entre elles firent l'objet de développements du temps où Epstein enseignait à l'IDHEC. D'autres sections correspondent à des questionnements qu'il n'avait pas abordés avec ses étudiants (par exemple, la nouvelle mentalité humaine créée par la culture cinématographique, le cinéma comme remède aux « fatigues psychiques de la civilisation » ou encore le pouvoir de sublimation du cinéma consécutif aux refoulements qu'entraînent les normes édictées par la société). L'exhumation de ces écrits (les conférences à l'IDHEC et les deux manuscrits inédits sur l'enseignement du cinéma) rend perceptible la nécessité, pour Epstein, de transmettre son savoir, sa mémoire du cinéma et le goût des films anciens aux jeunes générations de spectateurs qui, écrit-il, « ne peuvent que difficilement comprendre l'éclat de vie, la force de nouveauté, la puissance de conviction, dont rayonnèrent un instant ces vieilles images »[50]. Ce corpus de textes invite dès lors à une approche renouvelée de l'ensemble de son œuvre et permet de mesurer à quel point l'acuité de son propos qui, en son temps, ne trouva guère d'écho, demeure cependant aussi vive.

Ainsi, ce travail d'exhumation et d'analyse des écrits qui composent le projet pédagogique de Jean Epstein nous conduit non seulement à nous intéresser à un aspect remarquable et jusqu'ici inexploré de son œuvre (si les conférences à l'IDHEC furent certes considérées comme un échec par Epstein lui-même, cela ne saurait annuler leur valeur historique) mais ouvre également la voie à une réflexion plus large sur l'élaboration de l'enseignement du cinéma en France, à la fois comme objet historique mais aussi comme processus de création à part entière. En effet, s'il paraît nécessaire de poser la question des effets d'une telle pédagogie sur l'élaboration, la circulation et la patrimonialisation d'un savoir sur le cinéma, nous pensons qu'il est tout aussi intéressant d'appréhender cette expérience comme le lieu privilégié de l'évolution et de l'expérimentation

[50] Jean Epstein, « Deux grands maîtres à filmer », *La Technique cinématographique*, n° 38, 20 février 1947.

de la pensée de Jean Epstein sur le cinéma à partir de 1945. À cet égard, l'IDHEC au moment de sa création nous apparaît comme un lieu depuis lequel il est possible d'observer à la fois les ambiguïtés de la période d'Occupation et l'émergence du cinéma comme objet d'enseignement à part entière tant d'un point de vue technique que théorique.

Retrouver la trace du geste : caméra multiplane et profondeur de champ dans les films de la Tôei Dôga

Marie Pruvost-Delaspre

Si les techniques sont omniprésentes dans les discours qui portent sur le cinéma d'animation, bien souvent abordé sous l'angle de la spécificité du médium ou des mystères de sa fabrication, les travaux universitaires cherchant à mettre en perspective ces pratiques ou « arts de faire », pour emprunter l'expression de Michel de Certeau[1], dans une approche épistémologique de l'histoire des techniques d'animation, sont plus rares[2]. Pourtant, la façon de faire un film d'animation s'est profondément modifiée, des essais des pionniers aux nouveaux outils introduits par le numérique, et, de la même façon les gestes, les habitudes de travail des animateurs et des techniciens impliqués dans la production. Un certain travail de documentation a été mis en place concernant les pionniers du dessin animé, dont les « inventions » ont fait l'objet d'études approfondies, qui sont pour certaines mentionnées et intégrées dans la perspective de l'histoire du cinéma – c'est ce que tendent par exemple à prouver les travaux récents d'André Gaudreault et Philippe Marion[3]. D'autres chercheurs se sont attachés à décrire les processus d'innovation technique à l'œuvre dans les studios Disney, se concentrant souvent sur l'objet par excellence

[1] Michel de Certeau, *L'invention du quotidien*, vol. 2, « Arts de faire », Paris, Gallimard, 1990.

[2] Notons le travail épistémologique et historiographique de Jean-Baptiste Massuet. Voir Jean-Baptiste Massuet, *Quand le dessin animé rencontre le cinéma en prises de vues réelles : modalités historiques, théoriques et esthétiques d'une scission-assimilation entre deux régimes de représentation*, thèse de doctorat en études cinématographiques, sous la direction de Laurent Le Forestier, Université Rennes 2, 2013.

[3] André Gaudreault et Philippe Marion, *La fin du cinéma ? Un média en crise à l'ère du numérique*, Paris, Armand Colin, 2013.

du discours sur la technologie[4], la multiplane, cet appareil de prise de vues apparenté au banc-titre du dessin animé traditionnel, ainsi nommé car il permet de superposer plusieurs niveaux et créer divers plans dans la profondeur de l'image. Il s'agirait donc d'élargir le champ d'opération de ces recherches en testant leur validité auprès d'un autre objet, exotique et lointain, soit le cas du studio japonais Tôei Animation créé en 1956, qui a joué un rôle central dans la mise en place du modèle de production des films d'animation au Japon, et reste aujourd'hui encore un acteur de premier plan de la production de films et séries télévisées animés de l'Archipel. Cette approche, qui ne se veut pas comparatiste, permettrait également de revenir sur le préjugé consistant à percevoir l'histoire de l'animation dans une perspective purement américaine.

Cet objet méconnu offre, outre la perspective d'enrichir des connaissances souvent limitées sur la production japonaise, la possibilité d'interroger les moyens à la disposition du chercheur pour aborder l'évolution des processus de production, et en particulier la place que les documents de production peuvent occuper dans une telle analyse. En effet, les histoires de l'animation japonaise existantes à ce jour relèvent très largement de l'histoire orale. Que ce soit le travail fondateur de Watanabe et Yamaguchi en 1977 avec _L'Histoire de l'animation japonaise_[5], ou plus récemment les écrits de Jonathan Clements dans son ouvrage de synthèse _Anime: A History_[6], cette histoire se trouve avoir été écrite en grande majorité à partir de témoignages, oraux ou écrits, le plus souvent postérieurs aux événements qui s'y rattachaient. Sans chercher en rien à nier la valeur de ces travaux qui fournissent des sources de connaissances inestimables, ma démarche m'a amenée à réfléchir à une autre manière de faire l'histoire de ce cinéma, qui ne passerait pas uniquement par les récits de témoins – dont on sait au moins depuis l'École des Annales qu'ils peuvent prêter à confusion et doivent être pensés dans leur instabilité – mais qui s'appuierait sur des documents de production à partir desquels seraient formulées, et si possible validées, les hypothèses de travail.

Qu'il s'agisse des génériques dans les éléments qu'ils fournissent sur la répartition des équipes ou de l'image elle-même lorsqu'elle permet

[4] Voir par exemple Jay P. Telotte, _The Mouse Machine: Disney and Technology_, Champaign, University of Illinois Press, 2008.
[5] Yasushi Watanabe et Katsunori Yamaguchi, _Nihon animeshon eiga shi [Histoire de l'animation japonaise]_, Planet., Osaka, Yubunsha, 1977.
[6] Jonathan Clements, _Anime: A History_, London, Palgrave Macmillan, 2013.

d'entrevoir les étapes de fabrication, les films ne sont pas ici considérés comme extérieurs à la réflexion sur l'histoire de la production, mais s'y trouvent intégrés en tant qu'éléments centraux de la démonstration[7]. Associés et mis en regard des documents de production disponibles, et tout particulièrement des décors et des dessins d'animation, ils fournissent une base solide à la réflexion sur les « manières de faire » des techniciens, quand ils ne reflètent pas directement leurs préoccupations de création. Ainsi a émergé l'idée d'une histoire des techniques d'animation qui ne se préoccuperait pas uniquement des outils mais bien des processus de fabrication et des pratiques des animateurs. L'animation fournit, de ce point de vue, un matériau privilégié puisque l'on peut y voir, malgré les forces d'homogénéisation et de standardisation à l'œuvre, la trace du geste de l'animateur dans l'image finale. Cette articulation technico-esthétique, empruntée au travail de Réjane Hamus-Vallée sur les peintres de *matte painting*[8], permet de formuler et de vérifier certaines hypothèses, dont quelques exemples vont être exposés ici.

Les pratiques de l'animation à l'aune des archives de production

Il s'agit donc d'étudier, à l'aune des documents de production disponibles, les « manières de faire » des animateurs de la Tôei, dans l'idée d'y déceler un usage spécifique des techniques de l'animation, novateur ou conforme selon les cas à la pratique habituelle – en particulier américaine, celle-ci étant souvent considérée comme la norme. L'observation de sources et de documents de production permet ainsi de mettre en relief les traces, certes parfois ténues mais toujours décelables, laissées par les animateurs, techniciens et autres collaborateurs, pour les mettre en perspective avec les films mêmes de la Tôei. Cette analyse des documents de production demande, d'un point de vue méthodologique, de s'écarter des enquêtes archivistiques classiques, car bien souvent ceux-ci ne sont pas conservés au sein de collections préconstituées. Ainsi le studio Tôei,

[7] Voir à ce sujet Marie Pruvost-Delaspre, « Rêves d'Amérique : modèles de production dans le cinéma d'animation japonais des années 1950–60 », *Réseaux*, n° 188, 2014, p. 229–254.

[8] Voir Réjane Hamus-Vallée, *Peindre pour le cinéma : une histoire du* matte painting, Villeneuve d'Ascq, Presses universitaires du Septentrion, 2016.

suivant une pratique particulièrement fréquente dans les années 1960, n'a conservé que très peu des esquisses préparatoires, dessins d'animation et celluloïds peints, issus de la fabrication de ses films[9] – contrairement à l'exemple notoire des studios Disney, qui ont constitué de véritables « archives » de leurs documents de production. Comme cela est souvent le cas dans l'histoire des techniques cinématographiques, un travail d'enquête a été nécessaire pour rassembler les documents nécessaires, et ce aussi bien auprès d'organisme de conservation, comme le National Film Center (NFC) de Tokyo ou l'association *Nihon animêshon bunka zaidan*[10], que de collections particulières et autres catalogues de ventes aux enchères.

Un bon exemple de la façon dont les documents de production peuvent nous renseigner sur les usages en cours dans un studio se situe du côté de l'utilisation de la barre à ergots (*pegbar*) et de la perforation des feuilles d'animation qui lui est nécessairement liée. Dans la pratique industrielle mise en œuvre aux États-Unis dès les années 1920, les feuilles de papier utilisées par les animateurs sont perforées, ce qui permet l'utilisation d'une barre à ergots. Cet outil, aussi appelé règle à tenons, a été mis au point par Raoul Barré vers 1912, alors qu'il travaille pour John Randolph Bray. Il s'agit d'un simple système d'encoches par lequel les feuilles volantes, préalablement perforées, sont fixées à une réglette par des tenons (figures 1 et 2). L'embrèvement permet de stabiliser les feuillets et de maintenir le rapport de proportion d'un dessin à l'autre, mais aussi de faciliter le transfert vers le celluloïd et finalement la prise de vues. La disposition de cette barre sur la partie inférieure de la table à dessin va aussi donner naissance à un geste fondateur pour l'animation, le *flip* : les animateurs prennent en effet l'habitude de vérifier constamment la cohérence et la fluidité de la scène qu'ils sont en train de composer en feuilletant de la main libre les dessins réalisés.

[9] Jusqu'en septembre 2014, ces documents faisaient l'objet d'expositions thématiques autour des productions du studio dans un espace dédié, la « Tôei Gallery », situé dans les locaux d'Ôizumi, à Tokyo.

[10] La Fondation culturelle pour l'animation japonaise s'est donnée pour mission de constituer des archives de documents liés à l'animation au Japon, en particulier en incitant les professionnels au dépôt de leurs archives personnelles. Voir en ligne : <http://animationfoundation.jp/>.

Glass fitted into
rectangular opening
in the board

The two
registering pegs

Electric
light

"ANIMATOR'S" DRAWING-BOARD.

9 inches

12 inches

A SHEET OF PERFORATED PAPER AND THE REGISTERING
PEGS.

Figures 1 et 2. La table d'animation (haut) ; les feuilles perforées et la barre à ergots (bas), dans Edwin George Lutz, *Animated Cartoons: How They Are Made, Their Origin and Development*, New York, C. Scribner's Sons, 1920, p. 61–63. Source : Cornell University Library.

Mais l'examen des documents de production de la Tôei ne donne à voir l'usage de perforations que sur les feuilles de celluloïd, et celles-ci sont placées non pas en bas mais en haut de la feuille[11] (figure 3). Par ailleurs, les perforations elles-mêmes n'ont qu'une utilité réduite, puisqu'autant la bande annonce du premier long métrage de la Tôei, *Le Serpent blanc* (1958), qui montre l'équipe du film au travail, que les photographies d'époque des animateurs à leur table à dessin exposées à la Tôei Gallery, donnent à voir l'absence de toute barre à ergots dans le matériel utilisé. L'analyse des documents de production du *Serpent blanc* renforce cette hypothèse : si les celluloïds présentent bien des perforations supérieures, ce n'est pas le cas des dessins d'animation, qui semblent avoir été réalisés sur du papier classique. Le premier exemple de feuilles d'animation perforées apparaît en 1963 avec la première série télévisée de la Tôei, *Ken l'enfant loup* (figure 4). Ceci semble indiquer que le système d'embrèvement est jusqu'en 1963 utilisé uniquement à l'étape du banc-titre par les opérateurs de prise de vues, pour maintenir les celluloïds sur la table d'enregistrement, et non par les animateurs. Mais la présence des perforations sur les documents ne peut être tenue pour une preuve suffisante de l'usage de l'embrèvement, comme le montrent les propos du réalisateur d'animation américain Jimmy Murakami (1933–2014), dont Andrew Osmond raconte l'expérience comme consultant pour le studio japonais à cette même période : « Murakami se rend compte que la Tôei utilise à cette fin [l'embrèvement] des trombones, plutôt que des tenons ; à cause de cela, l'animation pouvait s'avérer instable.[12] »

[11] Pour plus de détails à ce sujet, voir Marie Pruvost-Delaspre, *Pour une histoire esthétique et technique de la production animée : le cas de la Tôei Dôga (1956–1972)*, thèse de doctorat en études cinématographiques, sous la direction de Laurent Creton, Université Sorbonne Nouvelle - Paris 3, 2014, p. 205–210.

[12] Andrew Osmond, « Jimmy Murakami – 1933–2014 », *Manga UK*, 16 février 2014, disponible en ligne : <http://goo.gl/CjqIjs>. Traduction de l'autrice.

Figure 3. Celluloïd des *Joyeux pirates de l'île au trésor* (1971) Tôei Dôga. Collection de l'autrice.

Figure 4. Un celluloïd et deux dessins d'animation de *Ken l'enfant loup* (1963). Tôei Gallery, Tokyo. Photographie de l'autrice.

Le remplacement de la règle à tenons par un trombone par les animateurs de la Tôei ne relève donc probablement pas d'une méconnaissance des processus de production développés quelques décennies plus tôt aux États-Unis, mais bien d'une volonté locale de ne pas appliquer cet usage. On peut apporter deux explications à cette

divergence, l'une relevant de l'histoire des techniques d'animation au Japon, et l'autre de la conception de l'animation des Japonais. En effet, l'embrèvement n'a vraisemblablement pas été utilisé dans les premières décennies du développement de la production animée japonaise, comme en attestent certains documents : qu'il s'agisse des dessins d'animation et celluloïds des films du pionnier Noburô Ôfuji, exposés au NFC de Tokyo, ou du seul celluloïd connu de *L'Araignée et la tulipe* (Kenzô Masaoka, 1943), force est de constater qu'ils ne portent aucune trace de perforations ce qui exclut tout usage d'une règle à tenons. Le studio d'animation de la Tôei ayant été soutenu à sa création par la présence de réalisateurs et producteurs formés avant-guerre, on peut suggérer une forme de continuité et une transmission de ces pratiques aux nouveaux animateurs recrutés par le studio. Une autre hypothèse renverrait à une conception différente de l'animation : en effet, si la pratique du *flip* favorise une approche intuitive et modulable du mouvement, que l'on peut vérifier et reprendre sans cesse, son absence suggère une approche du rendu de la scène animée beaucoup plus abstraite et intellectualisée. Cette approche plus calculée et théorique de l'animation, que représentent bien les deux animateurs principaux de la Tôei à ses débuts, Akira Daikubara et Yasuji Mori, permet aussi de comprendre l'importance de la supervision dans le système de production japonais, qui conduit Mori à inventer en 1964 un nouveau poste de travail, celui de directeur de l'animation.

La question des usages semble déjouer ici celle du déterminisme technique : ce n'est pas tant le matériel et les techniques qui impliquent un usage mais plutôt la vision que les animateurs japonais ont de l'animation qui a induit une certaine organisation du travail et utilisation des dispositifs. Cette vision peut aller jusqu'à totalement réinventer l'usage d'une technique et en subvertir la fonction première, comme le montre bien l'exemple de la multiplane.

Un exemple d'histoire de la production : la multiplane des studios Tôei

Pendant longtemps, on a considéré que la multiplane était un instrument lié aux studios Disney, suivant la conception de son président mis en œuvre par les ingénieurs du studio. En effet, c'est un ingénieur du studio de Burbank, William E. Garity, qui se trouve à l'origine du brevet déposé par Walt Disney en 1938 d'un banc-titre comportant plusieurs niveaux d'exposition. En 1936, Disney avait déposé un brevet

pour un banc-titre permettant de disposer un décor miniature derrière la surface exposée, de façon à pouvoir projeter l'ombre des personnages et économiser de l'animation, mais le studio a alors peu de moyens à investir dans les innovations techniques et le concept semble peu utilisable[13]. L'appareil développé par Garity n'utilise plus d'objets en trois dimensions, mais conserve l'idée de la superposition des plans : il propose un banc-titre composé de plusieurs niveaux de plaques de verre pouvant accueillir les feuilles de celluloïds qui, éclairées individuellement, peuvent ainsi créer des effets de profondeur par transparence. En réalité, la présence de ce dispositif se révèle très ancien dans l'animation : on en trouve la trace aussi bien dans l'industrie que chez les réalisateurs indépendants. Comme le note Chris Pallant, « malgré la référence à l'invention de la caméra mutliplane par un employé des studios Disney comme un exemple de l'inventivité du studio, la multiplane Disney n'était en réalité que la dernière étape dans l'évolution de la recherche de profondeur de champ en animation. »[14] Il serait donc intéressant de se questionner sur la manière dont les animateurs japonais développent l'idée d'un tel dispositif de prise de vues, et à partir de quels exemples ou de quelles expériences particulières se constitue la première multiplane japonaise.

Comme de nombreux dispositifs technologiques liés à l'industrie cinématographique, la multiplane[15], bien qu'elle désigne théoriquement l'appareil créé par William Garity, un ingénieur des studios Disney, et utilisé pour la première fois pour le court métrage *Le Vieux Moulin* (W. Jackson, 1937), possède des origines multiples, et plusieurs processus similaires apparaissent au Japon à partir des années 1930. En effet, l'appareil de prise de vues de Noburô Ôfuji, conservé au NFC, possède plusieurs niveaux de plaques de verre superposables, ce qui laisse imaginer que ce dernier utilisait, dès les années 1920, une forme certes simplifiée – la disposition des niveaux est fixe – mais néanmoins opératoire du principe de la multiplane. Plus tard, le réalisateur Tadahito Mochinaga fabrique pour le film de Seo Mitsuyo *Ari-chan* (1941) une caméra à plans multiples,

[13] Fraser MacLean, *Setting the Scene: The Art & Evolution of Animation Layout*, San Francisco, Chronicle Books, 2014, p. 60.

[14] Chris Pallant, *Demystifying Disney: A History of Disney Feature Animation*, New York, Bloomsbury Publishing, 2011, p. 28.

[15] On peut noter d'un point de vue sémantique que si l'expression « *multiplane camera* » est utilisée par la revue *Television Age* à propos du dispositif des studios Disney, les sources japonaises utilisent plus souvent le terme de « machine de prise de vues » (*satsuei-dai*) qui ne renvoie donc pas directement à l'invention de W. Garity.

qui pourrait lui avoir été inspirée par la projection du film des studios Disney *Fantasia* (1940), présentée dans une copie confisquée à quelques techniciens de la Tôhô, dont Mochinaga, Seo et Kenzô Masaoka[16]. Ce dernier met à profit cette expérience dans l'un des grands films animés de la période, *L'Araignée et la tulipe*, avant de perfectionner son emploi après la guerre dans une série de courts métrages, comme *Tora-chan le chat de gouttière* (1946), réalisé avec l'aide de l'opérateur Taiji Yabushita.

On sait, par divers témoignages, que se trouve dans les locaux de la Tôei à Ôizumi en 1958 une caméra multiplane, dont l'animateur Yasuo Ôtsuka[17] affirme qu'elle ne fonctionne que partiellement. Les films eux-mêmes représentent peut-être les traces les plus évidentes de sa présence. *Le Serpent blanc* comporte plusieurs scènes où l'usage du dispositif apparaît de façon claire dans la gestion des mouvements de caméra et le mouvement des personnages dans les décors. D'où proviennent les sources d'inspiration de cette construction à la Tôei ? Celles-ci sont probablement diverses, à commencer par l'expérience des animateurs les plus anciens ayant travaillé avant la guerre, ou les initiatives du studio lui-même, tel le voyage du réalisateur Taiji Yabushita à Burbank rapporté par Seiji Kanô[18]. Mais on peut noter également des sources extérieures au studio d'un certain intérêt, comme les reproductions dans des journaux spécialisés ou encore l'étude des films et des documents publicitaires, ainsi que des manuels d'animation. La revue japonaise *Television Age* publie ainsi, dans son septième numéro de décembre 1960, plusieurs schémas explicatifs du fonctionnement de la multiplane[19], qui ressemblent fortement à ceux utilisés en 1958 par Bob Thomas dans *The Art of Animation*[20] et donnent le sentiment que ceux-ci ont été traduits depuis l'ouvrage de Thomas. On y retrouve par exemple

[16] Voir à ce sujet Jonathan Clements et Barry Ip, « The Shadow Staff: Japanese Animators in the Tôhô Aviation Education Materials Production Office 1939–1945 », *Animation*, vol. 7, n° 2, 2012, p. 189–204.

[17] Yasuo Otsuka, *Animer à la sueur de son front [Sakuga ase mamire]*, Tokyo, Tokuma Shoten, 2001.

[18] Seiji Kano, *Les gens qui ont fait l'animation japonaise [Nihon no animêshon o kizuita hitobito]*, Tokyo, Wakakusa Shobô, 2004.

[19] Cette source a été mise à jour par le chercheur japonais Yuka Minakawa dans un article sur un studio concurrent de la Tôei, Otogi Pro. Voir Yuka Minakawa, « Nihon dôga kôbô-shi shôsetsu Tezuka gakkô hatsubai kinen entori », 2009, en ligne : <http://blog.livedoor.jp/hayashida2007/archives/1159808.html>.

[20] Bob Thomas, *Walt Disney The Art Of Animation: The Story Of The Disney Studio Contribution to A New Art*, New York, Simon and Schuster, 1958, p. 124.

des renvois identiques à l'usage des différents plans de prise de vues, l'un étant consacré à l'animation, les autres à différents niveaux de décors. Par ailleurs, la série des studios de Burbank *Le Monde merveilleux de Disneyland* (ABC, 1954–55), diffusée au Japon à partir de 1958, comporte un épisode nommé « Tricks of Our Trade », dans lequel Walt Disney revient sur la conception de la multiplane et son utilisation par ses équipes, un épisode qui aurait également pu servir de source aux techniciens de la Tôei.

Retrouver la trace de la multiplane de la Tôei et de sa conception

Il apparaît donc clairement que le studio d'animation de la Tôei était à sa création équipée d'une multiplane, présence qui doit probablement autant aux expérimentations des pionniers japonais depuis les années 1920 sur ce dispositif qu'à l'attrait exercé par le style disneyen, dont le directeur du studio Hiroshi Ôkawa se revendique le pendant oriental – l'expression de « Disney de l'Asie » lui est d'ailleurs attribuée pour parler de la structure.

Au cours des recherches menées sur l'usage de ce dispositif par le studio est ainsi apparue, à travers plusieurs signes, l'hypothèse d'un remplacement de la première multiplane utilisée, quelque part entre *Le Serpent blanc* (1958) et l'arrivée de la production télévisée (1963). Cette hypothèse, suggérée par différents témoignages et par l'analyse des documents de production, permet d'expliquer pourquoi l'animateur Yasuo Ôtsuka évoque dans ses mémoires une multiplane qui fonctionne mal. Elle apporte surtout un éclairage central sur le réaménagement que connaît le dispositif lorsqu'il est réapproprié par les techniciens japonais. La première multiplane de la Tôei probablement construite au moment ou après la fondation du studio en 1956, et utilisée sur la production du *Serpent blanc* en 1958, n'a pas été localisée. Cependant, la seconde (figure 5) a été conservée au Nerima Shakujiikôen Furusato Museum. Installée en 1959[21] pour la création du premier long métrage en ToeiScope (équivalent du format Cinémascope) du studio, *Sasuke le petit samurai* (T. Yabushita, 1959), elle paraît assez proche du modèle américain, que ce soit dans sa conception en colonnes sur quatre pieds, ses mollettes qui permettent de modifier les rapports d'espacement entre les niveaux, ou encore la double position des opérateurs de prise de vues, l'un placé avec la

[21] La date est confirmée par le catalogue du musée.
Voir en ligne : <http://www.neribun.or.jp/web/27_archive/detail.cgi?id=10277>

caméra tout en haut de la structure – on aperçoit l'escabeau prévu à cet effet sur le côté gauche –, et l'autre à ses pieds au niveau du tableau de commande.

La seconde multiplane (figure 6) – ou plutôt la troisième, si l'on compte le banc-titre utilisé pour *Le Serpent blanc* – exposée jusqu'à récemment à la Tôei Gallery des studios d'Ôizumi, présente des différences frappantes avec ce premier modèle. Tout d'abord la conception de la structure a été repensée et, au lieu des quatre colonnes qui soutiennent l'ancienne version, on est ici face à dispositif beaucoup plus horizontal, qui semble privilégier la possibilité pour les techniciens de se déplacer autour du banc-titre plutôt que de le surplomber en hauteur. Seule la caméra est installée sur un pied vertical, permettant de réaliser les mouvements d'appareil. La machine dispose également d'un plateau de moins, ce qui limite la possibilité de superposer les niveaux dans l'image – un choix étonnant, lorsque l'on sait que la multiplane de Disney connaît le développement inverse, le nombre de niveaux modulables augmentant jusqu'à atteindre le nombre de sept. On ne peut également pas manquer de noter l'importance prise par les molettes situées à l'avant, en lieu et place du tableau de contrôle, qui servent à déplacer latéralement le décor placé sur le niveau inférieur de la machine.

Figures 5 et 6. Première multiplane (gauche) et seconde multiplane (droite) de la Tôei Dôga. Sources : Nerima Shakujiikôen Furusato Museum et Tôei Gallery, Tokyo. Photographies de l'autrice.

On peut se demander, en particulier dans le cadre d'une conception de l'animation qui relève bien souvent d'une pensée téléologique du progrès technique, pourquoi avoir changé ce dispositif de prise de vues pour un autre, à première vue plus simple et moins sophistiqué[22]. Une première esquisse de réponse se trouve dans le matériel utilisé par la Tôei, et en particulier les feuilles de celluloïd, fournies par Fujifilm : plus épaisses que celles utilisées à Burbank, elles laissent plus difficilement passer la lumière, ce qui pouvait poser problème en termes d'éclairage au moment de la prise de vues et limitait, par conséquent, le nombre de couches de celluloïd que l'on pouvait superposer sans perdre en netteté et en qualité d'image. Mais on perçoit aussi dans cette modification de la conception de l'outil une conséquence de l'usage qui en est fait par le studio : on ne cherche pas tant à augmenter le nombre de superpositions qu'à accroître la surface dans l'idée d'une orientation horizontale et non verticale du mouvement. Ainsi, on peut faire l'hypothèse que cette troisième version de la multiplane, si elle ne répond pas à l'idéal disneyen d'accentuation de la profondeur de champ, correspond aux besoins des équipes de la Tôei, qui ne cherchent pas tant « l'illusion de la vie »[23] que le plaisir de l'illusion. On trouve dans la plupart des longs métrages animés de la Tôei des exemples de cette utilisation non réaliste de la multiplane, ne créant pas de profondeur mais renforçant la planéité de l'image.

Ainsi le héros des *Voyages spatiaux de Gulliver* (Y. Kuroda, 1965), lorsqu'il fuit à travers une épaisse forêt les gendarmes qui le poursuivent, voit-il les arbres et buissons s'écarter latéralement sur son passage jusqu'à l'apparition d'une clairière, dans une scène qui ne reproduit pas la réalité de la course mais s'intéresse plutôt à l'effet optique et visuel de cette fuite effrénée en avant, donnant un sentiment de transparence du dispositif plus que d'illusion de la vie (figures 7 à 10). Tout se passe donc comme si l'usage du dispositif dans le studio japonais venait renverser le rôle canonique attribué à cette invention, en particulier dans la forme développée par les studios Disney. Une comparaison avec le court métrage des studios de Burbank *Le Vieux Moulin* (W. Jackson et G. Heid, 1937),

[22] On pourrait aussi voir dans cette première phase de « simplification » des processus de production le point de départ d'une transformation globale de l'animation japonaise, qui va l'amener à se concentrer dès le début des années 1960, dans le cadre de la production télévisée, sur une rationalisation des logiques de fabrication.

[23] Voir Thomas Frank et Johnston Ollie, *The Illusion of Life: Disney Animation*, New York, Hyperion, 1981.

Figures 7 à 10 (gauche). Photogrammes des *Voyages Spatiaux de Gulliver*,
Y. Kuroda (Tôei Dôga, 1955). **Figures 11 à 14** (droite). Photogrammes du
Vieux Moulin, W. Jackson et G. Heid (Studios Disney, 1937).

donne à voir l'emphase placée du côté américain sur le mouvement vers le
fond du cadre, répondant au désir de développement de la profondeur de
champ (figures 11 à 14). Dans le film, la caméra, dont le point de départ
est souligné par les croisillons d'une toile d'araignée au premier plan,
avance d'abord vers le moulin situé en arrière-plan, puis se rapproche

de la porte, avant de nous faire enfin pénétrer à l'intérieur du moulin et découvrir les protagonistes de l'histoire, un couple d'oiseaux. Se forme ainsi un modèle technico-narratif qui se trouve repris dans nombre de séquences d'ouverture des films des studios Disney, dans un double mouvement d'avancée à l'intérieur de l'image et d'ouverture du récit.

La question du déterminisme technique semble avoir été ici parfaitement retournée : il apparaît clairement que ce n'est pas le matériel qui implique un usage mais bien la vision que les animateurs japonais avaient de l'animation qui a induit une certaine organisation de la production, de l'usage des objets et des techniques. Dans son travail sur la pratique du banc-titre et son rôle pour reproduire des effets optiques dans le *cartoon*[24], Kristin Thompson note qu'il est précisément nécessaire pour aborder ces questions de distinguer la technique, définie comme une pratique individuelle et située dans le temps, de la technologie, conçue comme processus de production. Cette différenciation permet, selon elle, de penser la multiplane comme une technique issue de la technologie du banc-titre et de la défaire ainsi d'une partie de la pensée déterministe qui lui est associée. La multiplane n'est donc pas, en elle-même, un outil du réalisme et de la vraisemblance. Les studios Disney l'ont utilisée en ce sens car l'esthétique visée par Disney était celle d'une recherche de proximité avec la prise de vues réelles. En ce sens, l'usage divergent de la multiplane ne se trouve d'ailleurs en ce sens pas limité au cas du Japon : on retrouve cette inspiration dans les courts métrages du studio United Production of America (UPA) par exemple, dans la quête d'une forme d'esthétique de la litote qui se rapproche du travail effectué par les animateurs de la Tôei.

De ce point de vue, la proposition de retournement sémantique opérée par Thomas Lamarre prend toute son importance. En effet, il propose dans *The Anime Machine* de remplacer la profondeur de champ (*depth of field*) par un « champ de profondeur potentielle » (*field of potential depth*) qui permet de décrire cette construction « distributive » du champ qui ne vise plus la proximité avec la vision humaine mais la mise en rapport de la planéité de l'image avec des effets d'artificialité et de représentation. Il écrit que « l'*animetisme* [conception de l'animation qu'il oppose au *cinématisme*, privilégiant la proximité avec la prise de vues réelles] ne concerne pas le mouvement vers la profondeur de l'image,

mais le mouvement sur et entre les surfaces de l'image. »[25] Mais pour Lamarre, cet usage renvoie surtout à la pratique du studio du *mangaka* Osamu Tezuka, Mushi Pro, le Tôei relevant selon lui d'une conception plus classique et disneyenne de l'animation. Force est de constater, à travers ces quelques exemples d'histoire des techniques employés par le studio d'Ôizumi, qu'il n'en est rien : la Tôei, au-delà des discours de son directeur sur l'influence du modèle disneyen, a bien été un des premiers studios d'animation japonais à subvertir des techniques conçues comme des imports des États-Unis pour les convertir à son propre usage.

[25] Thomas Lamarre, *The Anime Machine: A Media Theory of Animation*, Minneapolis, University of Minnesota Press, 2009, p. 7.

Pour une histoire française des images de synthèse[1]

Cécile WELKER

Malgré la masse de littérature qui accompagne les développements des effets visuels au cinéma, l'histoire de l'informatique graphique est encore méconnue et peu traitée. Nous discernons deux raisons principales à cet état de fait. Cette discipline scientifique est encore jeune[2]. Les historiens ont d'abord traité des dimensions techniques et humaines qui ont permis les développements des matériels informatiques, sans aller voir du côté de l'image[3]. D'autre part, les ouvrages consacrés au cinéma s'attèlent avant tout à dresser une chronologie des productions marquantes, sous-entendu des succès, laissant de côté les expérimentations des premiers temps parfois moins heureuses et souvent oubliées. Avec la dominance des productions américaines diffusées à l'étranger, cette histoire montre, par ailleurs, l'hégémonie des États-Unis[4]. Pourtant, la France a connu dès

[1] Cet article est dédié à Chantal Duchet, dont la bienveillance m'a orientée vers l'EnsAD pour développer le travail de recherche présenté ici.

[2] La première thèse consacrée à la discipline a été soutenue en 1968 : Michel Lucas, *Techniques de programmation et d'utilisation en mode conversationnel des terminaux graphiques*, thèse de troisième cycle, en mathématiques appliquées, sous la direction d'Olivier Lecarme, Université Joseph Fournier, Grenoble, 1968, 120 p. Le premier colloque dédié à l'histoire de l'informatique est organisé à Grenoble, place importante de la recherche appliquée, en 1988 : Philippe Chatelin, *Actes du colloque sur l'histoire de l'informatique en France*, Grenoble, 1988, 2 volumes.

[3] À l'exception récente de Christian Morandi, *Les nouvelles technologies dans la pratique professionnelle des architectes, 1959–1991 : les « méthodologistes », histoire de trois laboratoires d'informatique dans les écoles d'architecture en France*, thèse de doctorat, Université Versailles Saint-Quentin-en-Yvelines, 2011 ; Benjamin Thierry, *Donner à voir, permettre d'agir : l'invention de l'interactivité graphique et du concept d'utilisateur en informatique et en télécommunications en France (1961–1990)*, thèse de doctorat en histoire, sous la direction de Pascal Griset, Université Sorbonne Paris 4, 2013.

[4] Terrence Masson et Tom Sito, reconnus comme des acteurs de cette histoire, consacrent quelques lignes (5 à 8 citations sur 400 p.) aux expériences françaises, souvent très

les années 1980 une activité bouillonnante dans la réalisation d'images audiovisuelles 3-D. Une trentaine de sociétés de post-production ont ainsi été créées et ont fait la renommée d'un savoir-faire national dont les héritiers connaissent aujourd'hui un incontestable succès. Ainsi, Mikros Image voit le jour en 1985 et réalise depuis des effets visuels pour la publicité (*Dior-J'adore égéries*, Jean-Jacques Annaud, 2011), la télévision (série *Les Revenants*, Fabrice Gobert, 2015) ou le cinéma (*De rouille et d'os*, Jacques Audiard, 2012), jusqu'à proposer très récemment des longs métrages d'animation (*Astérix et le domaine des dieux*, Alexandre Astier, Louis Clichy, 2014). Buf Compagnie, créée à la même période par Pierre Buffin et Henri Seydoux, se fait d'abord connaître nationalement en proposant de petits films télévisuels pour La Cinq et Canal +, avant de participer à la réalisation de plans à effets sur des films de majors américaines tels que *Matrix* (Andy et Larry Wachowski, 2003). Fondée en 1985, la branche animation de MacGuff s'est vue rachetée en 2011 par la firme américaine Illumination après la réalisation du premier *Moi moche et méchant* (Pierre Coffin et Chris Renaud, 2010).

Afin de mieux connaître les enjeux de cette histoire nationale des images de synthèse, le programme de recherche EnsadLab Hist3D de l'École nationale supérieure des Arts Décoratifs développe, depuis 2007, un travail de mémoire : numérisation et indexation de créations tridimensionnelles animées par ordinateur en sa possession ; collecte de témoignages de pionniers. Tout en présentant les activités de ce programme de recherche, nous montrerons comment donner une cohérence et des pistes de lecture aux outils qu'il propose, en prenant comme point d'entrée les évolutions des technologies, des pratiques et des métiers liées à l'apparition des images de synthèse au cinéma et dans l'audiovisuel. Nous poserons ensuite la question de l'avenir de ce fonds, qui pourrait disparaître en même temps que le programme de recherche, arrivé à son terme.

Méthode : exploiter le fonds Hist3D

Pour comprendre l'origine du programme de recherche Hist3D, il faut revenir sur le parcours professionnel de Pierre Hénon. Professeur à l'École nationale supérieure des Arts décoratifs (EnsAD) depuis 1979,

parcellaires voire erronées. Terrence Masson, *CG101 : A Computer Graphics Industry Reference*, Riders Press, 1999 ; Tom Sito, *Moving Innovation: A History of Computer Animation*, Cambridge, Massachusetts, MIT press, 2013.

responsable de l'Atelier d'image et d'informatique (AII), il a accompagné l'intégration des outils informatiques au sein de l'école et a certainement formé un grand nombre d'infographistes. Lorsque l'atelier s'achève en 2007 (il est devenu entre-temps un post-diplôme), Pierre Hénon met en ligne la majorité des travaux des étudiants passés par l'AII[5]. En 2006, l'intégration des enseignements supérieurs français dans le cadre européen pose la question de la reconnaissance des diplômes des écoles d'art en qualité de diplômes d'enseignement supérieur valant grade de master et de doctorat. Les post-diplômes de l'EnsAD se transforment en programmes de recherche, amendés depuis par le doctorat SACRe[6]. Pierre Hénon fonda alors le programme de recherche Hist3D. Son objectif est de valoriser cette histoire française de l'image de synthèse dont il est partie prenante, notamment à partir du fonds de films qu'il avait déjà constitué tout au long de sa carrière. Assisté de Christophe Pornay (régie technique EnsAD), il s'entoure de Chantal Duchet (professeure à l'Université Sorbonne Nouvelle - Paris 3) et de Gilbert Dutertre (responsable du fonds Imagina pour l'Ina) pour mettre en place une patrimonialisation de ces films nativement numériques.

Bien que datant des années 1980, il n'existe alors aucun recensement des films de synthèse des premiers temps. En effet, les images de synthèse sont générées par ordinateur et de ce fait elles sont nativement numériques. Mais c'était un état temporaire. Jusqu'au milieu des années 1980, on savait représenter par ordinateur sans savoir conserver ces images. La puissance des machines ne permettait pas de les mémoriser et la pratique courante était alors de capturer l'image à l'écran à l'aide d'un appareil photographique ou d'une caméra, de sorte à repasser ces images numériques sur pellicule, à tel point qu'il n'existe quasi plus de masters des origines. Les sociétés de production comme les réalisateurs n'ont pas gardé les bobines, à diffusion interne ou à destination des télévisions et des festivals. Ainsi, le groupe de recherche a commencé par numériser,

[5] Voir en ligne : <http://aii.ensad.fr/>

[6] Ce programme est le résultat de la coopération de six institutions : les cinq grandes écoles nationales supérieures de création – le Conservatoire national supérieur d'art dramatique (CNSAD), le Conservatoire national supérieur de musique et de danse de Paris (CNSMDP), l'École nationale supérieure des arts décoratifs (EnsAD), l'École nationale supérieure des beaux-arts (ENSBA), l'École nationale supérieure des métiers de l'image et du son (La Fémis) et l'École normale supérieure (ENS). Ces institutions sont toutes membres de l'Université de recherche Paris Sciences et Lettres *Research University* (PSL).

découper puis indexer des programmes entiers d'images de synthèse provenant de *best-of* ou de bandes démo de sociétés de post-production, conservées sur des cassettes U-matic ou VHS, afin d'en extraire chaque échantillon – courts métrages, effets spéciaux, publicités, clips – valorisés à travers une base de données[7] de 1995 extraits filmiques.

Pour compléter cette première source, le programme a recueilli entre juin 2011 et janvier 2014 les témoignages des principaux acteurs de l'informatique graphique en France. Il ne s'agit pas d'entretiens dirigés. Pour en faire profiter le plus grand nombre, il a été proposé aux témoins d'intervenir dans un cycle de séminaires, en leur laissant la parole dans un temps donné. Toutes les séances ont été filmées, puis mises en ligne sur le site <hist3d.ensad.fr>. Ces rencontres ont permis au programme de récolter de nouveaux documents vidéo mais aussi textuels, qui viennent accompagner les productions : *storyboard, making of,* démo, articles de presse. Bien que les films ne soient pas directement accessibles en ligne, ce corpus vise à être un outil à destination de chercheurs ou de praticiens qui pourront le raisonner, comme tente de le faire le *wiki*[8] dédié, synthèse plus ou moins parcellaire des résultats « bruts » du programme Hist3D (fiches des sociétés, des personnes, des films).

Inscrite en doctorat à l'Institut de recherche sur le cinéma et l'audiovisuel (IRCAV), j'ai rejoint le groupe en 2011 pour effectuer un récolement du fonds documentaire et adosser ma thèse à ce travail d'archive[9]. Ce qui implique qu'avant même d'avoir défini mon sujet à proprement parler, une collection importante de films m'a été confiée. Ma première tâche au sein du groupe a été de poursuivre la numérisation, et surtout, l'indexation des échantillons. Ce rôle de « documentaliste » m'a donné une bonne place pour visionner un certain nombre de spécimens audiovisuels. Mes recherches ont donc commencé à rebours, en identifiant d'abord les produits de l'industrie culturelle des images de synthèse. Cette indexation m'a aidée à me familiariser avec des termes et des noms dont j'étais jusqu'alors peu coutumière, pour circonscrire une communauté, définir mon bornage chronologique, et délimiter mon champ d'étude. J'ai complété ces données par la transcription

[7] Voir en ligne : <http://histis.fr/h/liste.php>

[8] Voir en ligne : <histoire3d.siggraph.org>

[9] Cécile Welker, *La fabrique des « nouvelles images » : l'émergence des images de synthèse en France dans la création audiovisuelle (1968–1989)*, thèse de doctorat sous la direction de Bruno-Nassim Aboudrar, Université Sorbonne Nouvelle - Paris 3, 2015.

des témoignages récoltés par le programme, soit une cinquantaine de personnes actionnaires de cette histoire et classées selon trois catégories professionnelles : les chercheurs, les réalisateurs et les acteurs politiques stratégiques. Cette reconstitution socio-historique a permis de croiser les données avec les lectures historiques effectuées en parallèle, et s'est nourrie du dépouillement d'autres archives que celles d'Hist3D. L'enquête a dû prendre en particulier la voie de l'analyse des discours de l'État quand ils existaient, à travers des documents dépouillés aux Archives nationales dans les versements des ministères concernés par le Plan Recherche Image (ministères de la Communication, de la Culture, des Postes, Télégraphes et Téléphones (PTT), de la Recherche et de la Technologie) ; des structures qui leurs sont rattachées, et aux archives de l'Ina, acteur dominant de cette histoire française. Enfin, les revues de vulgarisation scientifique consacrées à l'informatique graphique ont été sondées, ainsi que les revues spécialisées dédiées aux images de synthèse (*Sonovision*, *La Lettre de l'image*) et des magazines connexes dédiés au cinéma (*Cahiers du Cinéma*), au cinéma d'animation (*Banc-titre*), et à l'audiovisuel (*Les Dossiers de l'Audiovisuel*, *Problèmes audiovisuels*). Autant de traces du contexte technique, politique et culturel de l'époque qui définissent une histoire « officielle »[10] des images de synthèse françaises, celle des recherches publiques, des réseaux institutionnalisés et des sociétés subventionnées par l'État. L'étude de ces archives aide à envisager les transformations des effets spéciaux à l'aune de l'image numérique.

Objet : l'infographie, un nouveau milieu

Si l'informatique graphique s'est affirmée comme une discipline de recherche fondamentale dès la fin des années 1960 en France, elle a connu une émergence médiatique plus tardive, au début des années 1980, lorsque les techniques d'imagerie sont sorties des laboratoires.

> Par quelle aberration peut-on, en ces temps de rigueur économique, dépenser autant d'argent, mobiliser les puissances de calcul des ordinateurs géants pour satisfaire les ambitions démiurgiques de quelques chercheurs ? Pour répondre

[10] Il existe de multiples histoires parallèles à la nôtre : celle des développeurs indépendants et non « *corporate* » (Jean-Paul Musso, François Helt), celle des démoscènes (pouet. net), la récupération par les artistes comme ceux de l'art vidéo (l'émission *Avance sur Image*, le Centre international de vidéo de Montbéliard), etc., qui sont tout aussi riches et viennent stratifier l'essor de la 3-D en France.

à la question, il suffit de savoir à qui profite le « crime ». [...] Entraîner un pilote d'avion ou un conducteur de char sur un simulateur est moins coûteux et moins risqué qu'utiliser un appareil réel. Le marché de la simulation civile et militaire a porté les premiers développements de l'image de synthèse. [...] Les nouvelles images, on le voit, irriguent un champ considérable et justifient pleinement les milliards d'investissement qui leur sont consacrés. Les applications audiovisuelles ne constituent qu'une retombée tardive et encore balbutiante des progrès accomplis dans cette imagerie révolutionnaire.[11]

Au cours de cette trajectoire, le rôle des pouvoirs publics est considérable. En mai 1981, le gouvernement socialiste qui arrive au pouvoir entretient un rapport privilégié avec les technologies, entendues au sens du progrès, qui sortiraient la France de son déclin. Au même moment, les images de synthèse sont à la croisée d'enjeux économiques (l'apparition du marché des nouvelles images), politiques (l'indépendance économique) et internationaux (la course à l'équipement et à l'innovation). La fièvre des « nouvelles images »[12] s'engage, attisée par la curiosité du gouvernement, qui voit en elles l'incarnation du changement, de la sortie de crise et de l'indépendance. Les pouvoirs publics mettent notamment en place le Plan interministériel « Recherche-Image » (PRI) animé par le Comité interministériel pour le développement de l'image de synthèse (CIDIS), qui rassemble la Direction des industries électroniques et informatiques (DIELI)[13], le Centre national de la cinématographie (CNC)[14], le Centre commun d'études de télévision et de télédiffusion (CCETT), l'Agence pour le développement de l'informatique (ADI)[15], l'Institut national de

[11] « Cinquième forum international des nouvelles images. Un frisson d'alchimiste. Les artistes reprennent le pouvoir aux ingénieurs », *Le Monde*, 16 janvier 1986.

[12] Il nous semble que c'est d'abord l'Institut national de l'audiovisuel qui a propagé cette expression, « Les nouvelles images*, des outils pour commander et agir », *Problèmes audiovisuels*, n° 4, Ina/La Documentation Française, novembre-décembre 1981 ; « Génération de nouvelles images pour la télévision d'aujourd'hui et de demain », thème des rencontres du premier « Forum international des nouvelles images », organisé par l'Ina (qui se rebaptisera *Imagina* en 1986), Forum international de télévision de Monte-Carlo, 5 au 7 février 1982 ; « Les nouvelles images**, des instruments pour la recherche et la création artistique », *Problèmes audiovisuels*, n° 6, Ina/La Documentation française, mars-avril 1982.

[13] La DIELI existait depuis 1974 (décret 74–661 du 29 juillet 1974 sur l'organisation de la Direction générale de l'industrie). Archives nationales, versement 19810642 article 72.

[14] Rappelons que le Conseil national de la cinématographie est créé le 8 décembre 1983.

[15] L'ADI, organisme sous tutelle du ministère du Redéploiement et du Commerce extérieur, fut créée en 1979 pour favoriser la création, la diffusion et l'utilisation des

l'Audiovisuel, par délégation de leurs ministères[16]. Soixante-quatorze et quatre cent quinze millions de francs sont engagés entre 1983 et 1989 pour promouvoir à la fois le développement (ou l'achat) de matériels et logiciels (43,4%), la production (16,3%) et la formation (13%) des futurs créateurs (figure 1).

Figure 1. Jean-Marc Peyron, *Bilan du Plan Recherche Image*, 1990, 14 p. Archives nationales versement 1997 0544 article 21 / PRI 1981–1990 (origine CNC).

On observe ici une première césure. Alors qu'il existait une recherche fondamentale importante en informatique graphique dans les universités françaises depuis la fin des années 1960, le Plan Recherche Image ne prend pas appui sur elle et préfère soutenir la production *in extenso* des sociétés de production, qui doivent développer leur propre matériel. Les réalisateurs expérimentent d'abord la 3-D en détournant les simulateurs

technologies, tant spécialisées que grand public. Elle est à l'origine du centre X2000, de l'opération URBA 2000 et du Plan Informatique pour tous. Archives nationales, Direction générale de l'industrie, service des industries de communication et de service (Mission économique et financière), versement 19910212 articles 1 à 12.

[16] Par délégation respective des ministères du Redéploiement industriel et du Commerce extérieur, de la Culture, des PTT et de la Communication. Le ministère de l'Éducation nationale est présent lors de l'élaboration du PRI mais disparaît progressivement des échanges.

de vol pour réaliser des courts métrages[17] ou des publicités[18], pour finalement l'adopter et aller jusqu'à développer des logiciels faits maison clé en main[19].

La deuxième ambition de l'État consiste à favoriser les formations spécialisées de sorte à inciter les usages des « nouvelles images ». Je n'ai pas défini une nouvelle nomenclature des professions dans ma thèse. Toutefois, on observe un phénomène très distinctement : les images de synthèse et leur enseignement ne se bâtissent pas au sein du milieu attendu. Les rapports préliminaires au PRI imaginent une intégration primordiale des écoles de cinéma. L'Institut des hautes études cinématographiques (IDHEC) et l'École nationale supérieure Louis-Lumière sont clairement visés, d'autant que l'Ina, acteur principal du plan gouvernemental, était également installé à Bry-sur-Marne. Ce sont finalement de nouvelles formations qui s'établissent avec l'aide étatique. L'École nationale supérieure des arts décoratifs (EnsAD) s'équipe de moyens informatiques dès 1982 pour proposer un Atelier d'image et d'informatique (AII) ouvert à tous les secteurs de l'école. La formation Arts et technologies de l'image (ATI) de l'Université Paris 8 Vincennes Saint-Denis s'ouvre officiellement à la rentrée 1984, dans le département d'Arts plastiques, après qu'Hervé Huitric, Monique Nahas, Michel Bret, Marie-Hélène Tramus, Anne-Marie Eyssartel, Jean-Louis Boissier, Liliane Terrier et Edmond Couchot (aussi bien mathématiciens qu'artistes) ont scellé leur rencontre non loin du groupe Art et Informatique de Vincennes. L'école Supinfocom, enfin, est créée en 1988 par la Chambre de Commerce et de l'Industrie du Valenciennois pour répondre aux besoins de main-d'œuvre de cette industrie culturelle naissante.

[17] *Europe 1-UGC*, 0:22, réal. Michel François, les Films Michel François et Thomson-CSF, 1981 ; *Maison vole*, réal. André Martin et Philippe Quéau, 2:15 Ina/SOGITEC AUDIOVISUEL, 1983.

[18] *Sharp*, réal. Xavier Nicolas, 0:30, 1983. Directeur technique Claude Méchoulam ; directeur artistique Jean-François Henry ; graphismes Myriam Feuilloley ; décors François Aliot, Philippe Adamov ; animation informatique Alain Grach, Daniel Poiroux ; musique Frédéric Rousseau ; annonceur Sharp bureautique France ; agence T.D. publicité ; production Black studio ; images synthétiques SOGITEC.

[19] Imagix3D, un modeleur 3-D qui permit à la société McGuff de réaliser ses premiers films; le logiciel Explore réalisé par TDI qui permettait à la fois modélisation, rendu et animation 3-D ; le logiciel Character, réalisé par Fréderic Nagorny au début des années 1990, qui permettait enfin de contrôler une véritable animation, et de gérer par exemple l'arrêt convenable des pieds du personnage sur le sol.

Nous pourrions d'ailleurs poursuivre en regardant plus précisément l'AII des Arts décoratifs. En 1979, ils étaient dix professeurs à composer un groupe de travail pour mettre sur pied un projet de laboratoire informatique. L'équipe formée ne rassemblait pas des enseignants du cinéma d'animation, mais des chercheurs universitaires en mathématiques, physique et informatique qui enseignaient tous la morphologie, et des enseignants plasticiens et designers, praticiens dans les domaines du design industriel mobilier, de l'architecture intérieure, de l'image et de la couleur. Ce n'est qu'en 1981, avec le changement de majorité, que le ministère de la Culture les prend au sérieux pour leur attribuer, tout au long du RPI, une gamme complète de matériels[20]: palettes électroniques, synthèse d'image 3-D, vidéotex, montage. Le prix des machines, néanmoins, ne permet pas encore un poste par élève (figures 2 et 3).

Figure 2. L'AII en 1987. Christian Stenz qu'on imagine en train de faire cours, manipulant seul l'ordinateur devant une dizaine d'étudiants. Photo : bibliothèque de l'EnsAD.

[20] Pierre Hénon, « L'Atelier d'Image et d'Informatique (1982–2007) », dans Sébastien Denis et al. (dir.), *Archives et acteurs des cinémas d'animation en France*, Paris, L'Harmattan, 2014, p. 195–198.

Figure 3. Marianne Guilhou devant la palette *Graph 9* en pleine réalisation de son film *Taureau* (03:50), AII EnsAD promo 1987.

La plaquette de présentation de l'atelier annonçait une « équipe pluridisciplinaire », et c'est cet intérêt large pour l'ordinateur qui explique, en partie, pourquoi AII a d'abord été un atelier à part, ouvert à tous les secteurs de l'école – scénographie, typographie, cinéma –, puis a disparu une fois que chacun des secteurs a intégré ces techniques dans ses pratiques. On le voit en étudiant les propositions de stage qui étaient faites à l'époque pour les personnes extérieures à l'école : on venait pour apprendre les « nouvelles technologies de l'image »[21] et non un métier en particulier. Cet apprentissage de la 3-D a des conséquences sur les productions actuelles. Aujourd'hui, à l'EnsAD, très peu de films du secteur animation sont réalisés en images tridimensionnelles et les programmes de recherche qui utilisent « massivement » le numérique sont plus portés sur les installations interactives que sur le cinéma d'animation. D'autre part, on l'observe par exemple à ATI, qui reste l'une

[21] *Formation aux nouvelles technologies de l'image*, stages de l'Atelier d'image et d'informatique de l'EnsAD, 1986, Archives nationales versement 1998 0355 article 7, dossier vert « ENSAD demandes 1982 ». Des stages de cinq jours sont proposés pour essayer, au choix, différentes techniques (palettes électroniques, synthèse d'image 3-D, vidéotex, montage), entre 6 500 et 9 500 francs.

des rares formations publiques dédiée, on forme à l'animation 3-D dans une posture généraliste, ce qui implique de connaître les bases de toute la chaîne de fabrication, de chaque élément du *pipeline* (modélisation, *rig*, animation, texture, *compositing*, etc.). Ce sont les étudiants qui se spécialisent ensuite dans l'animation, le *matte painting* ou les effets spéciaux. De même, sauf exception, ce ne sont pas les décorateurs du cinéma qui sont formés à la modélisation 3-D. Sur un tournage, on fait appel à un superviseur d'effets visuels et à une société de post-production pour réaliser les prolongements de décors numériques.

Nous comprenons mieux, par le biais de cette approche politico-économique, pour quelles raisons l'arrivée du numérique au cinéma et dans l'audiovisuel a été perçue comme une césure[22]. Cette assimilation de la technique peut aussi s'observer sous un angle esthétique, qui peut permettre une observation plus fine de l'apparition des métiers de l'infographie : invention puis évolution des techniques de modélisations, de rendu, de l'éclairage des scènes, etc. Prenons le cas de l'animation de personnages. Les membres du chat de *Sio Benbor* (figure 4) ne sont pas raccordés au tronc, ils sont comme en lévitation. De même, le renard des *Fables géométriques*[23] n'est composé que d'un seul cône roux, représentant à la fois son visage et son corps, dont le nez gonfle comme une poire de klaxon pour simuler la respiration. L'animation se faisait alors uniquement par déformation des objets modélisés qui sont tordus, allongés, gonflés ou encore enroulés point par point. Quelques années plus tard, *Le Pantin*[24] (figure 5) démontrait en revanche ses qualités gestuelles. Tous ses

[22] Cécile Noesser montre bien le clivage entre les « anciens » animateurs qui rejettent l'ordinateur et les « modernes » qui en sont curieux, *La résistible ascension du cinéma d'animation : socio-genèse d'un cinéma-bis en France (1950–2010)*, Paris, L'Harmattan, 2016.

[23] *Les Fables géométriques*, 50 épisodes de 3 min, produits par Fantôme de 1989 à 1992 : 1er épisode *Le Corbeau et le renard*, dernier épisode *Le Pouvoir des fables*. D'après Jean de La Fontaine, écrit et raconté par Pierre Perret, musique Jacques Davidovici, mixage Digison, réalisation Rénato, Georges Lacroix, Jean-Yves Grall, infographie Fantôme Animation, production Fantôme Animation/ France 3 Nancy, Logiciel Explore de TDI sur Silicon Graphics. Les premières *Fables Géométriques* seront diffusées sur Canal+ et France 3, puis, devenue un classique du genre, la série sera diffusée dans plus de vingt pays (en Europe, en Asie et en Amérique du Nord).

[24] *Le Pantin*, réal. Frédéric Nagorny, 02:12, 1990. Scénario, conception graphique, animation Frédéric Nagorny ; modélisation, direction technique, animation 3-D Raymond Perrin ; musique Alain Schneider ; postproduction son studio Merjithur ; développement animation 3-D Raymond Perrin, Frédéric Nagorny ; production Relief, co-production ADIS.

membres, sa main, son coude, son genou jusqu'à ses yeux et ses sourcils sont désarticulés et peuvent être contrôlés par l'animateur. On peut présager qu'entre temps, le *rig* (fait de doter les objets d'un « squelette » à manipuler pour les animer) a été inventé et intégré aux logiciels. Cette institutionnalisation des métiers s'observe également dans les génériques de films. Au générique de *L'Unique* (Jérôme Diamant-Berger, 1986), premier film français à mettre en scène des effets visuels numériques, seuls les deux premiers superviseurs sont cités (Christian Guillon et Christian Foucher), et l'équipe de réalisation des images de synthèse compte une petite dizaine de personnes de l'entreprise SOGITEC[25]. En 2016, au générique de *Captain America Civil War* (Anthony & Joe Russo), le spectateur patient peut lire les noms de plus de 1 130 infographistes, répartis entre une vingtaine de postes et seize studios.

Figure 4. *Sio Benbor*, Renato, Jean-Yves Grall, Georges Lacroix, société Fantôme, 1987.

[25] Direction des effets spéciaux Christian Guillon, trucages optiques Eurocitel, images de synthèse SOGITEC, réalisation Jean-François Henry et Christian Foucher, assistant de réalisation Eric Randall, direction de production Xavier Nicolas, direction technique Alain Grach, images médicales CHU de Bobigny, remerciements à Daniel Borenstein, Myriam Feuilloley, Alain Leroy, Georges Pansu – Eurocitel Max Debrenne.

Figure 5. *Le Pantin*, Frédéric Nagorny, 1990.

Limites : quel avenir pour la base Hist3D ?

Les outils proposés par le programme de recherche Hist3D (entretiens filmés, base de données PHP/SQL, *wiki*) ont constitué un cadre technique pour ma recherche. Suivre la voie des films nous apprend beaucoup. Afin d'insister sur le caractère novateur de la synthèse, ils sont en effet presque systématiquement présentés à l'aide de placards et de génériques très complets, qui indiquent, en plus de l'équipe de production, les matériels utilisés pour calculer les images, les financements et les partenariats. L'organisation des données par numéro d'inventaire a facilité la recherche dans les documents dépouillés. La captation des séminaires et la mise à disposition des films m'ont permis de proposer une « thèse augmentée »[26] sur Internet qui accompagnait l'écrit en donnant la possibilité aux membres du jury de visionner les vidéos en ligne. Toutefois, nous devons questionner les limites d'un tel travail documentaire, né d'une pratique « amateur » de l'archive. Quel avenir s'offre à ces documents audiovisuels hébergés par l'EnsAD, tandis que Pierre Hénon est à la retraite depuis juillet 2013 ? La base de données est consultable sur Internet, mais les films ne sont pas disponibles en libre accès[27]. Le travail d'indexation ne suit pas

[26] Voir en ligne : <http://lafabriquedesnouvellesimages.com/>

[27] Tous les chercheurs intéressés sont néanmoins les bienvenus pour la consulter à l'EnsAD, en en faisant la demande à Pierre Hénon.

les normes officielles, il n'a pas été pensé, réfléchi par des documentalistes professionnels. Il s'est construit sur le tas, hiérarchisant les données en fonction de nos usages et de nos découvertes. On ne peut pas faire de recherche thématique, on ne peut pas coupler les données pour filtrer. Les titres sont approximatifs, surtout dans le cas des publicités. Aussi, il est difficile pour une personne extérieure à nos activités de manipuler ce fonds et d'y trouver des informations exploitables, si ce n'est en dépouillant chacun des éléments pour les traiter, en ayant une recherche déjà très précise, ou en étant accompagné d'un membre du groupe pour le guider[28]. Pour faire évoluer cette base de données et la diffuser plus largement, au moins trois problèmes majeurs se posent : la question de la qualité des sources numériques (non originales), la question des droits d'auteur et la question du dialogue d'une telle base avec d'autres fonds, notamment ceux de l'Inathèque.

L'Ina a, en effet, été partie prenante du Plan Recherche Image. Interlocuteur privilégié du gouvernement pour établir le projet, il s'est vu confier le pilotage du CIDIS, comité coordonné par Henri False, directeur du département de la recherche de l'Ina jusqu'en 1989. Son secrétariat était assuré par Jean-Marc Peyron, chercheur en sciences humaines à la recherche prospective. Outre le développement d'outils et la production de formats dédiés[29], l'Institut a organisé pendant une vingtaine d'année le festival Imagina, lieu privilégié de diffusion des images de synthèse à Monte-Carlo. Si j'ai pu consulter les versements papiers disponibles à l'Inathèque[30], les films étaient encore en cours de traitement lors de la rédaction de ma thèse. Aujourd'hui, ces archives de festivals et de colloques sont accessibles. Composées d'œuvres,

[28] Ce qu'a fait par exemple Jessica Fèvres-de Bideran, *Infographie, images de synthèse et patrimoine monumental : espace de représentation, espace de médiation*, thèse de doctorat sous la direction de Philippe Araguas, Université Michel de Montaigne Bordeaux 3, 2012.

[29] *Maison vole*, André Martin & Philippe Quéau, 2:15, Ina/SOGITEC, 1983, court métrage diffusé le 7 février 1983 dans *Juste une image* sur A2 à 22h20.

[30] Il s'agit des documents de promotion ou de notes de chercheurs de l'Institut, qui sont parfois répétés dans plusieurs boîtes. Ils ne sont pas croisés, pour l'instant, avec les films. Il manque également une vision d'ensemble sur les documents administratifs de l'INA (qui ne sont pas mis à disposition du public), qui nous apprendraient bien plus (comme par exemple l'implication d'André Martin, figure importante du cinéma d'animation, dans ces développements technologiques).

de captations ou reportages, de supports audiovisuels utilisés par les conférenciers, elles doivent à la fois être redondantes avec les archives d'Hist3D (même si les deux indexations gagneront certainement à dialoguer pour préciser les notices), tout en offrant peut-être un spectre plus large et de meilleure qualité de conservation. Plutôt que de disperser les forces, ces initiatives mériteraient d'être organisées conjointement. Elles apporteraient, d'autre part, une dimension internationale à nos recherches. Depuis 1985, les prix Pixel Ina récompensent les meilleures créations européennes. Les « E. magiciens, Rencontres européennes de la jeune création numérique », sont destinées aux étudiants, enseignants et professionnels œuvrant dans l'univers du numérique. Les compilations de films reçus dans le cadre de l'organisation américaine du « Computer Animation Festival » sont éditées chaque année au SIGGRAPH (Special Interest Group on GRAPHics and Interactive Techniques). L'étude plus poussée de ces archives permettra de mettre en lumière les circulations des infographistes français comme étrangers, les transferts technologiques et les constructions des paysages de l'innovation, à des échelles régionales, nationales et transnationales, jusqu'à dégager peut-être une dimension européenne des images de synthèse.

Mais c'est certainement le rassemblement des témoignages[31] de pionniers qui constitue un apport essentiel et fondateur à la recherche, éclairant le manque de mémoire que nous avons des techniciens. Phac Le Tuan et Pierre Louis Dahan, par exemple, se souviennent de l'intérêt qu'avait Michel François, spécialiste des trucages reconnu notamment pour son travail sur les génériques de film, pour leurs travaux d'ingénieurs. Ils « jouaient » alors avec l'ordinateur de l'École nationale supérieure des télécommunications pour « dessiner ». Grâce à leurs développements informatiques, Michel François va anticiper les avancées numériques des images.

[31] Le programme Hist3D a interviewé cinquante-trois personnes de 2011 à 2014. L'Inathèque a également réalisé dix-sept entretiens de professionnels en 2009, en partenariat avec Pierre Hénon et l'association Paris ACM SIGGRAPH, qui se recoupent avec le travail fourni par la suite.

Les choix techniques liés aux outils dont nous disposions nous ont amenés à explorer des directions uniques inaccessibles aux autres acteurs de l'époque. On n'avait pas d'écran vidéo qui pouvait permettre de faire des images un peu comme à l'INA. Et donc les outils qu'on avait nous ont plus ou moins orientés vers la perspective au trait, naturellement en haute résolution.[32]

En prenant appui sur le programme de tracé en perspective *Phoebus*[33] des deux étudiants, Michel François va d'abord monter la Société Images Transfert France en 1981 pour « promouvoir des systèmes français dans le domaine de l'informatique graphique, adaptés à la définition cinématographique ». Il travaille aussi avec la société Le Matériel téléphonique (LMT) à Trappes, dont la division simulation devint par la suite celle de Thomson-CSF[34]. Si ses initiatives de haute définition se soldent par un échec, le court métrage *Humanonon*[35], tout comme les activités futures de Thomson-CSF[36], sont l'une des preuves d'une solution industrielle française dans le domaine de la 3-D.

[32] Témoignage de Pierre-Louis Dahan et Phac Le Tuan, le 3 mai 2012 dans le cadre du programme de recherche EnsadLab Hist3D, en ligne : <hist3d.fr/seminaire/les-pionniers-de-la-haute-resolution-3d/>, consulté en juin 2013.

[33] Pierre-Louis Dahan et Phac Le Tuan, *Approche théorique d'une technique : perspective et ombres calculées*, thèse de Docteur-Ingénieur, ENST, Paris, 1977.

[34] Europe 1-UGC, 0:22, réal. Michel François, les Films Michel François et Thomson-CSF, 1981.

[35] *Humanonon*, réal. Michel François, 3:40, 1982. Logiciel *Phoebus* Phac Le Tuan et Pierre-Louis Dahan ; composition en image par ordinateur Dominique François (la fille de Michel François) ; développement du logiciel graphique Benoît Comte ; logiciel de coloration Alain Carrière et Jacques Anielewski ; images ordinateur additives Jean-Luc Charrier ; montage Marie-François Leenhardt ; musique Alain Guelis.

[36] Thomson Digital Image (TDI), filiale de Thomson-CSF, sera la deuxième productrice de simulateurs de vol, avec Sogitec, et produire plusieurs films de synthèse avec l'Ina, tout en commercialisant le logiciel Explore, outil de modélisation, d'animation et de rendu 3-D, fleuron national concurrençant les firmes américaines, racheté par Wavefront en 1993.

Figure 6. Étude de volumes avec ombres portées réalisée par Phac Le Tuan et Pierre Louis Dahan avec leur logiciel *Phoebus*, publiée dans « L'art et l'ordinateur », *IBM-Informatique*, n° 13, 1975, p. 85. On remarque très légèrement leur technique de remplissage au trait, technique réutilisée par Michel François dans le film *Humanonon*, réal. Michel François, 3:40, 1982.

Figure 7. Photogramme d'*Humanonon*, « Temple », scan d'une diapo 24x36mm, archive personnelle Phac Le Tuan.

Seuls ces témoignages peuvent aujourd'hui nous aider à comprendre et à préserver les usages et savoir-faire des « premiers temps », à la croisée de la recherche fondamentale et de la recherche appliquée. Car si l'on envisage souvent les images numériques comme l'une des causes de la disparition de l'argentique, nous avons montré que l'histoire des images de synthèse pourrait elle aussi facilement tomber dans l'oubli. Ces inventions montrent la nécessité d'étudier le vaste champ des technologies considérées comme obsolètes ou des médias « imaginaires », restés dans un état virtuel, sans être pleinement réalisés. Cette « archéologie » s'insère par ailleurs dans la longue durée d'une histoire des images et des spectacles populaires, dans le sillage des recherches menées au sein de la *New Film History*. En adoptant plutôt un regard capable de prendre en compte la complexité et la multiplicité des facteurs qui ont accompagné l'apparition de ce nouveau médium, l'analyse de l'émergence des effets visuels numériques ne montre non pas une rupture, mais bien plusieurs points en commun, *mutadis mutandis*, avec la période des années 1890 et l'invention du cinéma.

Épilogue

Réflexions sur une rematérialisation du cinéma par ses techniques

Hélène FLECKINGER

En ouverture de *Classe de lutte*, film réalisé en 1969 par le groupe Medvedkine de Besançon, célèbre expérience de collaboration entre ouvrier·e·s et cinéastes, la caméra dévoile par un léger panoramique une inscription apposée sur le mur à proximité d'une table de montage : « Le cinéma n'est pas une magie – c'est une technique et une science, une technique née d'une science et mise au service d'une volonté : la volonté qu'ont les travailleurs de se libérer ». Au cœur du cinéma militant des années 1968 en France, la formule résonne comme un appel aux opprimé·e·s à s'approprier les moyens d'expression cinématographiques dans une perspective émancipatrice. Ni force occulte, ni puissance mystérieuse, le cinéma est l'affaire de toutes et de tous, selon les principes de démocratisation défendus par les États généraux du cinéma en mai-juin 1968 et, plus encore, il s'explique et s'apprend. Appréhender le cinéma à partir de sa réalité matérielle, encore trop peu considérée, c'est à ce déplacement de regard que l'épigraphe politique du film engage aussi – une démarche dont les vertus pédagogiques pourraient s'avérer très utiles aux enseignant·e·s fatigué·e·s de voir évoquées dans leurs copies « les vidéos de Méliès ».

Saisir le cinéma par le prisme technique, sa technicité comme ses techniques propres, c'est en effet esquisser une opération fondamentale de « rematérialisation », en écho avec la pensée de l'historien et philosophe des sciences François Dagognet, qui aimait se qualifier de « matérialisateur »[1] et défendait une « philosophie inversée » par rapport à une conception hégémonique se souciant plus du « sujet » (l'intérieur) que de « l'objet »

[1] François Dagognet, *Rematérialiser. Matières et matérialismes*, Paris, Vrin, 1989, p. 14.

(l'extérieur). C'est ce geste démystificateur que nous voudrions interroger en épilogue de cet ouvrage, en nous attachant aux différentes déclinaisons de sa mise en œuvre, dans une perspective de sensibilisation aux enjeux épistémologiques et historiographiques qu'il soulève.

Pour un retour aux objets et aux sources matérielles

Rematérialiser le cinéma par ses techniques, c'est d'abord replacer au cœur des préoccupations ses réalités concrètes, donc ses objets, et interroger ses conditions matérielles d'existence, de sa conception et sa production jusqu'à sa diffusion et sa conservation. C'est se démarquer des querelles envahissantes sur l'identité première du cinéma qui irriguent les discours jusqu'à aujourd'hui et, dans la lignée de Michèle Lagny, « refuser la traditionnelle dichotomie entre la justification esthétique d'un moyen d'expression devenu un "art" et l'analyse techno-économique d'une industrie (peu) profitable »[2].

Régulièrement cités par les chercheur·euse·s en études cinématographiques dans leur investigation méthodique et soignée des problématiques techniques[3], les écrits de Gilbert Simondon plaident plus généralement pour la réhabilitation, l'intégration et la revalorisation des objets techniques dans une culture qui les a écartés :

> La culture est déséquilibrée parce qu'elle reconnaît certains objets, comme l'objet esthétique, et leur accorde droit de cité dans le monde des significations, tandis qu'elle refoule d'autres objets, et en particulier les objets techniques, dans le monde sans structure de ce qui ne possède pas de significations, mais seulement un usage, une fonction utile.[4]

[2] Michèle Lagny, « Cinéma et histoire culturelle », *Cinémathèque*, n° 1, mai 1992, p. 7.

[3] Voir en particulier les travaux de Benoît Turquety. Les écrits de Gilbert Simondon sont aussi source d'inspiration pour penser l'articulation entre techniques et métiers, et éviter un prisme qui soumettrait les premières aux secondes, en cédant à l'hégémonie du paradigme du travail : « l'objet technique apporte une catégorie plus vaste que celle du travail : le fonctionnement opératoire » ; « C'est le paradigme du travail qui pousse à considérer l'objet technique comme utilitaire ; l'objet technique ne porte pas en lui à titre de définition essentielle son caractère utilitaire » (*Du mode d'existence des objets techniques* [1958], Paris, Aubier, 1989, p. 334).

[4] *Ibid.*, p. 10.

Si la culture s'est en effet constituée en « système de défense contre les techniques »[5], il convient au contraire de les introduire comme réalité humaine, porteuse de connaissances, de sens et de valeurs, en évitant mépris et méfiance mais aussi idolâtrie de la machine, « démesure techniciste et technocratique »[6].

Depuis une dizaine d'années, à échelles nationale et internationale, des travaux scientifiques de plus en plus nombreux se distinguent par un examen minutieux des réalités, objets et dispositifs techniques eux-mêmes, et d'abord des appareils, qu'ils s'appliquent à décrire, sans pour autant négliger leur environnement social et en les reliant souvent aux métiers du cinéma. Caméras, pellicules, matériels d'éclairage, systèmes d'enregistrement sonore, techniques de montage, appareils de projection font ainsi l'objet d'études approfondies, qui mobilisent les sciences fondamentales et expérimentales, notamment pour l'analyse des brevets. Les industries techniques – fabricants d'équipements, studios, laboratoires – sont à leur tour investies[7].

Mais les objets du cinéma, ce sont aussi les objets filmiques, certes actuellement valorisés en tant qu'objets esthétiques (comme les objets sacrés, rappelle Simondon), mais dont il ne faudrait pas pour autant occulter la propre matérialité. S'interroger sur les versions concrètes des films étudiés se révèle impératif pour éviter les analyses décontextualisées, les surinterprétations, les contresens et les anachronismes. Or cela engage une réflexion sur les techniques employées non seulement pour leur réalisation mais aussi pour leur archivage et leur éventuelle restauration, en même temps que cela exige une connaissance des variantes intellectuelles et matérielles des œuvres[8]. Sur quel matériau travaillons-nous, et plus précisément : quel support, quel format et quelle version du film ? La question mérite d'être systématiquement posée, même s'il n'est pas toujours aisé d'y répondre.

Vigilance critique et examen attentif des copies étudiées pourraient épargner à des étudiant·e·s pressé·e·s bien des écueils, comme celui d'analyser un film – et notamment son cadre – à partir de versions *pan and*

[5] *Ibid.*, p. 9.

[6] *Ibid.*, p. 17.

[7] Voir notamment la richesse des articles et dossiers relatifs au domaine technique parus récemment dans *1895, revue d'histoire du cinéma* (en particulier : n° 82, été 2017 et n° 87, printemps 2019).

[8] Voir le dossier « Le Film pluriel » co-dirigé par Marie Frappat et Michel Marie dans *Cinéma & Cie*, vol. IX, n° 13, automne 2009.

scan[9], encore abondantes dans les éditions commerciales, dans les médiathèques et en ligne. Cette pratique de recadrage mobile par retraitement vidéo, répandue à l'époque du marché de la VHS et de la télévision de format 4/3, marque en effet encore notre accès aux œuvres. Que vaudrait pourtant une étude du *Satyricon* de Fellini, sorti en 1969 en Cinémascope dans le format original Panavision de ratio 2.35, si elle s'appuyait sur la version *pan and scan* de format 4/3 (soit une image réduite de plus de 40 %) de l'édition VHS commercialisée par la Fnac dans sa « collection cinéma » ?

Ainsi, comme le montrent plusieurs contributions de cet ouvrage, adopter un prisme technique pour étudier le cinéma implique un retour aux sources et, suivant une démarche historienne classique, de convoquer des archives – écrites, iconographiques, sonores et audiovisuelles –, de les analyser et de les croiser avec les films et les collections d'appareils. De nombreuses institutions, publiques et privées, conservent des fonds de nature spécifiquement technique (revues dédiées, bulletins de sociétés scientifiques, modes d'emploi, brevets, plans techniques...), ou intéressants à explorer sous cet angle (photographies de tournage ou de studio, publicités...), très riches et pourtant encore peu exploités à ce jour.

Les archives audiovisuelles et sonores disponibles à l'Inathèque se révèlent particulièrement précieuses. Elles comprennent de nombreuses émissions télévisées relatives aux techniques et métiers du cinéma, notamment parmi celles remarquables réalisées par le Service de la recherche de l'ORTF[10] : par exemple, le célèbre film *Méthode I* de Mario Ruspoli consacré en 1963 à des essais techniques et formels de cinéma direct ; une émission *Hommes et caméras* diffusée dans la collection « Un certain regard » en 1964 ; ou encore des émissions sur la télévision scolaire en Italie et en Suède en 1964, au Niger en 1974. On

[9] Littéralement « panoramique et balayage », le *pan and scan* est un procédé destiné à recadrer les films lors d'un report vidéo. Il permet de remplir totalement l'écran vidéo par des coupes latérales qui évitent des bandes noires horizontales, mais aussi de « choisir la partie jugée essentielle de l'image et d'introduire des effets de panoramique en explorant latéralement l'image » (Vincent Pinel, *Dictionnaire technique du cinéma*, Paris, Armand Colin, 2008, p. 206). Le *pan and scan* introduit ainsi « traîtreusement au sein du film un découpage parallèle et de pseudo mouvements d'appareils » (*ibid.*).

[10] Parmi les travaux en cours autour des archives de l'Ina, citons ceux de Guillaume Soulez sur le Service de la Recherche de l'ORTF ou le projet « Les professionnel·le·s de la télévision (1946–1974) : stratégies de professionnalisation, discours médiatiques et culture de l'innovation » (Universités Paris 3 / Toulouse 2 / Ina).

peut aussi citer les grands entretiens patrimoniaux réalisés par l'Ina, en particulier les collections « Parole de cinéaste » et « Télé notre histoire » ; ainsi que d'autres fonds conservés à l'Inathèque, comme « Les archives sonores du cinéma français », série d'entretiens avec des personnalités du cinéma collectés par Philippe Esnault, dont le fonds de vidéogrammes déposé à la BnF, « L'image et la mémoire », représente un complément filmé ; et les « Leçons de cinéma » du Festival international de films de femmes de Créteil dirigé par Jackie Buet qui invitent à considérer les questions de genre.

Dans une perspective d'histoire des techniques et des métiers, la fabrication de sources orales sonores ou filmées, incluant parfois une démonstration de la manipulation des machines elles-mêmes, s'est imposée comme une source complémentaire indispensable. Le programme de collecte de mémoires, mené depuis 2013 par La Fémis sous l'intitulé « Filmographies : archives audiovisuelles des métiers du cinéma », est à cet égard exemplaire[11]. Chaque année, les étudiant·e·s d'un département réalisent un entretien approfondi avec un·e professionel·le du cinéma (directeur de la photographie, monteur, chef décorateur, scripte…).

Prendre en compte des considérations techniques, c'est donc d'abord réinsérer le cinéma dans une culture matérielle des objets et de ses traces qu'il convient de reconstituer, dont l'imaginaire ne saurait par ailleurs être nié et qu'il ne s'agit pas non plus de dissocier de leurs utilisateur·trice·s. Au-delà de la seule conception des appareils cinématographiques, il s'agit en effet d'appréhender les techniques du cinéma également par leurs pratiques, gestes, modalités d'appropriation et usages.

Pour une approche du cinéma par la *praxis*

Adopter un prisme technique pour étudier le cinéma, c'est aussi proposer un déplacement fondamental de point de vue, en portant son attention sur les processus de fabrication plutôt que sur la subjectivité des

[11] Voir la présentation des entretiens accessible en ligne sur le site de La Fémis : <http://www.femis.fr/-filmographies-archives-> ainsi que l'intervention de Barbara Turquier et Priska Morrissey lors des journées « Pédagogie de la création artistique. Sources, valorisations, histoire ? », le 22 octobre 2018 à l'École nationale des Chartes : <http://www.chartes.psl.eu/fr/actualite/pedagogie-creation-artistique-sources-valorisations-histoire>. Les entretiens sont déposés à la Cinémathèque française et consultables à la Bibliothèque du film. Outre leur vocation scientifique, historique et patrimoniale, ils s'inscrivent dans une perspective de formation à la recherche.

créateur·trice·s, spectateur·trice·s, critiques et cinéphiles. Rematérialiser le cinéma par ses techniques conduit ainsi à l'aborder sous l'angle de la *praxis*, voire de la *poïésis*. La formule qui ouvre *Classe de lutte* fait écho à une conception « laïcisée » de la technique, libérée de la magie et du religieux depuis l'âge classique en Grèce antique, comme le souligne Jean-Pierre Vernant[12]. L'étymologie *technè*, comme la pensée antique de la technique guidée par une vision instrumentaliste des activités de production humaine, invitent à orienter les réflexions sur le terrain d'un « art du faire ».

La question centrale devient celle de l'articulation entre technique et création. Elle s'inscrit contre un déterminisme technologique ou un technicisme qui appréhenderait l'histoire des techniques au prisme de l'idéologie du « progrès », dépouillé de toute fonction critique et émancipatrice. Dans une émission télévisée de 1961, Jean Renoir dénonce la dérive du perfectionnement des techniques qui tendraient à imiter de plus en plus fidèlement la nature, alors que « dans l'histoire de tous les arts, l'arrivée au réalisme absolu [coïnciderait] avec une parfaite décadence »[13]. La quête de réalisme extérieur, via la reproduction des phénomènes apparents, ne pourrait d'après lui créer que l'ennui et même la fin de l'art. Aussi la technique ne devrait-elle jamais prendre le pas sur l'intelligence pratique de l'artisan.

La nécessité de relier les questions techniques aux enjeux de création se retrouve au cœur des débats qui traversent la mise en place des études cinématographiques en France à la fin des années 1960[14]. Les fondateur·trice·s du département Cinéma du Centre universitaire expérimental de Vincennes, qui deviendra l'Université Paris 8, défendent majoritairement le principe d'une articulation étroite entre théorie et pratique. En résonance avec des questionnements stratégiques plus généraux sur le rôle de l'université – « est-il de produire et transmettre le savoir universitaire établi ou est-il de *faire* et apprendre à faire ? »[15] –, deux camps s'affrontent dès 1970 autour de

[12] Voir Jean-Pierre Vernant, « Remarques sur les formes et les limites de la pensée technique chez les Grecs », *Revue d'histoire des sciences et de leurs applications*, tome 10, n° 3, 1957, p. 205–225.

[13] Il s'agit d'une émission réalisée en plusieurs parties par le Service de la recherche et le Service des moyens extérieurs et du cinéma de la RTF : *Jean Renoir parle de son art*. Les propos de Jean Renoir sont recueillis par Janine Bazin, Jean-Marie Codefy et Jacques Rivette. Un épisode est consacré aux « Progrès de la technique ».

[14] Voir le projet « Le cinéma dans l'enseignement supérieur français des années 1960 aux années 1980 » (Universités Paris 1 / Paris 8 / École nationale des Chartes).

[15] Guy Berger, Maurice Courtois et Colette Perrigault, *Folies et raisons d'une université : Paris 8. De Vincennes à Saint-Denis*, Paris, éditions Petra, 2015, p. 503.

l'utilisation des (maigres) budgets alloués au département, qui permettent alors d'acheter soit une table d'analyse pour visionner des films, soit une caméra pour en faire. Les universitaires titulaires issu·e·s de la linguistique et de la sémiologie décident d'acquérir la table de montage, mais c'est sur cette opposition entre une approche purement théorique du cinéma et la volonté farouche d'introduire une véritable pratique que le département est refondé en juin 1971, lors d'une assemblée générale qui vote l'éviction des tenant·e·s du « discours sur » et consacre la victoire des partisan·e·s du « faire », « jeunes barbares gauchistes »[16].

L'enseignement des techniques suscite alors de vives discussions, qui conservent aujourd'hui une actualité saisissante. Comment enseigner le cinéma sans devenir un « département papier-crayon »[17] quand les moyens mis à disposition à l'université sont bien moindres que dans les écoles professionnelles de cinéma (l'IDHEC, future Fémis ou l'ENPC Vaugirard future ENS Louis-Lumière) ? Comment apprendre les techniques du cinéma à des étudiant·e·s possédant de très faibles connaissances en trigonométrie, en optique, en sensitométrie, en thermocolorimétrie ou en acoustique ? Dès les années 1970, Claude Bailblé se lance dans la rédaction de brochures techniques sur le son, puis sur l'image, retravaillées dans une série d'articles pour les *Cahiers du Cinéma*[18]. Partant du constat qu'il existe d'un côté des manuels strictement techniques, et de l'autre, « le dire théorique, où il n'est jamais questions des opérations, des réglages qui donnent au film son existence concrète, son style, son épaisseur narrative »[19], il entreprend de lier le savoir-faire technique à des interrogations plus vastes, en évitant l'hyperspécialisation technique et en favorisant l'acquisition d'une pluralité de compétences. Dans le contexte politisé des années 1968, la démarche de Claude Bailblé est guidée par une contestation de la division du travail, c'est-à-dire la « coupure entre les artistes et les techniciens, les créateurs et les exécutants »[20] : « Au

[16] Guy Berger, Maurice Courtois et Colette Perrigault, *op. cit.*, p. 504.

[17] La formule est de Jean-Paul Aubert, l'un des fondateurs du département Cinéma à Vincennes.

[18] Voir la série d'articles de Claude Bailblé « Pour une nouvelle approche de l'enseignement de la technique du cinéma », consacrés à une « Programmation du regard » et une « Programmation de l'écoute », et parus dans les *Cahiers du Cinéma* entre octobre 1977 et avril 1979.

[19] Claude Bailblé, « Programmation du regard. Pour une nouvelle approche de l'enseignement de la technique du cinéma », *Cahiers du Cinéma*, n° 281, octobre 1977, p. 6.

[20] *Ibid.*

cinéma, elle découpe des tâches, assigne des rôles, distribue des pouvoirs qu'un certain corporatisme s'emploie à immobiliser »[21].

Point de hiatus, donc, entre les dimensions techniques et esthétiques, mais au contraire une imbrication fructueuse. Si l'approche technique n'est aucunement incompatible avec des questionnements formels, certain·e·s inventeur·euse·s et cinéastes les ont même imaginés conjointement, sans pour autant envisager une relation automatique entre appareils et formes. Le dispositif cinématographique de triple écran, puis la « Polyvision », sont inventés par Abel Gance pour servir sa vision personnelle et un projet artistique autour de Napoléon[22]. Jean-Pierre Beauviala était lui-même guidé par une préoccupation constante d'« inventer quelque chose de rare »[23] qui transformerait les usages comme les formes. La « Paluche », caméra vidéo en noir et blanc de forme tubulaire issue du contrôle vidéo de l'Aaton 7 à la fin de l'année 1973, naît de sa volonté de modifier le point de vue du filmeur ou de la filmeuse. Se logeant au creux de la main, elle permet des approches et des cadrages qui ne sont « plus ceux de l'épaule, de la tête et des yeux, mais ceux du bras, de la main et des doigts »[24]. Ce qui intéresse fondamentalement Beauviala reste l'apport esthétique que cette invention peut induire par son ergonomie singulière et ses possibilités d'investigation sous des angles et avec une mobilité insolites. Dans *Les Glaneurs et la glaneuse,* sorti en 2000, Agnès Varda se met elle-même en scène promenant et manipulant une petite caméra mini-DV à la recherche de nouvelles formes et commente : « Ces nouvelles petites caméras, elles sont numériques, fantastiques, elles permettent des effets stroboscopiques, des effets narcissiques et même hyperréalistiques ». La cinéaste s'interroge sur la manière dont ce nouvel appareil contribue à transformer son rapport au monde et son écriture, se livre à des jeux de mains, s'amuse du poids et de la taille de la caméra devenue prolongement de son corps et nous émerveille des effets produits.

La compréhension concrète des aspects techniques du cinéma nourrit finalement aussi bien la création cinématographique que l'analyse

[21] *Ibid.*

[22] Voir Gérard Leblanc, « Les écrans variables », dans Jean-Jacques Meusy (dir.), *Le Cinémascope entre art et industrie*, Paris, AFRHC, 2004, p. 345–354.

[23] Entretien inédit avec Jean-Pierre Beauviala réalisé par Hélène Fleckinger et Alexia de Mari le 14 décembre 2018 à Paris dans le cadre du programme ANR Beauviatech.

[24] « La sortie des usines Aaton. Entretien avec Jean-Pierre Beauviala, 2 », *Cahiers du Cinéma*, n° 286, mars 1978, p. 13.

filmique elle-même. Rematérialiser le cinéma par ses techniques et l'aborder par la *praxis*, c'est s'attacher à la mise en scène, aux procédés de fabrication comme aux processus de travail. « La nature illusionniste du cinéma est une nature au second degré ; elle est le fruit du montage. [...] au pays de la technique, le spectacle de la réalité immédiate s'est transformée en fleur bleue introuvable »[25], note Walter Benjamin.

Pour une contextualisation idéologique, culturelle et médiatique

Adopter un prisme technique pour étudier le cinéma incite, enfin, à articuler plus largement les aspects techniques aux approches historiques, économiques, sociologiques, anthropologiques, philosophiques ou encore esthétiques, mais aussi à interroger les relations entre idéologie, modes de représentation et évolution des techniques. « Loin d'être autonome, le niveau technologique est soumis à toutes sortes de déterminations qui s'imbriquent de manière complexe et parfois contradictoire »[26], souligne Michèle Lagny : il ne s'agit pas de traiter « d'objets en soi, mais de champs relationnels en perpétuel mouvement »[27].

Dans les années 1970, un courant théorique s'applique ainsi à montrer la dimension idéologique des techniques[28] et rappelle qu'il ne saurait exister d'enregistrement mécanique du réel. Si ces conceptions ont été abondamment rediscutées, leur pertinence pour aujourd'hui ne saurait être systématiquement contestée au nom des aspects dogmatiques de certains écrits. « Pas plus que les miroirs, le cinéma n'est transparent à ce qu'il montre. Montrer n'a rien de passif, d'inerte, de neutre »[29], insiste Jean-Louis

[25] Walter Benjamin, « L'œuvre d'art à l'époque de sa reproductibilité technique » [1939], *Œuvres*, tome III, Paris, Gallimard, 2000, p. 299.

[26] Michèle Lagny, *De l'histoire du cinéma. Méthode historique et histoire du cinéma*, Paris, Armand Colin, 1992, p. 171.

[27] *Ibid*, p. 176.

[28] Voir en particulier Jean-Louis Baudry, « Cinéma : effets idéologiques produits par l'appareil de base », *Cinéthique*, n° 7–8, 1970, p. 1–8 ; et la série d'articles de Jean-Louis Comolli sur « Technique et idéologie » parus dans les *Cahiers du Cinéma* entre mai-juin 1971 et octobre 1972, et repris dans *Cinéma contre spectacle*, Paris, Verdier, 2009, p. 123–243.

[29] Jean-Louis Comolli, « Le miroir à deux faces », dans Jean-Louis Comolli, Jacques Rancière, *Arrêt sur histoire*, Paris, Centre Pompidou, 1997, p. 11–12. Sur la question

Comolli. Si les techniques ne sont ni neutres ni innocentes, mais déterminées notamment par une époque et une idéologie, alors leur étude nécessite de reconsidérer avec attention les contextes politiques et socio-culturels, comme le suggère François Dagognet à propos de l'objet, qualifié de « fait social total ». Il faut apprendre à « décrypte[r] sur sa carapace ou dans ses seules lignes, le culturel qui s'y loge. [...] Les fabrications appellent la lecture, le déchiffrement [...] un éclairage, qui livrerait leur raison d'être ainsi »[30].

À la suite de Brian Winston qui avait dénoncé dès 1985 la prétendue neutralité des procédés de reproduction des couleurs[31], Richard Dyer montre par exemple dans son ouvrage *White*[32] combien les techniques de prise de vues, le matériel d'éclairage et la pellicule sont idéologiquement orientés, tous ayant été conçus pour et en fonction d'une peau caucasienne. Comme le soulignent Priska Morrissey et Emmanuel Siety, la carnation sert de « référent culturel et idéologique incontournable dès la fabrique du matériel de prise de vues, puis tout au long de la création du film et même au-delà puisqu'elle sert un étalon essentiel de la restauration des images par les grands centres d'archives »[33], et c'est la peau d'un visage blanc occidental qui est retenue, une peau au taux moyen de réflexion de la lumière de 18 %, équivalent au gris neutre.

D'autres travaux, comme ceux de Rick Altman sur la notion de « perspective sonore » à Hollywood dans les années 1930, éclairent le rôle des technologies dans l'histoire de la représentation, en lien avec les pratiques culturelles. La force de sa démarche est résumée dans cette hypothèse : « On ne saurait représenter le réel ; seule la représentation peut être représentée. Car pour être représenté, le réel doit être connu ; or, la connaissance est déjà une représentation. »[34] De cette proposition

du point de vue, des déterminants techniques et idéologiques d'un film, voir également Jean-Louis Comolli, « Ici et maintenant, d'un cinéma sans maître ? », dans Jean-Louis Comolli, Gérard Leblanc, Jean Narboni, *Les années pop. Cinéma et politique : 1956–1970*, Paris, Centre Pompidou, 2001, p. 36–58.

[30] François Dagognet, *Éloge de l'objet*, Paris, Vrin, 1989, p. 40.

[31] Brian Winston, « A Whole Technology of Dyeing: A Note on Ideology end the Apparatus of the Chromatic Moving Image », *Daedalus*, Vol. 114, n° 4, Fall 1985, p. 105–123.

[32] Richard Dyer, *White: Essays on Race and Culture*, Londres/New York, Routledge, 1997.

[33] Priska Morrissey, Emmanuel Siety, « Le souci de l'épiderme », dans Priska Morrissey, Emmanuel Siety (dir.), *Filmer la peau*, Rennes, PUR, 2017, p. 8.

[34] Charles [Rick] Altman, « Technologie et représentation : l'espace sonore », dans Jacques Aumont, André Gaudreault, Michel Marie (dir.), *Histoire du cinéma : nouvelles approches*, Paris, Publications de la Sorbonne, 1989, p. 121.

découlent plusieurs principes, notamment celui-ci : « la réalité que toute nouvelle technologie représentationnelle se donne la tâche de représenter est en grande partie définie – mise en représentation – par les systèmes de représentation déjà existants »[35]. Selon Rick Altman, « une technologie naissante prend appui sur ses aînées »[36] et les premières années du cinéma dit parlant sont ainsi marquées par les « arbitres contemporains de la représentation sonore »[37] que sont la radio et le théâtre.

À rebours d'un questionnement ontologique, le geste de rematérialisation du cinéma par ses techniques s'impose comme une opération d'historicisation et de désessentialisation. Il invite à adopter une démarche de recontextualisation, en lien avec les études culturelles mais également les théories de l'intermédialité. Il exige ainsi de se défaire d'expressions consacrées comme « l'ère (du) numérique » ou « la révolution numérique », syntagmes qui évoquent des slogans publicitaires et tendent à ignorer les dynamiques historiques à l'œuvre. Nous leur préférons en effet la notion de « transition numérique », qui ne suggère pas de bascule franche « de l'argentique au numérique » dans tous les domaines simultanément, mais évoque une déstabilisation de l'identité médiatique du cinéma. Un enjeu historiographique consiste dès lors à revisiter les périodisations et les chronologies, en raisonnant non plus d'abord en termes de rupture ou de discontinuité, mais davantage de continuité, de cohabitation et d'hybridité. Il s'agit de se démarquer des approches techniques du cinéma focalisées sur les prouesses, les exploits et un certain sensationnalisme que la notion même d'« innovation technologique » tend à induire en considérant d'abord les périodes de transitions technologiques qui engagent les reconfigurations structurelles les plus conséquentes, notamment sur un plan économique.

Parmi les domaines de recherche encore peu défrichés en milieu académique, les techniques vidéo analogiques méritent ainsi d'être étudiées et réintroduites dans l'histoire du cinéma et de l'audiovisuel. Les travaux autour la « vidéo des premiers temps »[38], par exemple, s'attachent à une période charnière, celle des débuts de la vidéo légère, à ses

[35] Charles [Rick] Altman, « Technologie et représentation : l'espace sonore », *op. cit.*, p. 121

[36] *Ibid.*

[37] *Ibid.*

[38] Voir le carnet de recherche du groupe de recherche créé en 2012 : <https://earlyvideo. hypotheses.org/> et Hélène Fleckinger, *Cinéma et vidéo saisis par le féminisme (France, 1968–1981)*, thèse de doctorat sous la direction de Nicole Brenez, Université Sorbonne Nouvelle - Paris 3, 2011.

pratiques et ses usages, en revenant sur les moments d'expérimentations techniques, sociales, politiques et formelles, souvent occultés par une vision téléologique orientée par l'institutionnalisation du média dans le secteur de l'« art vidéo »[39]. Les frères Dardenne eux-mêmes rappellent régulièrement ce que leur cinéma doit à leur expérience de création collective en vidéo légère aux côtés d'Armand Gatti dans le Brabant-Wallon en 1973.

Autre exemple que le geste de rematérialisation du cinéma par ses techniques invite à explorer : l'étude des premières techniques numériques dans le domaine des images animées. Si l'apparition des images de synthèse a fait l'objet de travaux universitaires[40], qui connaît aujourd'hui le GAIV, groupe Art et Informatique formé dès 1969 dans le cadre du département d'Informatique du Centre universitaire expérimental de Vincennes, en liaison avec les départements de Musique et d'Arts Plastiques ? Des objets numériques, tels que les CD-ROMs, restent ordinairement ignorés de l'histoire du cinéma et mériteraient pourtant aussi d'être considérés voire intégrés[41] : ils appartiennent à l'archéologie des webdocumentaires et autres plateformes relevant des « nouvelles écritures audiovisuelles ». Jean-Louis Boissier dès le vidéodisque *Le Bus* en 1984–1985, ou Chris Marker avec *Immemory* initialement sur CD-ROM en 1997, ont ainsi réalisé des travaux pionniers relevant d'un véritable « cinéma interactif »[42] qu'il s'agirait d'étudier dans cette perspective.

La question du rapport à la matière et la matérialité irrigue les enjeux relatifs aux technologies numériques, contrairement à ce que suggèrent les discours sur la dématérialisation, ce « nuage schizophrénique qui nous guette et déjà nous enveloppe »[43]. L'usage répandu du mot-valise

[39] Robert Godon, « Art vidéo, histoire d'une sectorisation », article paru le 19 mai 2018 dans la revue électronique *Sens public* : <http://sens-public.org/article574.html>.

[40] Voir en particulier la thèse de Cécile Welker, *La fabrique des « nouvelles images » : l'émergence des images de synthèse en France dans la création audiovisuelle (1968–1989)*, Université Paris Sorbonne Cité, 2015 et sa contribution à cet ouvrage.

[41] Voir François Albera, « Archéologie de l'intermédialité : SME/CD-ROM, l'apesanteur », *Cinémas*, vol. 10, n° 2–3, printemps 2000, p. 27–38.

[42] Voir Jean-Louis Boissier, « Propositions pour un cinéma interactif expérimental », dans Jean-Marie Dallet (dir.), *Cinéma, interactivité et société*, Poitiers, Université de Poitiers/CNRS, 2013, p. 142–163.

[43] François Dagognet, *Rematérialiser, op. cit.*, p. 15. Il qualifie la dématérialisation (en général) d'« opération de détournement ou d'évaporation » et appelle à restituer « un peu de la chair de l'univers, son grain ou ses fibres » (p. 18).

« *le* numérique », adjectif substantivé qui l'essentialise, occulte l'immense base matérielle et logicielle pourtant sous-jacente[44]. Ces préoccupations matérielles ont gagné le domaine esthétique lui-même. Le pixel de l'image numérique étant fixe, les constructeurs de caméras ont par exemple cherché à recréer artificiellement, selon une approche mimétique, le phénomène de granulation, sorte de fourmillement produit par la disposition aléatoire des cristaux d'halogénure dans l'émulsion de la pellicule, qui caractérise l'image argentique. C'est avec la caméra Aaton Penelope Delta qu'une première solution technique est développée : « c'est le capteur de la caméra qui bouge, mécaniquement, d'un demi-pixel entre chaque prise de photogramme dans le but de créer de l'aléatoire en numérique »[45]. Aujourd'hui, les techniques numériques offrent par ailleurs elles-mêmes de remarquables possibilités de (re)matérialisation du cinéma avec la 3D : des caméras sont scannées en trois dimensions, certaines (re)construites avec des imprimantes relevant de cette technologie.

Le 13 février 2016, lors de la conférence donnée à l'INHA dans le cadre du colloque à l'origine de cet ouvrage, Jean-Pierre Beauviala mime les postures de prise de vues possibles avec différentes caméras, lui-même incarnant les techniques dans des gestes. C'est une *mise en corps* qu'il nous propose, pour montrer ce qu'induisent les appareils en terme de point de vue : le « chat à l'épaule », la « Paluche », la « Penelope Delta » et celle qu'il imagine alors comme la caméra du futur, sa « Libellule » en devenir. Par la matérialité des objets qu'il manipule, par son corps souple et agissant, par sa fougue contagieuse de pédagogue, Jean-Pierre Beauviala invite à expérimenter les techniques sans jamais les dissocier des recherches esthétiques, et nous introduit avec éclat à la *praxis* du cinéma.

« Le formalisme, l'oubli et le mépris des ancrages apprend à réduire le poids des réalités »[46], rappelle François Dagognet. Inscrit dans une perspective non essentialisante, éloigné de toute conception idéaliste, le geste de rematérialisation du cinéma rappelle que « le » cinéma n'existe pas plus que « le » numérique ». Opération nécessaire de retournement,

[44] Voir Alexandre Moatti, « Le numérique, adjectif substantivé », *Le Débat*, n° 170, mai-août 2012, p. 133–137.

[45] Jean-Louis Comolli, Vincent Sorrel, *Cinéma, mode d'emploi. De l'argentique au numérique*, Lagrasse, Verdier, 2015, p. 66. Voir également Martin Roux, *Persistance ou l'influence de l'esthétique argentique sur les technologies numériques*, mémoire de fin d'études et de recherche sous la direction de Frédéric Sabouraud et Caroline Champetier, ENS Louis-Lumière, 2012.

[46] François Dagognet, *Rematérialiser*, *op. cit.*, p. 29.

aussi bien théorique que pratique, il consiste à matérialiser à nouveau ce qui l'était, mais qui a fait l'objet d'une dématérialisation. Car le dispositif-cinéma est bien le produit d'une élaboration technique, économique, sociale, culturelle et discursive, renforcée par des théories et des critiques du cinéma qui, historiquement, en ont majoritairement occulté les dimensions matérielles. Rematérialiser le cinéma par ses techniques, c'est donc inviter à lever le voile magique d'une illusion savamment construite, à rendre visible ce qui a fait l'objet d'un cache volontaire pour favoriser l'impression de réalité, à dépasser sa passion parfois aveuglante pour le cinéma afin d'en étudier les conditions matérielles d'existence. Métaphoriquement, on élargit le cadre, on libère son horizon et, sur un plateau de tournage, on aperçoit dans son champ de vision des micros, des perches, des éclairages, des câbles, peut-être une Louma et même des travailleur·euse·s affairé·e·s.

Bibliographie

ABBOTT Andrew, *The System of Professions. An Essay on the Division of Expert Labor*, Chicago/Londres, The University of Chicago Press, 1988.

AKRICH Madeleine, « Comment décrire les objets techniques ? », *Techniques et culture*, n°9, 1987, repris dans *Techniques et culture*, n°54–55, 2010, p. 182–199.

ALBERA François, *Albatros, des Russes à Paris 1919–1929*, Paris/Milano, Cinémathèque française/Mazzotta, 1995.

ALBERA François, « Archéologie de l'intermédialité : SME/CD-ROM, l'apesanteur », *Cinémas*, vol. 10, n° 2–3, printemps 2000, p. 27–38.

ALBERA François, TORTAJADA Maria (dir.), *Ciné-dispositifs. Spectacles, cinéma, télévision, littérature*, Lausanne, L'Âge d'homme, 2011.

ALTMAN Rick, « Toward a Theory of the History of Representational Technologies », *Iris*, vol. 2, 2ᶜ semestre 1984, p. 111–125.

ALEKAN Henri, DOISNEAU Robert, *Question de lumières*, Paris, Stratem, 1993.

ALEKAN Henri, *Le vécu et l'imaginaire : chroniques d'un homme d'images*, Paris, La Sirène, 1999.

ALION Yves, CAMY Gérard, *Le cinéma par ceux qui le font*, Paris, Nouveau Monde éditions, 2010.

ALMENDROS Nestor, *Un homme à la caméra*, Renens-Lausanne/Paris, 5 Continents/Hatier, 1980.

ALMIRON Miguel, JACOPIN Esther, PISANO Giusy, *Stéréoscopie et illusion*, Villeneuve d'Ascq, Presses universitaires du Septentrion, 2018.

ARONOVICH Ricardo, *Exposer une histoire : la photographie cinématographique*, Paris, Dujarric, 2003.

AUDÉ Françoise, *Ciné-modèles, cinéma d'elles : situation des femmes dans le cinéma français (1956–1979)*, Lausanne, L'Âge d'homme, 1981.

AUDÉ Françoise, *Cinéma d'elles 1981–2001 : situation des cinéastes femmes dans le cinéma français*, Lausanne, L'Âge d'homme, 2002.

AUMONT Jacques, GAUDREAULT André, MARIE Michel (dir.), *Histoire du cinéma : nouvelles approches*, Paris, Publications de la Sorbonne, 1989.

BAILBLÉ Claude, « Pour une nouvelle approche de l'enseignement de la technique de cinéma », *Cahiers du Cinéma*, n° 281-282, octobre-novembre 1977 ; n° 292–293, septembre-octobre 1978 ; n° 297, février 1979 ; n° 299, avril 1979.

BAMWELL Jane, *Production Design: Architects of the Screen*, Londres/New York, Wallflower, 2004.

BANKS Miranda, CONOR Bridget, MAYER Vicki, *Production Studies, the Sequel ! Cultural Studies of Global Media Industries*, New York, Routledge, 2015.

BARNIER Martin, *En route vers le parlant : histoire d'une évolution technologique, économique et esthétique*, Liège, éditions du Céfal, 2002.

BARNIER Martin, « Les premiers ingénieurs du son français », *1895, revue d'histoire du cinéma*, n° 65, hiver 2011, p. 200–217.

BARNIER Martin, SIROIS-TRAHAN Jean-Pierre (dir.), « Nouvelles pistes sur le son. Histoire, technologies et pratiques sonores », *Cinémas*, vol. 24, n° 1, 2014.

BARNIER Martin, KITSOPANIDOU Kira, *Le cinéma 3-D : histoire, économie, technique, esthétique*, Paris, Armand Colin, 2015.

BARNIER Martin, BONHOMME Bérénice, KITSOPANIDOU Kira, « L'évolution numérique des métiers du cinéma et de l'audiovisuel. Transformations, renouvellements et nouvelles qualifications », *Mise au point*, n° 12, 2020.

BARSACQ Léon, *Le décor de film (1895–1969)*, Paris, Veyrier, 1985.

BAUDROT Sylvette, SALVINI Isabel, *La script-girl : cinéma/vidéo*, Paris, La Fémis, 1995 [1989].

BAUDRY Jean-Louis, « Cinéma : effets idéologiques produits par l'appareil de base », *Cinéthique*, n° 7–8, 1970, p. 1–8.

BEAULIEU Jacqueline, *La télévision des réalisateurs*, Paris, Ina/La Documentation française, 1984.

BECKER Howard S., *Les mondes de l'art*, traduit de l'anglais par Jeanne Bouniort, Paris, Flammarion, 1988, (1ère édition 1982).

BELTON John, HALL Sheldon, NEALE Steve, *Widescreen Worldwide*, Bloomington, Indiana, Indiana University Press, 2010.

BENJAMIN Walter, « L'œuvre d'art à l'époque de sa reproductibilité technique », *Œuvres*, tome III, Paris, Gallimard, 2000 [1939].

BERGER Guy, COURTOIS Maurice, PERRIGAULT Colette, *Folies et raisons d'une université : Paris 8. De Vincennes à Saint-Denis*, Paris, éditions Petra, 2015.

BERTHOMÉ Jean-Pierre, *Le décor au cinéma*, Paris, Cahiers du Cinéma/ éditions de L'Étoile, 2003.

BESSIÈRES Irène, GILI Jean A. (dir.), *Histoire du cinéma : problématique des sources*, Paris, INHA/MSH/Université Paris 1 Panthéon-Sorbonne, 2002.

BINH N. T., FIGASSO Jean-Paul, *Écrire par l'image. Directeurs et directrices de la photo*, Bruxelles, Les Impressions nouvelles, 2019.

BINH N.T., SOJCHER Frédéric (dir.), *Écrire un film : scénaristes et cinéastes au travail*, Bruxelles, Les Impressions nouvelles, 2018.

BOISSIER Jean-Louis, « Propositions pour un cinéma interactif expérimental », dans Jean-Marie Dallet (dir.), *Cinéma, interactivité et société*, Poitiers, Université de Poitiers/CNRS, 2013, p. 142–163.

BONHOMME Bérénice, *Techniques du cinéma : image, son, post-production*, Paris, Dixit, 2011.

BONHOMME Bérénice, LABROUILLÈRE Isabelle, LACOSTE Paul, « La création collective au cinéma », *La création collective*, n° 1, 2017.

BONHOMME Bérénice, LABROUILLÈRE Isabelle, « L'équipe de film : innovations et inventions », *La création collective*, n° 2, 2019.

BORDWELL David, STAIGER Janet, *Technology, Style and Mode of Production*, dans David Bordwell, Janet Staiger, Kristin Thompson, *The Classical Hollywood Cinema: Film Style and Mode of Production to 1960*, London, Routledge, 1991 [1985], p. 243–261.

BORDWELL David, THOMSON Kristin, *L'art du film : une introduction*, Bruxelles, De Boeck, 2009.

BOSSENO Christian, *200 téléastes français*, CinémAction, HS, Condé-sur-Noireau/Paris, Corlet/Télérama, 1989.

BRETON Philippe, *Histoire de l'informatique*, Paris, Seuil, 1987.

BRIGAUD-ROBERT Nicolas, *Les producteurs de télévision : socio-économie d'une profession*, Paris, Presses universitaires de Vincennes, 2011.

BRUNET Sophie, JURGENSON Albert, *Pratique du montage*, Paris, La Fémis, 1995.

CARDINAL Serge, « Entendre le lieu, comprendre l'espace, écouter la scène », *Protée*, Chicoutimi, Université du Québec, automne 1995, p. 94–99.

CARDON Vincent, « Produire "l'évidence". Le travail d'appariement et de recrutement dans le monde du cinéma », *Sociologie du Travail*, Volume 58, Issue 2, 2016, p. 160–180.

CERAM C.W. [Kurt Wilhelm Marek], *Archéologie du cinéma*, Paris, Plon, 1966.

CHALVON-DEMERSAY Sabine, PASQUIER Dominique, *Drôle de stars : la télévision des animateurs*, Paris, Aubier, 1990.

CHALVON-DEMERSAY Sabine, *Mille scénarios : une enquête sur l'imagination en temps de crise*, Paris, éditions Métaillé, 1994.

CHATRAND Alain, CAILHIER Diane, *Le métier d'assistant-réalisateur au cinéma*, Montréal, Lidec, 1990.

CHION Michel, *Le cinéma et ses métiers*, Paris, Bordas, 1990.

CHION Michel, *L'audio-vision*, Paris, Nathan, 1990.

CHION Michel, *Un art sonore, le cinéma : histoire, esthétique, poétique*, Paris, Cahiers du cinéma, 2003.

CLEMENTS Jonathan, *Anime: A History*, London, Palgrave Macmillan, 2013.

COISSAC Georges-Michel, *Histoire du cinématographe de ses origines à nos jours*, Paris, éditions du Cinéopse, 1925.

COLLECTIF, *État des lieux du montage : cinéma, télévision, comment les monteurs vivent leur profession*, Paris, Les monteurs associés, 2004.

COLPI Henri, HUREAU Nathalie, *Lettres à un jeune monteur*, Biarritz, Séguier/Archimbaud, 2006.

COMOLLI Jean-Louis, RANCIÈRE Jacques, *Arrêt sur histoire*, Paris, Centre Pompidou, 1997.

COMOLLI Jean-Louis, LEBLANC Gérard, NARBONI Jean, *Les années pop. Cinéma et politique : 1956–1970*, Paris, Centre Pompidou, 2001.

COMOLLI Jean-Louis, *Cinéma contre spectacle*, Paris, Verdier, 2009.

COMOLLI Jean-Louis, SORREL Vincent, *Cinéma, mode d'emploi. De l'argentique au numérique*, Lagrasse, Verdier, 2015.

CORNU Jean-François, *Le doublage et le sous-titrage*, Rennes, Presses universitaires de Rennes, 2014.

CORSET Pierre, MALLEIN Philippe, PERILLAT Joëlle, SAUVAGE Monique, « Sociologie d'un corps professionnel : les réalisateurs de télévision », Sociologie de la télévision, *Réseaux*, HS, CNET, 1991.

COSTE Catherine, *Scripte : pratique du métier en mono ou multi-caméras*, Paris, De Boeck, 2002.

CRETON Laurent, DEHÉE Yannick, LAYERLE Sébastien, MOINE Caroline (dir.), *Les producterurs : enjeux financiers, enjeux créatifs*, Paris, Nouveau Monde éditions, 2011.

DAGOGNET François, *Rematérialiser. Matières et matérialismes*, Paris, Vrin, 1989.

DAGOGNET François, *Éloge de l'objet*, Paris, Vrin, 1989.

DAGNAUD Monique, *Les artisans de l'imaginaire : comment la télévision fabrique la culture de masse*, Paris, Armand Colin, 2006.

DARRÉ Yann, « Esquisse d'une sociologie du cinéma », *Actes de la recherche en sciences sociales* n° 161–162, 2006, p. 122–136.

DE CERTEAU Michel, *L'écriture de l'histoire*, Paris, Gallimard, 1975.

DE CERTEAU Michel, *L'invention du quotidien*, Paris, Gallimard, 1990.

DE VERDALE Laure, « Une analyse lexicale des mondes de la production cinématographique et audiovisuelle française », *Sociologie*, Vol. 3, 2, 2012, p. 179–197.

DENIS Sébastien et al. (dir.), *Archives et acteurs des cinémas d'animation en France*, Paris, L'Harmattan, 2014.

DIAMANT-BERGER Henri, *Il était une fois le cinéma…*, Paris, Jean-Claude Simoën, 1977.

DOUARINOU Alain, *Un homme à la caméra*, Paris, éditions France Empire, 1989.

DOUY Max, DOUY Jacques, *Décors de cinéma : les studios français de Méliès à nos jours*, Paris, éditions du Collectionneur, 1993.

DUGUET Anne-Marie, *Vidéo, la mémoire au poing*, Paris, Hachette, 1981.

DURING Simon, *Modern Enchantments: The Cultural Power of Secular Magic*, Cambridge/Londres, Harvard University Press, 2002.

DYER Richard, *White: Essays on Race and Culture*, Londres/New York, Routledge, 1997.

ÈDE François, *GTC, histoire d'un laboratoire cinématographique*, Paris, Fondation Jérôme Seydoux-Pathé, 2016.

ELSAESSER Thomas, *Film History as Media Archaeology: Tracking Digital Cinema*, Amsterdam, Amsterdam University Press, 2016.

ETTEDGUI Peter, *Les directeurs de la photo*, Paris, La Compagnie du Livre, 1999.

FARGE Arlette, *Le goût de l'archive*, Paris, Seuil, « Points Histoire » n° 233, 1989.

FECHNER Christian, *La magie de Robert-Houdin*, vol. 3, Boulogne, éditions FCF, 2002.

FEIGELSON Kristian, *La fabrique filmique : métiers et professions*, Paris, Armand Colin, 2011.

FÈVRES-DE BIDERAN Jessica, *Infographie, image de synthèse et patrimoine monumental : espace de représentation, espace de médiation*, thèse de doctorat sous la direction de Bruno-Nassim Aboudrar, Université Montaigne Bordeaux 3, 2012.

FIANT Antony, HAMERY Roxane, MASSUET Jean-Baptiste (dir.), *Point de vue et point d'écoute au cinéma : approches techniques*, Rennes, Presses universitaires de Rennes, 2017.

FIHMAN Guy, « La stratégie Lumière : l'invention du cinéma comme marché », dans Pierre-Jean Benghozi, Christian Delage (dir.), *Une histoire économique du cinéma français (1895–1995) : regards croisés franco-américains*, Paris, L'Harmattan, 1997, p. 35–46.

FLECKINGER Hélène, *Cinéma et vidéo saisis par le féminisme (France, 1968–1981)*, thèse de doctorat sous la direction de Nicole Brenez, Université Sorbonne Nouvelle - Paris 3, 2011.

FOREST Claude, *Les dernières séances : cent ans d'exploitation des salles de cinéma*, Paris, CNRS éditions, 1995.

FRAPPAT Marie, MARIE Michel (dir.), « Le Film pluriel », *Cinéma & Cie*, vol. IX, n° 13, automne 2009.

GAILLARD Jean, *La fabrication d'effets spéciaux numériques en France*, mission réalisée pour le CNC, juin 2016.

GARÇON Anne-Françoise, *L'imaginaire et la pensée technique : une approche historique (XVIe-XXe siècles)*, Paris, Classiques Garnier, 2012.

GAUDREAULT André, MARION Philippe, *La fin du cinéma ? Un média en crise à l'ère du numérique*, Paris, Armand Colin, 2013.

GAUDREAULT André, LE FORESTIER Laurent (dir.), *Méliès, carrefour des attractions*, Rennes, Presses universitaires de Rennes, 2014.

GAUDREAULT André, LEFEBVRE Martin, *Techniques et technologies du cinéma : modalités, usages et pratiques des dispositifs cinématographiques à travers l'histoire*, Rennes, Presses universitaires de Rennes, 2015.

GAUTHIER Christophe, VEZYROGLOU Dimitri (dir.), *L'auteur de cinéma : histoire, généalogie, archéologie*, Paris, AFRHC, 2013.

GRIMAUD Emmanuel, « Les coulisses du sublime. Cascades de cinéma, machineries, effets spéciaux », *Ateliers d'Anthropologie*, n° 35, 2011.

GRISET Pascal, *Informatique, politique industrielle, Europe, entre Plan Calcul et Unidata*, Institut d'histoire de l'industrie, Paris, éditions Rive Droite, 1998.

HAMUS-VALLÉE Réjane, *Les effets spéciaux*, Paris, Cahiers du Cinéma, 2004

HAMUS-VALLÉE Réjane, RENOUARD Caroline, *Les métiers du cinéma à l'ère du numérique*, CinémAction, n° 155, Condé-sur-Noireau, éditions Charles Corlet, 2015.

HAMUS-VALLÉE Réjane, *Peindre pour le cinéma : une histoire du* matte painting, Villeneuve d'Ascq, Presses universitaires du Septentrion, 2016.

HAMUS-VALLEE Réjane, RENOUARD Caroline, *Superviseur des effets visuels*, Paris, Eyrolles, 2016.

HIDALGO Santiago (dir.), *Technology and Film Scholarship. Experience, Study, Theory*, Amsterdam, Amsterdam University Press, 2018.

HUHTAMO Erkki, PARIKKA Jussi (dir.), *Media Archaeology: Approaches, Applications, and Implications*, Berkeley & Los Angeles, University of California Press, 2011.

JOHNSTON Keith, *Coming soon. Film trailers and the selling of Hollywood Technology*, Jefferson, North Carolina, 2009.

JULLIER Laurent, *Les images de synthèse de la technologie à l'esthétique*, Paris, Armand Colin, 1998.

KANO Seiji, *Les gens qui ont fait l'animation japonaise [Nihon no animêshon o kizuita hitobito]*, Tokyo, Wakakusa Shobô, 2004.

KESSLER Frank, LARRUE Jean-Marc, PISANO Giusy, *Machines. Magie. Médias*, Villeneuve d'Ascq, 2018.

KITSOPANIDOU Kira, *L'innovation technologique dans l'industrie cinématographique hollywoodienne : le cinéma-spectacle des années 1950, une mise en perspective des stratégies liées à l'Eidophor et au Cinémascope*, thèse sous la direction de Laurent Creton, Université Sorbonne Nouvelle - Paris 3, 2002.

KOSZARSKI Richard, *History of American Cinema 3: An Evening's Entertainment. The Age of the Silent Feature Picture, 1915–1928*, New York, Scribner, 1990.

LAGNY Michèle, « Cinéma et histoire culturelle », *Cinémathèque*, n° 1, mai 1992, p. 7–16.

LAGNY Michèle, *De l'histoire du cinéma. Méthode historique et histoire du cinéma*, Paris, Armand Colin, 1992.

LAMARRE Thomas, *The Anime Machine: A Media Theory of Animation*, Minneapolis, University of Minnesota Press, 2009.

LARRUE Jean-Marc, PISANO Giusy, *Les archives de la mise en scène : hypermédialité du théâtre*, Villeneuve d'Ascq, Presses universitaires du Septentrion, 2014.

LEFEUVRE Morgan, *De l'avènement du parlant à la Seconde Guerre mondiale : histoire générale des studios en France 1929–1939*, thèse de doctorat sous la direction de Michel Marie, Université Sorbonne Nouvelle - Paris 3, 2016.

LE FORESTIER Laurent, MORRISSEY Priska (dir.), « Histoire des métiers du cinéma en France avant 1945 », *1895, revue d'histoire du cinéma*, n°65, AFRHC, hiver 2011.

LEGRAND Guy, *Trucages numériques et Images de synthèse : cinéma et télévision*, Paris, Dixit, 1998.

LEMONNIER Pierre, « L'étude des systèmes techniques, une urgence en technologie culturelle », *Techniques et culture* n° 1, 1983, repris dans *Techniques et culture*, n° 54–55, vol. 1, 2010, p. 46–67.

LEROI-GOURHAN André, *Milieu et techniques*, Paris, Albin Michel, 1945.

LEROI-GOURHAN André, *Évolution et techniques : I. L'homme et la matière*, Paris, Albin Michel, 1971 [1943].

LIGONNIÈRE Robert, *Préhistoire et histoire des ordinateurs : des origines de calcul aux premiers calculateurs électroniques*, Paris, Robert Laffont, 1987.

LORILLEUX Lydia, *Le décor de film en France entre 1929 et 1939*, mémoire soutenu à l'École Supérieure de Journalisme, 1984.

LOURIÉ Eugène, *My work in films* [biographie], San Diego, New-York, London, Harcourt Brace Jovanovitch, 1985.

MACLEAN Fraser, *Setting the Scene: The Art & Evolution of Animation Layout*, San Francisco, Chronicle Books, 2014.

MALTHÊTE Jacques, SALMON Stéphanie, *Recherches et innovations dans l'industrie du cinéma : les cahiers d'ingénieurs Pathé (1906–1929)*, Paris, Fondation Jérôme Seydoux-Pathé, 2017.

MANNONI Laurent, *Trois siècles de cinéma : de la lanterne magique au cinématographe*, Paris, Cinémathèque française/Réunion des Musées nationaux, 1995.

MANNONI Laurent, *Le grand art de la lumière et de l'ombre : archéologie du cinéma*, Paris, Nathan Université, 1999.

MANNONI Laurent, *La Machine Cinéma, de Méliès à la 3-D*, Paris, Lienart/ Cinémathèque française, 2016.

MASSUET Jean-Baptiste, *Quand le dessin animé rencontre le cinéma en prises de vues réelles : modalités historiques, théoriques et esthétiques d'une scission-assimilation entre deux régimes de représentation*, thèse de doctorat sous la direction de Laurent Le Forestier, Université Rennes 2, 2013.

MAYER Vicki, *Production Studies: Cultural Studies of Media Industries*, New York, Routledge, 2009.

MAYER Vicki, *Below the line: Producers and Production Studies in the New Television Economy*, Durham/London, Duke University Press, 2011.

MENGER Pierre-Michel, *Les intermittents du spectacle : sociologie du travail flexible*, Paris, EHESS, 2011 (nouvelle édition).

METZ Christian, « Trucage et cinéma », dans *Essais sur la signification au cinéma (tome 2)*, Paris, Klincksieck, 1972, p. 173–192.

MEUSY Jean-Jacques (dir.), *Le Cinémascope entre art et industrie*, Paris, AFRHC, 2004.

MILLER Pat, *Script supervising and Film Continuity*, Focal Press, Butterworth-Heinemann, 1999.

MOATTI Alexandre, « Le numérique, adjectif substantivé », *Le Débat*, n° 170, mai-août 2012, p. 133–137.

MOREAN René, *Ainsi naquit l'informatique : les hommes, les matériels à l'origine des concepts de l'informatique d'aujourd'hui*, Paris, Dunod, 1981.

MORRISSEY Priska, SIETY Emmanuel (dir.), *Filmer la peau*, Rennes, Presses universitaires de Rennes, 2017.

MORRISSEY Priska, *Naissance d'une profession invention d'un art : l'opérateur de prise de vues cinématographiques de fiction en France (1895–1926)*, thèse de doctorat sous la direction de Jean A. Gili, Université Paris 1 Panthéon-Sorbonne, 2008.

MOUNIER-KUHN Pierre-Éric, *L'informatique en France de la Seconde Guerre mondiale au Plan Calcul : l'émergence d'une science*, Paris, Presses Universitaires de Paris-Sorbonne, 2010.

MURCH Walter, « Walter Murch », *Transom Review*, vol. 5, avril 2005.

NAUDIER Delphine, « La construction sociale d'un territoire professionnel : les agents artistiques », *Le Mouvement Social*, 2013/2 (n° 243), p. 41–51.

NOESSER Cécile, *La résistible ascension du cinéma d'animation : socio-genèse d'un cinéma-bis en France (1950–2010)*, thèse de doctorat sous la direction de Bruno Péquignot, Université Sorbonne Nouvelle - Paris 3, 2013.

NORTH, Dan, *Performing Illusions: Cinema, Special Effects and the Virtual Actor*, London, Wallflower Press, 2008.

OLDHAM Gabriella, *First Cut: Conversations with film editors*, Berkeley/London, University of California Press, 1995.

ONDAATJE Michael, *Conversations avec Walter Murch*, Paris, Ramsay, 2009.

OTHNIN-GIRARD Valérie, *L'assistant réalisateur*, Paris, La Fémis, 1988.

OTSUKA Yasuo, *Animer à la sueur de son front [Sakuga ase mamire]*, Tokyo, Tokuma Shoten, 2001.

PACI Viva, *La machine à voir : à propos de cinéma, attraction, exhibition*, Villeneuve d'Ascq, Presses universitaires du Septentrion, 2012.

PALLANT Chris, *Demystifying Disney: A History of Disney Feature Animation*, New York, Bloomsbury Publishing, 2011.

PASQUIER Dominique, *Les scénaristes et la télévision : approche sociologique*, Paris, Nathan/Ina, 1995.

PELÉ Gérard, PISANO Giusy (dir.), *Archéologie des médias*, dossier de la revue numérique de l'ENS Louis-Lumière, *Cahiers Louis Lumière*, n° 10, décembre 2016.

PIEUCHOT Jean, *Régisseur de cinéma*, Paris, Dualpha, 2003.

PINEL Vincent, *Dictionnaire technique du cinéma*, Paris, Armand Colin, 2008.

PINTEAU Pascal, *Effets spéciaux : un siècle d'histoires*, Genève, Minerva, 2015.

PISANO Giusy, *Une archéologie du cinéma sonore*, Paris, CNRS éditions, 2004.

PRÉDAL René, *La photo de cinéma*, Paris, éditions du Cerf, 1985.

PRÉDAL René, *Les scénaristes de télévision*, CinémAction TV, n° 2, Condé-sur-Noireau/Paris, Corlet/Télérama, juin 1992.

PRUVOST-DELASPRE Marie, *Pour une histoire esthétique et technique de la production animée : le cas de la Tôei Dôga (1956–1972)*, thèse de doctorat sous la direction de Laurent Creton, Université Sorbonne Nouvelle - Paris 3, 2014.

RANNOU Pierre, « Du rôle et de la fonction de l'espace sonore au cinéma », *Inter : art actuel*, n° 98, Québec, éditions Interventions, 2008, p. 40–43.

ROBERT-HOUDIN Jean-Eugène, *Les secrets de la prestidigitation et de la magie*, Paris, Michel Levy, 1868.

ROGERS Ariel, *Cinematic Appeals : the Experience of New Movie Technologies*, New York, Columbia University Press, 2013.

ROT Gwenaële, « Noter pour ajuster. Le travail de la scripte sur un plateau de tournage », *Sociologie du travail*, n° 56, 2014, p. 16–39.

ROUSSELOT Philippe, *La sagesse du chef opérateur*, Paris, J-C. Béhar, 2013.

ROUX Martin, *Persistance ou l'influence de l'esthétique argentique sur les technologies numériques*, mémoire de fin d'études et de recherche sous la direction de Frédéric Sabouraud et Caroline Champetier, ENS Louis-Lumière, 2012.

RUIVO Céline, *Le Technicolor trichrome : histoire d'un procédé et enjeux de sa restauration*, thèse de doctorat sous la direction de François Thomas, Université Sorbonne Nouvelle - Paris 3, 2016.

SADOUL Georges, *Le cinéma, son art, sa technique, son économie*, Paris, La Bibliothèque française, 1948.

SERCEAU Michel, ROGER Philippe (dir.), *Les archives du cinéma et de la télévision*, CinémAction, n° 97, Condé-sur-Noireau/Paris, Corlet/Télérama/Ina, 2000.

SIMONDON Gilbert, *Du mode d'existence des objets techniques*, Paris, Aubier, 1989 [1958].

SIMONDON Gilbert, *Sur la technique*, Paris, Presses universitaires de France, 2014.

SITO Tom, *Moving Innovation : A History of Computer Animation*, Cambridge, Massachussetts, MIT press, 2013.

SOUCHON Frédéric, *Tribologie d'un enregistreur magnétique hélicoïdal : contact tête silicium/bande magnétique*, thèse de doctorat sous la direction d'Yves Berthier, INSA Lyon, 1997.

STERNE Jonathan (dir.), *The Sound Studies Reader*, New York, Routledge, 2012.

TABET Frédéric, « Les Archives de l'art magique, ou pour en finir avec le mythe de la source secrète », *L'archive-forme, création, histoire, mémoire*, Paris, L'Harmattan, 2014, p. 287–296.

TABET Frédéric, *Le cinématographe des magiciens*, Rennes, Presses universitaires de Rennes, 2018

TARR Carrie, ROLLET Brigitte, *Cinema and the Second Sex: Women's Filmmaking in France in the 1980's and 1990's*, New York/Londres, Continuum, 2001.

TELOTTE Jay P., *The Mouse Machine: Disney and Technology*, Champaign, University of Illinois Press, 2008.

THIERRY Benjamin, *Donner à voir, permettre d'agir : l'invention de l'interactivité graphique et du concept d'utilisateur en informatique et en télécommunications en France (1961–1990)*, thèse de doctorat sous la direction de Pascal Griset, Université Sorbonne Paris 4, 2013.

THOMAS Bob, *Walt Disney: The Art Of Animation: The Story Of The Disney Studio Contribution to A New Art*, New York, Simon and Schuster, 1958.

THOMAS François, *Alain Resnais, les coulisses de la création*, Paris, Armand Colin, 2016.

THOMAS François (dir.), « Dossier : La scripte, mémoire du film », *Positif*, n° 685, mars 2018, p. 94–115.

TRAUNER Alexandre, *Décors de cinéma*, Paris, Jade/Flammarion, 1988.

TURQUETY Benoît, *Inventer le cinéma. Épistémologie : problèmes, machines*, Lausanne, L'Âge d'homme, 2014.

TURQUETY Benoît, « Propositions pour une histoire des techniques en cinéma », *1895, revue d'histoire du cinéma*, vol. 82, n° 2, 2017, p. 8–13.

VERNANT Jean-Pierre, « Remarques sur les formes et les limites de la pensée technique chez les Grecs », *Revue d'histoire des sciences et de leurs applications*, tome 10, n° 3, 1957, p. 205–225.

VIGNAUX Valérie (dir), « Archives », *1895, revue d'histoire du cinéma*, n° 41, AFRHC, octobre 2003.

VIGNAUX Valérie, TURQUETY Benoît (dir.), *L'amateur en cinéma, un autre paradigme : histoire, esthétique, marges et institutions*, Paris, AFRHC, 2016.

WATANABE Yasushi, YAMAGUCHI Katsunori, *Nihon animeshon eiga shi [Histoire de l'animation japonaise]*, Planet, Osaka, Yubunsha, 1977.

WELKER Cécile, *La fabrique des « nouvelles images » : l'émergence des images de synthèse en France dans la création audiovisuelle (1968–1989)*, thèse de doctorat sous la direction de Bruno-Nassim Aboudrar, Université Sorbonne Nouvelle - Paris 3, 2015.

WILLOUGHBY Dominique, *Le cinéma graphique : une histoire des dessins animés, des jouets d'optique au cinéma numérique*, Paris, Textuel, 2009.

WINSTON Brian, « A Whole Technology of Dyeing: A Note on Ideology end the Apparatus of the Chromatic Moving Image », *Daedalus*, Vol. 114, n° 4, Fall 1985, p. 105–123.

WITTA-MONTROBERT Jeanne, *La lanterne magique : mémoires d'une script*, Paris, Calmann-Lévy, 1980, p. 39.

ZEDERBAUM Vladimir, *Cours de technique générale du cinéma : six leçons complémentaires*, Paris, école universelle par correspondance, 1931.

ZIELINSKI Siegfried, *Archäologie der Medien : Zur Tiefenzeit des technischen Hörens und Sehens*, Reinbek bei Hamburg, Rowohlt, 2002 (trad. *Deep Time of the Media: Toward an Archaeology of Hearing and Seeing by Technical Means*, Cambridge [MA], MIT Press, 2006).

ZURSTRASSEN Zoé, *La scripte d'aujourd'hui*, Paris, Dujarric, 1988.

Résumés / Abstracts

PROLOGUE
Pour une histoire des appareils et des métiers du cinéma et de l'audiovisuel

Les archives s'ouvrent aujourd'hui aux chercheurs avec davantage de facilité. Les appareils et documents techniques concernant les métiers du cinéma sont de plus en plus accessibles. Des thèses et des séminaires de recherche investissent le terrain de l'histoire des techniques et des métiers de l'audiovisuel, mais ce champ disciplinaire demeure encore peu développé. La coopération entre chercheurs et archivistes mérite notamment d'être approfondie. Dans ce prologue, la parole est donnée à des représentant.e.s d'institutions tels que la Cinémathèque française, l'Institut national de l'audiovisuel, les Archives françaises du film du CNC et la Fondation Jérôme Seydoux-Pathé, afin de comprendre la façon dont la disponibilité des archives du cinéma et de la télévision a évolué sur la période récente.

The Film history was first made describing cinematographic technics. But in a recent period, new kind of archives have been accessible to film scholars. Digitalized text and films help researchers, as well as the opening of collection of apparatus and many kind of documents: rushes, videos and interviews with technicians, etc. Recent PhD thesis are proposing new approaches on color technics history, social analyses of the French studios employees, etc. because cooperation between archives have been improved so much in the last 15 years that new fields are open concerning machines, technics and film industry jobs. In this prologue representatives of Institutions like Cinémathèque française, Ina, Archives françaises du film du CNC or Fondation Jérôme Seydoux are talking about the recent evolution of the disponibility of archives in France.

PREMIÈRE PARTIE
MACHINES ET GESTES TECHNIQUES

Histoire des machines / histoire des techniques : à partir de Bolex

La marque d'appareils cinématographiques Bolex fait l'objet d'un projet de recherche qui cherche à établir l'histoire des machines et celle de leurs liens avec les pratiques des cinéastes amateurs. Mais comment penser l'écriture de cette histoire et l'articulation de ce lien ? Croisant les méthodes de la technologie culturelle, de l'histoire des techniques et de l'analyse simondonienne des objets techniques, cette contribution propose de développer, sur l'exemple de la caméra Bolex H16, une archéologie axée sur les opérations techniques des utilisateurs et une épistémologie décrivant l'architecture des problèmes engagés dans la structure même de la machine.

The Bolex brand of film apparatuses is the object of a research project that aims at establishing the history of the machines and that of their links with amateur film practices. But how can the writing of such a history be conceived, and these links be articulated? Using the Bolex H16 camera as an example, and borrowing conceptual tools from material culture studies, history of technology and Simondon's analysis of technical objects, this contribution proposes to develop an archaeology based on the users' technical operations, and an epistemology able to describe the architecture of the problems involved in the machine's very structure.

Voyages aériens en images : sources et objets pour une histoire du cinéma utilitaire

Adoptant une approche décentrée du cinéma, cette étude met à l'épreuve les procédures méthodologiques qui ont été développées par un courant de recherches consacrées à des objets périphériques que l'on tend à regrouper sous le nom de « cinéma utilitaire ». Structurée en trois temps autour des revues « éloignées », des films orphelins et des appareils hybrides, cette réflexion s'efforce de dégager quelques-unes des questions directrices permettant d'envisager les rapports entre industrie des images et industrie du voyage au moment de l'essor du transport aérien commercial. Révélatrice des contacts entre l'utilitaire et le spectaculaire, cette étude des usages du film dans le secteur du voyage amène non seulement à reconsidérer le rôle d'une production promotionnelle fondée sur la notion de « prestige », mais aussi à situer à l'extérieur du milieu

cinématographique l'une des impulsions données au cinéma pour qu'en soient renouvelés les espaces et les techniques, avec la conversion des avions de ligne en salles de projection.

Assuming a decentered approach to cinema, this study tests the methodological procedures developed by research on peripheral objects that are often grouped together under the term "useful cinema". Structured in three parts about non-film journals, orphan films and hybrid devices, this paper tries to identify some of the guiding questions that enable us to consider the relationship between the cinema and the travel industries in the age of commercial air travel. Revealing the contacts between the useful and the spectacular, this study of the uses of film in the travel sector leads us not only to reconsider the role of a promotional production based on the idea of "prestige", but also to situate outside of the film industry one of the impulses given to renew the spaces and the techniques of cinema, with the transformation of aircrafts into movie theatres.

La manufacture mondialisée de l'animation : *Motion Makers*, ouvriers et petites mains de l'intervalle

Des milliers d'heures d'animation sont désormais visionnées chaque année par des spectateurs de tous âges, sur une prolifération d'écrans de toutes sortes, produites par une industrie mondialisée et fabriquées manuellement par des milliers de « travailleurs de l'intervalle », ou *Motion Makers*, répartis dans des studios disséminés sur tous les continents. La division et la délocalisation du travail de l'animation sont devenues des paramètres systématiques d'ajustement financier sur un marché saturé, engendrant une baisse des budgets. S'appuyant sur son expérience pratique de création, sur des travaux de recherche sur l'histoire et l'esthétique de l'animation, sur des entretiens avec des animateurs et des sources professionnelles et syndicales, l'auteur dresse un historique et un état des lieux de ce phénomène aux États-Unis, au Japon et en France.

Thousands hours of animation are viewed every year by spectators of all ages upon all kind of proliferating screens, produced by a world industry, and manually made by thousands of in betweeners working in studios all over the world. The division and outsourcing of the animation work has become a systematic economical adjustment parameter in a saturated marketplace, generating budget shrinkings. A historical and contemporary recapitulation of this process is made about U.S., Japan and France animation industries based on the author's own practice and research on animation history and

aesthetics, as well as on interviews with animators and data relating to trade unions and associations.

Norman O. Dawn, créateur d'effets spéciaux : de la technique au métier

Norman O. Dawn, pionnier des effets spéciaux, a travaillé de 1907 au tout début des années 1950, des États-Unis à l'Australie, en passant par des films réalisés en Alaska ou en Bolivie. Tour à tour producteur, réalisateur, technicien en effets spéciaux, inventeur de trucages qu'il brevette, Dawn a laissé une partie de ses archives à disposition, sous forme de cartes illustrées reprenant une partie des 861 trucages qu'il réalisa au cours de sa carrière. Cet article se demande ce qu'apportent les archives personnelles de Dawn à la compréhension de sa place dans l'histoire des techniques, en croisant les données issues de ces archives, disponibles en ligne, avec des références bibliographiques et filmiques. En quoi les schémas et anecdotes, rédigés souvent *a posteriori*, rentrent-ils en phase avec les éléments directement sortis des tournages, dessins préliminaires et morceaux de pellicules ? Quels enjeux méthodologiques cette étude de cas comporte-t-elle dans une réflexion plus large sur les enjeux de la recherche en histoire des techniques et des métiers, en particulier des effets spéciaux ?

Norman O. Dawn, a pioneer of special effects, worked from 1907 to the early 1950s, from the United States to Australia, and also made films in Alaska or Bolivia. Alternately producer, director, special effects technician, inventor of special effects and patents, Dawn has left part of his archives at disposal, in the form of illustrated cards containing informations, drawings and technical elements about some of the 861 tricks he made during his career. This paper will ask what Dawn's personal archives bring to the understanding of his place in the history of techniques, by crossing the data from these archives, available online, with bibliographic and filmic references. Are the diagrams and anecdotes, often written a posteriori, *in phase with the elements directly out of the shootings, preliminary drawings and pieces of cellophanes films? What are the methodological issues involved in this case study, in a broader analysis on the issues of research in the history of techniques and trades, especially in the special effects field?*

DEUXIÈME PARTIE
LES MÉTIERS DU CINÉMA ET LEURS ÉVOLUTIONS

Décors et décorateurs de cinéma : approches et méthodes

Avec l'apparition des techniques numériques, les décorateurs du cinéma français redéfinissent leur rôle et leurs responsabilités, se mobilisent pour défendre leur profession. Si de nouvelles sources écrites ou audiovisuelles viennent mettre en lumière le décor et ses mutations, la collection de dessins de la Cinémathèque française reste une source majeure. Documents anciens ou acquisitions récentes, ces archives mettent en perspective les pratiques du passé avec celles d'aujourd'hui.

With the advent of digital technologies, french production designers are pressed to redefine their role and responsibilities as well as actively mobilize to defend their profession. Whereas newly discovered sources, whether written or audiovisual, may illuminate the art of production design and its mutations, the collection established in the Cinémathèque française remains a major source. Older documents and recent acquisitions, these archival materials serve to provide a comparative perspective between past practices and those of today.

À travers les collections de la Cinémathèque française

Depuis son installation à Bercy, la collection des maquettes de décors de la Cinémathèque française s'est enrichie de nombreux documents concernant le cinéma de ces vingt dernières années. Composée aujourd'hui de plus 7 000 dessins et de plusieurs maquettes en volume, elle couvre 100 ans de cinéma et constitue un formidable outil d'investigation sur le travail des chefs décorateurs.

The collection of scale models of sets of the French Cinematheque has been enriched, since its installation at Bercy, by many documents on the cinema of the past twenty years. Composed of over 7 000 drawings and several models in volume, the entire collection spans 100 years of cinema and becomes a great investigative tool on the work of the production designers.

Truquer les décors de cinéma en France : quelle visibilité des métiers et des techniques, d'hier à aujourd'hui ?

Le cinéma français regorge d'effets spéciaux – notamment de décors truqués – dès ses débuts, et tout au long de son histoire. L'objet de cet article est de mettre en lumière l'une des techniques phares des trucages de décor en France, celle de l'extension de décor, en revenant sur l'importance de ceux qui ont contribué à son essor, Nicolas Wilcké et Paul Minine. En étudiant les traces qui demeurent aujourd'hui des pratiques d'un métier du passé, il s'agit de mettre en perspective un métier du présent, et inversement.

French cinema has been full of special effects (especially by shrinking the size of set location) since its early days. The purpose of this paper is to highlight techniques of set extensions, like forced perspectives, foreground miniatures and digital matte painting – with a portrait of those who contributed to its rise: Nicolas Wilcké and Paul Minine. By studying old practices and forgotten professions, we will put into perspective practices and profession of the digital age, and vice versa.

Le regard des opérateurs nord-américains sur la pellicule panchromatique dans sa période d'expérimentation (1917–1923) : que nous apprend la presse technique et corporative ?

Eastman Kodak a commercialisé en 1923 sa pellicule panchromatique, qui permet un meilleur rendu des valeurs en noir et blanc que l'orthochromatique. Avant cela, cette nouvelle pellicule avait été testée au moins depuis 1917. Cette contribution explore cette phase expérimentale du point de vue des opérateurs. En s'appuyant sur la presse spécialisée de l'époque et sur des témoignages postérieurs, l'auteur analyse les discours et les silences des opérateurs concernant cette innovation technique.

Eastman Kodak marketed panchromatic film – which allowed a better rendition of black and white tonal values than orthochromatic film – in 1923. Prior to that, panchro was tested at least from 1917 on. Priska Morrissey's paper explores that experimental phase from the point of view of cinematographers. Based on trade and technical press from the period as well as later accounts, the paper analyzes the discourses, silences and perceptions of cinematographers concerning that technical innovation.

Questionner le passage au numérique : la vision du chef opérateur. Approches méthodologiques

L'objectif de cet article est de proposer une réflexion méthodologique à partir des travaux en cours de l'autrice sur l'impact du numérique sur le métier du chef opérateur. Il s'agit, en particulier, de mettre en exergue la constitution de « la boîte noire numérique » en s'inspirant de la sociologie de la traduction et en articulant parole de la fabrique et modélisation théorique afin de montrer comment s'est imposée la technologie numérique et les stratégies d'adaptation qui en découlent.

The purpose of this paper is to discuss methodological issues and approaches regarding current research conducted by the author on the impact of digital technology on the craft of the cinematographer, Taking inspiration from developments in the sociology of translation ("sociologie de la traduction") and bringing together practice and theory, the author aims to highlight the building of the "digital black box", in order to show how digital technology has become established as well as the strategies of adaptation which ensue from it.

Changement technique et geste artistique : questionner le passage au son numérique à travers l'œuvre de Walter Murch

Cette contribution a pour objectif de mieux comprendre les enjeux du passage du cinéma analogique au numérique, dans une perspective axée autour de l'évolution de la bande sonore et en comparant plusieurs films « mis en son » par Walter Murch. Le lecteur aura ainsi l'occasion de revisiter l'œuvre de ce concepteur son (qui relève autant de l'enregistrement que du montage et du mixage) et de constater que le progrès technique apporté par l'audionumérique a beaucoup à voir avec le geste artistique qui le sous-tend.

The goal of this chapter is to better understand the issues involved in both analog and digital cinema, through an analysis of the evolution of the different soundtracks created by Walter Murch. It will revisit the work of this sound designer (also renowned for his talent in recording, editing and mixing) and establish that the technical progress brought by digital audio has much to do with the artistic gesture that underlies it.

TROISIÈME PARTIE
FAIRE L'HISTOIRE DES TECHNIQUES ET DES MÉTIERS

Le cinéma au prisme du magique ou pour une réactivation de la figure du physicien-fantasmagore

L'évolution du cinématographe a souvent été rapprochée de certains moments de l'histoire de l'art magique : les récréations scientifiques du XVIIe siècle, la fantasmagorie du XVIIIe siècle ou la magie optique du XIXe siècle. Cet article examine l'hypothèse d'une analogie fine qui propose de comprendre l'histoire du cinéma et de ses techniques par le biais de l'écriture magique. La spécificité de ces spectacles tient à la manière dont de multiples pratiques ont été présentées. Explorer les principes à l'œuvre et saisir les effets des outils de construction qui créent un sentiment d'émerveillement contrarié permettent de comprendre pourquoi le spectacle cinématographique a été perçu comme magique.

Often, cinematography has been brought closer to the history of stage magic: 17th century's "scientific recreations", 18th century's Phantasmagoria, or 19th century's Optical magic. This paper examines the hypothesis of an in-depth analysis that proposes to study the history of cinema and its techniques through magical writing. The specificity of these shows relies on particular exhibition's technique. Exploring the principles at work and grasping the effects of their tools, helps to understand why the cinematic spectacle is always perceived as magical.

Les techniciens et ouvriers des studios dans les années 1930 : enjeux et limites d'une histoire générale des métiers de la production cinématographique

Prenant en considération la dimension collective de la création cinématographique et la porosité existant entre les métiers de la production dans les années 1930, cette contribution propose une réflexion sur la pertinence, les limites et les difficultés d'une approche globale de ces métiers. Sans chercher à donner la priorité à une catégorie professionnelle sur une autre, il s'agit de s'interroger sur la faisabilité d'une histoire générale des travailleurs de la production et sur les éclairages spécifiques qu'une telle démarche peut apporter à l'histoire des métiers et des techniques cinématographiques. Cette approche plurielle qui vise à replacer les métiers de la production dans leur contexte économique et socio-culturel permet de mieux comprendre leurs interactions et leurs complémentarités. Elle n'est toutefois pas sans poser quelques difficultés

d'ordre méthodologique face auxquelles l'outil numérique s'avère être un précieux allié pour les chercheurs.

Taking into consideration the collective dimension of the film creation and the permeability between the professions of the film production in the 1930s, this paper offers a reflexion about the relevance, the limits and the difficulties of a global approach of those professions. Without singling out a profession and prioritizing any professional categories, the aim here is to question the feasibility of a general history of the film production workers and the specific perspectives that such an approach can bring to the history of the film professions and techniques. This plural approach which aims at putting the film industry professions into their economical and socio-cultural contexts allows a better understanding of their interactions and complementarities. It's not totally without yielding methodological difficulties against which digital tools are a precious ally for the researchers.

Faire l'histoire du métier de scripte à partir de ses documents de travail

Apparu au début des années 1930 en France, le métier de scripte a accompagné les bouleversements qui ont animé la filière cinématographique. Accompagné car le scripte, qualifié de « mémoire du film », est producteur d'abondantes archives administratives, techniques et artistiques qui forment le témoignage le plus riche de la genèse des films, du travail de l'équipe sur le plateau, de l'évolution des pratiques et des outils. Accompagné également, car son rôle a tendu à se complexifier, passant de celui de secrétaire de plateau à celui d'interlocuteur majeur du réalisateur. Le numérique, en questionnant aujourd'hui l'utilité de certaines de ses fonctions, ouvre-t-il sur une redéfinition du métier ?

Ever since it appeared in France in the beginning of the 1930s, the profession of script supervisor has evolved along with the changes in the cinema industry. One could describe this as the "memory of the movie". Indeed, it provides a huge amount of administrative, technical and artistic archives which create the most abundant testimony of the genesis of a movie, of the technical work of the teams, and of the evolution of tools and practices. Over the decades, the role of the script supervisor has evolved from being a sort of film set secretary to being a main interlocutor of the director. Nowadays, digital technologies challenge some of his tasks. Does it imply a redefinition of this profession's duties?

Aux origines de l'Institut des hautes études cinématographiques : de la création du Centre artistique et technique des jeunes du cinéma (CATJC) aux conférences de Jean Epstein à l'IDHEC (1941–1945)

Par quels moyens le cinéma dévoile-t-il des phénomènes qui, d'ordinaire, se dérobent à notre perception ? Cette question, qui hante l'œuvre du cinéaste et théoricien français Jean Epstein (1897–1953), se situe au fondement de sa *pédagogie du cinéma*. Depuis le début des années 1920 jusqu'à sa mort, Epstein s'est continûment employé à transmettre ses réflexions sur le cinéma sous des formes très variées (conférences, projets de films, enseignement) qui composent un édifice théorique encore largement méconnu. Loin de se réduire à une préoccupation annexe, la pédagogie du cinéma, telle que la pratique et la théorise Jean Epstein entre 1920 et 1950, constitue un processus de création à part entière, au même titre que ses activités cinématographiques et littéraires. En occupant la chaire d'esthétique de l'Institut des hautes études cinématographiques (IDHEC), créé sous l'Occupation, Jean Epstein accompagne dès l'automne 1945, les premiers pas de ce qui deviendra plus tard l'école nationale supérieure des images et du son (La Fémis). Suivre le parcours de ce cinéaste, que la législation antisémite tenait alors à l'écart de son environnement professionnel, nous conduit à traverser cette époque troublée et à interroger les enjeux institutionnels et politiques qui présidèrent à la fondation de l'IDHEC.

By what means does cinema unveil phenomena that ordinarily evade our perception? This question, which haunts the work of the French filmmaker and theorist Jean Epstein (1897–1953), lies at the foundation of his pedagogy of cinema. From the beginning of the 1920s until his death, Epstein continued to transmit his reflections on cinema in a wide variety of forms (lectures, film projects, teaching), which constitute a theoretical building still largely unknown. Far from being reduced to a secondary concern, the pedagogy of cinema such as the practice and theory of Jean Epstein between 1920 and 1950 constitutes a process of creation in its own right, as well as its cinematographic and literary activities. In the autumn of 1945, Jean Epstein occupied the chair of aesthetics at the Institut des hautes études cinematographiques (IDHEC). He accompanied the first steps of what would become the National School of Images and Sound (Fémis). Since it was created under the Occupation (1943), to follow Epstein's path, which anti-Semitic legislation kept away from its professional environment, leads us through this troubled period and to question the institutional and political stakes that presided over the founding of IDHEC.

Retrouver la trace du geste : caméra multiplane et profondeur de champ dans les films de la Tôei Dôga

Si les techniques sont omniprésentes dans les discours qui portent sur le cinéma d'animation, bien souvent abordé sous l'angle de sa spécificité ou des mystères de sa fabrication, les travaux académiques cherchant à mettre en perspective ces « manières de faire » dans une histoire des techniques d'animation sont plus rares. Il s'agirait donc, à partir du cas d'étude du studio d'animation japonais Tôei, qui a joué un rôle central dans la mise en place du modèle de l'animation japonaise, d'interroger les moyens à la disposition du chercheur pour aborder l'évolution des processus de production, et tout particulièrement la place que les documents de production peuvent occuper dans une telle analyse.

Animation is often approached in research in terms of its distinctive features and the mystery of its production; therefore the question of technical skills and know-hows is ever-present in discourses on the medium. Nevertheless, academic works focusing on the gestures and practices of animators and technicians is far less common. Taking the example of Japanese animation studio Tôei, which played a central part in the building of the local animation industry, this paper aims at questioning the means available to address the subject of the evolution of the production processes, and more specifically the role played by production documents in such an analysis.

Pour une histoire française des images de synthèse

Pour entrevoir les prémices de mutations des métiers du cinéma en même temps que l'arrivée des techniques d'imagerie numérique, nous proposons de présenter le travail mis en œuvre par le groupe de recherche EnsadLab Hist3D qui s'attache à reconstruire l'histoire encore mal connue des images de synthèse françaises à partir d'un récolement de films et de témoignages de pionniers. Cette histoire orale est fondatrice pour comprendre la « révolution » numérique des effets spéciaux. Les premiers « balbutiements » des infographistes – leurs développements techniques, leurs gestes, leurs simulations techno-esthétiques – sont loin de représenter une phase initiale, imparfaite et inachevée de l'histoire des images numériques. Pour nous aider à penser les transformations actuelles, ils doivent eux-aussi être cartographiés et préservés, aux côtés des techniques plus anciennes du cinéma.

To glimpse the origins of the mutations of cinema professions with the arrival of the digital image, we propose to present the work carried out by

the research group EnsadLab Hist3D, which attempts to reconstruct the still little-known history of French computer graphics images from an inventory checking of films and testimonies of pioneers.

ÉPILOGUE

Réflexions sur une rematérialisation du cinéma par ses techniques

En lien avec la pensée de l'historien et philosophe des sciences François Dagognet, cet épilogue propose des réflexions autour de l'opération théorique et pratique de « rematérialisation » du cinéma par ses techniques, ainsi que sur ses enjeux épistémologiques et historiographiques. Rematérialiser le cinéma par ses techniques invite d'abord à se focaliser sur ses réalités concrètes, ses objets et ses sources matérielles. Cette démarche implique ensuite d'aborder le cinéma à travers sa *praxis*, et donc ses processus de création. Enfin, c'est un geste d'historicisation et de désessentialisation qui encourage plus largement une recontextualisation idéologique, culturelle et médiatique.

In connection with historian and philosopher of sciences François Dagognet's thinking, this epilogue offers some reflections on the theoretical and practical operation of the "rematerialization" of cinema by its techniques, and on its epistemological and historiographical issues. Rematerializing cinema by its techniques invites first to focus on its concrete realities, its objects and its material sources. This approach implies then to consider cinema through its praxis, *and thus its processes of creation. Finally, it is a gesture of historicization and desessentialization that encourages more broadly an ideological, cultural and media recontextualization.*

Auteurs / Autrices

Après des études de lettres et d'histoire de l'art, Jacques AYROLES a travaillé au Musée du Jeu de Paume et au Centre Georges Pompidou. Il est actuellement le chef de service du Département Affiches, Dessins et Matériel publicitaire de la Cinémathèque française. Il a été commissaire de deux expositions dans ce lieu : « Profession : chef-décorateur » en 2014 et « L'écran japonais » en 2016.

Martin BARNIER est professeur en études cinématographiques et audiovisuelles à l'Université Lumière Lyon 2. Il travaille sur l'histoire du son au cinéma, sur les biopics et sur la 3-D. Il participe aux revues *Mise au Point* et *Écrans*. Il a publié récemment, avec Kira Kitsopanidou, *Le cinéma 3-D : histoire, économie, technique, esthétique* (Armand Colin, 2015), et seul, *Bruits, cris, musiques de films* (Presses universitaires de Rennes, 2010).

Lauren BENOIT a consacré ses travaux de recherche au métier de scripte dès 2011 à l'Université Paris Diderot. Son mémoire de Master 1 porte sur les documents de travail des scriptes conservés à la Cinémathèque française. Son Master 2 est consacré à la création d'un prototype de site documentaire visant à faciliter la compréhension de ces archives aux chercheurs. En 2015, elle a été co-commissaire avec Joël Daire de l'exposition *Dossier Scriptes* présentée au Musée de la Cinémathèque française.

Bérénice BONHOMME est maîtresse de conférences en cinéma à l'Université de Toulouse Jean-Jaurès (ESAV). Elle est membre du laboratoire de recherche LARA-SEPPIA. Elle travaille actuellement sur les thématiques suivantes : image et imaginaire ; la technique cinématographique dans son rapport à la création ; l'équipe de film. Elle a publié *Les techniques du cinéma* (Dixit, 2010) et co-dirigé *Tim Burton, horreurs enfantines* (avec Adrienne Boutang et Mélanie Boissonneau, L'Harmattan, 2016). Elle développe un projet de recherche sur « Les chefs opérateurs français dans leur lien au numérique », sujet sur lequel elle a écrit

plusieurs articles. Elle coordonne, en outre, avec Katalin Pór (Université de Lorraine, 2L2S), un projet de recherche sur l'équipe de film, intitulé « Création collective au cinéma » (<https://creationcollectiveaucinema.com/>)

Hélène FLECKINGER est maîtresse de conférences en études cinématographiques à l'Université Paris 8 Vincennes Saint-Denis (ESTCA). Elle a dirigé *Caméra militante. Carole Roussopoulos : luttes de libération des années 1970* (MétisPresses, 2010), un numéro de *La Revue Documentaires* sur « Mai 68 : tactiques politiques et esthétiques du documentaire » (avec David Faroult, n° 22–23, 2010) et *SCUM Manifesto* (avec Julien Bézille et Callisto McNulty, Naïma, 2018). Spécialiste de la « vidéo des premiers temps », initiatrice avec Nadja Ringart de la plateforme « Bobines féministes », elle mène actuellement des recherches sur l'apport des technologies numériques à une éditorialisation et une contextualisation « en rhizomes » des archives audiovisuelles, dans une perspective scientifique, pédagogique et culturelle.

Réjane HAMUS-VALLÉE est maîtresse de conférences habilitée à diriger des recherches au sein de l'Université Évry-Val d'Essonne, Centre Pierre Naville, où elle dirige le Master « Image et société : documentaire et sciences sociales ». Elle travaille sur les effets spéciaux (*Les effets spéciaux*, Cahiers du cinéma/CNDP, 2004), sur les métiers du cinéma et de l'audiovisuel avec Caroline Renouard (*Superviseur des effets visuels pour le cinéma*, Eyrolles, 2015), et sur la sociologie visuelle et filmique (*Sociologie de l'image, sociologie par l'image*, CinémAction, n° 147, 2013). En 2016, elle a publié *Peindre pour le cinéma : une histoire du* matte painting (Presses du Septentrion) et dirigé « Trucage et télévision » (*Revue du CIRCAV*, n° 25).

Kira KITSOPANIDOU est professeure en études cinématographiques et audiovisuelles à l'Université Sorbonne Nouvelle - Paris 3 (IRCAV). Spécialiste de l'économie du cinéma et de l'audiovisuel, elle a consacré une partie de ses travaux à l'histoire des techniques du cinéma et de la télévision ainsi qu'à l'histoire des métiers. Elle notamment publié *Le cinéma 3-D : histoire, économie, technique, esthétique* (avec Martin Barnier, Armand Colin, 2015). Ses recherches récentes portent, en particulier, sur l'histoire des professionnels de l'audiovisuel.

Sébastien LAYERLE est maître de conférences en études cinématographiques et audiovisuelles à l'Université Sorbonne Nouvelle - Paris 3 (IRCAV). Il consacre l'essentiel de ses activités de recherche aux rapports entre cinéma et histoire, à travers l'étude du cinéma et de l'audiovisuel militant des années 1960 et 1970. Il est l'auteur de *Caméras en lutte en Mai 68* (Nouveau Monde éditions, 2008) et de *Chroniques de la naissance du cinéma algérien : Guy Hennebelle, un critique engagé* (avec Monique Martineau-Hennebelle, Corlet, 2018). Il a co-dirigé *Les producteurs : enjeux financiers, enjeux créatifs* (avec Laurent Creton, Yannick Dehée et Caroline Moine, Nouveau Monde éditions, 2011) et *Voyez comme on chante ! Films musicaux et cinéphilies populaires en France, 1945–1958* (avec Raphaëlle Moine, PSN, 2014).

Morgan LEFEUVRE est docteure en études cinématographiques et ATER à l'Université Rennes 2. Elle est l'autrice de *Les manufactures de nos rêves : histoire des studios de cinéma français des années 30*, préface de Jean-Pierre Berthomé (publication en cours aux Presses universitaires de Rennes) et de *Comprendre et interpréter un storyboard*, préface de Marc Vernet (éditions BiFi, 2004). Ses recherches portent actuellement sur la mobilité des acteurs et techniciens de la production, en particulier entre la France et l'Italie durant les années 1930–1970.

Violette LIBAULT est enseignante à l'Institut supérieur des techniques du son à Paris, ainsi qu'à l'École supérieure de réalisation audiovisuelle de Rennes. En 2014, La Création sonore, un laboratoire de recherche rattaché à l'Université de Montréal, publie ses travaux *La révélation de l'espace sonore par Walter Murch* et *Au-delà des mots : mise en scène des poèmes au cinéma*. Elle est également productrice de livres sonores pour de nombreuses maisons d'édition françaises.

Priska MORRISSEY est maîtresse de conférences en études cinématographiques à l'Université Rennes 2, membre de l'équipe « Arts pratiques et poétiques » et du programme de recherche *Technès*. Elle est l'autrice d'un ouvrage consacré aux relations entre réalisateurs et conseillers historiques (*Historiens et cinéastes : rencontre de deux écritures*, L'Harmattan, 2004). Elle a co-dirigé deux numéros thématiques de *1895, revue d'histoire du cinéma* – le premier consacré à l'histoire des métiers du cinéma (2011, avec Laurent Le Forestier) et le second aux procédés couleur (2015, avec Céline Ruivo), ainsi que l'ouvrage collectif *Filmer la peau* (avec Emmanuel Siety, Presses universitaires de Rennes, 2017).

Marie PRUVOST-DELASPRE est maîtresse de conférences à l'Université Paris 8 Vincennes Saint-Denis. Elle est l'auteur d'une thèse, soutenue en 2014 sous la direction de Laurent Creton, sur l'histoire de la production animée du studio Tôei, et de plusieurs articles sur l'animation et le cinéma japonais, dont : « Rêves d'Amérique : modèles de production dans le cinéma d'animation japonais des années 1960 » (*Réseaux*, n° 188, 2014), « De Godzilla aux Super-Sentai : les trucages des séries télévisées japonaises » (*Revue du CIRCAV*, « Trucage et télévision », n° 25, 2016), « Persepolis, une école de la liberté ? » (dans Barbara Laborde (dir.), *Persepolis, dessin de vie*, Le Bord de l'eau, 2016). Elle a dirigé l'ouvrage *L'animation japonaise en France : réception, diffusion, réappropriations* (L'Harmattan, 2016).

Caroline RENOUARD est maîtresse de conférences en esthétique du cinéma à l'Université de Lorraine (2L2S). Ses travaux portent principalement sur les effets spéciaux visuels et les interdépendances anciens et nouveaux médias. Avec Réjane Hamus-Vallée, elle a co-dirigé le numéro de *CinémAction* consacré aux métiers du cinéma à l'ère du numérique (n° 155, juin 2015) et publié *Superviseur des effets visuels pour le cinéma* (Eyrolles, 2015).

Diplômé de l'École nationale supérieure Louis-Lumière, Frédéric TABET est maître de conférences à l'Université de Toulouse Jean-Jaurès au sein de l'École supérieure d'audiovisuel. Sa thèse, soutenue à l'Université Paris-Est Marne-la-Vallée, et ses publications portent sur les modalités d'échanges et les emprunts entre l'art magique et les médias. Il est l'auteur de *Le cinématographe des magiciens* (Presses universitaires de Rennes, 2018).

Marie-Charlotte TÉCHENÉ est doctorante et ATER en cinéma à l'Université Paris 1 Panthéon-Sorbonne (ED 441, HiCSA). Sa thèse intitulée « *Des ondes pour nous imperceptibles* ». *La pédagogie du cinéma selon Jean Epstein : création et rayonnement d'une œuvre des années 1920 aux années 1980* est dirigée par Sylvie Lindeperg et Dimitri Vezyroglou. Elle enseigne par ailleurs l'histoire et l'esthétique du cinéma depuis 2013.

Stéphane TRALONGO est premier assistant à la Section d'histoire et esthétique du cinéma de l'Université de Lausanne. Docteur ès Lettres et arts, il est l'auteur d'une thèse sur l'émergence du spectacle cinématographique dans le contexte des arts de la scène en France. Ses recherches portent sur le cinéma des premiers temps, l'histoire des

techniques cinématographiques et les usages domestiques, industriels ou publicitaires du film.

Diplômé d'architecture et d'histoire des Arts du spectacle, Alexandre TSEKENIS a été assistant décorateur pour le cinéma et scénographe pour le spectacle vivant, puis coordinateur du département décor de La Fémis (2003–2011). Programmateur, exploitant de salle, il enseigne l'histoire et l'esthétique du cinéma (décor, costumes, trucages) à l'Université Sorbonne Nouvelle - Paris 3.

Benoît TURQUETY est professeur assistant à la Section d'histoire et esthétique du cinéma de l'Université de Lausanne. Il est directeur du pôle suisse du partenariat international de recherche *Technès* sur les techniques et technologies du cinéma, et membre du Network of Experimental Media Archaeology. Diplômé de l'École nationale supérieure Louis-Lumière, il a soutenu en 2005 à l'Université Paris 8 Vincennes Saint-Denis une thèse intitulée *Danièle Huillet et Jean-Marie Straub*, « *objectivistes* » *en cinéma* (L'Âge d'homme, 2009). Il dirige le projet FNS « Histoire des machines et archéologie des pratiques : Bolex et le cinéma amateur en Suisse » ainsi que l'axe de recherche « EPIMETE/Épistémologie des médias numériques ». Son ouvrage *Inventer le cinéma. Épistémologie : problèmes, machines* (L'Âge d'homme, 2014) a reçu le Prix international Maurizio Grande 2015.

Cécile WELKER est docteure en cinéma et professeure à l'École supérieure d'art et de design d'Amiens (ESAD) où elle encadre l'option images animées. Elle a notamment publié, avec Laurent Jullier, *Les images de synthèse au cinéma* (Armand Colin, 2017). Illustré d'exemples et d'entretiens de spécialistes, ce livre propose une synthèse sur les évolutions des technologies, des pratiques et des métiers liées à l'apparition des images de synthèse au cinéma.

Dominique WILLOUGHBY est cinéaste et professeur au département cinéma de l'Université Paris 8 Vincennes Saint-Denis. Spécialiste du cinéma expérimental et du cinéma graphique et d'animation, il a notamment publié *Le cinéma graphique : une histoire des dessins animés, des jouets d'optique au cinéma numérique* aux Éditions Textuel en 2009 ; et *Alexandre Alexeïeff : écrits et entretiens sur l'Art et l'Animation (1926–1981)* aux Presses Universitaires de Vincennes en 2016.